DATE DUE

DEMCO 38-296

Behold the Hero
General Wolfe and the Arts in the Eighteenth Century

General James Wolfe's death on 13 September 1759 at the moment of British victory over the French on the Plains of Abraham in New France instantly elevated him to the pantheon of British heroes. His courage, his glorious death, and his leadership of the English and their American colonial brethren in the pursuit of liberty was celebrated in sermons, poetry, drama, music, sculpture, prints, paintings, and decorative arts. Exploring the reasons behind Wolfe's posthumous popularity, Alan McNairn examines depictions of Wolfe in literature and visual arts in England and North America and their aesthetic and political meaning.

McNairn analyses representations of Wolfe in both popular culture and high art, from mass-produced ceramics to Benjamin West's famous painting of the death of Wolfe, from popular songs to the writings of Oliver Goldsmith, Horace Walpole, Tobias Smollett, Thomas Godfrey, Benjamin Franklin, and William Cowper. He argues that Wolfe became the embodiment of British patriotism and the superiority of the English way of life, and that the multitude of literary and visual works about Wolfe, which primarily focus on his death, were created in an environment in which legends of inspiring, politically persuasive heroics were much in demand.

Behold the Hero will be of interest to historians of eighteenth-century England and America, art historians, material historians, and students of eighteenth-century English literature and drama.

ALAN McNAIRN, former curator at the National Gallery of Canada and former director of the New Brunswick Museum, is director of the Canadian Filmmakers Distribution Centre.

Behold the Hero

General Wolfe and the Arts in
the Eighteenth Century

ALAN McNAIRN

McGill-Queen's University Press

Montreal & Kingston · London · Buffalo

© McGill-Queen's University Press 1997

~735-1539-9

urth quarter 1997
ionale du Québec

on acid-free paper

y in the European Union
Jniversity Press

This book has been published with the help of a
grant from the Humanities and Social Sciences
Federation of Canada, using funds provided by
the Social Sciences and Humanities Research
Council of Canada.

McGill-Queen's University Press acknowledges the
support received for its publishing program from
the Canada Council's Block Grants program.

Canadian Cataloguing in Publication Data

McNairn, Alan
Behold the hero : General Wolfe and the arts in
the eighteenth century
Includes index.
ISBN 0-7735-1539-9
1. Wolfe, James, 1727–1759 – Portraits.
2. Wolfe, James, 1727–1759 – In literature.
3. Popular culture – Great Britain – History –
18th century. 4. Popular culture – Canada –
History – 18th century. 5. Popular culture –
United States – History – 18th century. I. Title.
NX652.W58M33 1997 700'.451 C97-900859-X

Typeset in New Baskerville 10.5/13
by Caractéra inc., Quebec City

For my parents
Robert and Rose McNairn
who fostered my interest in art and history
and
for my wife
Kate Greene
my love and my inspiration

Contents

Figures

Preface

Generals Wolfe and Montcalm were both inebriated. They were dressed in grubby eighteenth century costumes and sporting tricorns squashed from use as pillows. Montcalm was carrying a small green plastic suitcase and Wolfe was holding two sword hilts from which the blades had wisely been removed. They stumbled along the Ottawa sidewalk, regaling passing women with verbal enticements carried on wafts of cognac fumes. Montcalm turned around as we approached and introduced himself. My companion told Montcalm that I was writing a book on Wolfe. "I hope its better than Frances Parkman's *Montcalm and Wolfe*," bellowed Montcalm with an alcoholic puff, referring to the rather biased late nineteenth-century standard text on the siege of Quebec. He asked, "Do you think that Wolfe recited that poem. What was it? The one that says 'the paths of glory lead but to the grave.'" Before I had a chance to identify the poem as Gray's *Elegy in Country Churchyard* he asked whether I thought that Wolfe ever got over his love affair with Miss Lawson and what did I think about his fiancé, Katherine Lowther? Montcalm seemed to be very well informed. As I was preparing an appropriately thoughtful answer, Wolfe and Montcalm bobbed their heads and meandered over to an unaccompanied woman who had stopped to inspect the two drunken officers. "Hello I'm Montcalm, this is Wolfe," said the French general, clearly more interested in talking with women than in getting the historical record straight.

My chance meeting in 1993 with Wolfe and Montcalm as they weaved their way home after entertaining at a festival of francophone culture proved to me that the subject of my research, the life-after-death of

Wolfe, was indeed germane to the contemporary world. This was also driven home when I read the line "Thursday morning was one of the moments suspended in time ... paving the way for a dawn of hope" – which sounds like something taken from a 1759 American or English newspaper about the Battle of the Plains of Abraham at Quebec – in a report by a Philadelphia journalist on the beginning of the ground assault in the Persian Gulf War. That war, like all wars, produced heroes for instant public consumption. But our contemporary heroes, military or otherwise, have a remarkably short active heroic lifespan when compared to General Wolfe.

If truth is the first casualty of war – or its equivalent, sport – then hyperbole is the first dividend. Whatever is true for war and sport is doubly true for the heroes they produce. Adulation of a champion has a life of its own, quite divorced from its subject. It is oblivious to fact. It swells and contracts with changes in national or civic sentiment. Today's hero may even be tomorrow's villain, and in becoming a knave acquire those human qualities that were previously intentionally banished from print.

This book is about the life of General James Wolfe as hero. It is not a biography of the man whose life ended at Quebec in 1759: it is the story of Wolfe's life after death. It is a "necrography," an account of the general's multiple post-mortem manifestations and occasional fictitious epiphanies, and as such is a tale of how his admirers gave enduring life to his spirit.

The commodification of heroes is such a common phenomenon in our world that it is taken for granted. But the mass marketing of the hero is just over two hundred years old. It was born at the same moment as the industrial revolution and its twin, the consumer revolution. Wolfe was blessed in departing this world just at the moment when it became possible to reach a huge audience through print, music, theatre, pictures, and other affordable consumer goods.

In collecting material for this book I have been given information and leads by a number of individuals. Among them were Jacinta McNairn, Mark Holton, Mimi Cazort, Maija Vilcins, Satoko Parker, Alan Rayburn, H.T. Mason, Alan Staley, Herbert Reynolds, Paul Castle, and Peter Larocque. I am grateful to the staffs of the various libraries, museums, archives, and galleries where I have gathered information and to Michael Pantazzi, Ludwig Kosche, and my wife, Kate Greene, all of whom read the manuscript for this book and gave valuable advice on how to improve the telling of the story.

I would like to thank the staff of McGill-Queen's University Press, and in particular Joan McGilvray, for turning my manuscript into a book.

I have tried to keep the footnotes to a minimum, using them only to identify the source of direct quotes which otherwise might be difficult to find. This has meant that my indebtedness to the work of others in areas covered by this book is not always as clear as I would have wished. I have drawn heavily on the wealth of information in the excellent monograph by Helmut von Erfa and Allen Staley, *The Paintings of Benjamin West* (New Haven and London: Yale University Press 1986), Ann Uhry Abrams' *The Valiant Hero: Benjamin West and Grand-Style History Painting* (Washington, DC: Smithsonian Institution Press 1985), and J. Clarence Webster's and John Kerslake's studies of Wolfe and the visual arts.[1]

For the dates of the many individuals who had major and minor roles in the story of Wolfe's long life-after-death the reader is referred to the appendix.

Behold the Hero

1

Up, Up, with Roast Beef

In late October 1759 an enterprising English journalist mystically transported himself to the Elysian Fields, where he happened upon two new immigrants who were conversing. Recognizing the reluctant new-comers as General James Wolfe and the Marquis de Montcalm, whose recent actions as commanders of opposing armies in Canada had sealed their fate and set an ineluctable course for the history of North America, he eavesdropped as they discussed the termination of their terrestrial lives. Knowing a good story when he heard one, the writer transcribed the dialogue and, on his return to London, published it.[1]

As he reported it, the two former antagonists were taking advantage of the untroubled atmosphere of Elysium to analyse their fateful encounter on the Plains of Abraham, adjacent to the walled town of Quebec, and exchange thoughts on the meanings to be found in their deaths. Wolfe had perished at the moment of victory on 13 September 1759 and Montcalm had succumbed to his wounds a day later. From their heavenly perspective, both generals judged death in service of a nationalist cause to be an unrewarding experience.

Montcalm, magnanimous in his praise of Wolfe, confessed to covet-ing his successful adversary's valour and fame. His own misfortune, he claimed, was due to his inferior soldiers. They were unlike the intrepid and courageous English troops, who had shown themselves to be "aces at picket," standing against cannon-fire "with a composure and a steadiness not to be expected among the French." Montcalm said his troops were like "puppets," losing "their activity and motion" when even minor strings broke. Their faint-heartedness, however, was not unjustified, for their irresolute behaviour reflected the attitude of

France herself to her domain in North America. Montcalm damned his nation's government for its disinterest in Canada. His army, he felt, had been ill-supplied by an uncaring nation. With sincere sorrow he recalled his unhappy duty, leading forces condemned to a futile defence of Canada for a monarch who was "governed by a company of comedians."

Even more distressing to Montcalm than defeat was the loss of his own life. The disillusioned, now-defunct marquis compared the significance of his sacrifice for the French with Wolfe's for the English, predicting accurately that the memory of the victorious Wolfe would "be forever dear and glorious to posterity," and generations of Englishmen would extol his virtues and exploits. Montcalm cheerlessly declared that his demise, glorious as it was, would "not even be considered as a sacrifice, but rather as an act of despair." "I have foreseen nothing in my last moments," he said dismally, "but the decline of the French empire."

Wolfe's post-mortem disposition, in contrast to that of his old foe, was devoid of melancholy. He responded to his opponent's plaint with a generosity quite foreign to his former earthly character. He applauded the French plan for the defence of Canada, noting that its failure was due solely to the lack of sufficient regular soldiers to hold the vast territory. France had brought defeat on herself. Wolfe lectured Montcalm on how patient the English had been over the continual harassment of her frontier settlements by the French and their Indian allies. It was only in exasperation, said Wolfe, that the English had settled on a plan for the complete reduction of the French in North America.

Concluding his speech on the issue of national interest in the domination of North America, Wolfe became uncharacteristically introspective. Perhaps because he found Elysium an environment conducive to the catharsis of confession, he bared his soul, candidly unveiling his feelings about valour and fame. "If I was to live again," he announced forthrightly, "I should be a great coward." He acknowledged that, given a second chance on earth, his instinct for self-preservation would "prevail above the thirst of that chimera called glory." With a vision improved by death, Wolfe concluded that both he and Montcalm, brethren Europeans, had been fools to abandon their families and relinquish the pleasures of life in order to fight each other in a remote land. Having "established themselves by violence and cruelties" in America, the English and French had merely duplicated their behaviour in Europe in Canada. In an unusual attempt at prescience, Wolfe

predicted inaccurately that within a century or two America, usurped by Europeans, would witness their expulsion by the natives.

However much Montcalm regretted military virtue and honour having eluded him, Wolfe assured him that they were in fact of little consequence. He ended his reflective monologue on his Quebec adventure by considering the paths of glory and fame, admitting to his French companion that, when all was said and done, he would rather have avoided the whole glorious affair. While his countrymen would dwell on his valour, pity his fate, glorify his exploits in the newspapers, and, he supposed, erect a monument to his memory in Westminster Abbey, Wolfe asked, "can all these frivolous encomiums make amends for the loss of my life?" He ended his gloomy speech by telling Montcalm, who at this point must have been reduced to open-mouthed incredulity, "I should prefer the company of a pretty girl for a day or two, with some bottles of your French wine, to all that stuff of glory and reputation."

The English correspondent who recorded the heavenly dialogue and published it in November 1759 intended it to compound the honours being daily bestowed on the memory of General Wolfe, who had departed the earth two months before. Even in the short time since his passing, praise in print of his virtue, honour, and glorious life and death had become commonplace. The author of the posthumous dialogue, however, emphasized Wolfe's heroism by presenting a tongue in cheek picture of him totally at odds with the real Wolfe.

A francophobe, the real James Wolfe, like all esteemed eaters of roast beef and drinkers of beer, would never have contemplated, even for a moment, a seductive and sensuous dalliance with "a pretty girl for a day or two, with some bottles of French wine." For an English hero, amorousness and epicureanism were anathema to virtue. The gustatory monotony of English cuisine, the spurning of piquant sauces, delicate soups and fine wine, functioned as a kind of patriotic nutritional hair-shirt. What was consumed at the English table symbolized restraint and constitutionally guaranteed liberty. The daily repast was a constant reminder of the need to guard against French license and tyranny. "Down, down with French dishes, up up with roast beef," went a popular song. "We came, saw, and conquer'd, the French lilies droop, / Their towns we toss'd up, just as they swallow soup." To honour the power of English fare the song ended with the toast "Here's LIBERTY, LOYALTY, – aye – and ROAST BEEF."[2]

Not only was the consumption of roast beef a patriotic act, so also was the preference for beer over wine. In a popular song of the time

the French were damned for their consumption of "the squeezings of half-ripened fruit," while the English, blessed with hop-grounds to mellow their ale, were, "rosy and plump, and have freedom to boot." The refrain warned the "wine-tippling, dram-sipping" French to retreat because, "beer-drinking Britons can never be beat." In short, "beef-eating, beer-drinking Britons are souls / Who will shed their last blood for their country and King."[3]

James Wolfe lived, died, and was granted eternal fame as the embodiment of distinct British values. This book shows how he came to fill this role and, in so doing, became part of the national mythology.

2

Sorrow Turned into Joy

It was reported that every British soldier on the battlefield outside Quebec on 13 September 1759 "exerted himself as if possessed with an extraordinary spirit for the honour of old England." The men steeled themselves by shouting out "death or victory."[1] Their commander, thirty-two-year-old General James Wolfe, threw himself into the battle, embracing simultaneously both death and victory, and in so doing won immortality.

When news of the death of Wolfe and the fate of Quebec, "the contested prize" which would "decide the fate of a western world,"[2] reached home over a month after the event, there was an instantaneous outpouring of joy. Horace Walpole described the mood of a nation transformed from "despondency to sudden exultation." The people triumphed and wept and "joy, curiosity, astonishment, was painted on every countenance."[3] Yet such was the intensity of passion over Wolfe's death that it was proposed that the English people, in the same way as "the Roman matrons mourned for [Lucius Junius] Brutus, the defender of their chastity," put themselves in a protracted state of mourning. Sense, however, prevailed and such a drastic expression of sorrow, which would have led to shop closing and commercial loss, was not legislated.[4]

Expressions of grief over the loss of the courageous general were temporary and symbolic. Celebrating his death with wild hurrahs was more appropriate, for through Wolfe's sacrifice Britannia had been delivered a victory, salvation had been granted to the battered national ego, and the recent erosion of Albion's divinely ordained supremacy could be seen as merely a temporary aberration in the progressive

revelation of the destiny of the nation. Thus, as one of his several memorialists wrote, in Wolfe's death, "what is commonly abhored as an evil, seems pleasing, welcome and desirable" – a noble demise indeed. For "so to die, is not die in effect, is not to be extinct and forgotten, but to live in the memory of future ages, 'til that duration comes when time shall be no more."[5]

Lamentation over Wolfe's passing was for the most part expressed through sympathy for the grief of his mother and fiancé. "General Wolfe is to be lamented but not pitty'd," wrote Mary Wortley Montagu to her daughter. "Compassion is only owing to his Mother and intended Bride, who is I think the greatest Sufferer (however sensible I am of a Parent's tenderness.)"[6] Wolfe's providentially just death required a polite modicum of public grief but this was to be far exceeded by joy. "Pardon us, most gracious Sovereign," the House of Commons addressed the king, "if we suspend awhile our otherwise unclouded joy, to lament the loss of that gallant general. How gloriously he finished his short, but brilliant career."[7]

The national elation was in keeping with the supposed ecstasy of the dead hero himself. His death, an obituary writer said, was "to himself the most happy that could be imagined, and the most envied by all those who have a true relish for military glory."[8] Military glory was necessary for the propagation of liberty and it was faith in liberty that enabled British armies to defeat the tyrannical French. An anonymous poet lauded the conquest of Canada with the lines: "Blessed liberty! how absolute thy power. / How strong thine arm in the decisive hour."[9] It is no wonder that Wolfe's death in victory was happy – it stood as a symbol for the potency of English liberty.

As an essay intended to help the readers understand how the death of the virtuous Wolfe was especially courageous and heroic explained, the courageous do not indiscriminately expose themselves to death. Real courage is different from despair and death does not "hold out as many charms to the brave as the unfortunate." The genuinely virtuous and valorous do not hold life in contempt. The brave person "through a certain force in the soul may expose himself to mortal danger as often as he is obliged to do so by duty."[10]

The ultimate victory over the French represented by their defeat in Canada was confirmed again and again in the English mind by a rash of celebratory speechifying, writing, and image-making which took the victorious General Wolfe as its central subject. James Wolfe was granted eternal fame as the embodiment of distinct British values. His establishment as national hero began in the aural and literary arts and was

continued and expanded in the visual arts. By the end of the eighteenth century Wolfe's face and scenes of his death were the most widely recognized images in England.

It was Wolfe's death around which writers, composers, and artists piled their patriotic verbal, musical, and pictorial wreathes, for in this single sacrificial military lamb were to be found all the traits required for the flawless incarnation of the ultimate in English virtue. With his death Wolfe bequeathed to the literary and visual artists of England an event that nourished patriotism, fed xenophobia, and enhanced belief in the superiority of the English way of life. The English, in part, defined their faith in the inherent rightness of everything English by contrasting it to what was to them the self-evident total iniquity of their traditional enemy, France. In this era of fervent nationalism, Wolfe and his victory epitomized the undeniable fact of inevitable global Britannic rule and the universal institution of English liberty.

The mentality of a people prepared to absorb and magnify the memory of a hero like Wolfe had been nourished in an environment rife with sentiments such as those expressed by the poet James Thomson in his nationalistic paean "Rule Britannia," which, set to music, became an immensely popular song after its debut at the masque performed on the accession of King George II in 1740. Thomson wrote that his country's "cities shall with commerce shine" and, "All thine shall be the subject main, / And every shore it circles thine." Britannia would rule the waves and hence "Britons never will be slaves." This celebration of the progressive expansion of the British dominion through the authority of commerce and unmistakably superior, constitutionally guaranteed civic liberty was sung over and over again, inspiring the English at home and abroad. In the American colonies, *Rule Britannia* may have had its greatest impact when it was sung at the College of Philadelphia as part of a Christmas holiday entertainment in 1756–57. Thomson's inspiring words, reverberating in the midst of an unmelodious war in which the English had yet to receive significant signs of success, may well have provoked the audience to even greater exertion for their England, their crown, their constitutional liberty, and the unfettered expansion of British commerce.

For the English on both sides of the Atlantic, Wolfe's definitive victory at Quebec was a vindication – in the unlikely case that such were needed – of the self-evident truth of constitutional liberty, Protestant beliefs, and unrestrained capitalism. For a nation imbued with the sentiments expressed in *Rule Britannia,* news of the fall of Quebec in 1759 could not but give rise to spontaneous ebullient euphoria.

The suddenly exalted populace vented their emotions in ephemeral manifestations that, although much less interesting because less unusual than the enduring memorials to Wolfe and the capture of Canada, are indicative of the powerful feelings about the event. In London on Wednesday, 17 October, cannon were fired, bonfires lit, and windows illuminated some with transparencies inscribed with nationalistic slogans. Tobias Smollett said that the victory was greeted with "rapture and riot," and "all was triumph and exaltation with the praise of the all accomplished Wolfe" who the populace "exalted even to a ridiculous degree of hyperbole."[11] The hyperbole was sufficient to stir Oliver Goldsmith to an acerbic attack on the excesses of the English crowd. In his satire he reported that he had ventured forth to survey the capital, view the illuminations, and observe the people. He first encountered an old waiter at a punchhouse lecturing his customers on the ease with which England might now capture Paris, which he knew to be very poorly defended. Goldsmith then came upon a large crowd listening to a woman berating her husband who, swept away by joy, had pawned his waistcoat to buy a candle for the illumination. On Fleet Street the riot of jubilation was played out in artificial daylight created by lights placed in every window. Goldsmith saw, "every face dressed in smiles, the mob shouting, rockets flying, women persecuted by squibs and crackers, and yet seeming pleased with their distress." Having recovered from the shock of a firecracker exploding in his hair, the satirist reflected on how blessed he was to be part of a "glorious political society, which thus preserves liberty to mankind and to itself, who rejoice only in the conquest over slavery, and bring mankind from bondage into freedom." At George's Coffeehouse Goldsmith saw a group of men handing around a piece of paper and laughing uproariously. He at first thought they were reading about Wolfe's victory in the *Gazette* but on closer examination found them to be studying a French heroic poem. It was an epic commemorating the French defeat of the English at Minorca. The men were mocking the poetic propaganda of the enemy as "it now bore the appearance of the keenest irony." In the verse, the French, portrayed as "the children of Mars, the thunderbolts of war," seemed absurd in their boast of world conquest. To the jolly group of gentlemen the words of the poem "were now construed as burlesque."[12]

The victory parties in the provinces were no less spectacular than those in the capital. "I dare say," a newspaper reporter wrote, "there is not a village, a parish, or a hamlet, ever so obscure, which has not copied the joys of the metropolis – London raised her pile of triumph,

and every village lent its faggot, without a metaphor, to the blaze of our national illumination."[13] At Bath, where Wolfe had from time to time resided and where he had become engaged to the second love of his life Katherine Lowther, the bells rang, a flag was hoisted on the Abbey tower, and canon were fired. In the evening the highlight of the illumination was Ralph Allen's mansion, Prior Park, which "outshone anything in imagination, being one grand appearance of light, and making the most sparkling and lively appearance yet seen."[14] In the town of Newbury the bells rang all day. "Twenty pieces of cannon were several times discharged. The gentlemen gave a public entertainment [and] an whole ox which was roasted in the streets with plenty of exhilarating liquors, and [in] the evening [there] were fireworks, illuminations etc." The letter writer who described this civic victory party ended his account by lamenting "the fall of Gen. Wolfe, tho' he died gloriously conquering."[15] In the Sussex village of East Hoathly the celebration centred around a huge bonfire and a hogshead of beer. A self-righteous shopkeeper of the village, Thomas Turner, wrote in his diary that he did not attend the party because he thought this an improper way to celebrate victory. He confided to his journal that he considered the festivity only an excuse for "people to get drunk and run themselves farther into sin." It was "in reality of no service to any individual, whereas I think as God giveth the victory, to Him should thanks and praises be returned."[16] A similar sentiment was expressed by a former neighbour of Wolfe, who on seeing the streets of London "noisy with marrow bones and cleavers and preparations for bonfires & illuminations" thought "Providence ought to be thankfully acknowledged," and the nation ought to show its "concern in the loss of General Wolfe, who fell in the attack, after the noblest conduct that human capacity ever allowed."[17]

On 29 November, the day appointed for national thanksgiving, less spontaneous celebrations were held. Before the second instalment of secular fetes, God's intervention in the affairs of state was acknowledged. A prescribed form of prayer and thanksgiving, hastily published on 20 October, ensured that the church services throughout the kingdom were standardized.[18] Less than a month after stating his wish for a proper recognition of the role of God in the victory, Thomas Turner thus heard what he thought to be a very excellent sermon by the Reverend Thomas Porter, rector of East Hoathly. Porter preached thanks to God using the text of Psalm 50, verse 23, "Whoso offereth praise glorifieth me: and to him that ordereth his conversation aright will I show the salvation of God".[19]

In London the branches of government received separate thanksgiving sermons. The Reverend Dr Louth preached to the king and court in the Chapel Royal on words from Isaiah 14,7; "I form the light, and create darkness: I make peace, and create evil. I the Lord do all these things." His message was undoubtedly an acknowledgement that Divine Providence had decreed that by means of a new genesis the Protestant English were destined to save the world from Catholic French chaos and tyranny. Assembled in Westminster Abbey, the lords heard the Lord Bishop of Worcester preach thanksgiving for the victory, basing his remarks on the words of Daniel, "Blessed be the name of God for ever and ever, for wisdom and might are his."[20] Dr Dayrell preached to the members of the House of Commons on the first two verses of Psalm 95: "O Come, let us sing unto the lord ... make a joyful noise."[21] At St Paul's the lord mayor and aldermen of London were treated to an address by the Reverend Mr Townley on the text "They shall prosper that love" (Psalm 122, 16), in which he told his illustrious listeners and the readers of his published sermon that the love a man bears for his native country is a universal principle. "All men," he said, "are born with this exalted principle; it is stamped on every heart: But to be in a situation that may make it of great and signal service is the lot only of a few." The man blessed with true patriotism, according to Townley, gives proof of his virtue by showing reverence to the religion of his country and by observing the nation's laws. Civic duty and divine providence had combined in Wolfe to produce a victory that every man must behold "with rapture and amazement, though his joy must feel a check, at the loss of that gallant commander who fell in compleating that wonderful victory." Townley, caught up in the joy of the moment, perhaps overstated the case when he said that Wolfe, "by his extraordinary wisdom, valour and experience, by every great and every amiable quality, hath purchased to himself a name surpassing all the names of antiquity." He concluded, "this is an era in the annals of Great Britain, which posterity will remember with admiration and reverence. They will think us an happy generation; surely then we ought to think ourselves so."[22]

The market for published sermons at the time, larger than that for most other types of writing, enjoyed a burst of activity in response to the defeat of the French at Quebec. Many London booksellers promptly added thanksgiving sermons to their stock.[23] Of the several printed versions of orations which appeared on the market, the most popular was that by the Reverend Thomas Smith, who delivered his remarks first at St Giles, Cripplegate, and then at Stratford-Bow.[24] His

self-published and self-marketted text sold very well, going into a fourth printing in 1777.

Thanksgiving services were also held in North America. The first of these was presided over by the Reverend Eli Dawson, chaplain of H.M.S. *Sterling Castle*, who delivered a sermon in the Chapel of the Ursuline Convent at Quebec on 27 September. Dawson dedicated the subsequent publication of his remarks to Wolfe's mother who was, he said, "the object of envy to all British matrons." He invited his listeners to think of the One who inspires the "hero with courage," and "the commander with wisdom and ability." "Whence," he asked, "cometh the original genius for war?" And given this genius, who "brings it to light and exhibits it on the theatre of public life and action?" It is God who does these things. Dawson, at the climax of his sermon, appealed to nature to testify to the victory on the Plains of Abraham. In referring to local topography, the cleric invoked the image of a biblical nation-founder and deliverer, for the name of Abraham, whether by coincidence or providence, was intimately connected with the salvation of the New World. "Tell … ye mountains of Abraham decorated with his trophies, tell how vainly ye opposed him, whither he mounted your lofty heights with the strength and swiftness of an eagle. Stand fixed forever upon your rocky base, and speak his name and glory to all future generations!" Continuing to implore nature to cooperate in broadcasting the heroic tale, he asked the waters of the St Lawrence and the wind to "speed the glad tidings to his beloved country!" He begged the "heralds of Fame already upon the wing" to stretch their flight and swell their "trumpets with the glory of a military exploit through distant worlds," as Wolfe's courage, "shall rank with the choicest pieces of ancient or modern story in the temple of fame, where it remains immortal."[25]

In Boston, the first official service of thanksgiving was held on 16 October. News of the successful siege had reached town some time before so Samuel Cooper, pastor of Brattle Street Church, had had ample time to prepare his sermon for Governor Thomas Pownall and the members of his council and the House of Representatives. Cooper told the colonial elite that divine providence had always served "in defence of the church, and in favour of the cause of truth and the rights of conscience, against … usurpation and tyranny." God was not indiscriminate in his choice of sides within the Christian church. At Quebec he had embraced "the reformed religion, founded upon free inquiry and the right of private judgement, and so friendly to the enlargement of knowledge, and to the liberty which never can be too

dearly purchased." Providence had brought the true religion to Great Britain and "shielded and preserved it" with those secular "rights and privileges which are closely interwoven with it, when they have been threatened with an utter extirpation by foreign and domestic foes." God, said Cooper, inspired the king's concern for his American colonies because "the dignity of his crown, and the power and commerce of Great Britain are so closely connected," and because the colonies have suffered "from an enemy unprovoked, unless by our growth and prosperity." Divine providence had worked through the king and Wolfe in the New World to guarantee "peace, prosperity and unhindered commercial expansion."

He went on to direct his listeners to consider the conquest of Canada in light of the character of the enemy. The French were "an inveterate and implacable enemy to our religion and liberties; inflamed with Romish bigotry, perfidious, [and] restless." But they were not just misguided in their religion and character – they were also envious of British "superior advantages and growth." Cooper's development of his theme from the theological to the political, from celebrating the victory of the true religion to a victory for mercantile growth, reflects his belief in the morality of colonial American territorial and commercial expansion. Only when the threat on the frontiers was ended could a liberated continent pursue unhindered growth. With the cessation of French commercial envy, manifested in their use of "savages to drench our borders with the blood of the unarmed," America could pursue its own destiny.[26]

Amos Adams, pastor of the First Church in Roxbury, preached a more temperate and less overtly political sermon of thanksgiving. He confessed that he was as overjoyed as anyone at the victory but instructed his congregation to remain mindful of Christian charity. It was not unlawful to rejoice in military success but victors must not revel in the fall of enemies and their miseries. The victorious should not dwell on the economic distress inflicted on the vanquished but rather enjoy "the pleasing prospect" of newly won protection for trade and commerce and "undisturbed and lasting peace." The joy of victory should not arise solely from the natural feeling of gratitude for the preservation of lives, properties, and religion and from vengeance satisfied by seeing the enemy reduced but rather should include joy arising from magnanimity issuing forth from pity held in the forgiving heart. The Reverend Adams proposed a temperate nationalism. "Even the love of our country," he told his parishioners, "becomes excessive and faulty, when we are thereby detached from the general good;

when we are led to seek its interest to the real prejudice of any part of the human species." He warned his parishioners of the danger of thinking of the English nation "as a family having privileges or natural claims above the rest of the world." "All nations are one offspring," he said, "they have one father, they have the same natural rights, they make but one family."[27]

The theme of humility in victory was similarly stressed by Jonathan Townsend in his sermon *Sorrow Turned into Joy* delivered to his congregation at Medfield on 25 October, the day appointed, in the Massachusetts-Bay colony to thank God for the victory at Quebec. The Reverend Townsend inverted the usual form of the thanksgiving sermon, beginning with a detailed history of the French and Indian War and concluding with the religious and secular meanings of the victory. Townsend emphasized the military aspect of the victory and explained the role of General Wolfe in the divine plan. He characterized Wolfe as a "worthy and a valiant General, who in this distant land ... appeared as zealous, active, bold and intrepid, as though the cause was his own or that in which he was personally and very deeply interested." Like so many of his contemporaries, Townsend used the contrast between the sadness one might feel over the death of Wolfe with the happiness of his victory to heighten the meaning of the dramatic moment at Quebec. "So we, tho' we have gotten the Victory and this day rejoice in our Acquisition, can do no less than drop a tear over the urn of our great commander, and the many valiant men besides who fell in the cause."[28]

In Boston, Jonathan Mayhew delivered a two-part thanksgiving oration to his congregation at West Church. In the morning he gave a history of the recent war in Europe and America and at the climax, the subjugation of Quebec, considered the two contending generals. "Wolfe," he said, "was one of those rare military geniuses, which like the Phoenix, appear but once an age, except perhaps in Great Britain." He was, according to Mayhew, one of those gifted men whose "courage nothing could abate, whose ardor, regulated by prudence, nothing could damp, whose resolution no difficulties however great, could shake or alter, [and] ... whose wisdom and address at a critical juncture, were not inferior to his other great military accomplishments." As to Wolfe's opponent, the Boston preacher asked why Montcalm would risk Canada, even with superior numbers, when he should have known that with British troops "there is something else of more consequence than numbers." Did Montcalm not know "that God has given men different nerves, sinews, arms and hearts?" Did he not know

that "those who fight for a tyrant will not fight like free-born Britons?"
Montcalm's failure was in misplaced faith. Mayhew, rhetorically
addressing the Catholic Montcalm, said, "perhaps thou thinkest thy
relics, thy crosses, and thy saints, either St Peter, or thy great Lady,
whom thou profanely stylest 'The Mother of God,' will now befriend,
and make thee victorious. But remember, that little host now in array
against thee, worship the God that made the heavens, earth, and seas,
… the Lord of hosts is his name. He is the glory and the victory." Had
Montcalm won, according to Mayhew, an unutterable horror would
have been visited upon the English in North America. They would
"have been deprived of the free enjoyment of the Protestant religion,
harassed, persecuted and butchered by such blind and furious zealots
for the religion of Rome, under the direction of a priesthood and
hierarchy, whose wisdom, to be sure, is not from above."

In his afternoon discourse Mayhew continued to admonish his audi-
ence to recognize God's services to the faithful English. His glory on
the battlefield, where the trenches "turned into canals running with a
purple tide, till choked with the dead and dying, fallen promiscuously
on one another," ensured deliverance from "the ravages and barbari-
ties of faithless savages, and more faithless Frenchmen." The French
alone were responsible for these horrors, for the Indians "would have
lived in peace without the French prodding them." Although the
natives of America are "different in complexion," announced Mayhew,
they are "much the same in heart" as the English. To document the
savagery of the French, the New England preacher included a foot-
note in the printed text of his sermon stating that the governor gen-
eral of New France, the Marquis de Vaudreuil, "had the inhumanity,
or may I not rather say? the brutality, to ornament a room with English
scalps hung round it, which he used to show to his unhappy prisoners,
to insult them, pointing out to them which were the scalps of their
near relations, friends and neighbours."

Mayhew, an outspoken advocate of American commercial expan-
sion, concluded that the victory would produce some practical and
purely secular advantages. Without having to fight the French and the
Indians money would be saved, less tax would be necessary, more set-
tlers would arrive, and greater prosperity would follow as commerce
with the Indians expanded. As well, with the French excluded from
the hemisphere, commercial competition from the French West
Indian sugar islands and the French fishery would vanish. Mayhew
predicted a flourishing America with great cities, but he added in
parentheses that this new empire would not be an independent one.

(The possibility of such an independent empire had clearly crossed his mind and was not entirely anathema to his listeners.) The good fortune which would come to the New World, said Mayhew was due to divine providence having worked through Wolfe, "untimely, though gloriously fallen," a man, mortal in body, "but immortal all beside!" He praised Wolfe as being immortal in deeds, immortal in memory and immortal in fame.[29]

Mayhew's francophobia was exceeded by that of his Boston colleague, the non-expansionist Reverend Andrew Eliot of New North Church. Eliot began his address to his congregation, Boston's largest, with a long, detailed and biased history of the English struggle against popery and the "grasper temper" of the French, who sought "in the process of time to drive us into the sea." The enemy had armed the Indians and "filled them with prejudices against the English," encouraging them "in inhumanities unknown to civilized nations." The French, along with their Indian mercenaries, perpetrated "the most unmanly cruelties upon the women and children." To Eliot it was natural that God sided with the English and "carried our forces through the difficulties and dangers of the siege. He preserved their health. He inspired our troops with courage. He removed the French General. In fine, it was God, the great Ruler of the universe, that gave Quebec into our hands." God did all this through Wolfe, who, "as if satisfied with life, ... resigned his great soul, and bid adieu to the world and all things in it." Eliot ended his sermon with the supposition that the victory might have been granted to the English so that they could spread the gospel among the Indians.[30] He pointedly omitted any reference to the potential for commercial expansion now that the French and the Indians had been defeated.

Even after the special thanksgiving services New England preachers continued to moralize on the victory at Quebec and evoke the memory of Wolfe in explaning the divine plan for colonial America.[31] Sober consideration of divine providence, however, did not prohibit less restrained civic revelry. In Boston on 16 October there were public rejoicing and fireworks to celebrate what the newspaper called "the greatest, the most happy and glorious event that ever took place in America."[32] A royal salute was fired in Philadelphia upon the arrival of the good news from Quebec and the ships in harbour hoisted their colours. The following evening there was a general illumination and fireworks were set off. It was reported that "the general joy was perhaps as great as ever known."[33] The town of Flushing, New York, held a party on 7 November to mark the "reduction of that long dreaded sink

of French perfidy and cruelty, Quebec." A huge banquet was laid out and toasts were drunk to "all and sundry." A hundred canon were fired and there was a bonfire and illumination – "the whole conducted with the greatest harmony and decency."[34] Decency during the victory parties was rare enough for Pastor John Burt of Bristol, Rhode Island, to warn his flock of the "excesses which men are apt to run into upon such occasions ... Carnal joy which degenerates into rioting and debauchery, into revelling and drunkness."[35]

Celebration and thanksgiving were not confined to England and her colonies. A most unusual victory party was said to have been hosted by Voltaire at his country house near Geneva. The after-dinner entertainment, according to a newspaper report, included a production of Voltaire's play "Le Patriot Insulaire" [sic] in which the author, in the title role, "drew tears from the whole audience." The scenery consisted of emblems of liberty and over the stage was an inscription which read in part "spite of the French." When the play was over "the windows of the gallery flew open and presented a spacious court finely illuminated and adorned with savage trophies. In the middle of the court, a magnificent firework was played off, accompanied with martial music; the star of St George shooting forth innumerable rockets, and underneath a representation, by girandoles, of the cataracts in Canada."[36] That the only account of this celebration appeared in the English press suggests that the story is apocryphal or completely garbled, as was and is common in such periodicals. It is true, however, that Voltaire considered Canada to be a snow-covered wasteland and the war between the English and French in North America to be "a trifling quarrel" over "a country to which neither had the least right."[37]

The meaning of the conquest of Canada obviously varied. For Voltaire, if the report of his party was true, it may have represented the punishment of France for misguided principles of government, in particular the denial of the kind of civic liberty enjoyed in England. For expansionist-minded American colonists, the victory stood as a turning point in colonial commercial development. As John Adams later wrote, it was not until the defeat of the French in North America that Britain dared to wake the acts of trade from dormancy and attempt to extract a national revenue from North America. "This produced, in 1760 and 1761," said Adams, "an awakening and a revival of American principles and feelings, with an enthusiasm which went on increasing till, in 1775, it burst out in open violence, hostility, and fury."[38] Other residents of the imperial periphery in American thought that the greatest good resulting from the reduction of the French was the

opening of the continent to Christianity and Protestantism, with the sacrifice of General Wolfe an unfortunate prerequisite to these benefits. For the English, Wolfe's glorious death symbolized the propriety of their suzerainty over North America and Wolfe assumed prominence in the pantheon of national heroes whose lives exemplified the values necessary for the English as they strove to obtain dominion over greater and greater expanses of the globe. This divinely appointed dominion was seen as the inevitable result of the inherent rightness of the English constitution and Protestant values, both of which protected liberty and guarded against tyranny and licentiousness.

The soil of eighteenth-century England was uniquely suited to the flowering of passion for the spirit of General Wolfe. Conservative English values and fear of French ideas combined to promote quick germination and accelerated growth of an industry which metamorphosed the historical facts of the battle for Canada and the death of General Wolfe into symbols of British virtue and its fruit, parliament and empire. The promulgation of the message of Wolfe in eighteenth-century England, driven by commerce and nationalism, was nourished by evolving concepts of religion, politics, history, art, and literature. The transformation of General Wolfe into a timeless symbol serving the needs of the English nation required the re-creation of his mortal manifestation. Wolfe, as the personification of British virtue and British might, grew with his post-mortem fame to assume characteristics expected of Britannia incarnate. The events of his brief life could not be considered accidental, for patriotic legend holds no brief for chance. In the literature and art of the eighteenth century, Wolfe appeared as pre-destined to follow the path of martyrdom. That he went happily to the grave reflected his blameless, if in the end somewhat reckless, commitment to what he considered to be his patriotic duty.

3
The Glorious Catastrophe

The English were not unanimous in applauding Wolfe's sacrifice and victory at Quebec: a contrary few used "all their eloquence and art to detract from that glorious patriot."[1] The pamphlets of some shrill naysayers who precipitated a minuscule debate on the capture of Quebec and General Wolfe's behaviour there are interesting less as evidence of the capacity of the nation to ignore opposing views than as testimony to the unassailable power of the symbolic Wolfe who came to stand for all that was good and just in the destiny of the nation.

A writer to *The Monitor* in October 1759 anticipated that some might question the value of Wolfe's success. The anonymous correspondent's letter dealt first with the issue of the importance of the conquest of Canada and the intention or accident which led to the victory. "At a time when the nation rings with exultation and joy from every quarter, … it may seem a paradox to caution your readers against any … attempt to represent the victory over the Canadian army, and the taking of Quebec, to be actions either not of that consequence as is generally conceived; or to have been the accidental issue of a rash resolution of the Commander in chief; or of such a nature as to deserve no merit." The writer went on to say that critics of the victory were politically motivated and as such were bent on attacking not only the wisdom of the prime minister but also the reputation of those who had carried out his orders at Quebec. He warned of attempts to besmirch the reputation of Wolfe by people who were "trying every argument to reflect upon the conduct of the officers to whose wisdom and behaviour we are indebted for the possession of Quebec." These insidious contrarians, he said, "spare no pains to represent this

conquest as an obstacle to a peace; or to lessen the merit of the enterprise, by raising false notions of military duty."

According to him, not only were some cantankerous rumour-mongers casting aspersions on the behaviour of the officers at Quebec but, even worse, a few were attacking the reputation of Wolfe, "the gallant general" whose "universal conduct has left an heroic example of military skill, discipline and fortitude." Some critics were accusing Wolfe of "acting against the opinion of his council" or saying that his victory was attributable "solely to chance and uncertain events in the heat of battle." The writer ended his essay by praising Wolfe, whose "memory will ever shine in the British annals!" History was invoked to give a sheen to the general's heroism. Wolfe revived "the courage of our Edwards and Henries" and gave a new life to "that military skill and discipline which enabled those puny armies at Poitiers, Cressy, and Agincourt to defeat the vast armies of France."[2]

Some of the ammunition used by politically motivated curmudgeons who denigrated the victory was supplied by surviving major protagonists in the event. Wolfe's three brigadiers at Quebec, Robert Monckton, James Murray, and George Townshend, held strong opinions on strategy and on Wolfe's character both during and after the siege. Townshend wrote to his wife a week before the final battle that he had "never served [in] so disagreeable a campaign as this. General Wolfe's health is but very bad. His generalship not a bit better. His orders throughout the campaign show little stability, stratagem, or fixt resolution."[3] Even before his return to England in late November 1759, Townshend had been accused of disrespect to the memory of General Wolfe and attempting to usurp the laurels of victory. The gossip drove one of Townshend's defenders to write to both the *Public Advertiser* and the *London Chronicle*, pointing out that it was well known that Townshend's only motive for engaging in the dangerous enterprise in Canada was his desire to serve the cause of his country and warning the public that Townshend's "abilities and integrity make him too valuable to the public to be lightly lost." To demonstrate Townshend's regard for General Wolfe the writer appended a letter from the brigadier to the secretary of state in which he said "I have lost but a friend in General Wolfe" and, further, "if the world were sensible at how dear a price we have purchased Quebec in his death, it would damp the general joy ... Our best consolation is that providence seemed not to promise that he should remain long among us." Wolfe himself was "sensible of the weakness of his constitution, and determined to crowd into a few years actions that would have adorned length of life."[4]

The aristocratic Townshend had brought the disdain of rumour-mongers on himself. In his dispatch announcing the outcome of the battle at Quebec, which he had prepared as commander of the forces after Wolfe's death and Brigadier-General Monckton's wounding, he considered the death of a career soldier such as Wolfe to be worth only a mention in passing. Had Monckton also been dead, as was erroneously reported in the newspapers,[5] Townshend, who disliked Wolfe, might well have attempted to usurp all the laurels of victory. As a hostile pamphleteer later observed, Townshend's dispatch had failed to pay "one civil compliment to the memory of General Wolfe" or to include "one kind expression of esteem or affection with regard to his person."[6] The unfortunate and probably intentional omission was brought to public attention shortly after the dispatch was published. A newspaper writer said "the surviving in command omitted (I hope it was no more) to raise one stone to his rival's merit."[7] In a letter of January 1760 the poet Thomas Gray gave a clear picture of the current rumours. "No great matters are attributed to his [Townshend's] conduct. The Officer [Colonel Hale] who brought over the news, when the Prince of Wales asked how long General Townshend commanded in the action after Wolfe's death, answered, 'A minute.'" Gray said that Hale then told the Prince that, "it is certain he [Townshend] was not at all well with Wolfe, who for some time had not cared to consult with him, or communicate any of his designs to him."[8]

On his return home, however, Townshend was greeted with warmth by his supporters. At Honningham, near his brother Charles's estate, he was heartily cheered by the public, who celebrated his return with fireworks, a bonfire, and a feast of fat sheep and strong beer.[9] On 21 November William Pitt, secretary of state for the southern department and architect of the expedition to Quebec, speaking in parliament on a motion of thanks to the generals and admirals involved in the capture of Quebec, addressed his longest and warmest praise to Townshend who, he said, "had gone unrequested whither the invited never came." The recorder of Pitt's generous words on Townshend, however, pointed out that "this was far from being strictly the fact". Townshend was not a volunteer. He had been sent, so it was believed, by Pitt "who wished to get rid of so troublesome a man."[10]

The controversy surrounding Townshend did not die quickly. The hostile pamphlet quoted above drove the brigadier to challenge the Duke of Albemarle, who he supposed to be its author, to a duel. The contest was aborted and Townshend vented his rage in a less dangerous fashion. He, or a surrogate author, attacked by pen and fired off

a pamphlet in refutation.[11] An indulgent reviewer of the resulting acrimonious essay observed that in spite of some regretfully "low" and "illiberal abuse of two or three characters," it presented such a convincing argument that "every impartial man, and real lover of true merit," would be persuaded of Townshend's generosity and courage.[12] To add substance to his vindication of Townshend, the pamphleteer reprinted the letter from the brigadier to the secretary of state.

It is unlikely that Townshend's feelings toward Wolfe were as he purported them in print. Shortly after returning to England he wrote to General Murray at Quebec assuring him that the government was fully satisfied with the behaviour of Wolfe's three brigadiers and advised Murray not to criticise Wolfe who was "deserving on many accounts so much from his country."[13] Townshend at times could be more pragmatic than truthful.

In spite of George Townshend's efforts to present himself as an admirer, his disdain of General Wolfe is clear in eight satirical drawings, now in the McCord Museum, Montreal, which he presumably did at Quebec before Wolfe's death.[14] He sensibly kept these records private. For one of the drawings, inscribed *Shade of Cromwell Has England then come to this*, he ransacked English history to find a prototype for the vicious behaviour of his commander (Fig. 3.1). In another drawing Townshend pictured what he considered to be Wolfe's unnecessarily draconian measures against French civilians, with a caption in which the general says (in French so the Canadians can understand), "My orders are firm. For each man caught, a bullet – for each woman – two." Townshend felt that Wolfe would continue to provide reprehensible leadership after the fall of Quebec, when Townshend expected that the Canadians would be in even greater peril from him. He depicted this in a drawing of Wolfe being petitioned by two Canadian ladies who are asking that he spare the women if Quebec falls. Wolfe replies, "Send 50 beautiful virgins immediately, and we will see."

Later in life Townshend held his tongue and controlled his pen on the subject of Wolfe. He politely declined to assist General Murray, who was collecting material for an exposé of Wolfe's generalship. Murray himself had not gained a good reputation through his service in Canada. After the conquest he served as governor of Quebec from 1760, where he "got into a mistake and a morass, and was enclosed, embogged, and defeated" by the French at Ste-Foy,[15] until 1766, when he was recalled to England to face charges of showing partiality to the French. Murray, whom Wolfe had once called "my old antagonist," confessed to Townshend in 1774 that he was "knocking [his] obstinate

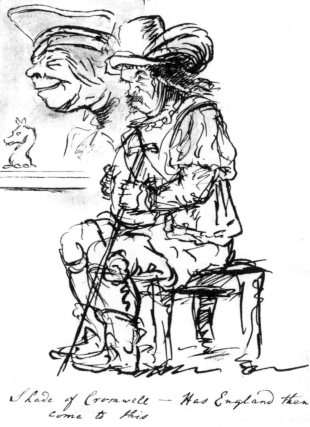

Shade of Cromwell — Has England then come to this

Fig. 3.1 George Townshend, *Shade of Cromwell –
Has England then come to this*. Drawing, 1759
(McCord Museum of Canadian History, Montreal)

Scotch head against the admiration and reverence of the English mob
for Mr Wolfe's memory." It was his intention to write an accurate his-
tory of the siege of Quebec and in it he believed, "truth must prevail
at last."[16]

What Murray considered to be untruths were ubiquitous in print.
Particularly irksome to him would have been argumentative prose such
as that of one Richard Gardiner who, in the introduction to his book
of documents on the siege, stated that his purpose was to prove incor-
rect "a remark too frequently made, and a very severe censure it is
upon military gentlemen in general, that is, allowing them bravery,
they still are deficient in their knowledge of the art of war." Gardiner

said that the documents demonstrated that Pitt and Wolfe, the former possessing "extensive genius" and the latter "matchless intrepidity," deserved inestimable praise for the "reduction of all Canada to his Majesty's obedience." Wolfe and his officers, who "triumphed beyond all hope and opinion, surmounting obstacles judged to be insurmountable, and reaping such iron harvests of the field, could not be men very ignorant in their profession, or remarkably deficient in their knowledge of the art of war."[17] Murray, while probably pleased to accept such praise of himself, considered Wolfe to have been a feeble strategist, an incompetent tactician, and deficient in directing his officers and thus entirely undeserving of the kind of accolades given him by the likes of Gardiner.

Townshend was reluctant to renew, some fifteen years after the fall of Quebec, what had heretofore been a private debate on Wolfe's military skill. Declining to be Murray's ally, he said, "the public admire Mr Wolfe for many eminent qualities, and revere his memory; and, therefore, any distinction that may be made, upon the merit of a field where he fought and died, will be but ill received, and, in fact, be deemed an irreverence to a tomb, where it is to be wished, the laurels may ever sprout."[18] Horace Walpole encapsulated the evolution of the dispute when he wrote, "from the first he [Townshend] received great assurances of countenance – but the passion of gratitude with which the nation was transported towards Wolfe's memory overbore all attempts to lessen his fame. It was not by surviving him that he could be eclipsed."[19]

Townshend concluded his argument for not re-opening the debate on Wolfe's leadership at Quebec by observing that he had "lived long enough to see people not only divided in their opinions upon those who served there, but even upon the utility of the service itself, and of that important acquisition."[20]

The English were, in fact, almost undivided in admiration of General Wolfe. They did not, however, unanimously applaud his subordinates, nor were they of one mind on the importance of the acquisition of Canada. Lord Chesterfield, a neighbour of the Wolfe family on Croom Hill, Blackheath, in his letter of 25 June 1759 to his son, observed with dismay that some were even then considering the likelihood of restitution to France of the as yet unconquered Canada. "But must ... the advantages purchased at the price of so much English blood and treasure, be at last sacrificed as a peace-offering?" Many held, with some justification, that England had the unfortunate habit of negating the advantages of military might through timid negotiation

of terms of peace. Chesterfield predicted that the thought of giving up Canada would fuel a bilious opposition. "God knows what consequences such a measure may produce: the germ of discontent is already great, upon the bare supposition of the case; but should it be realized, it will grow to a harvest of disaffection."[21] In October of 1759 the less perspicacious Pitt, eager for swift peace, mulled over the options. He wanted to keep Senegal and Gorée, didn't care one way or the other about Guadaloupe, was resigned to keeping Minorca, thought Niagara, the lakes, and Crown Point should be held as a security buffer for the American colonies, and concluded that Quebec, Louisbourg, and the as yet uncaptured Montreal should be traded to the French for something worthwhile.[22]

After the victory at Quebec, Pitt's choices with regard to Canada were limited by public opion. Many in England could have marshalled arguments to answer the pamphleteer who wrote: "It is something paradoxical, if not inconsistent, that Canada, being of so very little importance to France, can be so much the greater to us ... by retaining [Canada] we can expect it to become no other than a colony, without trade and inhabitants."[23] Benjamin Franklin sent a satirical letter to the *London Chronicle* on Christmas Day 1759 in reply to a suggestion that Canada should be given back to the French as a symbol of English moderation and magnanimity. Franklin listed several appropriately ludicrous reasons for the restitution of Canada to France, among them that if the French were to control Canada "by means of their Indians," they might carry on "a constant scalping war against our colonies and thereby stint their growth ... For otherwise," he said, "the children [the American colonies] might in time be as tall as their mother." In his ninth reason for abandoning Canada, Franklin referred to the cost of the acquisition of the colony. "What can be braver," he wrote, "than to show all Europe we can afford to lavish our best blood as well as our treasure in conquests we do not intend to keep? Have we not plenty of Howe's, and Wolfe's etc. etc. etc. in every regiment?"[24] The *London Chronicle* which included Franklin's letter also announced publication of his long and persuasive pamphlet *The Interest of Great Britain Considered with Regard to her Colonies and the Acquisition of Canada and Guadaloupe.* In this essay Franklin developed a rational argument for the retention of Canada based on the economic advantages that this would have for to Britain and her American colonies. Others advocating English control of Canada argued the need to free the continent from the threat of another Anglo-French war and the necessity of British control of the fishery, the fur trade, and trans-Atlantic commerce.

Among the dozens of pamphlets published on the issues were some arguing for the opposing view. The Duke of Bedford, England's peace negotiator, observed perceptively that giving Canada back to the French would diminish the chances of commercial expansion or revolt in the American colonies. A pamphlet of 1761 argued that a large army would be required in order to subjugate the French in Canada. This would lead to emigration, the depopulation of Britain, and increased American strength. The inhabitants of North America would become more "licentious from their liberty, and more factious and turbulent from the power that rules them,"[25] an accurate prediction of subsequent exertion of colonial rights over the authority of the crown.

However all political and economic considerations in the discussion on the fate of the captured territories were overshadowed by the memory of the brilliant and selfless Wolfe. Arguments for the retention of other trans-Atlantic territories captured by the English lacked the suasive power of noble blood shed in the cause, such as that which had flowed from Wolfe's wounds. The weight of his image is exemplified by satiric print published on 10 February 1763 which shows a balance with on one side the English peace negotiator, the Duke of Bedford, on his hobby horse and on the other the French negotiator, the Duc de Nivernois, on his. In Bedford's pocket are labels inscribed, "Wolfs [sic] monument defased" and "Conquests restored."[26] In making war, for the most part, the English eagerly followed the government but in the making of peace, they would not. Such an important matter could not be left to politicians who had such a wretched record in diplomacy.

Wolfe's importance to such arguments had developed in a relatively short period. In the fall of 1759 the British patriotic crowds dancing, drinking, and praying in commemoration of his death and victory knew little if anything about North America, Canada, or Quebec – and virtually nothing about their new hero. The process of creating the image of the martyr from a smattering of facts overlayed with large dollops of fiction had, however, started the instant news of his death reached home. The literature and art discussed in the following chapters have little to do with General Wolfe and the Battle of the Plains of Abraham as they would be described by today's scholarly scientific biographers and historians. Yet the gilded untruths are infinitely more revealing than stark facts. The fictions about the conquest of Canada are stranger, in many case more informative, and, for the eighteenth-century English public in particular, far more useful and entertaining than the facts.

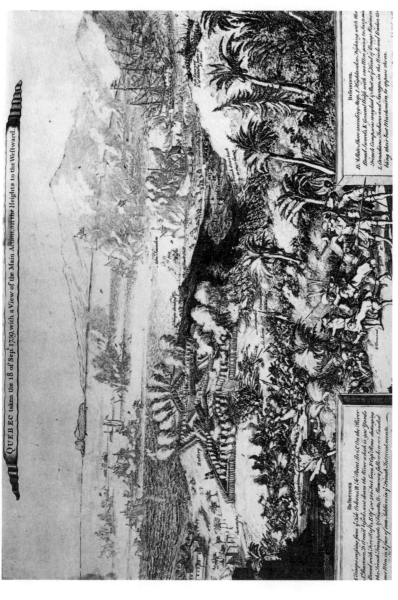

Fig. 3.2 *The Siege and Taking of Quebeck.* Engraving, c. 1769, pulled from a recut plate, showing the incorrectly dated capture of Quebec, which is situated among palm trees. (Webster Canadiana Collection, The New Brunswick Museum, Saint John)

The unadorned reporting of the moves of the British at Quebec makes for flat, uninteresting, and unheroic prose. Eyewitness accounts of what happened on 13 September 1759, valuable as they might be to historians, were of little use to those who were to memorialize General Wolfe. Charles Holmes, accurately, if blandly, described the battle in a letter home. "About midnight 1800 troops embarked from the ships in boats, about half past two the boats got underway." After scaling the cliff with his troops, Wolfe "from eight to ten," was "busy in assembling and drawing up his army." Montcalm led his troops from the fortifications of Quebec to face the English. "About 10 he marched in order of battle and attacked. They fired twice before he [Wolfe] made any return. Then commenced the battle; which hardly lasted a quarter of an hour. Wolfe fell early in the action and only lived long enough to know that his troops were victorious."[27] Another account from an English eye-witness filled in some of the details. Montcalm had led his troops from the city in three columns at about nine in the morning. He drew them up in line of battle six deep. The flanks were covered by thick forests on each side "into which they threw above 1000 Canadians and Indians, who galled us much." The French line "gave their first fire at about 50 yards distance, which we did not return, as it was General Wolfe's express orders not to fire till they were within 20 yards of us ... In about 15 minutes the enemy gave way on all sides, when a terrible slaughter ensued."[28] The Reverend Mr Cotton's report to Lord Temple was even more terse. Wolfe "landed early in the morning of the 13th, with very little opposition, and about 10 o'clock the armies had a close and warm engagement, and the enemy was entirely routed."[29] The only regret over the conflict that appeared in print concerned its brevity: the English troops were frustrated at not having had "a better opportunity of shewing their discipline and valour."[30]

In contrast to these matter-of-fact reports, what happened after Wolfe and his troops disembarked below the cliffs at Quebec was quickly absorbed into the legend of the hero of Quebec created to meet the desires of a voracious patriotic audience. Pitt summarized the sequence of events on that fateful day and the import of the successful amphibious assault much more eloquently: "The horror of the night, the precipice scaled by Wolfe, the empire he, with a handful of men, added to England and the glorious catastrophe of contently termi- nated life when his fame began."[31]

Who was Wolfe? It would seem that his hero, this secular world's equivalent of a saint, must have accomplished incredible feats and

have had superhuman prowess in strength or cleverness. A worthy biography and an identifiable physical presence were prerequisite to Wolfe's assumption of eternal fame. It did not matter that such materials had not been collected before his death – they could rapidly be acquired or fabricated after his death, strict adherence to truth in the creation of a hero's biography and appearance being of little or no consequence.

The amount of creativity involved in reporting Wolfe's triumph has made the truth about his life and appearance elusive. It is useful to delve into what the facts may have been only in so far as they illustrate the very tenuous strand that connects them with the character and appearance of the man as he came to be known in the period after his death. Wolfe's father, Edward Wolfe, then a lieutenant-colonel, and his mother, Henrietta Thompson, were married in 1724 in York, where they spent the first two years of their lives together. They then moved to Westerham, Kent, where James was born in 1727, his baptism registered in the village church of St Mary's.[32]

Shortly after news of Wolfe's death reached England newspapers reported that "the late brave General Wolfe was born in the city of York."[33] This was corrected by a correspondent who provided evidence of Wolfe's birth in Westerham. Peeved at this assault on his civic pride, a man from York replied, "to give the (Kentish man's) assertion the colour of truth, he palms a sham register upon us without a name to it. It is an easy matter, to whip up such a dab of evidence and I should not be surprised if such a one was to be produced, from every county in the kingdom, as I have read the natives of ten different ones claim the deceased, yet ever living leader. But certain it is, he was born in the City of York, and educated there for several years."[34] This led a poet, observing this municipal rivalry, to remark on the classical precedent for such claims and counter-claims over a hero's nativity.

> Contending cities then, inspired by fame,
> To Homer's birth advanced their eager claim.
> Not with less pride, each county now behold!
> Among her sons lies gallant Wolfe enrolled.[35]

In his youth in Westerham Wolfe established a lifelong friendship with his neighbour George Warde of Squerryes Court, who would later do much to preserve the memory of Wolfe in his native town. In 1738 the Wolfe family moved to Greenwich, where James and his younger brother Edward attended the Reverend Samuel Swinden's school. At

the age of 14 Wolfe was appointed 2nd lieutenant in his father's regiment, the 44th foot. The following year he received the rank of ensign in the 12th foot. The young soldier earned rapid promotion in his chosen career. He served on the continent in the War of the Austrian Succession and at the age of 18 was made brigadier-major. He had his horse shot from under him at the battle of Dettingen and was wounded in the Battle of Laeffeldt in 1747. Following the Peace of Aix-la-Chapelle (1748) he served in Scotland under the command of the brutal Duke of Cumberland and the ferocious General "Hangman" Hawley, an apprenticeship in the savagery of modern English warfare. His active participation in the devastation of the Scots and their land, before, during, and after the battle of Culloden, would serve him well in Canada, first in his bloody rampage through the Gaspé in 1758 and later in terrorizing Canadians in and around Quebec.

In Scotland he nursed his fragile constitution, impatiently waited for action in which he could distinguish himself, and pined after Miss Lawson, who lived next to his parents on Croom Hill at Blackheath. "Some people reckon her handsome," he said of the object of his affections, "but I, that am her lover, don't think her a beauty." Wolfe admired her "sweetness of temper," good sense and "very civil and engaging behaviour." More to the point, according to the young officer, she had refused engagement to a clergyman endowed with an annual income of £1,300! Miss Lawson's wealth, Wolfe confessed, was "no more than I have the right to expect viz £12,000." The only objection the future hero of Canada could find in the match was that the tall and thin woman was about his own age. To a confidant Wolfe complained that if he were confined to Glasgow too long, "the fire will be extinguished," as "young flames must be constantly fed, or they'll evaporate."[36]

The love affair led to a temporary rift in the Wolfe household. At home on leave, James argued with his parents about his choice of a bride. He stormed from the house and went to London where, as he confessed to a friend, he "committed more imprudent acts" than in all his life before. "I lived in the idlest, dissolute, abandoned manner that can be conceived."[37] His flirtation with libertinism left him ill. Of course, none of this appeared in his eighteenth-century canonical biography. His frank comments on his love-life, even if known, would certainly have been ignored by the patriotic writers. As recently as 1901 an editor of the letter containing Wolfe's thoughts on Miss Lawson tactfully avoided tarnishing the hero's reputation by censoring the material quoted above. To explain the deletion he repeated verbatim

a statement that had accompanied the first bowdlerized publication of the letter in the nineteenth century: the text had been expurgated because it related to "private matters, which must be held sacred."[38]

There is nothing more distressing to an ambitious soldier, even one distracted by love, than service in peacetime. This was especially true in eighteenth-century England where, in the intervals between wars, the army was neglected by a government chronically parsimonious in its military appropriations. Peace prevented promotion. Officers survived longer, there were fewer soldiers to be led, and no battles in which to distinguish one's self. As an early memorialist of Wolfe wrote, "peace put a stop to his career, and prevented him from gathering fresh laurels in the fields of Mars."[39] The young officer felt the boredom of peace acutely. "We fall every day," he wrote in a melancholy state, "lower and lower from our real characters, and are so totally engaged in everything that is minute and trifling, that one would almost imagine the idea of war was extinguished amongst us; ... he is the brightest in his profession that is the most impertinent, talks loudest, and knows least."[40] But he was not always discouraged. "It is not time," he wrote his mother, "to think of what is agreeable; that service is certainly the best, in which we can be most useful; for my part I am determined never to give myself a moment's concern, about the nature of the duty which his Majesty is pleased to order us upon; & whether it be by sea or by land, that we are to act in obedience to his commands: I hope we shall conduct ourselves so as to deserve his approbation"[41] He confided to his mother in a letter of 26 March 1755, "All my hope of success must be grounded upon right & just pretensions ... I must serve & serve well, or I can't get forward."[42]

In 1757 the eagerly awaited hostilities re-commenced for Lieutenant-Colonel Wolfe when he served as quartermaster and chief-of-staff under General John Mordaunt in an abortive raid on the Biscay port of Rochefort. Wolfe may have known his commander quite well for Miss Lawson was Mordaunt's niece. The complete failure of the Rochefort expedition was the subject of a court of inquiry that went against Mordaunt, who was sent for court martial, charged with disobeying his Majesty's orders and instructions. He was acquitted on account of declining health and advanced age.[43]

Wolfe, the consummate soldier, was disappointed with the Rochefort raid and wrote to his mother, "I am ashamed to have been of the party. The public could not do better than dismiss six or eight of us from the service." His career plans were, however, undisturbed. He was posted to serve under General Amherst, where he distinguished himself in the

siege and capture of Louisbourg in 1758. Wolfe understood the theory behind the American campaign. In 1750 he had written to his friend Captain William Rickson, stationed in Nova Scotia saying how interested he was in the conflict in North American and expressing his belief that the despotic and bigoted French were suppressing the innocent, who would gain their freedom if the English were successful.

After the fall of Louisbourg on 27 July 1758 Wolfe sailed with three regiments to the Gulf of St Lawrence where he reported they did "a great deal of mischief" and "spread the terror of His Majesty's army". He returned to England and actively lobbied for a new commission. In January of 1759 he wrote that "being of the profession arms, I would seek all occasions to serve; and, therefore, have thrown myself in the way of the American War, though I know that the very passage threatens my life, and that my constitution must be utterly ruined and undone; and this from no motive either of avarice or ambition."[44] Wolfe told his mother that he was by reputation "one of the best officers" of his rank in the services. "I am not at all vain of the distinction," he immodestly told her and readily advanced his theory that "the consequences will be fatal to me in the end; for as I rise in rank, people will expect some considerable performances; and I shall be induced in support of an illgot reputation, to be lavish of my life, and shall probably meet that fate which is the ordinary effect of such a conduct."[45]

Wolfe's letters reveal his intention to be an exemplary hero. He seemed to be quite prepared for, and indeed to relish, the prospect of the happy death – the inevitable reward of the perfect military servant of the crown. His letters, unavailable to eighteenth-century memorialists, confirm the motives imaginative writers and artists naturally ascribed to him after his demise. In the words of Horace Walpole, "the incidents of dramatic fiction could not be conducted with more address."

Reputation and fate led to Wolfe's selection by William Pitt to command the expeditionary force to Quebec in 1759, although Pitt apparently had second thoughts about his choice. On the eve of his departure for America Wolfe was entertained at dinner by Pitt at Hayes Place in Kent. The only other guest was Pitt's brother-in-law Lord Temple. "As the evening advanced, Wolfe – heated perhaps by his own aspiring thoughts, and the unwonted society of statesmen, broke forth into a strain of gasconade and bravado. He drew his sword – he rapped the table with it – he flourished it round the room – he talked of the mighty things which that sword was to achieve." The two politicians, nonplussed by this performance, wondered how a man with any "real

sense and real spirit" could behave in such a way. After the young officer had departed, Pitt, who "seemed for the moment shaken in the high opinion which his deliberate judgement had formed of Wolfe, ... lifted up his eyes and arms and exclaimed to Lord Temple, 'Good God! that I should have entrusted the fate of the country and of the administration to such hands.'"[46]

In the field, however, Wolfe's bravado infected his troops. Its vehement expression, unbecoming in the company of gentlemen, was appropriate in their presence. The underpaid and often reluctant "volunteer" soldiers were encouraged to breathe fire and anticipate the slaking of their thirst for French blood by bellowing *Hot Stuff* to the tune of *Lilies of France*. "Come, each death-doing dog who dares venture his neck, / Come, follow the hero that goes to Quebec," they sang. "And ye that love fighting shall soon have enough / Wolfe commands us, my boys; we shall give them Hot Stuff."[47]

The invasion, however, proved to be slow and difficult. In the midst of it Wolfe's father died and the young general, confessed to his mother on 31 August 1759 his non-heroic plan "of quitting the service, which I am determined to do at the first opportunity."[48] This sign of desperation may indicate that his fragile constitution was on the verge of collapse. It was related to Wolfe's friend George Warde "that poor Wolfe, was seized with a fit of the stone immediately on his landing [below the Plains of Abraham] and made bloody water, so that his natural life was probably near a period."[49]

On any account, the struggle for Canada was a nasty affair. An English history of 1770, which naturally painted the French as villainous, said the enemy, motivated by wickedness, "chose to abandon their habitations, rather than remain quiet and confide in the general's promise of protection. Instead of such prudent conduct, the Canadians joined the scalping parties of the Indians, who skulked among the woods, and falling on the English stragglers by surprise, murdered them with the most inhumane barbarity."[50] A British soldier reported that on 24 August his troops "were attacked by a party of French, who had a priest for their commander; but our party killed and scalped 31 of them, and likewise the priest their commander."[51]

There were, however, acts of charity amidst the barbarity. A French nun said that in one skirmish the Indians' "hideous yells of defiance tended to intimidate our foes," who retreated. She recorded that the sisters "charitably conveyed their wounded to our hospital, notwithstanding the fury and rage of the Indians who, according to their cruel custom sought to scalp them".[52]

The gritty reality of the conquest of Canada was that it was made up of short, bloody, and indecisive skirmishes that held none of the attraction of the grand spectacle of a decisive destructive set battle. Wolfe had observed in letters to his mother that "the Marquis de Montcalm is at the head of a great number of bad soldiers and I am at the head of a small number of good ones."[53] On 11 September he wrote that the French army "is kept together by the violent strong hand of Government and by the terror of savages." "The Canadians," he wrote, "have no affection for their government, nor no ties so strong, as their wives and children." He considered the Canadians "a disjointed, discontented, dispirited peasantry, beat into a cowardice by Cadet, Bigot, Montcalm and the savages."[54] On the eve of the final battle he informed his troops that "the officers and men will remember what their country expects from them, and what a determined body of soldiers are capable of doing against five weak battalions mingled with a disordered peasantry."[55] Wolfe's views were certainly not the stuff of legend, where one's adversaries must not only be more numerous but stronger and better supplied. (They must also, at the same time, be less courageous individually, possess inferior military skills and lack moderation and magnanimity.) From the skirmish between the pamphleteers shortly after Wolfe's death until 1969, the unheroic side of Wolfe remained unnoticed in print. That two centuries were to elapse before a text like that proposed by General James Murray in 1774 was printed is understandable: the biased muse of history inspires the recreation of the past according to the needs of the present. As Samuel Johnson wrote in 1758, because "every historian discovers his country … it is impossible to read the different accounts of any great event, without a wish that truth had more power over partiality."[56]

Johnson's contemporary the Swiss scholar Johann-Georg Zimmerman said histories are "memorials of the partiality of nations for themselves."[57] The post-mortem use of General Wolfe and the meanings in the variety of contending "facts" about his character and campaign can thus be used to help us understand the view of their own nations that various historians have reflected. The modern Quebecois historian Guy Frégault, who is here quoted as a stand-in for Murray, wrote from a nationalist perspective opposite to that which guided Horace Walpole in the eighteenth century. In 1969 Frégault described Wolfe as "a man of violent character," who "set out for Quebec breathing fire." Professor Frégault quotes Wolfe as saving "I own it would give me pleasure to see the Canadian vermin sacked and pillaged and justly repaid their unheard-of cruelty." He further notes that Wolfe tried "to

terrorize the Canadian population," saying that if they resisted him
they would suffer "the utmost cruelty that war could offer." Wolfe "car-
ried out his threat so thoroughly that it might have been thought his
chief objective was the destruction of the small rural communities of
Quebec."[58]

According to Frégault, Wolfe's "war machine functioned badly and
in relation to its strength gave very poor results. In Wolfe's hands it
seemed heavy, slow, awkward." Wolfe was clumsy in using his army,
thought Frégault. "He pushed it about, forced it, mishandled it. It
creaked and balked and came very close to breaking down completely
– while the obstacle it might have crushed stood and faced it for
months, and finally fell of itself."[59]

The nineteenth-century historian Thomas Carlyle, infected with
even stronger nationalism than his predecessor Walpole, wrote an
almost perfect antithesis to Frégault's passage on Wolfe's command in
an aside in his history of Frederick the Great.

Truly a bit of right soldierhood, this Wolfe. Manages his small resources in a
consummate manner, invents, contrives, attempts and re-attempts, irrepress-
ible by difficulty or discouragement. How could Friedrich himself have man-
aged this Quebec in a more artistic way? The small Battle itself, 5,000 to a
side, and such odds of Savagery and Canadians, reminds you of one of
Friedrich's wise arrangements, exact foresight, preparation corresponding;
caution with audacity; inflexible discipline, silent till its time come, and then
blazing out as we see. The prettiest soldiering I have heard among the English
for several generations.[60]

The kind of debate which one could imagine taking place between
the trio of Frégault, Murray, and Townshend and the team of Carlyle
and Walpole would have been unthinkable in eighteenth-century
England. Murray and Townshend were silenced and Frégault, if he
were to find himself by some misfortune transported back in time to
Georgian London, would be politely ignored as an apostate. For the
vast majority of the English at home and abroad there was, as we have
seen, little interest in debating Wolfe's tactical and strategic skills. That
he won North America, that he died in the process, and that the
French were defeated in their global conflict with Britain were all that
mattered. In war the means of victory are never subject to the kind of
scrutiny accorded the causes of defeat.

Wolfe's appearance, like his character and military prowess,
depended on the bias of the beholder. A French eyewitness described

James Wolfe as "a young man of about 30 years old, very skinny, red haired and very ugly."[61] A more flattering description was given by the equally biased Dr. Hinde, Wolfe's personal physician, who claimed to have held the general as he died. To Hinde, Wolfe was "a tall and robust person, with fair complexion and sandy hair, possessing a countenance calm, resolute, confident and beaming with intelligence."[62] Based on surviving data, that is, on idealized post-mortem portraits, a modern admirer of Wolfe concluded that his head "was the most striking part of his anatomy," and that its general expression was "very pleasant."[63] Ugliness and skinniness were inappropriate attributes for a national hero, so whatever Wolfe's physiognomic and physical defects they do not appear in art, having vanished as if corrected by a celestial host of cosmetic surgeons clustered on the path to apotheosis.

Not only was Wolfe's physical appearance modified but the stains in his character were also removed by literary launderers. Some of these blemishes Wolfe even recognized himself. He once confessed to his mother, "I want that attention, and those assiduous cares that commonly go along with good-nature and humanity." But he knew "in the common occurrences of life," he was "not seen to advantage."[64] He need not have worried for the obituary writers and memorialists, some of whom may even have met Wolfe, saw him to advantage in all things. He was "an ornament to the army," and "quite the humane and humble man, which fitly qualified him for the great post in which he died."[65] He was "wise in councils of war – unwearied in labours – undaunted in dangers – head always cool – heart always warm."[66] Wolfe was "by nature formed for military greatness." He had a retentive memory, good judgment, and a quick mind. He was courageous and daring "perhaps to an extreme" possessing "strength, steadiness, and activity of mind, which no difficulties could obstruct, nor dangers deter." Although he was lively "almost to impetuosity of temper," he controlled his passion. He was free from pride and a paragon of generosity. In Wolfe's army no deserving soldier ever went unrewarded and "even the needy inferior officer frequently tasted of his bounty." Wolfe possessed all the characteristics of a model commander. He was "manly and unreserved, yet gentle, kind and conciliating in his manners." Everyone liked him. "And, to crown all, sincerity and candour, a true sense of honour, justice, and public liberty seemed the inherent principles of his nature, and the uniform rules of his conduct."[67]

This picture of Wolfe is at variance with that rendered in his private correspondence where he not infrequently expressed contempt for his soldiers. The American provincials he commanded at Louisbourg were

to him "dilatory, ignorant, irresolute." They were "the dirtiest, the most contemptible, cowardly dogs," who "desert by battalions, officers and all." He characterized English regulars as having bad discipline and precarious valour: "They frequently kill their officers through fear, and murder one another in confusion."[68]

In contrast, two possibly imaginative stories serve to show that Wolfe may have been quite exceptional in some of the "everyday occurrences in life." According to the recollections shared with the public by a writer to a newspaper who knew him, Wolfe had special skill in dancing. "It was generally remarked he was always ambitious to gain a tall graceful woman to be his partner." When dancing with such a woman, "the fierceness of the soldier was abandoned in the politeness of the gentleman." In his dancing Wolfe "seemed ambitious to display every kind of virtue or gallantry that could render him amiable." He was a perfect partner for when circling round the floor, "such a serene joy was diffused over his whole manner, mien, and deportment that it gave the most agreeable turn to the features of that hero who died for his country."[69] As well, Horace Walpole retold a story which he had heard from a veteran of Quebec. This soldier was shot through the lungs in the heat of battle. Wolfe, happening upon him, "stopped to press his hand ... praised his services, encouraged him not to abandon the hope of life – assured him of leave of absence and early promotion." This tale inspired Walpole to characterize Wolfe as one who "gave the most minute attention to the welfare and comfort of his troops; and instead of maintaining the reserve and stateliness so common with other commanders of that day, his manner was frank and open, and he had a personal knowledge of perhaps every officer in his army."[70]

The good Wolfe, the perfect military hero, that man unrelated to Townshend's and Murray's commander, a man alien to Frégault's Wolfe, was pictured in a masterpiece of eighteenth- century propaganda produced for the hungry and discriminating public by Tobias Smollett. He wrote that Wolfe "inherited from nature an animating fervour of sentiment, and intuitive perception, an extensive capacity, and a passion for glory." Through study, Wolfe became a consummate strategist and tactician. His military skill was balanced by a "noble warmth of disposition." He was "brave, above all estimation of danger." According to Smollett, "he was also generous, gentle, complacent, and humane; the patron of the officer, the darling of the soldier." The conclusion to his prose paean to Wolfe was remarkably restrained. He bemoaned the general's early death for "had his faculties been exercised to their full extent by opportunity and action, had his judgment

been fully matured by age and experience, he would without doubt have rivalled in reputation the most celebrated captains of antiquity."[71]

Most of Smollett's contemporaries thought that Wolfe, despite the premature termination of his life, had already surpassed the ancient heros. Not the least reason for this feeling might have been that, as Elizabeth Montagu said about Wolfe to Lord Lyttleton, "everyone can endure to give praise to a dead man." She admitted that there was "certainly something very captivating in his character. He took the public opinion by a *coup de main*, to which it surrenders more willingly than a regular siege." Further she observed acutely, "the people had not time to be tired of hearing him called the brave."[72]

This awareness was reflected in another laudatory memorial to Wolfe which acknowledged that the hero was "far removed from all the difficulties and dangers of his former profession, and beyond the reach of the cankering blasts of envy, and the poisonous shafts so often launched from the bow of detraction." Wolfe, safe from attacks on his character, his military skill and, although the writer did not mention it, his physical appearance, was pictured as entombed, "his mortal part in the chambers of the grave" where are "blended the particles of his earthly tabernacle with the dust." While the corporeal form of the hero had vanished "his actions shall be enrolled in the records of fame, and pursued with delight by succeeding ages."[73] The memorialist was remarkably accurate. The defunct general was even more useful to the English nation than the living Wolfe. His audience expanded. His conquest became more profound. After his death he won the ability to touch the very soul of the nation – to sway the minds and elevate the spirits of patriotic Englishmen. His immanence was to be manifest in politics, poetry, prose, music, drama, sculpture, painting, and the decorative arts.

4

Too Short Was His Life,
But Immortal His Deeds

The first memorials to General Wolfe were created by writers. Within a few months of the capture of Quebec most major London book-seller-publishers had produced, in addition to the printed thanksgiving sermons, at least one title on Wolfe or his final battle and tales of Wolfe's deeds at Quebec quickly became important items in the publishing trade. Jacob Robinson was the first off the mark with an instant history entitled *An Accurate and Authentic Journal of the Siege of Quebec* by "a gentleman in an eminent situation on the spot."[1] On 24 October Henry Whitridge and A. and Charles Corbett announced the publication of *Genuine Letters from a Volunteer in the British Service at Quebec.*[2] Later in the month Thrush advertised for sale at his shop the poem *Triumph in Death or Death Triumphant, Exemplified in the Death of the late glorious, and ever blessed in memory, Major-General Wolfe*, the verses of which were dismissed as being "as nonsensical as their title page."[3] In November John Millan published *An Ode to the Memory of General Wolfe*, priced at six pence, and Robert and James Dodsley and John Scott published *Daphnis and Menalcas; A Pastoral Sacred to the Memory of the Late General Wolfe*, for sale at their stores for a shilling. By December the first edition of John Pringle's *The Life of General Wolfe* was on the shelves at George Kearsley's store. This, the earliest attempt at a full-fledged biography of the hero, was panned by the critics as "fitted to a preachment rather than an oration,"[4] and "a very florid (not to call it fustian) eulogium."[5] (The book is in fact an extended obituary puffed up by bombastic prose.) In the same month J. Burd published a ridiculous book by Joseph Grove of Richmond, extravagantly titled *A Letter to a Right Honourable Patriot, upon the glorious success*

at Quebec; in which is drawn a parallel between a good and bad general, a scene exhibited wherein are introduced (besides others) three of the greatest names in Britain; and a particular account of the manner of General Wolfe's death.

Mr Grove's work is illustrative of the depths to which some publishers sank in their pursuit of profits in the Wolfe market. A review in the *British Magazine* noted sarcastically that Grove had "industriously ransacked the newspapers to inform Mr. Pitt of what we can hardly suppose he was ignorant." Another reviewer castigated Grove for merely compiling already well known accounts of Wolfe's exploits. The absence of all originality from this narrative of events at Quebec probably did not diminish the author's and publisher's profits from the venture. Grove's book is typical of the kind of work which more often than not satisfied publishers' insatiable demand for copy. Dr Johnson's statement that "no man but a blockhead ever wrote except for money" serves as a motto for the rampant capitalism which had recently struck all aspects of publishing.

Grove appended to his cut-and-paste chronicle "a scene from a modern tragedy" which, as one reviewer gleefully observed, "to the honour of the managers of the theatres" had been rejected when it was "offered for exhibition."[6] In the play, about the transmission of the good news from Quebec to King George, the messenger, who held Wolfe in his last moments, sadly reports to His Majesty;

I saw the expiring hero as he fell,
Amidst the sanguine trophy he had raised;
This arm sustained his last remains of life,
His valour streaming through unnumbered wounds
While thus he feebly cried, – 'I die for Britain;
Commend me to the king; – Entreat his goodness
To my tender mother:' He could say no more;
For death forbid the utterance.[7]

Neither the theatre managers nor the reviewer were required to exercise particularly acute critical abilities in rejecting this piece of dramaturgical froth.

The wave of books on Wolfe gathered momentum in the first months of 1760. Works such as Eli Dawson's sermon *A Discourse Delivered at Quebec*, published by Ralph Griffiths, and Jacob Belsham's latin alcaic ode *Canadia Ode Επinikioς*, published by J. Clarke, R. and J. Dodsley and James Buckland in March of 1760 are typical.

Early in the following year the publisher John Coote, who had had
the good fortune to launch his *Royal Magazine* in the news-filled year
of 1759, gathered a selection of articles pertaining to Quebec from the
first volume of his magazine, bound the group of offprints, and sold
them in his store as a separate publication.[8] Among the articles were
"A Short History of the Present War" in several parts, the addresses of
the House of Lords and the House of Commons to the king congrat-
ulating him on victory, observations on Quebec, a memoir on the life
of Wolfe, and "Remarks on the Glory of a Nation, its great advantages,
and the manner of acquiring it" extracted from a recently published
English translation of Emerich de Vattel's *Le Droit des Gens*. This essay,
which dealt in part with contemporary thought on territorial conquest,
was relevant to the general theme of the volume. "The glory of a
nation," de Vattel proposed, "depends entirely on its power." For him
it was "therefore of greatest advantage for a nation to establish its glory
and reputation, and consequently it becomes one of the principal
duties it owes itself." Power, so the author claimed, was derived from
"virtue, and by the great actions which are the fruits of it."[9] By binding
this article in the patch-work volume on the conquest of Canada the
publisher was pandering to his readers' strong belief that the fall of
Quebec and Canada was a sign of virtue in the victorious nation.

The most prolific of writers on Wolfe and the battle at Quebec were
poets.[10] Inspired by the death of Wolfe, a veritable regiment of British
poetasters attempted memorial verses. Most of these confirmed Pope's
fears for English letters in an age of mass consumption in which "Prose
swell'd to verse, verse loit'ring into prose: / How random thoughts now
meaning chance to find, / Now leave all memory of sense behind."[11]
The instantaneous flood of poems proved Oliver Goldsmith's observa-
tion that "upon the death of the great ... the poets and undertakers
are sure of employment."[12] As predicted by one unusually sensible poet
when he began his elegy with the line, "When, ages hence, this song is
known no more,"[13] most of the poems on Wolfe which peppered news-
papers, monthly magazines and the shelves of entrepreneurial book-
sellers have over time lapsed into deserved literary limbo.

Even the general himself might have found the flattering tributes to
be wanting in literary merit. Most of the poets failed to equal even the
standard of a work attributed, probably falsely, to Wolfe himself, who is
said to have composed a farewell ditty to his fiancée which began:

I go where glory leads me,
 And dangers point the way;

Though coward love upbraid me,
 Stern honour bids obey.[14]

The following works are not cited as examples of good poetic art but are evidence of the sincere gratitude felt by scores of patriotic amateur poets.

Some of the first poetic tributes to Wolfe were created through the expedient means of reusing pre-existing verses. Almost at the instant that news of his death was announced the *London Chronicle* printed a modified epitaph; "Underneath a hero lies / WOLFE the young, the brave, the wise, / No tomb-stone need his worth proclaim, / Quebec for ever shall record his fame."[15] A popular ballad *Brave Wolfe*, known also as *The Death of Brave General Wolfe*, was composed by adding several quatrains dealing with the actions at Quebec to three verses telling how an unnamed man wooed and proposed to a young woman.

I went to see my love only to woo her,
I went to gain her love, not to undo her –
When'er I spoke a word, my tongue did quiver,
I could not speak my mind, while I was with her.[16]

By making Wolfe by implication the subject of the ballad, he is given an emotional warmth absent in most other writing about him.[17]

James Wolfe is mentioned by name for the first time in the fourth quatrain of the ballad, where he is shown parting from his fiancée Katherine Lowther, who is not identified by name. "Brave Wolfe, then took his leave of his dear jewel, / Most surely did she grieve, saying don't be cruel." A jaunty hero he goes off "To free America from her invasions," where "He landed at Quebec with all his party, / The city to attack, both brave and hearty."

Some of the other poems on Wolfe contrasted the very personal grief of Katherine Lowther and his mother with the noble national ritual mourning.

Forbear with unrelenting sighs
Your deathless son to mourn;
Forbear with ever-weeping eyes
To wet his hallowed urn.

Not you alone, but to his name
Millions shall trophies raise,

And with fond echo still proclaim
With gratitude his praise.[18]

While the poets assumed that there was a different and special qual-
ity to the love and grief felt by Wolfe's fiancée and mother, they could
express this only in the most general terms as very few details about
the hero's character, his relationship with his mother, or his impend-
ing nuptials were public knowledge. It was known that Wolfe "was to
have been married on his return to England, to a sister of Sir James
Lowther, a young lady, whose immense fortune is her least recommen-
dation ... She had shewn so much uneasiness" at his departure for
America, it was said that, "nothing but the call of honour could have
prevailed with him to accept of that command, in the discharge of
which he fell so gloriously."[19]

The idea that national duty had precedence over romantic love was
repeated almost a century later in a possibly apocryphal story. Lord
Frederick Cavendish, General Wolfe, General Monckton, and Admiral
Keppel were said to have agreed "at the commencement of the seven
years war in Germany not to marry 'till peace, nor be interrupted by
domestic affairs."[20] This self-inflicted celibacy, distinct from chastity,
should be understood as a pre-requisite to achieving the highest stan-
dards of military virtue – at least for the English.

Ignorance of Wolfe's personal life did not prevent poets from pic-
turing his loved ones suffering a kind of generic grief. For example,
in *An Ode to Miss L——. On the Death of General Wolfe* an anonymous
poet wrote:

You, gentle maid, above the rest,
His fate untimely mourn;
Who wooed, if heaven should spare his youth,
With love, with constancy, and truth,
To crown his wished return.[21]

Another anonymous poem portrays Katherine Lowther awaiting her
lover's return: "But destiny denied, and doomed those eyes, / Which
should have viewed thy triumphs, to overflow / With piercing sor-
rows," while Mrs. Wolfe "Is racked with anguish, she in plaintive
strains / Bemoans thy fate, regardless of her own."[22]

Several pompous poetic tributes to Wolfe were dedicated to his
mother. In one of the earliest of these Wolfe was compared to Cato,
whose patriotic defence of Roman liberty culminated in his suicide in
46 B.C.E.

Rome has beheld her much loved Cato bleed
An aged Priam mourn'd his Hector dead:
Grieve not, thou honoured parent, WOLFE shall live,
While grateful Britain can just praises give.[23]

Cato was an ideal archetype for Wolfe. Comparing the two required neither great knowledge of history nor imagination for the story of the Roman martyr was well known through a very popular tragedy by Joseph Addison. A memorialist writing in the *Royal Magazine* applied lines to Wolfe which he said were derived from Addison's *Cato*. "In joys of conquest he resigns his breath, / And fill'd with England's glory smiles in death."[24] Addison has Cato, while mourning the death of his son Marcus, say:

How beautiful is death when earn'd by Virtue!
Who would not be that youth? What Pity is it
That we can but die once, to serve our country.

This passage was published in the *Pennsylvania Gazette* on 7 February 1760 immediately following the poem "To the Memory of General Wolfe" by J. Copywell taken from an English periodical. "Copywell" began by characterizing Wolfe as "nobly fighting in a nation's cause, / And bravely dying to maintain its laws."

The amateur poets, like the authors of obituaries and biographies, felt no obligation to adhere to the facts, if indeed any were known to them. They ignored contemporary military dress and manners, details of the chronology of the campaign, and the topography of Quebec. This was not a careless disregard of available information but rather a well-intentioned effort to create the kind of image expected by their audience, one that would enhance the quality of national jubilation through picturing the glorious pageantry of the conquest of Quebec. An imaginative poet wrote; "In the thick of the fight, Wolfe's plume was displayed / And his coat was dusty with gory, / As flashed on high his saber's blade, / O'er that field where he fell with such glory."[25] Perhaps the most colourful description of Wolfe in battle, however, was that in Jacob Belsham's Latin encomium *Canadia Ode Eπinikioς* in which the general, abandoning his role as commander, engaged personally in the bloody fray. He is depicted as covered with dust and swinging his fiery sword as he waded into the enemy lines.[26]

The landscape of Quebec was also often coloured by invention. The poets described the city and its surrounding cliffs and river in terms of vastness and obscurity, roughness and irregularity. Just as Wolfe's

fate was seen as combining the beauty of his heroism with the blemish of his necessary, yet untimely, death, so the landscape of Quebec was shown to be both beautiful in its primordial obscurity and blemished by its ruggedness. Lack of geographical facts abetted the poets in the creation of a dramatic environment for dramatic events.

> In vain the precipice, the rolling flood,
> The craggy mountain, and the gloomy wood,
> The rugged rock, the steep and thorny cliff,
> Opposed the progress of the British chief.
> They climb by night the mountain's bristly sides.[27]

The climax of the typical narrative poem on the siege comes at the instant the dying general learns of the victory and hence can expire confident of his promotion to the pantheon of national heroes.

> But short was the hero's immortal career,
> For as the battle was nearly o'er,
> He fell from the ball of a French musketeer,
> Which bathed his breast with gore.
>
> When wounded he leant on a soldier nigh,
> And the victory just won, –
> For he heard aloud the cheering cry,
> "They run! they run! they run!"
>
> He faintly asked from whence that sound,
> And being answered, "the Enemy fly!"
> He exclaimed, as he slowly sank to the ground,
> "Oh God! in peace I die."[28]

And then, according to another poem,

> He closed his eyes with joy on human glory,
> And left each earthly toy, so transitory;
> Brave Wolfe is now enrolled the first of heroes,
> And joins a host of those who feel no sorrow.[29]

Not all contemporary poets were convinced, as was the critic Daniel Webb, that "poetry is a union of the two powers of musick and picture," in which the imagination "prefers extravagance to justness; or

false beauties to true."[30] Wolfe's death and the horror of war motivated a small number of poets to attempt to paint a more or less convincing picture of the pain of martyrdom – a departure from the more common cleansed and extravagantly imaginative version of the hero's undoubtedly uncomfortable demise. In some poems Wolfe's wounds ooze with gore as, torn by enemy shot, the hero dies slowly enough to permit the authors to grapple with the horrific scene.

> Shot after shot, the British leader feels;
> At length he greatly falls; the purple tide
> Sprouts from his breast and trickles down his side;
> Cold drops of sweat then round his temples hung.[31]

Stretched out on the blood-stained green he died nobly while,

> The troops around him shared a glorious grief,
> And while they gathered laurels wept their chief:
> Their chief! to whom the great Montcalm gave way;
> And fell to crown the honours of the day![32]

There were a few attempts to acknowledge that Wolfe was not the only officer involved in the victory at Quebec. One poet praised brigadier Townshend: "Shall Townshend's deeds o'er Canada renowned / So faint in British eulogies resound! No grateful bard in some exalted lay / Brave Townshend's worth to further times convey."[33] His suggestion in *Call to the Poets, on the Taking of Quebec*, published in 1760, went unheeded. The ghost of Wolfe had a monopoly on poetics celebrating the capture of Canada. Some poets felt this acutely, as did one who complained in a poem on the death of Lieutenant Stuart,

> While Wolfe alone employs each poet's lays,
> And every clime resounds his deathless name,
> Shall dauntless Stuart claim no share of Praise,
> Who godlike fell, altho' unknown to fame.[34]

It was rare for poets to mention the role of the king, his government, and military leaders other than Wolfe in the glorious conquest. The Boston preacher Jonathan Mayhew, in a poem appended to the published version of his sermon of thanksgiving, exhibited unusual generosity.

> Great source of liberty! The Tyrants awe,
> Boundless in power, but goodness still thy law,
> Still then such kings as George to Britain lend;
> Such ministers as Pitt successive send,
> Such admirals as late have ruled the main,
> Such generals as fought on Abraham's plain;
> (Wolfe, not till death immortal, Name renowned!)
> Or Amherst still with annual laurels crowned.[35]

In an Irish schoolmaster's song *Britannia Rejoice,* sung to the tune of *Smile Britannia,* one hears a mild sigh over the ubiquitous poetic attribution of victory to Wolfe alone.

> For gallant Wolfe we drop a tear;
> His fame fair Quebec will revere.
> But if applause is due
> To chiefs by sea and land,
> How much, O PITT, to you
> Who these just measures planned!
> Whom Britain's genius did ordain
> To add lustre to great George's reign.[36]

For most poets it was, however, Wolfe's service, Wolfe's military brilliance, and Wolfe's death which had turned the tide of the war in favour of the side of justice and liberty.

> The generous youth with noble ardour glowed
> With tears of joy his piercing eyes o'er flowed! –
> He grasped the pike! – bid pleasure train begone!
> And Britain's genius prayed to lead him on
> To death or glory. – Both the goddess gave –
> Alas! thy country can but add a grave![37]

The throng of versifiers striving to characterize the simultaneous grief and thanksgiving of the English people depicted that added grave as a sepulchral urn. This became the symbol of the highest form of national service. An object to be approached on bended knee, it stood elevated at the centre of all the manifestations of patriotic pride. To writers of the period, the funerary urn stood for death, that paradoxically sad and happy instant separating the mortal from the immortal soul. Urns proliferated like weeds in the verdant fields of memorial poetry.

What are the strokes that wound domestic rest

...

To those that public sorrows well bestow,
When patriot ashes fill the sacred urn;
When nations consecrate the sigh of woe,
And with united voice a people mourn?[38]

"Ever shall Britannia mourn / O'er her darling hero's urn,"[39] a poet
said and another addressing the hero's ghost stated that the English
shall "weeping speak thy fame" and "pour out their pious sorrows o'er
thy urn."[40]

Wolfe's urn was the subject of one of George Townshend's harsh sat-
ires, in which it was shown as an object venerated by the dancing Irish
Venus (Fig. 4.1). In several of Townshend's sketches the naked goddess
gyrates before cenotaphs to Wolfe, some of which are urns. While Town-
shend expected England to sprout cenotaphs and urns commemorating
General Wolfe, only one seems to have actually been built, that commis-
sioned by Wolfe's boyhood friend George Warde for the garden of
Squerryes Court in Westerham. This large neo-classical urn on a plain
plinth marked the place where young Wolfe stood when he received
news of his first commission in the army. The base is inscribed

Here first was Wolfe with martial ardour fired,
Here first with glory's brightest flame inspired;
This spot so sacred will for ever claim
A proud alliance with its hero's name.

In the rarefied atmosphere created by the limited literary class of
"professional" poets, the classical world played a greater role than
among their amateur colleagues. The professional poets' emulation of
their betters in Rome's Augustan Age was imitated by more than a few
inferior word-smiths who adapted their passion for the hero to various
popular forms of versification – elegy, pastoral, epic, and ode – as if
following Goldsmith's council on the "several ways of being poetically
sorrowful" on the death of a great person. A grieving poet might,
advised Goldsmith, assume the role of "some pensive youth of science,
who sits deploring among the tombs" thus producing an elegy, or, he
could write a pastoral acting as "Thyrsis complaining in a circle of
harmless sheep." If an epic was the goal, the poet might cast himself
as Britannia who "sits upon her own shore and gives a loose to mater-
nal tenderness" or the writer of the ode might be Parnassus for "even

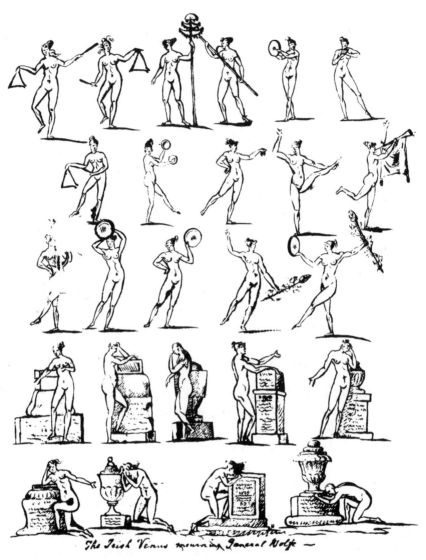

Fig. 4.1 George Townshend, *The Irish Venus Mourning General Wolfe.*
Drawing, 1759 (McCord Museum of Canadian History, Montreal)

the mountain Parnassus, gives way to sorrow, and is bathed in tears of
distress."[41]

One of the more ambitious efforts in the pastoral genre was an
anonymous work entitled *Daphnis and Menalcas, a pastoral sacred to the
name of Gen. Wolfe.* This poem, unlike the straightforward verses submit-
ted to the magazines and newspapers, was praised by one reviewer, who

wrote, "though the strictness of criticism might find fault with some things in it, yet few detached poems, warbled in this our day, have appeared to us to have more merit."[42] It received, however, a damning notice from the reviewer for the *Gentleman's Magazine*, who opined that "pastoral dialogues on the death of the great are so common, and have been the vehicles of flattery so gross, and images so trite that the very idea is become ridiculous." It was to be regretted "that the virtues of Gen. Wolfe are not celebrated in another manner."[43]

The pastoral *Daphnis and Menalcas* opens with the conventional apostrophe or invocation of the muse, who is asked to hand the poet the inspirational flame of Homer or Virgil. The poet then cautions himself against unbridled literary ambition noting that "Here Apollo checks my soaring wing, / Of wars, and fighting fields forbids to sing." The poem itself begins with Daphnis observing the peace of nature and praising Menalcas's poetic genius. "Soft is the music of that murm'ring spring, / But not so tuneful as the notes you sing." Menalcas states what he sees as the prospect for the new world which, "by nature's forming hand / From chaos raised for Britons to command." Daphnis says that the two of them cannot continue to amuse themselves contemplating the arcadian ambience of America. War is to come and,

> Whom should we sing but Wolfe the bold and brave?
> Whose finished Virtue finds an early grave;
> Who conquering for his country, smiled in death
> And worlds bequeathed her with his parting breath.

Menalcas then utters his lament.

> Begin the song, resound the warrior's praise;
> Myself shall answer in no vulgar lays.
> Both worlds shall weep the hero brave and young;
> The world he conquered, that from which he sprung.

The popular poetic form of the pastoral was based on a passage in Virgil's *Eclogues* in which Menalcas rejoices at the resurrection of Daphnis. When Daphnis, the mythical founder of the shepherd's song, died, the creatures of nature united in a concert of grief. His subsequent migration to heaven was a cause for jubilation in nature. In the pastoral on Wolfe the hero's resurrection elicits a similar chorus of joy among the wild animals and a quieting of the predatory natives of Canada.

Rejoice! a golden period is begun:
Rejoice! the fates a happier thread have spun:
Behold his chosen chief our patriot sends,
On France the brandish'd thunderbolt descends.

Ye flocks and herds, along the meadows stray;
By purling streams, ye lambs securely play:
Your flocks and herds in peace, O shepherd tend,
Your song may lengthen till the sun descend;
Then back in safety to your cot repair,
And hope to find your wife and children there:
No ambushed Indian lurks to rob your life,
Your tender children and your faithful wife.[44]

Thanks to Wolfe, the environs of Quebec have taken on the peaceful-
ness of the Virgilian landscape of ancient Italy. Quebec itself resembles
Brigadier George Townshend's description of it to the poet Thomas
Gray: the region around the town of Quebec is much like Richmond
Hill "and the river as fine (but bigger) and the vale as riant, as rich
and as well cultivated."[45] This tamed topography resembles that por-
trayed in the several more or less fictional contemporary illustrations
of the siege where in maps, bird's-eye views, and topographical prints
the St Lawrence was shown flowing like the Thames below a city placed
on a European hill surrounded by expansive tilled fields. Wolfe has
restored Canada to its arcadian state, in which the animals of the forest
romp freely for the hunters taking and the Indians are pacified.
Through his heroic death and heroic resurrection Wolfe has instilled
order in the formerly chaotic new world.

After 1760 the publication of verses memorializing Wolfe and cele-
brating his triumph suddenly ceased for more than a decade. The
event at Quebec, however, continued to be popular as an episode in
longer poems dealing with the broad sweep of British history. Of the
better poems, the most interesting, if only for its wonderful title, is
James Ogden's *The British Lion Rous'd or Acts of the British Worthies*,
published in Manchester in 1762. Ogden, whom a critic dismissed as
a "ryhme-weaver" and versifyer of newspaper accounts,[46] wrote the fol-
lowing on Wolfe.

Foiled, in the presence of her fierce allies,
While, fugitive the Gaul to covert Lies;
Supported by the sorrowing officers,

Wolfe faints – and now the victor shout he hears;
Those eyes, which late had from their function ceased,
Brightning again – Again himself he raised;
Yet, for the soldiers while his bowels yearn,
Anxious the fortune of the day to learn,
Who runs? – Said Wolfe – The officers reply,
'Tis France – Then God be praised, content I die,
Nor utters more, but pious bowed his head,
Winged in such words the active spirit fled;
A lifeless corpse, on Abraham's-height he lies.[47]

Wolfe as a subject had very little effect on the evolution of the higher forms of English poetic art as most of the greater poets in England and in America avoided the subject. The novelist and poet Charlotte Smith is said to have written a little poem on Wolfe in her youth.[48] William Shenstone was asked by his friend the bookseller-publisher Robert Dodsley to write an elegy on the death of General Wolfe. Dodsley thought the subject of Wolfe's delayed marriage to Katherine Lowther lent itself to poetic pathos. "The scene, might be laid in her chamber," he suggested, "on the rejoicing night for the taking of Quebec." In the narrative Miss Lowther's friends could conceal the death of her fiancé while the noise of the festive victory celebration is heard in the distance. Wolfe's ghost would then appear, inform Katherine Lowther of his death, and console her. Dodsley attempted to tantalize Shenstone by suggesting that the scene provided "room for description, reflection and true pathetic." "Such a story as this in your hands" he told Shenstone, "could not fail to be fine."[49] Shenstone was not convinced and never wrote about Wolfe.

Some have attributed to Oliver Goldsmith, Shenstone's contemporary, a poem entitled "On the Taking of Quebec," although it is difficult to ascribe such an inferior work to him. Of Wolfe the poem says:

O Wolfe, to thee a streaming flood of woe
 Sighing we pay, and think e'en conquest dear,
Quebec in vain shall teach our breast to glow
 Whilst thy sad fate extorts the heart-wrung tear.

Alive the foe thy dreadful vigour fled
 And saw thee fall with joy-producing eyes;
Yet they shall know thou conquerest, though dead!
 Since from thy tomb a thousand heroes rise.[50]

If Goldsmith did write this, he may have been motivated by his distant kinship with General Wolfe.[51]

The ubiquitous use of Wolfe as the archetypical English modern hero is reflected in the use of the conquest of Quebec as the set subject for the undergraduate poetry competition at Oxford in 1768. The topic may have been chosen not only because it was a fit test of the mettle of young poets but because the subject had been debased in so many prior trite verses – the judges may have hoped for a poem that would advance the art. The winning entry by Middleton Howard did not do this, but his passage on Wolfe was better than the efforts published earlier in magazines and newspapers.

> But while the British chief his troops led on
> To pluck those laurels which their Arms had won,
> Some winged Fate his mighty Bosom tore,
> And low to Earth the gallant Warrior bore;
> His Friends with Pity mark his parting Breath,
> And pause suspended from the Work of Death.[52]

The set subject was so popular that not only the winner but also at least two of the losers found publishers for their efforts. The Reverend William Cooke's entry was judged both as possessing "a good share of merit"[53] and, by another critic, as "a tissue of frigid narrative, and absurd or trifling conceits" with his account of Wolfe's death being "merely a paragraph in the Modern Universal History tagged with rhime [sic]"[54] Joseph Hazzard's poem was characterized in a damning review as showing that "the poor, the rich, the impious and the good, bleed in promiscuous heaps."[55]

American colonials, while less prolific than their patriotic English poetaster cousins, also produced some verses on Wolfe and Quebec. The Reverend Jonathan Mayhew's New England compatriot Martha Brewster of Lebanon, Connecticut, wrote a poem about Wolfe and Canada. Circulated as a broadside in 1761, her work, *A Final Conquest of Canada or, God Reigning over His and Our Enemies*, began,

> Come all ye sons of Britanne,
> Come celebrate this jubilee:
> Released from wars, and bloody thralls
> Of popish and perfidious Gauls.[56]

In the same year "Poem Sacred to the Memory of James Wolfe," attributed to Thomas Young, who eventually become an active revolutionary,

was published in New Haven. For Young the attraction in the story of Wolfe lay in the drama of his parting from his family, in this case non-existent sisters and fiancée, Deidamia, who

> Fawning about his neck her arms she throws,
> Then swooning asks him if he really goes,
> Or do I dream, said she, how dim the light
> Lie still my dearest, it is surely night.[57]

There was also a burst of poetical tributes to Wolfe in late 1759 and early 1760 in Philadelphia. These poems are discussed below in the context of Benjamin West's picture of the death of General Wolfe.

The story of Wolfe's victory was much slower to become an example of virtue for writers of prose. His novelistic apotheosis came to fruition first in parenthetical form in the last three decades of the eighteenth century and then more substantially in the nineteenth and twentieth centuries. Wolfe did, however, make a few appearances in fiction immediately after his death.

He is the subject of an episode in one of the best-selling novels of the time, the now almost unreadable *Chrysal: or the Adventures of a Guinea* by Charles Johnstone.[58] A guinea coin, the narrator of the Johnstone's tale, is passed to Wolfe. In his pocket it overhears Wolfe telling his mother that his prayers have been answered: he is, he says, to be able to show his patriotism with a soul now fired with the assurance that he "shall have the happiness of crushing the injurious power of our enemies." Mrs. Wolfe, proud of her son's motives, cautions him to remember "that prudence distinguishes true courage from rashness," and that he would betray his country's trust if he were to die as a result of unnecessary boldness. The young general assures his mother that she will never have cause to apologize for him. "If life is to be short, let it be well filled: one day of glory is better than an age of idleness, or dishonour." The guinea relates the tender moment when Wolfe "paused a moment to wipe away the pious tear, which filial duty owed to such a parting."[59]

For another contemporary novelist, the environment of her story made it impossible to avoid mention of the hero of Canada. Frances Brooke's epistolary novel *The History of Emily Montague*, written during her sojourn in Canada in 1763–67, deals with the subject of the English martyr right at the beginning. "Where shall I begin?" she has her hero, recently arrived in Quebec, write to his sister, "Certainly with what must first strike a soldier: I have seen then the spot where the amiable hero expire'd in the arms of victory; have traced him step by

step with equal astonishment and admiration: 'Tis here alone it is possible to form an adequate idea of an enterprize, the difficulties of which must have destroy'd hope itself had they been foreseen."[60]

Tobias Smollett made very different use of Wolfe in a satire of political and military events during the period of the Seven Years War entitled *The History and Adventures of an Atom*, published in 1768 and 1769. Wolfe, unlike most of the other characters in the book, escapes the deflating prick of the author's pen. The Japanese general Ya-loff (Wolfe) is sent against the well-defended Quib-Quab (Quebec) with too few soldiers and the hope by Taycho (Pitt) that fortune would turn in the favour of the Japanese. In the midst of the campaign, Hydra (parliament) howled and grinned and gnashed its teeth and writhed itself into a thousand contortions as if it had colic. Taycho called for the royal physician to give parliament an enema but no one would administer the cure as "the patient was such a filthy, awkward, lubberly, unmanageable beast." "If what comes from its mouths" said they, "be so foul, virulent, and pestilential, how nauseous, poisonous and intolerable must be that which takes the other course." Just in the nick of time news came that Quib-Quab was taken. The hydra was suddenly cured, "raising itself on its hind legs, [it] began to wag its tail, to frisk and fawn, to lick Taycho's sweaty socks; in fine, crouching on its belly, it took the orator on its back, and proceeding through the streets of Meaco, brayed aloud, 'Make way for the divine Taycho! Make way for the conqueror of Quib-Quab!'" Tobias Smollett went on to say that everyone rejoiced except Dairo Got-hama-baba (King George) who had no interest in America. The king was alone in this for "nothing was now seen and heard in the capital but jubilee, triumph, and intoxication, and, indeed, the nation had not for some centuries, seen such an occasion for joy and satisfaction."[61]

One of many writers who became intoxicated with the euphoria of victory was George Cockings. His first effort to capture the grand victory at Quebec consisted of a episode in his *War: An heroic poem. From the taking of Minorca by the french, to the raising of the Siege of Quebec, by General Murray,* published in London in 1760 and again in Boston and Portsmouth, New Hampshire, in 1762. He prefaced his epic with a much-needed apology, claiming quite correctly that he did not deserve the title of poet. He did assert that he wrote "truth (without flattery) unadorned with poetic fiction (which like nauseous daubing, on a beautiful face, hides the sweet attractive smiles and native simplicity of the features)."[62] The poet, who may have possessed some facts about America as it was said he had lived in Boston in the early 1760s,

followed his disclaimer with many lines of poetic fiction and nauseous daubing.

He successfully scoured history and nature for analogies to the virtuous and fearless Wolfe. "So Anthony, dared Caesar once to oppose: / And never since then, till now, meet two such foes." He wrote that Wolfe, like the conspirator Mark Antony, slew the tyrant who suppressed liberty. Wolfe assumes for a time the role of the British lion. On the Plains of Abraham at Quebec, "Wolfe like a lion growl'd, when held at bay; / And roared an answer, on this fatal day." And when he was wounded in the wrist, he wrapped it with his handkerchief and continued to fight,

Like a lion, whom the dogs surround,
By hunters vexed, and roused by painful wound;
The fearless beast, will all their terrors dare
He growls, and foams, and shakes his shaggy hair.

The wounded leonine Wolfe, "roars aloud, with new collected might: / With rage indignant now, his tail he swings."[63]

Cockings' readers, apparently indiscriminate in matters of content and style, liked his telling of the epic tale and it sold very well, going into a fourth edition by 1765. The following year Cockings published a play, *The Conquest of Canada: or The Siege of Quebec. An Historical Tragedy of five acts*, which was read and performed on both sides of the Atlantic, republished in Baltimore and Philadelphia in 1772, in Albany in 1773, and in London in 1796. The poet turned dramatist, dismissed by a contemporary critic as "the author of several contemptible performances,"[64] admitted in the preface to his play that he was unacquainted with the required directions for theatrical productions and begged indulgence of his audience. While he apologized for neither his poetry nor plot, for most consumers, no apology was needed.

In the inauspicious preamble to the script, Cockings spoke of the classical prototype for Wolfe's victory, in which the "regal Leonidas, with his few chosen, and ever renowned Spartans, Thebans, and Thespians [sic] nobly fall, in the defence of their country."[65] The *dramatis personae* of *The Conquest of Canada* includes in addition to Leonidas, Wolfe, Leonatus, Britannicus, Sophronia (Wolfe's Mother), and Sophia (Wolfe's fiancée).

The play opens with Wolfe taking leave of Sophronia, who, aghast at the thought of her son going off to war in distant Canada says, "Oh! direful thought! in battle fell'd you may / Be trodden underfoot, in

the purple / Stream flowing from the fountain of your heart (weeps)."[66] In scene two Wolfe bids adieu to Sophia, and pines;

> I'm wrapped in amorous doubt, mixed with a sweet
> Perplexity! Love's fierce desires inform
> My glowing soul! the wish'd for malady
> With ardent tremour rolls through every vital part![67]

After scenes at Portsmouth and in the environs of Quebec in which the characters ruminate on the meaning of the war and other matters, the action accelerates with the commencement of the battle on the Plains of Abraham. Leonitas (Monckton) is shot in the lungs and cries, "My wound would plead with sanguined eloquence for fame," and then says sadly,

> I must quit the field!
> For though my spirit is resolved yet the
> Poignant torments, and expense of blood, roll
> Cooling tremors to my heart, and weigh frail
> Nature down.[68]

Wolfe appears. Mortally wounded, he is supported by four soldiers. "I'll lay me back, and rest awhile," he says, "perhaps this cooling tremor may wear off." The stage directions call for him to lay "back against a soldier (sitting for that purpose)" and instructs that "as he falls back [he] groans, and lies as dead." An officer surveying the battle reports, "Our wings and main corps boldly cross their lines! / They've beaten down the oriflame of France / And now they trample it in Gallic gore!" Then in joy a messenger says, "Oh how they scatter! – now they flee full speed! / victory! – Victory! – by heavens they run!" The script calls for "a shout of victory and Indians yelling." Wolfe raising himself asks the question "Who runs?" on being answered, he dies content.[69]

 The drama abruptly switches back to England. Sophronia is told, at an excruciatingly slow pace, of the death of her son. This attempt at dramatic tension is repeated as Sophia is told of of her lover's doom. The officer bearing this bad news then turns to the audience and says:

> Should France again Europe in broils engage,
> And dare to rouze the dormant lion's rage;
> Methinks I see your souls around me glow
> With flame indignant, against the insidious foe.

To glory's goal what Briton would not wish to die!
Who would not fight the treaty breaking Gaul!
When George, and liberty, and martial honour call.[70]

The play brought a contemporary dramatic event to audiences infat-
uated with their new national hero. The tale of Wolfe at Quebec was
ideal material for those who took to heart the critic Joseph Warton's
plea in 1756 that dramatists "search for subjects in the annals of
England, which afford many striking and pathetic events, proper for
the stage." "*Domestica facta*," Warton said, were "more interesting, as
well as more useful," than foreign subjects, although he undoubtedly
had works of better quality in mind than Cockings' play.

Wolfe was celebrated on several English stages. A "Rhapsody on the
Death of Wolfe" by Joseph Gaudry was sung at the New Theatre in the
Haymarket on 8 September 1760.[71] At Southwark Fair on 18 Septem-
ber, 1760 the production of "Don Quixote in England" was "gar-
nished," as the advertisement for the show announced, "with singing
and dancing, particularly a song on the late victories obtained by our
fleets and armies." This song would probably have resembled one sung
at the time by the most popular tenor of the day, John Beard, "in the
character of a recruiting sergeant" at Covent Garden Theatre, which
included the verse:

Of Roman and Greek
Let fame no more speak
How their arms of the Old World did subdue;

Through the nations around,
Let our trumpets now sound,
How Britons have conquered the new.[72]

The Southwark Fair variety show also included "a hornpipe by a British
genius, whose valour was conducive to the reduction of Quebec," a
"view of a magnificent monument erected to the memory of the late
General Wolfe," and a "monody to be spoken on the death of that
brave and much lamented hero."[73] Unfortunately one can only guess
at the appearance of this magnificent, if ephemeral, monument and a
similar one revealed at the end of a musical production called the *Siege
of Quebec; or Harlequin Engineer* in the Spring of 1760.[74]

The text of the monody has fortunately survived, as it was published
for those who admired it at the fair and those who had, by some

misfortune, missed the performance. Its review in the *London Magazine* was not favourable: "We know too much of the unhappiness of many youths, who are cursed with a *singing in the head*, which they mistake for poetical genius, to wonder at such a monody's being written: But we are greatly amazed, that a bookseller could be found who would print it."[75] The monodist began by invoking the memory of the virtuous hero and the common call to all not to let him die unsung.

> In virtue's list, behold the hero stand,
> The first and foremost in the rolls of fame;
> Nor foe, nor precipice, his arm oppose,
> Alike they dread, alike revere his name.

> But, O ye powers! – whither did ye fly?
> Could ye forget whence your mandate sprung?
> Could ye forget 'twas WOLFE you had in charge?
> How could ye let him fall, and fall unsung?[76]

The admonishment in this "nonsensical catchpenny"[77] not to let Wolfe die unsung was completely unnecessary. Only a few days after news of his death reached England the music publisher J. Johnson placed a notice in the *Public Advertiser* announcing "new music speedily will be published, proper to be sung at this juncture." Johnson's rapid grab at the market consisted of a new edition of "English Heroes against French Invaders" with words by Mr. Lockman, music by Mr. Morgan, and sung by Thomas Lowe at Vauxhall Gardens. The advertisement promised that the song was to be updated with the addition of a verse which ran,

> But Wolfe greatly fell, whilst with laurels he shone,
> For the loss of this Hero, Ah! what can atone? -
> His death is revenged, for Quebec is our own.[78]

Johnson's addenda to "English Heroes" turned out to be even better than promised. After the hastily produced advertisement, the publisher, perhaps influenced by the swirl of rumours about George Townshend, reconsidered the additional lyrics and when eventually published the song included not one but two new stanzas.

> Behold Wolfe and Townshend, in glory's bright way,
> Toward Quebec marching in dreadful array
> Ye fates! Victory give, as on Blenheim's famed day.

See! See! Quebec falls, whilst Wolfe greatly bleeds.
How fatal a loss this high conquest proceeds!
Too short was his life, but immortal his deeds.[79]

At the end of the momentous year the song, "Britain's Glory: Or the Year 1759" was published. It, of course, included praise of the courageous Wolfe.

But true British courage no dangers can fright,
Brave Saunders and Wolfe determined to fight;
O'er lakes, rock and rivers these heroes advance,
Despising the threats and the bluster of France.

Made bold by despair the French stood at bay,
But our highland broad-swords drove them quickly away;
'Sacra Dieu!' they roared out, 'our Monarch's undone,'
'Those Britons are devils;' so from them they run.[80]

The glorious year of 1759 was commemorated in dozens of other patriotic songs. John Beard, with other soloists and the childrens' choir of the Chapel Royal, performed an *Ode for the New Year 1760*, written by the Poet Laureate William Whitehead, before the king on New Years Day 1760. The epode ran as follows:

Genius of Albion, hear the Prayer!
 O bid them all with lustre rise!
Beneath thy tutelary care
 The Brave, the Virtuous, and the Wise
Shall mark each moment's winged speed
 With something that disdains to die,
The Hero's, Patriot's, Poet's meed,
 And Pass-port to eternity.[81]

In the period immediately after his death poets and song writers warbled incessantly, if untunefully, about Wolfe. If the hero's ghost would have been disappointed by the quality of his literary apotheosis, he could not but be elated by his subsequent commemoration in the visual arts.

5

They Vote a Monument of Lasting Fame

Patrick Gibson, who said he had assisted in the sad duty, recalled that General Wolfe's corpse was removed from the Plains of Abraham at ten minutes after ten o'clock on 13 September 1759. According to Gibson, a detail of some sixty sailors and marines carried the body solemnly to the St Lawrence and rowed it out to the frigate Sea-Horse.[1] Captain Thomas Bell, one of Wolfe's aides-de-camp, prepared the corpse for transport to England, helping himself to a souvenir lock, or, more likely, several locks, of Wolfe's red hair and supervising the embalming of the body "in a stone shell fetched out of the chief convent at Quebeck."[2] Bell boarded the *Royal William* on 23 September with Wolfe's corpse.

Upon its arrival in England the general's remains were accorded appropriate military honours.

On Saturday, Nov. 17, at seven o'clock in the morning ... the body was lowered out of the ship into a twelve oared barge, towed by two twelve oared barges, and attended by 12 twelve oared barges ... Minute guns were fired from the ships at Spithead, from the time of the body's leaving the ship to its being landed at the point at Portsmouth, which was one hour ... At nine the body was landed, and put into a travelling hearse, attended by a mourning coach ... and proceeded through the garrison.[3]

The funeral, in contrast to the public progress of the body, was a private affair. Wolfe's corpse was interred in the family vault in St Alphege's, Greenwich, on 20 November. Among those present were Captain Thomas Bell and Captain Delaune, both personal friends of

Wolfe.[4] Both officers had witnessed his will, drawn up 8 June 1759 shortly after Wolfe received the news of the death of his father.[5] Delaune returned Wolfe's belongings to his mother in Greenwich and it was probably he who delivered Wolfe's copy of Gray's *Elegy* to Katherine Lowther in Bath and carried out Wolfe's wish that his fiancée's picture be set in 500 guineas worth of jewels and returned to her.

The Duke of Richmond, upon hearing of the arrival of the *Royal William* at Spithead, had dispatched the sculptor Joseph Wilton to record Wolfe's face. Richmond and Wolfe had first met in Paris in 1752. The young Wolfe, impressed by Richmond's military and social superiority, said of him, "at eighteen he is not entirely taken up with the outward appearances and gildings of soldiership, but aims at the higher and more solid branches of military knowledge."[6] Both possessed a common sense of duty to the nation and pride in their respective military careers. They corresponded regularly. Wolfe wrote to his friend on 10 July 1757, "If we mean to deliver down our country and constitution whole and entire to our posterity – self-denial, courage, temperance, and magnanimity must be the channel to convey these great blessings to those that come after."[7] The officers agreed on the strategy necessary to finish the war with France in North America. Wolfe wrote to Richmond, "I am entirely of your Grace's opinion that the reduction of Quebec is the only effectual blow that we can strike upon the continent of America: Louisbourg would save us – but together, would give us the advantage of the war; why such an enterprise is not projected, amazes me."[8]

When Joseph Wilton opened the stone cistern which held Wolfe's body to take a plaster mask for the Duke of Richmond, he found the face too distorted to be of much use. It was said that a servant of Lord Gower was found who looked like Wolfe and the sculptor modelled his face while Lord Edgcumbe (Richard 2nd baron Edgcumbe of Mount-Edgcumbe) corrected it from memory.[9] Edgcumbe was qualified to assist Wilton in his important commission as he was an early patron of the portraitist Joshua Reynolds and was himself an accomplished draughtsman. The procedure permitted Wilton to model a likeness which would have borne as close a resemblance to his subject as would the work of a present-day forensic sculptor.

Wilton's initial model of the head of Wolfe (or, more accurately, his corrected study of the face of the servant of Lord Gower) has disappeared, but from it, and perhaps another source, the sculptor subsequently produced a series of three busts. (None of these portrait busts are recorded as having been in the collection of the Duke of

Richmond.) That Wilton should make three busts after his initial model of Wolfe is an indication of the kind of market he anticipated for images of the departed hero.

Wilton's surviving portrait sculptures differ in details. One in the National Portrait Gallery, London, might be the first, as it has what might be the least idealized face of Wolfe[10] (Fig. 5.1). It is a full-size plaster, as is what may have been Wilton's next portrait of Wolfe, which is known from two eighteenth-century casts. One of these, now in the Canadian War Museum, was once the property of a descendant of the Reverend Richard Board, Vicar of Westerham, and the other was acquired by Governor Simcoe in 1784.[11] Wilton did not have either of these busts cut in marble. He did produce another model, since lost, which was cut in stone (Fig. 5.2).

Working in the then-current neo-classical style, Wilton presented Wolfe in the guise of a Roman general, with some concessions to contemporary fashion and symbolism such as the gorget, wolf-head epaulettes (a visual pun), and the lion of England in relief on the antique breastplate. The diagonal sweep of the cloak and the balanced arrangement of the head and shoulders are accomplished essays in the eighteenth-century English classical idiom. This transformation of the conqueror of Canada of 1759 into a timeless statement is composed with antique grammar finely tuned to contemporary taste.

Taste for the antique and for the contemporary re-creation of it using neo-classical forms was based on the assumption that the primary function of art was to instruct. Specifically, art was to advocate virtue. Timeless virtue, in its most refined state, was to be found in the heroes of the ancient world and so for artists, and for poets as well, the only appropriate forms for conveying the essence of virtue were to be found in the ancient world. The style of the ancients was infused with decorum and restraint, as was the English character, and thus it was felt that it was entirely appropriate for poets intent on commemorating modern heroism and virtue to choose the ancient forms of ode, epic, pastoral, and elegy, and for sculptors and painters to render virtue visible through the stylistic repertoire of the ancients.

Art and poetry dealing with virtue were necessarily beautiful because virtue itself was beautiful. Lord Shaftesbury enunciated this Platonic theory of beauty at the beginning of the eighteenth century, enormously influencing the arts in England. He wrote that "the most natural beauty in the world is honesty and moral truth" or virtue, for all beauty is truth.[12] Beauty and truth were derived from harmony and proportion.[13] The majority of English connoisseurs of the time had an

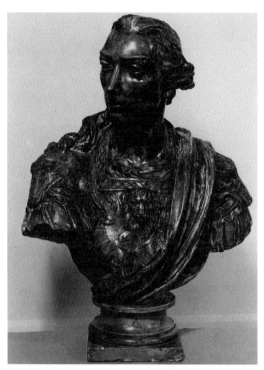

Fig. 5.1 Joseph Wilton, *General Wolfe.* Plaster, c. 1760 (National Portrait Gallery, London)

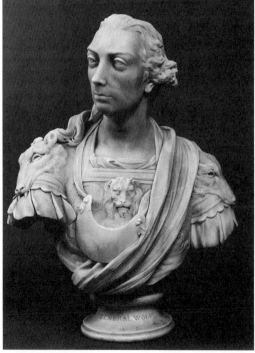

Fig. 5.2 Joseph Wilton, *General Wolfe,* Marble, c. 1760 (National Gallery of Canada, Ottawa. Bequest of the 6th Earl of Rosebery, 1975)

abiding taste for classical forms in which ancient beauty, considered to
be synonymous with ancient virtue, could be recapitulated. Wolfe was
not alone in being re-created in terms of the ancient archetype of
virtue, but among his contemporaries he was the ideal candidate for
such an ideal role.

The more profound of eighteenth century English connoisseurs
understood ancient virtue in terms put forth by Sir William Temple,
whose ideas on the subject, although a product of the late seventeenth
century, were kept current through periodic new editions of his essays.
Temple wrote that ancient characters such as Epaminondas, Alcibia-
des, Julius Caesar, Trajan, and others possessed "noble and transcen-
dant virtues and heroic qualities" which included "their fortitude, their
justice, their prudence, their temperance, their magnanimity, their
clemency, their love to their country and the sacrifice they made of
their lives, or, at least of their ease and quiet to the service thereof."[14]
The ancient heroes had "eminent virtues" through which they won
victories, promoted nationalism and earned the admiration of their
contemporaries and succeeding generations. Heroic virtue, according
to Temple, "arose from some great and native excellency of temper or
genius transcending the common race of mankind in wisdom, good-
ness, and fortitude." Those who possessed this virtue appeared as
"something more than mortals, and to have been born of some mix-
ture between divine and human race; to have been honoured and
obeyed in their lives, and after their deaths bewailed and adored."
Temple's description of how the ancient heroes used their valour was
equally applicable to Wolfe, as was his description of their virtue. The
ancient heroes employed their bravery "in defending their own coun-
tries from the violence of ill men at home, or enemies abroad; in
reducing their barbarous neighbours to the same forms and orders of
civil lives and institutions, or in relieving others from the cruelties and
oppressions of tyranny and violence."[15]

The eighteenth century taste for the classical, for beauty in charac-
ter arising from antique virtue, is apparent in a poetic parallel drawn
between the Roman conqueror of Britain and General Wolfe. An
example of scouring the past for a precedent for Wolfe, this poem
confirms the appropriateness of the neo-classical style used in portraits
of the national hero.

To Rome from Pontus, thus great Julius wrote,
I came, I saw, and conquered ere I fought.

In Canada, brave Wolfe, more nobly tried,
Came, saw, and conquered – but in battle died.
More glorious far than Caesar's was his doom.[16]

Wolfe, who died bringing liberty to an oppressed region, was seen as a kind of perfected Caesar, equal or superior to the even greater classical heroes Cato and Romulus and, according to one poet, mourned with no less passion than that exhibited by the Romans at the passing of Nero.

When ancient Romans did lament,
And Nero's death gave discontent
Well may England then complain,
Her chiefest glory, Wolfe, is slain.
Mourn England, mourn, mourn and complain
Thy chiefest glory, Wolfe, is slain.[17]

The virtues possessed by the heroes of ancient history were thought to be unaffected by the passage of time. They could be recapitulated by great men in any age and this repetition of antique virtue, if it were to be demonstrated to the public and given a didactic presence in society, must be communicated through the arts. In the essay *Soliloquy: or, Advice to an Author,* Lord Shaftesbury led his readers through an argument demonstrating the natural connection that existed between art, politics, and history. All nations need poets, historians, and antiquarians to record the achievements of civil and military heroes. Although military men are often themselves untutored in the arts, "they are yet, in reality, the most interested in the cause and party of these remembrancers ... The greatest share of fame and admiration," Shaftesbury concluded, "falls naturally on the armed worthies." Without poets, the reputations of great men would be carried to posterity only by chance. Shaftesbury observed that his own era had produced few heroes who, like Xenophon or Caesar, could write their own memoirs, and noted that the writings of statesmen were so self-interested as to be sickening. "It is" wrote Shaftesbury, "the able, and disinterested historian, who takes place at last; and when the signal poet, or herald of fame, is once heard, the inferior trumpets sink in silence and oblivion."[18]

For some, because national virtue was eternal, it could be continually instructive: the present could teach about the past and vice versa. In

his *Enquiry Concerning Human Understanding* (1748) David Hume proposed that "there is a great uniformity among the acts of men, in all nations and ages" and suggested that if one wished to know the sentiments and inclinations of the Greeks and Romans one had but to look at the temper and actions of contemporary English and French.[19] Others, however, particularly the artists and poets, believed that only by reference to the virtues of the ancients could the highest ideals be taught to the modern world. As rightness of character was established in the past, so virtue and its corollary, beauty, were to be found there also. For someone like Joshua Reynolds, however virtuous the present, this virtue could only be pictured in forms of the past. To picture Wolfe as an ancient general, as Wilton did, magnified and, more importantly, transformed his example into a timeless icon of virtuous behaviour.

The precise formal rules for sculpture enunciated by Reynolds in his discourse delivered to the students of the Royal Academy on 11 December 1780 dealt with the simultaneity of beauty in art and the inherent beauty of its subject. Reynolds's attitude to art, as expressed in his writing, represents the absolutist faction of his day. The majority of connoisseurs were less vociferous and more flexible proponents of neo-classical taste.

In his address to the students Reynolds made it clear that sculpture was a simpler and more uniform art than painting. "The object of its pursuit," he said, "may be comprised in two words, form and character: and those qualities are presented to us but in one manner, or in one style only."[20] The acceptable style was the classical. The unique austere quality of sculpture demanded, according to Reynolds, the "utmost degree of formality in composition." By formality he meant adherence to the classical cannon which disallowed the picturesque. "Everything is carefully weighed and measured, one side making almost an exact equipoise to the other." He proposed further rules for sculpture: "The form and the attitude of the figure should be seen clearly, and without any ambiguity, at the first glance of the eye"[21] and as sculpture is "formal, regular, and austere," it should avoid use of all familiar objects, as incompatible with its dignity. The latter direction prohibited the use of modern costume. Fashion was mutable and transitory; virtue, beauty, and truth were immutable. Finally, in sculpture which adhered to the rules, quality could be established by consideration of the goal of "a settled uniformity of design, where all the parts are compact, and fitted to each other, every thing being of a piece."[22]

Given the emphasis on the timeless and idealized form in sculpture – the universalized canon of the ancients – it is a wonder that the

individual, his unique physiognomy, that part of him which tied him to the contemporary world, still managed to rend the veil of timeless idealized beauty. Yet Wilton and his contemporaries sought to achieve an elusive balance between the accidents of nature that formed the individual and the canon of absolute beauty. Reynolds recognized this problem. In his fourth discourse at the Academy in 1771, he said, "it is very difficult to ennoble the character of a countenance but at the expense of likeness"[23] ... and in his fifth discourse he said, "when a portrait is painted in the historical style ... it is neither an exact minute representation of an individual nor completely ideal."[24]

Wilton did not present Wolfe as being "incredibly ugly," as he was once described. He did, however, smooth out much of the angularity of his face, although its distinguishing beak-like character remained. Wilton's sculptures were intended to be identifiable portraits and they succeed in this. As well as using Wolfe's corpse and Wolfe's look-alike, Lord Gower's servant, Wilton may also have studied Wolfe's physiognomy by means of a life sketch, a minimal pencil profile identified by an inscription on the verso as the work of Hervey Smyth, one of Wolfe's aides-de camp (Fig. 5.3). An addendum to the inscription states that this was the sketch "from which his bust was principally taken," lending credence to the supposition that Wilton had the sketch at hand while modelling the head.[25]

Wilton was eventually to be responsible for an even more distinguished sculpture of Wolfe. On 1 November 1759 it was reported that the king had sent orders to the Board of Works for the preparation of a plan and estimates for a monument to General Wolfe to be erected in Westminster Abbey. It was reported that the expenses, not to exceed £3,000, were to be borne by the king's private purse.[26] This last information apparently came from an unreliable source as on 13 November the readers of the *Public Advertiser* were informed that the monument would be erected at public expense. This news was followed by a long editorial comment on the need to avoid the usual practice of patronage which had led to monuments of such abysmal quality as to discredit the patron, the subject, and the artist himself. The newspaper suggested a fair competition in which preference would be given only on the basis of merit. Several artists of eminence who could show similar completed works should be invited to submit designs. In this way, said the writer, the nation could expect something original, as distinct from the common contemporary monuments which he characterized as a "load of lumber" made up of fragments stolen from old ruins.

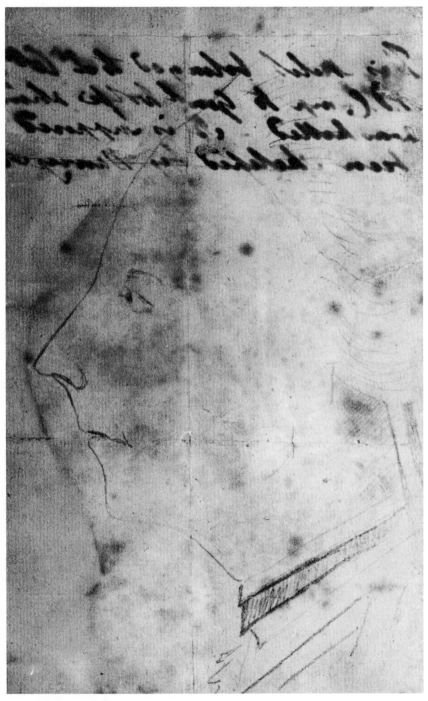

Fig. 5.3 Attributed to Hervey Smyth, *Profile of General Wolfe.* Drawing, 1759 (Quebec House, a property in the care of the National Trust, Westerham)

On 21 November 1759, the day after his interment at Greenwich, Parliament passed an act for the erection of a monument to General James Wolfe.[27] There was great interest in the proposed monument. A writer to the *Scots Magazine* in December of 1759 suggested how "one of the most brilliant actions which adorn the annals of any people," should be memorialized in sculpture. His words reflect the understanding of sculpture then current in England. It was, the contributor wrote, the practice of the Greeks, "the masters of all mankind in the fine arts," to memorialize their heroes "in some action or attitude according to the fancy of genius of the artist, and on the pedestal of which some of his most memorable exploits were engraven in basso relievo." The proposed monument to Wolfe should follow this model of the ancients to achieve "nobleness of aspect ... for the pleasures of the beholder." The writer went on to argue, in line with the theory common at the time, that the sister arts – visual art and poetry – obtain their glory from invention, which is the gift of heaven and as such distinguishes genius from mechanics. Invention comes from the stars but may be improved by viewing the best art, by observing nature, and by studying good literature, especially poetry. Therefore he asked his readers to consider a poem he had written entitled *Daphnis and Menalcas, a pastoral, sacred to the memory of the late Gen Wolfe.* (The title, the same as a previously mentioned work, is evidence of the popularity of the idea of the pastoral in glorifying the dead.) This, he said, was not only an entertaining piece of literature but could serve as an inspirational text for sculptors in designing the monument to Wolfe.[28]

The poem itself, which, despite its title, is not in fact a pastoral, outlines the various scenes the author thought should be depicted in relief on the base of the monument. One side should show Wolfe's bravery at Quebec, where he should appear like the ancient gods: "Show him like Phoebus, patron of the bow, / Graceful in youth, like Jove's his awful brow."

> With wreaths of laurel let his brows be bound,
> With broken arms and truncheons strew the ground,
> Plant armies, senates, princes weeping round.
> By golden armour, and a radiant crest,
> And martial port, distinguished from the rest,
> Place noble Granby, Amherst, Townshend there,
> Mourning their friend, and brother of the war.

On another side of the pedestal should be a relief showing the mourning of Wolfe's mother, his fiancée, and others.

Fixed as a statue, near his much-loved side,
In silent sorrow, place the beauteous bride.
But oh! what magic sculpture can express
The parent's grief, the mother's deep distress!
Like Hector's mother be the matron laid,
A sable mantle o'er her reverend head,
Growing to earth, the grovelling on the dead.

The king should accompany the two women, his outspread hands simultaneously invoking heaven and demonstrating his sorrow. Beside the king should be the prime minister and hovering above them Britain's Genius who hears the King's commitment to "raise to his memory and deathless name / The sculptured tomb, and monument of fame." Below this scene the sculptor should engrave his vow, "The conquered world, that caused the fatal strife, / Shall pay the price of this lamented life."

On the third side of the pedestal should be carved the apotheosis of Wolfe. In this scene he is welcomed to the elect by his father and seated between the ancient Theban General Epaminondas, who died at the moment of victory in the Battle of Mantinea in 326 B.C.E., and the valiant Swedish King Gustavus Adolphus, who died in victory at the Battle of Lutzen in 1632.

Now high above let opening heaven display
Its everlasting gates, that flame with day;
Place gods, and demi-gods, and heroes round,
By Jove himself the sacred synod crowned:
Let all behold the immortal spirit rise:
With song and Muses hail him to the skies:
His seat with those who conquered as they bled,
Betwixt the Theban and the valiant Swede;
While his great father, with a father's joy,
Receives, alas! too soon, his darling boy.[29]

While the competitors for the monument to Wolfe may not have followed the specific advice of this anonymous critic and poet, extant designs show that their concepts for the memorial were created with a similar reverence for the ancient art of memorial sculpture.

The list of entrants in the competition for the prestigious commission included all the best English sculptors of the time. Joseph Wilton, the winner of the commission, had the advantage of his prior study of

Wolfe. Among the unsuccessful competitors were Robert Adam, England's premier architect and designer, two sculptors at the beginning of their careers, Robert Chambers and William Tyler, and the older and well-established artists Sir Henry Cheere, the Antwerp-born John Rysbrack, the French-born Louis François Roubiliac.[30] Agostino Carlini may also have competed for the commission.[31]

Robert Adam's proposal consisted of an elaborate broad structure centred on a large, almost square, picture in relief (Figs. 5.4 and 5.5). Against what appears to be a truncated pyramid or stubby obelisk, Adam intended to place a structure like a fireplace elevated on a sarcophagus flanked by squat columns. The entablature was to be raised on two semi-nude caryatids. The decorative details of Adam's proposed monument are characteristic of his personal neo-classical manner, which inclined toward the picturesque in opposition to slavish recreation of ancient forms, as is apparent in his design for the relief of the death of Wolfe (Fig. 5.6). In front of a huge tent or drapery, Wolfe is shown expiring on a couch, pathetically gesturing to the soldier who has come to tell him of the victory. The participants in the tragic scene wear battle dress and hold weapons of ancient vintage. In the background the soldiers move across land reminiscent of the Roman Campagna. Adam's proposed monument was huge, as were those of the other competitors, their sheer size and complexity reflecting the grandeur of the individual they were intended to commemorate.

Louis François Roubiliac's design is known through an engraving[32] (Fig. 5.7) and a drawing.[33] He proposed a sculpture showing Wolfe falling into the arms of victory with fame crowning him with laurel. Magnanimity, at Wolfe's left, is seated on a globe and holding a wreath. Her right hand rests on a shield, an eagle is at her shoulder, and the club of Hercules is at her feet. A contemporary criticised the symbols on the left side of the pedestal as lacking "the usual brilliancy of imagination which Roubiliac possessed." They included "the British lion triumphing over the savage, a map of Quebec on which the Indian prostrate rests his right hand, and in his left his bow, with a beaver peeping out underneath."[34] Roubiliac's design for the monument departed from strict adherence to the antique. Wolfe, although shown with allegorical figures and symbols derived from ancient prototypes, is in modern clothes and holding a modern sword.

A proposal by an anonymous competitor has been preserved in a drawing not from the hand of Chambers, Tyler, or Cheere.[35] Although the rococo character of the design is reminiscent of Cheere's work it is not by him. The overly crowded pyramidal composition for the

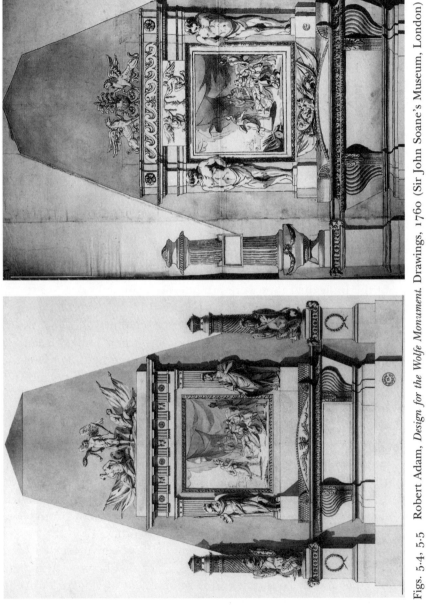

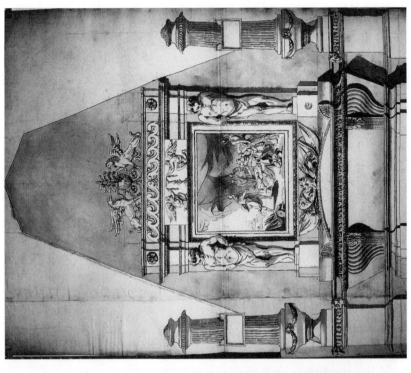

Figs. 5.4, 5.5 Robert Adam, *Design for the Wolfe Monument.* Drawings, 1760 (Sir John Soane's Museum, London)

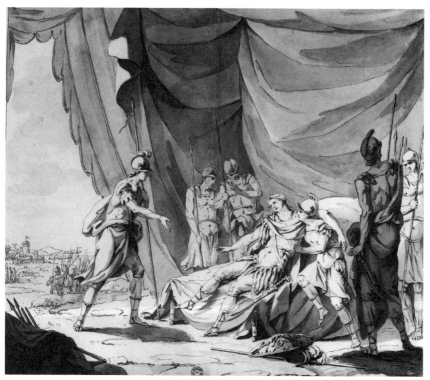

Fig. 5.6 Robert Adam, *Design for a Relief of the Death of General Wolfe.*
Drawing, 1760 (Sir John Soane's Museum, London)

monument has all the required symbols for a memorial to a heroic
general, including a supplicant Indian at his feet and a personification
of Victory crowning him with a laurel wreath. By 1760, however, the
design, with its agitated folds of the tent and the drapery on the fig-
ures as well as the narrative relief of the battle with minuscule people
in a landscape filling the oval cartouche on the sarcophagus would
have seemed out-of-date to English connoisseurs enthralled with the
linear neo-classical style.

A drawing for Rysbrack's submission shows that his proposal was
neo-classical in content and style (Fig. 5.8). The expiring Wolfe, hold-
ing the baton of command, is dressed in Roman armour. He is
attended by a similarly dressed soldier and two female figures symbol-
izing Britannia and Victory. Above the group with a panoply of flags
hovers an angel holding a laurel wreath and blowing a horn. The
upper part of the monument is backed by an obelisk and on the plinth

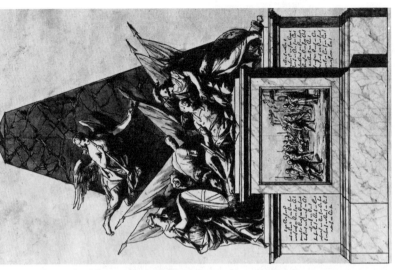

Fig. 5.8 John Rysbrack, *Design for a Monument to General Wolfe*. Drawing, 1760 (Victoria & Albert Museum, London)

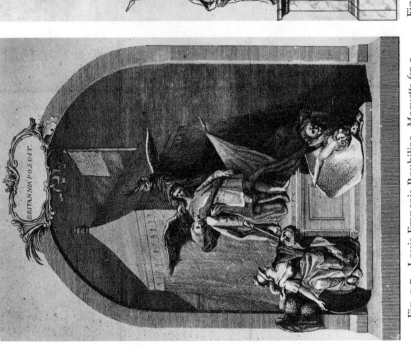

Fig. 5.7 Louis François Roubiliac, *Maquette for a Monument to General Wolfe*. Engraving, 1789 (*Gentleman's Magazine*, 5 January 1789)

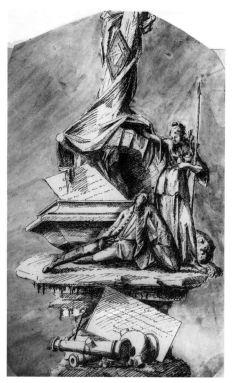

Fig. 5.9 Anon. *Design for a Monument to
General Wolfe.* Drawing, 1760
(Sir John Soane's Museum, London)

it was proposed to set a relief carving of robed soldiers removing the
body of Wolfe on a stretcher from the field of battle.

Another drawing for the monument, unattributable to any of the
known competitors, shows a clumsy and unbuildable free-standing pile
(Fig. 5.9). On a pedestal already mouldering under a fringe of moss,
the body of the dying or dead Wolfe is propped on a shield. Behind
him Victory with laurel wreath and spear lifts back a shroud to reveal
the mouth of a grotto or cave inhabited by the elderly Britannia. A
teetering sarcophagus supporting an inscribed tablet leaning in the
opposite direction blocks the mouth of the grotto. Below the unstable
sculptural ensemble are captured canon and a mortar backed by a
second inscribed tablet. The monument looks to have stood the test of
time. It is a healthy habitat for plant life and seems to have been
roughly shaken by the trembling earth. Wolfe, in modern military
clothing, has in a sense been transported back in time to the era when

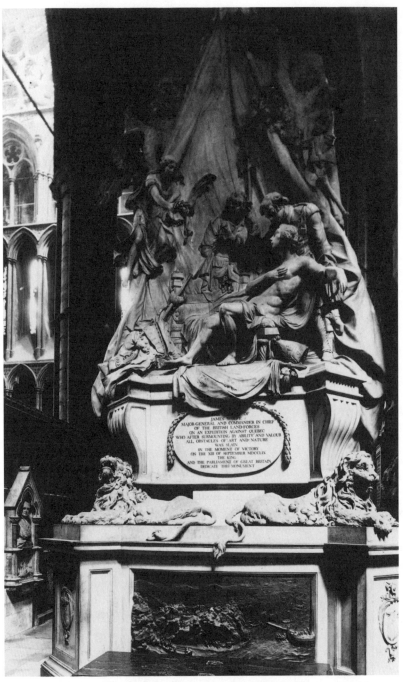

Fig. 5.10 Joseph Wilton, *Wolfe's Monument*, unveiled 1773. Marble
(Westminster Abbey, London)

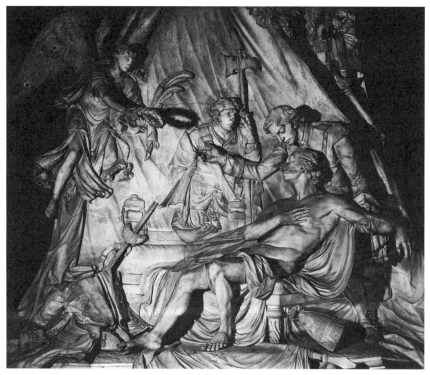

Fig. 5.11 Joseph Wilton, *The Death of General Wolfe*. Detail of Wolfe's
Monument. Marble, 1773 (Westminster Abbey, London)

another cave blocked by stone was shaken by the quaking earth and its
entombed body was resurrected, instigating the salvation of mankind.

Upon winning the competition, Joseph Wilton received an advance:
a warrant was issued to forward 1,000 pounds to him on 20 October,
1760.[36] His huge pyramidal monument, which took more than a
decade to complete, has three distinct sections (Figs. 5.10 and 5.11).
Set into the base is a bronze relief showing the boats disgorging troops
at the foot of the cliffs near Quebec while the British lines are drawn
up on the heights above. This relief is by a sculptor named Capitsoldi
or Capizzoldi, who had been Wilton's travelling companion on his trip
home in 1755 after a period of study in Italy.[37] The scene, which is not
entirely fanciful, was probably based on a contemporary engraving. On
top of the base are two lions and a neo-classical sarcophagus with an
inscription. The high point of Wilton's monument is the crowning
scene of Wolfe's death. The head of the dying general resembles that
produced by Wilton in his earlier busts. The nude and muscular Wolfe,

his right hand to his breast, is supported by a grenadier whose hat is on the ground at his feet. It has been observed that "Wolfe's nudity is threefold: he is nude like a classical hero, nude like a secularized saint, and functionally nude as well, for his uniform is piled on the floor at his feet."[38] Wolfe's tunic, hat, and rifle are on the ground to the left and under the general's feet is the French flag. His silver gorget, an item of some importance in Wilton's portrait busts of the hero, is hung on the bedpost.

Wilton's use of modern costume and modern appurtenances of war led some post-eighteenth-century writers to suggest that the sculptor had historical accuracy in mind when he designed the monument and names have been suggested for the grenadier and the highland soldier. Although there is no evidence whatsoever that Wilton had men who served at Quebec sit for him as he modelled the figures, speculation on the identity of the characters is still not without interest. The highland soldier may represent Malcolm MacPherson, who became known to posterity through information transmitted to the London audience via a report from Edinburgh. Apparently when General Townshend assumed command at Quebec he happened upon a seventy-year-old Scot who, having taken a rest behind a mound of bodies "most of whom he had slain with his own hand," threw off his coat and charged into the French and at every blow of his broad sword brought one to the ground. Townshend was impressed with the aged highlander's ferocity and asked him to report to headquarters at the end of the battle. In the subsequent interview Malcolm MacPherson was asked by Townshend why a man of such advanced age should volunteer for war in a very inhospitable place. The hearty Scot said he was motivated by the "perfidious behaviour" of the French and that he was happy that his broad sword, which had been in his family for more than 300 years, had revenged his country's foe. MacPherson, the report went on, was so fond of his broad sword that he took it to bed with him every night.[39]

Another candidate suggested for the highland soldier in Wilton's monument is James McDougall, although there is no indication given as to why he should have been shown by Wilton. A more likely sitter for the supposed portrait would have been Sergeant Donald McLeod of Fraser's Highlanders. The Scots seemed never to tire of war, for this McLeod, like MacPherson, was seventy at the time of the battle at Quebec. There is some evidence that McLeod was with Wolfe in his final moments: the author of a biography of McLeod published in 1791 was told by his aged subject that he had been wounded in the

shin and arm during the battle on the Plains of Abraham. "It was, under his weight of actual suffering, and sympathetic sorrows some consolation to the good old Serjeant ... that the tender which he made of his plaid, for the purpose of carrying the dying general to some convenient place off the field of action, was accepted. In Serjeant McLeod's plaid was General Wolfe borne by four grenadiers."[40] Wilton's highlander doesn't look seventy years old, but he does have his arm tucked into his tunic and he is resting on a pike. McLeod, being an invalid, was sent home with General Wolfe's corpse on the Royal William. He may have met Wilton at Spithead during the attempt to take a death mask.

Although Wilton's monument resembles that of the other competitors, he bettered Roubiliac in using a tent to create a triangular upper section. The tent is ingeniously set against a tree. Foliage frames the peak of the tent and forms the upper terminus of the ensemble. Hung on the tree are two tomahawks and an Indian knife. The composition is conceived in strictly classical terms with fine interplay of carving in the round, high relief, and low relief. The drapery of the angel holding a laurel wreath, the shroud on which Wolfe lies, the tent, and the flag are created in the classical idiom. The form and pose of the nude Wolfe are derived from ancient sculpture and the bed on which he reclines is based on a Roman model. In Wilton's monument the neoclassical sculptural and architectural style peppered with items of purely contemporary meaning serves to render homage to a modern hero through the spiritual connection of the eternal past and the moment of present.

The Wilton monument to Wolfe has received less-than-universal praise. The Pennsylvanian Mary Shackleton, who toured the Abbey in 1784, said that Wolfe's face did not seem to capture "the sentiments which we suppose he felt," and that the monument was not as pleasing to her as another contemporary commemorative ensemble.[41] A modern critic damned the death scene, faulting it specifically for combining the naturalism of the two soldiers and the "Baroque allegory of the Victory" which "together bordered on the grotesque." It was, she said, "here more than in any other work the confusion, and perhaps the pretentiousness, of the artist is apparent."[42] This echoes the opinion of the late nineteenth-century critic Edmund Gosse, who wrote that although Wilton and his contemporaries considered the monument to be his masterpiece, it is clearly an example of an artist's reach exceeding his grasp. "In the first place, the mixture of low relief with figures in the round is highly unfortunate, and the design, which fails

to interest, overpowers the detail of the modelling. The lions at the base are ludicrous, and there is no escaping from them." Gosse did temper his condemnation of the ensemble by defending it against the slings of eighteenth-century critics who, he said, "found fault with the fact that the naked body of the hero is supported by soldiers in modern uniform." There is, however, no evidence of objections in the eighteenth century to the naked Wolfe or the uniformed men. Gosse perhaps assumed that criticism made of other representations of the death of General Wolfe would also have been levelled against Wilton's monument. Concluding his remarks on the ensemble, Gosse praised it for "the way in which the illumination of the whole enormous structure is focused on the head and shoulders of the dying general."[43]

The figures for the death of Wolfe were carved by Nathaniel Smith, the author of a drawing of Roubiliac's maquette, who had entered Joseph Wilton's studio on the death of his previous employer in 1762. It apparently took him three years to accomplish his task.[44] In 1772 the components of the monument were taken from Wilton's studio and assembled in Westminster Abbey where the monument was unveiled to the public in November 1773.[45]

The announcement that the monument to Wolfe was in its last stage of construction led an informal group of gentlemen who met at Almack's Assembly Rooms to offer a prize of £100 for the best epitaph to Wolfe, promising that the winning entry in the competition would be inscribed on the monument. This contest unleashed a second flood of ink from the pens of ardently nationalistic would-be-memorialists, most of whom had mercifully refrained from sending in their verses on Wolfe to the press for more than a decade.

Some poets criticized the very idea that General Wolfe needed an epitaph. A lady wrote, "Silence ye Bards, your various contests cease, / And let Wolfe's precious manes rest in peace."[46] Other writers said Wolfe did not need the musings of minor versifiers as his eternal fame was already ensured. The Scottish poet Robert Fergusson wrote three epitaphs. In one he took up the theme that the bards should be silent as "it is enough to say that Wolfe lies here." In another he criticized the mercenary poets who, seeking the prize, had assumed "the arch-tongued lawyer's trade." In his third poetic response to the competition Fergusson considered the amount of the prize.

> One hundred pounds! too small a boon
> To set the Poet's muse in tune
> That nothing might escape her.

What? Wolfe's achievements to relate
With every action good and great?
 Pshaw! 't wouldn't buy the paper.[47]

To dozens and dozens of self-confident epitaph writers the prize, or rather prizes – money and immortality – were significant. So many poems appeared that one writer believed Wolfe suffered more from his compatriots' words than he did from enemy action.

Not all the force of France and Spain
Could give me, living too much pain,
As now I'm dead, I feel from those,
Who would my Epitaph compose
Much less I hate those French I brought to ruin
Than my own native fools and what they now are doing.[48]

The epitaph had been a popular form in the initial rash of memorial writing on Wolfe. John Pringle had appended an enormous one in English and Latin to his 1760 biography of Wolfe. It outlined the career of the young general and concluded with a triumphant statement on the siege of Quebec which ran in part:

Art had conspired with Nature
To render the Place impregnable:
But he, undaunted amidst such a Scene of Difficulties,
Climbs over Rocks and Precipices,
Lays the Lower Town in Ashes,[49]

Upon hearing of the victory at Quebec, Valentine Nevill penned *An Essay to an Epitaph on the truly great and justly lamented Major-General Wolfe, who fell victoriously before Quebec, Sept. 12, 1759.* His essay in poetic form was apparently produced in great haste, for the date of the death of Wolfe is wrong, perhaps reflecting the inexactness in the first reports that reached England. Nevill mailed his poem to General Monckton at Quebec. In his covering letter he made the obligatory self-effacing apology for his supposed lack of literary talent, calling his work an essay, "since I have not the vanity to flatter myself with hopes of succeeding equal to my wishes in so arduous a subject!" He had a valid excuse for failing to create an encomium of excellence befitting its subject, for he said, his "mind and harp," were "still out of tune" from the blow he had received from Wolfe's death. Seeking to enlarge

his audience, Nevill subsequently sent his poem to the press. One of the better early epitaphs to Wolfe, it began, "Here rests from toil, in narrow bounds confined / The human shell of a celestial mind." Nevill wrote that the patriotic zeal of Wolfe was inspired by public virtue, not selfish passion. He was, "In action ardent, in reflection cool," and

> As wont to smile on danger, smiled on death;
> And, having bravely for his country fought,
> Dyed nobly as he wished, and calmly as he ought.[50]

The amateur poets who entered approximately a hundred epitaphs in the competition of 1772–73 were not as ingenious as their predecessors in the poetic celebration of Wolfe's victory and death, and the narrow requirements of an epitaph, ignored by many of the competitors, did not serve to stem the tide of verse. The optimistic poets were not discouraged by the challenge of the competition, although there was an apt warning at the beginning of one submission which went "Hence idle epitaph! (mere pomp of verse) / There needs no pencil to adorn this hearse," or as Miss Anne Penny asked "Then on his tomb the pomp of verse forbear, / Enough to say – Victorious WOLFE rests here."[51]

Many of the epitaphs were instead long poems quite unsuitable for inscription on the marble monument. The writers used a limited vocabulary in praising Wolfe, – brave, dauntless, wise, young, and patriotic – and in describing the battle – fierce and bloody – and they inevitably turned to the allegorical figures of Victory or Britannia to crown Wolfe. Not only the sentiments themselves but also the way in which they were expressed remained as fixed as they had been in the first poetic tributes to Wolfe.

> O Wolfe, the favourite of the tuneful throng,
> The theme of every Muse, the boast of every tongue,
> For thy dear country's weal, alas! too soon,
> Thy rapid radiant race of life is run.[52]

> Resolved, collected, stern, yet void of hate,
> The Graces bore him to the field of Fate:
> Dauntless in Death, he charged the haughty foe,
> And Victory bound the lilies on his brow.

No conqueror but his mighty self he knew,
Your brightest pattern here, ye sons of glory view.[53]

A better epitaph was produced by the Reverend Everhard Ryan, who succumbed to the eighteenth-century epidemic of suicide in England at the tender age of 25. His effort was published posthumously in his collected works in 1777.

> ... Gallant WOLFE,
> In early prime who conquered, and expired
> Exulting in the arms of conquest, here
> Bequeaths his fame to BRITAIN, to adorn
> Her annals, and incite her valiant race
> To preserve in virtue. If your hearts
> Throb, and are filled with ardour, and if tears
> Of generous sympathy descend, rejoice!
> Preserve the impression, and be well assured
> That ye have virtues that deserve renown.
> Go cherish them, and gain what ye deserve.[54]

A contestant who signed himself "an ensign" offered verse which, although excruciatingly bad poetry, took a novel tack in heaping praise on Wolfe, attempting a word-play on the hero's name as Wilton had done with the wolf-head epaulettes in his busts.

> Wolfe – to thy worth the votive bust we frame
> And weeping add twas all you asked, a name;
> Great comprehensive name! the sum the end!
> Conqueror in mercy seated! hero! friend!
> Compassion boundless! orphans, widows stay!
> Thyself a father on the dismal day
> Oh snatched too soon! yet living to rehearse,
> The accomplished conquest of – an universe,
> Oh may we earn through thee the encircling need,
> And every Briton be a WOLFE indeed.[55]

One wag, who signed himself Singletonius, prefaced his entry with a note: "I have the vanity to think the following Epitaph will carry off the Premium from all my Competitors at the Society at Almack's, as it is composed in two languages, and so happily adapted to music that it

may be substituted at the head of a catch [a round] at the next anniversary meeting of that illustrious body." His epigram would indeed have best been sung by a slightly inebriated chorus of Almackians.

> Britannia leaning on her *hasta pura*
> Beheld the foe at Quebec so secure – a,
> "Go Wolfe, she cries, thy name's in Latin *Lupus*:
> "Thou art a Briton: let not Frenchmen dupe us."
> Up rose the Hero, filled with her *afflatus*,
> He conquered, dyed, and taught them how to rate us.[56]

The only other musical epitaph seems to have been one composed in 1773 by Edmond Ayrton, assistant director of the choir at St Paul's.[57]

Francis Douglas of Paisley sent an interminable epitaph to the *London Chronicle* which started with Wolfe travelling to America and ended with an observation on the durability of the marble shrine being erected in Westminster Abbey. If his entry had been carved on the monument, it would have covered the entire surface, figures and all. It ran, in part:

> Such was the man, to whose immortal name,
> The Muse, with pleasure, consecrates her theme!
> When time shall moulder marble into dust,
> And from its base shall fall the tottering bust;
> To the rude vestige of the Hero's shrine
> Britons shall point, a long succeeding line
> And when no longer Virtue warms the brave,
> His fame and time shall share one common grave.[58]

Another entrant had a similar concern about the eternal memorializing of Wolfe through a monument prone to deteriorate over time.

> Marble! to thee! my darling! intrust;
> Protect! protect! my Wolfe's most sacred dust;
> For should earthquake, the elegiac tomb
> She'd snatch voracious to her yawning womb;
> All-but her general wreck I can defy,
> And make his fame to live 'till nature die.[59]

The crumbling monument of decaying marble or the catastrophe of earthquake levelling the man-made memorial were common themes in

the epitaphs, perhaps because ruins evocative of past glories were ubiquitous in the kingdom and the fear of earthquakes was real. In the spring of 1750 two earthquakes in London a month apart caused public panic and sudden religious fervour. A decade later, on the day after National Thanksgiving for Wolfe's victory, Catherine Talbot wrote to her friend Elizabeth Carter, saying, "I am much pleased to hear that the churches were quite as much crowded yesterday, as I remember them in the terrors of the earthquakes."[60] The fear of a third tremor in 1750 was exacerbated by the "predictions of a crazy lifeguardsman" who dashed about London prophesying a cataclysm in which the city would be destroyed and Westminster Abbey would be reduced to rubble.[61] Public anxiety over the infirmity of the earth was exacerbated by the startling news of a cataclysmic tremor centred in Lisbon on 1 November 1755.[62]

The poetic expression of fear of the disintegration of the Wolfe's monument was first raised in 1760 by George Cockings in *War: An Heroic Poem.*

> In Lords and Commons, such the grateful flame,
> They vote a monument of lasting fame
> With glorious truth, his honour to display,
> Til marble-blocks, (themselves,) shall fade away.[63]

The motif of the eventual ruination of the monument came naturally to epitaph writers who were surrounded by real and newly built facsimiles of ruins in which *sic transit gloria mundi* was translated into the language of architecture. The authors of the epitaphs to Wolfe imagined that the marble monument would moulder as had its ancient prototypes, suggesting that their words alone were unsusceptible to decay and would stand as indestructible memorials to the immortal Wolfe. (The fears for the survival of the marble memorial to Wolfe have so far proved unfounded; the poets should instead have feared for the mouldering of their epitaphs for, unlike the monument, which continues to be available for contemplation, their poems have all been confined, perhaps justly, to uninterrupted obscurity until resurrected here.)

While most of the epitaphs entered in the competition were lengthy, there were a few from slightly more talented epigrammatists suited for inscription on the monument. These pithy statements belong to the familiar funerary four-line memorial. One of many examples read:

> Briton, approach in sorrow's silent gloom,
> With reverential awe behold his tomb

Intrepid Wolfe lies here, – his country's pride
He came, he saw, he conquered – and he died.[64]

In spite of the profusion of poetic possibilities for the inscription on
the monument to Wolfe, the society at Almack's was unsuccessful in
having the winning entry cut in marble. It is not clear that the society
had any right to expect that the commissioners in charge of the mon-
ument would be amenable to a suggestion for the text. The words
eventually inscribed on the monument say that he "who after sur-
mounting by ability and valour all obstacles of art and nature was slain
in the moment of victory." These lines are a quote from the motion
passed by parliament for the initiation of the monument project four-
teen years before the epitaph competition.

A contestant from Crediton, Devon, who signed himself M.M., sent
in an epitaph to the newspaper on 18 September 1772 which perhaps
shows that the author knew about the controversy over fitting the
massive Wolfe monument into an Abbey already chock-a-block with
tombs, tablets, busts, and monuments.

Of all the illustrious dead, whose tombs around
Crowd every angle of this hallowed ground,
Than thine, brave WOLFE, there's not a single name
Ought to rank higher on the lists of Fame.[65]

Antiquarians had squared off against those promoters of the Wolfe
monument who proposed removing existing memorials in the abbey
to make room for the new monument. Horace Walpole, roused to
anger over the suggestion that the fourteenth-century tomb of Aymer
de Valence be dismantled to make way for Wilton's monument, suc-
ceeded in convincing the authorities of the wisdom of preserving the
earlier tomb.[66] Antiquarians also had to fight a similar battle over the
possibility that the tomb of Francis de Vere would have to be modified
in order to wedge in the Wolfe Monument. One wrote, "the workmen,
I observe, have by their carelessness much damaged and defaced the
kneeling figures that support the monumental table of Sir Francis
Vere; thus destroying with one hand, while they rear with the other."[67]

For some, the delay in completion of Wilton's monument seemed
to suggest that Wolfe was not being properly honored. M.M. from
Crediton was unjustly critical of national sentiment. He wrote:

We've seen as yet no votive column rise
Have seen no flame-topt urn or laureled bust,

To guide our footsteps to thy sacred dust,
To inform us, while we drop the pious tear,
Quebec's great Conqueror reposes here.[68]

M.M. was right in observing that Wolfe's tomb at St Alphege in Greenwich was not conspicuously marked to aid patriotic pilgrims. The same was true in Quebec, where not until 1790 was a simple cairn erected on Wolfe's Hill on the Plains of Abraham to mark the place where the hero expired. The cairn was mentioned in the anonymous poem *Quebec Hill, Or, Canadian Scenery* published in London in 1797. "Close by a stone, that swells upon the heath, / 'Twas WOLF [sic], victorious, clos'd his eyes in death!".[69] There had been, however, monuments unknown to the English provincial poet raised to Wolfe's glory. Lord Temple, brother-in-law to William Pitt and witness to Wolfe's egotistical gasconade on the eve of his departure for Canada, had erected an obelisk to Wolfe on his estate at Stowe in 1761. He had also commemorated the battle of Quebec in a relief medallion, part of an ensemble of sculpture celebrating victories in the war inside his garden temple of Concord and Victory, which was dedicated in 1762.[70] By 1766 an obelisk that resembled Lord Temple's had been raised on the estate of the late Admiral Sir Peter Waren in New York at the head of Greenwich Lane (subsequently sometimes called Monument Lane). Although never built, a monument to be erected in Boston in the form of a marble statue of Wolfe was alleged to have been voted by the Massachusetts Assembly.[71] A monumental urn had been set up at Squerryes Court by George Warde and there were the busts that Wilton had made of Wolfe. Perhaps the Devonshire poet intended only to criticize the keepers of the public purse, whom he thought had been particularly parsimonious when it came to commemorating Wolfe.

The magnitude of English enthusiasm for monumental patriotic commemoration of Wolfe is reflected in the understandably cranky observation of the Jacobite James Johnstone, who was with the French at Quebec in 1759. In a text, which he failed to publish, entitled *A dialogue in Hades. A Parallel of Military Errors, of which the French and English Armies were Guilty, during the Campaign of 1759 in Canada,* Johnstone complained of the poor treatment accorded the memory of Montcalm, whose "ashes, mingled with those of Indians, repose neglected far from his native country, without a magnificent tomb or altars." General Wolfe, however, had statues in England commemorating "the many faults he committed during the expedition in Canada." This situation caused Johnstone to cry "O unjustice of mankind!" For "history which ought to be the sacred asylum of truth, shows that

statues and panegyrics are almost always the monuments of prejudice, and that flattery seeks to immortalize unjust reputations."[72] Although no one in England at the time of the inauguration of the monument to Wolfe would ever have admitted it, Johnstone may have been right in his ideas about the role of prejudice and flattery.

Johnstone's outcry might have been softened had he known that Pitt had facilitated the French commemoration of their fallen hero. "The honour paid, under your ministry, to Mr Wolfe, assures me," wrote Jean-Pierre de Bougainville, secretary of the Academie des inscriptions, to Pitt, "that you will not disapprove of the grateful endeavours of the French troops to perpetuate the memory of the Marquis de Montcalm." Pitt graciously granted de Bougainville's petition for a passport for a latin marble inscription to be sent to Quebec and installed on the tomb of Montcalm in the Ursuline Church. The inscription was much longer than anything ever cut in marble in memory of General Wolfe.[73]

6

A Coat and Waistcoat Subject

The national sentiment in England that promoted General Wolfe's active life after death in literature also provided incredibly fertile ground for the same subject in the visual arts. The instant books, poems, and entertainments dealing with Wolfe were soon followed by a profusion of visual commemorations of the hero. The interest in the artistic community over the hotly contested monument competition was certainly an incentive for many to consider what fame and profit they could reap from the subject of Wolfe.

It was not long after the battle on the Plains of Abraham that the first painting on the subject of General Wolfe was shown to the public. In 1763, George Romney, a painter new to the London scene, presented a monumental work entitled the *Death of General Wolfe* at the Society of Artists exhibition. The picture was a success, due as much, if not more, to the choice of subject as to the level of excellence in its execution. Romney's first public demonstration of his abilities as a history painter, *The Death of Rizzio*, exhibited at the Society exhibition the previous year, had been passed over in silence by his colleagues and rejected by the few collectors of English art. The dejected artist cut the heads from his picture and destroyed the rest. Romney's unsuccessful participation in 1762 was not, however, a wasted effort. Among the pictures in the show, which he would have visited frequently, was a full-length portrait of General Wolfe by J.S.C. Schaak (see Fig. 11.1), the first image of Wolfe to be shown in a public exhibition. It may have suggested to Romney the subject for his attempt in 1763, which received a completely different reaction.

Romney's *Death of General Wolfe* reflected the national pride recently reinforced by the terms of peace declared in March of 1763, which re-confirmed English control of Canada. In the atmosphere of the much-anticipated formal cessation of war, Romney's painting served as a reminder of past success, a confirmation of present glory, and a symbol of the everlasting indomitability of England.

The *Death of General Wolfe* won a prize for its creator. Perhaps of even more consequence to the novice painter, his picture found a buyer. A banker, Rowland Stephenson, acquired the work for the respectable sum of 25 guineas. He sent the canvas as a gift to the governor of Bengal, Harry Verelst, who installed it in the council-chamber in Calcutta. The painting has since disappeared,[1] but there is enough evidence to reconstruct its appearance. Three studies of heads in the painting have survived. One of these, a slightly less than life-size head of Wolfe, is puzzling because it appears more a finished work than a sketch[2] (Fig. 6.2). Wolfe is shown wearing a scarlet coat, yellow waistcoat, and white shirt. His metallic skin colour, unseeing eyes, lolling head, and open mouth suggest that Romney's painting captured the moment after his death. Another small painting, this one clearly a sketch, shows Wolfe's head and that of a sad yet stoic soldier supporting him (Fig. 6.3). There is some dispute about the authorship of this sketch as the handling of paint does not conform with that in the sketch of the head of Wolfe alone. Whether it is autograph or not, it undoubtedly preserves information about the character of Romney's lost canvas. A third study, a sketch of the head of the soldier supporting the dying or dead commander (Fig. 6.1), also attributed to Romney, is stylistically dissimilar to the other two pictures and carries a different and subtle psychological message as the artist portrays the soldier showing horror, resignation, and grief.[3]

There are distinct similarities in Romney's portrayal of Wolfe's physiognomy with that in Schaak's painting. Because at the time there was no canonical image of the hero, it seems reasonable to suppose that Romney used information from Schaak's portrait and from the story of Wolfe's last moments as described in poetry and prose in popular books and magazines to create a uniquely topical work. The subject was guaranteed to appeal to the audience of avid consumers of writing about Wolfe and to vociferous debaters of the terms of the recently concluded peace with France.

Romney's visual representation of the theme of Wolfe's death, previously the exclusive domain of the poets, was sanctioned in contemporary art theory. Poetry and painting were regarded as sister arts. The

Horatian dictum *ut pictura poesis* was ubiquitous in contemporary the-
oretical writing on work in both media. For example, in 1760 Daniel
Webb wrote that poetry arose from the union of music and picture.
He considered painting to be the source for poetic style, suggesting
that poets borrow their images and metaphors from visual art. Style in
poetry originates in painting, which teaches poets how "to group and
arrange their objects; to shade and illumine their figures; to draw the
outlines of grace; to lay on the tints of beauty; and all the colouring
of words brightens as from the touches of the pencil."[4] Other contem-
porary theorists considered the transmission of ideas and forms to
move from poetry to painting. However all critics agreed that a subject
suitable for one medium was also suitable for the other. In creating a
visual death of Wolfe Romney was in effect transforming what had
heretofore been a successful motif in poetry into one which because
of this prior use was a fitting and proper motif in painting.

The attempt to translate poetry into a visual medium did, however,
leave the artist open to new areas of criticism. The artist, teacher, and
critic Edward Edwards, who saw *The Death of General Wolfe* in the exhi-
bition of 1763, described the canvas in his book on contemporary
painters published in 1808.[5] He condemned Romney's picture as "a
coat and waistcoat subject, with no more accuracy of representation
than what might be acquired by reading in the Gazette an account of
the death of any General." "Such productions," Edwards added unsym-
pathetically, "should never be classed among the efforts of historic
painting."[6] In dismissing the picture as a pedestrian "coat and waist-
coat subject," Edwards was expressing a view held by other writers of
his time, particularly Joshua Reynolds, who promulgated his views in
regular lectures at the Royal Academy from 1769 on. On this theory
Romney's picture lacked accuracy because it went no further than
illustrating the event as it actually happened: the story as told by
Romney extended only as far as the visual facts. The painting was
devoid of a higher meaning – it conveyed nothing about the universal
and timeless moral truth to be found in General Wolfe's martyrdom.
Edwards's inability to elicit the essential meaning of the death of Wolfe
from the painting was the result of the artist's inability to surmount
the superficial, commonplace, and inferior facts that fixed the tale in
a particular time. Edwards preferred moral examples drawn from his-
tory in which the import of the works, their subjects, the eternity of
their messages were signified by the use of wardrobe, set, and proper-
ties of ancient vintage with a style to match. Romney's presentation of
the death of Wolfe within a context that might have been reported in

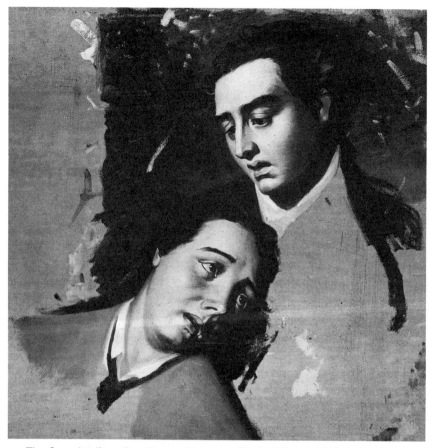

Fig. 6.3 Attributed to George Romney, *Head of General Wolfe and a Soldier.*
Oil on canvas, 1762–63 (Abbot Hall Art Gallery, Kendall)

the newspaper could not accurately represent the immutable truth to be found in the general's heroic passing. In contemporary theorizing about art, accuracy meant truth to nature and nature was to be found in ancient art.

Romney's breech of accepted principles of history painting, leading to what Edwards saw as a non-heroic, mundane, and inaccurate picture, was not the unintentional act of a naive novice. Romney certainly knew the accepted conventions of history painting. He deliberately chose to depart from standard practice, choosing a subject as yet untried and lacking the legitimacy conferred by time. His attempt to translate the death of Wolfe into another medium worked in spite of, or more likely precisely because of, its coats and waistcoats.

Romney was right in assuming that his audience, already somewhat prepared for this kind of historical presentation, would notice and appreciate a story told through selective and limited use of classical motifs. The artistic milieu in which his *Death of General Wolfe* appeared was loosely organized in terms of institutional structure and rules of taste – during the germination of the English national school of painting there was an aesthetic fluidity that gradually diminished as institutions and formal writing on art matured. The most public demonstration of the lack of one perspective in taste and style was found in Francis Hayman's ensemble of pictures at Vauxhall Gardens which included *The Surrender of Montreal to General Amherst* (1761) and *Lord Clive Receiving the Homage of the Nabob* (1762). In both paintings, which would have been known to Romney's audience, Hayman depicted elevating events in recent history in contemporary costume.[7]

The Society of Artists, to which Romney submitted *The Death of General Wolfe*, had held its first exhibition on 21 April 1760. A prize of one hundred guineas was offered for "the best original historical picture, the subject to be taken from English history only, containing not less than three human Figures as large as Life."[8] A second prize of fifty guineas was also offered. The previous year a committee of the Society had established a set of rules for the competition in history painting that required the artists to work on a subject chosen by the Society. Six historical episodes were proposed for the subject of the 1760 competition. Three of the themes were from ancient history – the death of Socrates, the death of Epaminondas, and Regulus taking leave of his friends – and three were from English history – Boadicea telling her distress to Cassibelan and Paulinus, Queen Eleanor sucking the poison from the wound of King Edward I, and the Birth of Commerce as described by Mr. Glover in his poem *London*. Ancient and medieval history had equal importance in the list, with the history of England assuming a position indicative of its rising role in the national consciousness. The designation of precise subjects was dropped after the first year, but the general categories of ancient and English histories continued.

Symptomatic of the growing audience for English history in this period was the appearance of the first popular, modern, indigenously produced national history: Tobias Smollett's *A Complete History of England from the Descent of Julius Caesar to the Treaty of Aix-la-Chapelle*, published in 1748. It enjoyed brisk sales for many years and a second edition was published in 1758. The first volume of David Hume's much better *History of England* was published in 1754. Hume's text

quickly supplanted the previously accepted standard history of England by the French historian Rapin. For Rapin the grand cycle of English history was to be seen in the centuries of progressive loss of original liberty to tyrants and the recapturing of that liberty in the constitutional battles of the seventeenth century. The struggle between liberty and tyranny provided many early English history painters with a set of archetypes that served as metaphorical fodder for pictorial statements on contemporary political disputes.

Just as there were changing views on the role for art, so there was discussion on the meaning and purpose of national history. One aspect of the debate particularly germane to the subject of Romney's painting was touched on by the writer Elizabeth Carter in a letter to Elizabeth Montagu. Carter said that she thought that history presented as a series of political events was dull, "but personal adventures and catastrophes are all life and action; every reader is concerned in them, as every reader has either felt the passions and principles from whence they are produced in his own breast, or has been affected by their operations on others."[9] Her views were symptomatic of an increasing national preference for the dramatic moments of history over the dry recitation of constitutional advances.

The members of the Society of Artists did not consider themselves apolitical aesthetes isolated from contemporary historical and political events but sought to create a role for themselves within English society as influential national propagandists, as illustrated by one of their first public demonstrations. The members of the Society contributed a substantial monument for the celebration of George III's birthday in 1761, erecting a temporary obelisk surmounted with a crown on Gerrard street at Turk's Head Tavern. On one side of the pedestal was an allegorical figure of Providence holding a profile of the King inscribed "Born and Educated a Briton." On the other side was an "altar charged with a pyramid; on the summit of which was the Crown with the Scepter and Sword; on the right, the mitre and pastoral staff, on the left Magna Charta, the cap of Liberty, the Purse, Mace, Scales of Justice etc, and on the steps of the Altar, pen and ink, pallet and pencils, mallet and chisel, with a bust, compasses, architectonic sector" and so on inscribed "All the Objects of his concern."[10] It was the firm belief of the Society of Artists that "nothing tends to elevate the mind so much as the enjoyment of liberty and a just sense of the value of this inestimable blessing; and without this elevating of the mind, the sciences, and more especially the fine arts, must necessarily languish."[11]

Given the avowed intent of the Society of Artists in promoting the national interest through the promulgation of English liberty, one can readily understand the positive response of the Society jury to Romney's depiction of the death of the latest and greatest proponent of liberty, General James Wolfe. The jury of the Society awarded Romney second prize in the category of history painting restricted to themes taken from English history. Unfortunately for the then virtually unknown Romney, when the general membership reviewed the nominations for awards they overturned the jury's decision and granted the second prize to John Hamilton Mortimer for his picture *Edward the Confessor stripping his Mother of her Effects.* This picture of a conventional elevating moment in English medieval history conformed to current practices in art by showing the cast clad in hybrid costumes of distinctly more classical than medieval cut. The membership's veto of Romney's award was rightly seen by the jury as an injustice and they voted to give him a special premium or bounty of twenty-five guineas. Edwards and Romney's contemporary biographer, the poet and playwright William Hayley, reported that Romney had told him he believed Joshua Reynolds was behind the overturning of the jury's decision.[12] According to Romney, Reynolds, "with great justice" decided that Mortimer's picture was superior. Romney, always the gentleman, said that he accepted the fairness of the reversal and "was far from repining at being obliged to relinquish a prize too hastily assigned to him."[13] It is unlikely, however, that Reynolds was singlehandedly able to scotch the award committee's decision, for at this point in his career he was still developing his aesthetic credo and had yet to assume the role of doyen in English art, politics, and taste.

An anonymous annotation in a copy of the catalogue for the 1763 exhibition suggests another reason for the painting's rejection by the Society membership.

The genl. is represented leaning against & supported (by) two officers who express great concern, the blood appears trickling from the wound in his wrist & from that in his breast agt. which one of the officers holds his hand a third officer is coming to the Genl. (to) inform him the French give way & appears greatly struck with surprize ... the great fault found with it was the Genl.('s) countenance which was more like a dead than a dying Man's.[14]

This critic, who had undoubtedly looked carefully at the painting, found no fault with the costuming. He took exception to the absence of vital signs in Wolfe that correspond to his appearance in the surviving

studies by Romney. The probable source of inspiration for the head of Wolfe, and a work with which it would have been compared by contemporary knowledgeable connoisseurs, was the ancient sculptured head called the *Dying Alexander* (Uffizi, Florence) widely known in England through engravings and plaster casts.[15] It was natural that Romney would have been influenced by what was then thought to be the bust of Alexander the Great. Wolfe, as the modern world's greatest general, would naturally invite comparison with the ancient world's most astute military strategist and greatest empire builder. There were also similarities in the last moments of the ancient and modern hero's lives. Alexander, as he lay dying in 322 B.C., was visited by his troops. As they filed past his bed, their commander, too weak to speak, lifted his head and greeted them with his eyes. What can be read simultaneously as a baleful and an ecstatic expression on Alexander's face in the sculpture was repeated in a modified form by Romney in his Wolfe, who had also died at the age of 32. Edwards, in his criticism, had apparently failed to note that in quoting the head of the dying Alexander Romney was studying nature – that is, the perfected art of the ancient world.

Richard Cumberland, a noted dramatist and occasional publicist for the artist, recounts some of the objections to Romney's *Death of General Wolfe* in his flattering memoir of Romney published in 1803. Some in the faction opposing his initial award faulted the picture because "the Officers and Soldiers were not all in their proper regimentals, that Wolfe himself had on a handsome pair of silk stockings, against the costume of a General in the field of battle, and some objected to the deadly paleness of his countenance."[16] Romney's error, according to some of his hostile colleagues, was not his failing to show the officers in classical costume but in being insufficiently accurate in the portrayal of contemporary military dress.

In another copy of the exhibition catalogue, annotated by Horace Walpole, we learn that the figures in Romney's picture were as large as life and that the picture was "better than Manini's picture of Edward the Black Prince & John of France."[17] That Walpole, a knowledgeable and opinionated connoisseur, did not find fault with the way the soldiers were dressed or mention any public objection to the picture suggests that Romney's picture did not elicit negative reaction outside the cliques of the Society of Artists.

Romney's painting, unlike Benjamin West's similar picture of the same subject, was not venerated as a national icon, nor did its author claim that it had caused a reformation of the principles of history

painting. It was exported and virtually forgotten. There is, however, a passage in William Hayley's *Poetical Epistle to an Eminent Painter [George Romney]*, published in 1778, that suggests that Romney and his enco-miast had not forgotten his innovative canvas. Hayley wrote:

> But some there are, who, with pedantic scorn,
> Despise the hero, if in Britain born:
> For them perfection has herself no charms,
> Without a Roman robe, or Graecian arms;
> Our slighted countrymen, for whose fame they feel
> No generous interest, no manly zeal.[18]

The removal of Romney's painting to India at a crucial time in the evolution in English art prevented it from being considered in discussions of history painting. For many, and in particular for West, its disappearance from the scene allowed it to be conveniently ignored.

Theoretically, because the subject of Romney's picture was drawn from contemporary history it could not be judged in the same light as the polemical histories exhibited with it. And yet it was, the jury even considering it superior to Mortimer's *Edward the Confessor*. The notion that the subject of Wolfe's death could be thought of as history is itself remarkable, indicating the Society's collective assent to the potential didactic power of this critical moment in current events. For them the subject of Wolfe's recent heroic death was equivalent or even superior in moral forcefulness and didactic lucidity to the enduring and widely used archetypes drawn from more remote times. For Romney, his fellow artists, and indeed all his contemporaries, comprehension of the meaning of the death of Wolfe did not require temporal distancing. The event contained self-evident immutable truth. Further, the truth in Wolfe's death was fully and instantly revealed.

Unlike its ancient prototypes, such as Cato's suicide as recreated in Joseph Addison's tragedy, *Cato*, Wolfe's death roused horror unmiti-gated by time and space. The critic Edward Young, writing in 1759, found in Addison's tragedy, "much to be admired, but little to be felt." The playwright failed to present a convincing rendition of Cato's pain, from which the audience in turn would have received pleasure for, as Young wrote, "the movement of our melancholy passions is pleasant, when we ourselves are safe: We love to be at once, miserable, and unhurt."[19] If successful, Romney's *Death of General Wolfe* would have

caused its audience pleasure through evoking melancholy passions. As interpreted, Wolfe's sacrifice evoked an entire range of strong emotions from sadness to joy. It was inherently paradoxical. It was at once pathetic and wonderful, horrific and delightful. It was repulsive and attractive. Its aspects of wonder, delight, and beauty rendered it a suitable subject for artistic expression. But the presence of the pathetic, the horrible, and the repulsive in the violent termination of Wolfe's life presented a conundrum to those who considered the object of taste to be beauty and beauty to be the proper subject of art.

The theoretical discourse through which literary and visual artists, critics, and connoisseurs attempted to resolve the problem of the appropriateness of the un-beautiful in art was given focus and resolution by Edmund Burke in his *Philosophical Enquiry into the Origin of Our Ideas of the Sublime and Beautiful,* first published in 1757. Burke presented a logical definition of taste and a reasoned argument for the correctness of representation of the sublime as well as the beautiful in art. Part of Burke's essay assists in understanding why the *Death of General Wolfe* twice swayed a jury of aesthetes.

The sublime, said by Samuel Johnson to be the "comprehension and expanse of thought which at once fills the whole mind, and of which the first effect is sudden astonishment, and the second rational admiration,"[20] found its source, according to Burke, in "whatever is fitted in any sort to excite the ideas of pain, and danger, that is to say, whatever is in any sort terrible, or is conversant about terrible objects, or operates in a manner analogous to terror." As pain is stronger than pleasure, he said, "so death is a much more affecting idea than pain." Pain is preferable to death and obtains its strength because it is a messenger of death and "when danger or pain press too nearly, they are incapable of giving any delight, and are simply terrible."[21] Distance from pain and death, as in a play or in a painting, allows them to bestow delight on the audience. One who mourns is likewise able to feel delight in his sadness as it is separated from death itself. One who is grief stricken, Burke said, lets his passion grow upon him: "he indulges it, he loves it." Those who grieve keep the object of their sorrow continually before them "to present it in its most pleasurable views."[22] Sympathy is a kind of substitution, "by which we are put into the place of another." The sympathetic are affected by grief or death in the same way as the mourner. Thus in painting or poetry the emotions of others are transferred to the viewer or reader and works of art are consequently "often capable of grafting a delight on wretchedness, misery, and death itself." It is in this way that Burke explains the

attraction of misery. "There is no spectacle," he wrote, "so eagerly pursued, as that of some uncommon and grievous calamity; so that whether the misfortune is before our eyes, or whether they are turned back into history, it always touches with delight." "I am convinced," he said, "we have a degree of delight, and that no small one, in the real misfortunes and pains of others."[23] This kind of anti-classical belief in the unmitigated sublimity of horror, of grief, of sadness, and even of pain itself allowed Romney's fatally wounded Wolfe and grieving fellow soldiers to be seen as an exercise in the sublime.

Burke's radical thesis legitimized what everyone knew. The subjects of death and dying were very popular among his contemporaries – Burke merely provided a theoretical justification for the delight in death already endemic in his society, which was passionately attracted to illness and suicide, elegies, eclogues, odes, pastorals, dirges, funerary urns, tombs, monuments, ruins, and pictorial and dramatic tragic narratives. Burke, without recourse to theology, removed the puzzlement of the paradox in death. For those who followed his argument there could be purely secular delight in horror, or joy in terror, or attraction in the repulsive. Contemplation of Wolfe's ultimate pain and death thus was a legitimate source of delight quite apart from its greater meaning in the unfolding of the destiny of the nation.

The year after Romney exhibited his prize-winning *Death of General Wolfe* another picture of the same subject by Edward Penny was shown at the Society of Artists exhibition (Fig. 6.4). This diminutive work, with figures much smaller than the life-sized ones required by the rules for competing history paintings, is signed and dated 1763. It lacks the theatrical monumentality with which Romney invested his work. Where Romney poetically thundered, his successor, an established painter who recognized and was reconciled to his technical limitations, painted in measured and modest prosaic terms, producing a pedestrian moral didactic work in which the sublime has been all but banished. It was not Penny's intent to transmit the horror, pain, or intense sorrow in Wolfe's death. Horace Walpole noted blandly that Penny's narrative was "well told and not hard nor glaring as most of the present time."[24]

The story is told clearly. Slightly to the right of centre in the foreground Penny placed a group of three soldiers surrounding Wolfe, who has collapsed like an unstrung marionette on the ground behind the British lines. One of the soldiers, in the uniform of the Louisbourg grenadiers, supports Wolfe by holding his left hand under the lapel on

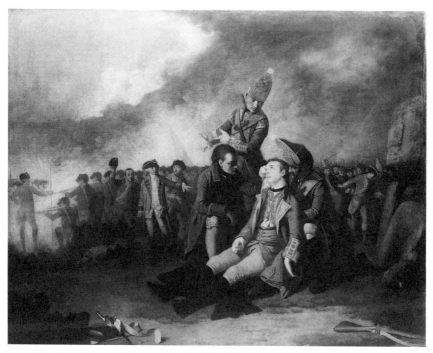

Fig. 6.4 Edward Penny, *The Death of General Wolfe.* Oil on canvas, 1763
(Ashmolean Museum, Oxford)

the General's breast. A second kneeling soldier, presumably a surgeon's
mate, mops Wolfe's temple, and a grenadier standing behind gestures
to the lines where the word of the victory is being relayed to the rear
to be passed on to the expiring commander. Wolfe's right hand and
wrist are bandaged. The composition of the group around Wolfe is
very similar to that which is suggested in the extant sketches for Rom-
ney's picture. This should not, however, be taken to imply that the
earlier painting had influenced Penny's composition, as both pictures
correspond generally to what was reported in the press – the common
source for both artists' narratives.

While the accounts in newspapers and magazines, the early histories
of the war, and obituaries of General Wolfe differ in the details of
Wolfe's final moments, common to them all are the wounding of
Wolfe, his removal to the rear of the British lines, and his being
informed of victory over the French just before he succumbed to his
wounds. The story reported in the *Annual Register for the Year 1759* is
typical of accounts of the sequence of events.

But there – tears will flow – there, when within the grasp of victory, he first received a ball through his wrist, which immediately wrapping up, he went on, with the same alacrity, animating his troops by precept and example; but, in a few minutes after, a second ball, through his body, obliged him to be carried off to a small distance in the rear, where rouzed from fainting in the last agonies by the sound of "they run," he eagerly asked, "Who run?" and being told, the French, and that they were defeated, he said, "Then I, thank God; die contented;" and almost instantly expired.[25]

The officer in the background of Penny's painting, holding the baton of command, hearing the news of victory from the soldier waving a hat is directed by him to the group surrounding the dying Wolfe. The cut of this officer's uniform and its facings and colours are identical to that worn by the subject of a portrait by the American artist Benjamin West shown in the same exhibition as Penny's picture. West's portrait, identified in the catalogue as "A Gentleman, whole length," was one of three pictures he sent to the 1764 exhibition as his inaugural public contribution to painting in England.[26] The subject of the portrait, whose name is inscribed on the undated canvas, is General Robert Monckton. West's Monckton and Penny's officer have a common pose derived from the well-known ancient sculpture the *Apollo Belvedere*. Although the face of the officer figure in Penny's painting is generalized and undistinctive, it can be assumed on the basis of the careful depiction of his uniform that it was intended he be identified as Monckton.

The officers surrounding Wolfe in Penny's painting have been given names by some modern writers who have assumed incorrectly that the picture is a visual document of an historical event. The surgeon's mate has been taken to be Heriot or Wilkins, the grenadier holding Wolfe has been identified as Lieutenant Browne, and the other grenadier has been said to be James Henderson. The man in the background waving his hat has been said to be Captain Curry.[27] The identity of these soldiers was determined not on the basis of physiognomic similarities with known portraits of the individuals but rather through reference to names taken from the eye-witness accounts. The propensity to identify all the people in paintings of contemporary historical events arose as a result of West's influence through engravings made more than a decade after Penny exhibited his picture and would not have been part of the reaction of the contemporary audience. It is likely that apart from Wolfe, and perhaps Monckton, Penny intended the figures in his picture to be generic soldiers and not identifiable portraits.

By presenting the soldiers in more or less correct military costume, Penny's *Death of General Wolfe*, like Romney's picture, lies outside that form of heroic history in which picturesque and transitory fashions were studiously avoided in favour of the timeless appurtenances appropriate to the classical world. The painting was not intended to vie with grand histories but rather was to be seen as a modest visual lesson in elevated moral behaviour. That it was considered as such in its day is clear from the fact that a reviewer of the 1764 exhibition, while praising the grenadiers as "true pictures of such" and the "deep concern shown by Wolfe's servant," classed the picture as a "conversation,"[28] in other words, a visual operetta as opposed to a grand opera or a ballad as opposed to an epic. A much later critic was to call one of Penny's pictures "art in the cause of virtue and morality."

The *Death of General Wolfe* is a visual comment on the principles of military virtue on a very human level at a particular moment in time. The moral didacticism intended in the work becomes even clearer when the picture is considered with its companion, Penny's *John Manners, Marquis of Granby, giving Alms to a Sick Soldier and his Family*, shown in the spring exhibition of the Society of Artists in 1765. As the title shows, the purpose of this later work was within the tradition of moral *genre* founded in England by the much better artist William Hogarth. Penny's *Death of General Wolfe* does not celebrate the deep meaning of the English victory over the French through reference to visual archetypes of military sacrifice. Instead, the picture tells a simple story. There is no attempt at the transfiguration of a contemporary historical event.

In the 1768 exhibition of the Society of Artists Penny presented a painting of similar intent entitled *The Generous Behaviour of the Chevalier Baiard, who finding that an officer's widow was induced through distress to prostitute her daughter, sends for her, and after a severe reprimand, restores the young woman, with a donation for their support*. The three pictures, of Wolfe, Granby, and Bayard, all the same size, each representing an example of military virtue, were brought together in 1768 when the Society of Artists put on a special exhibition in honour of the King of Denmark, who had come to England to visit his brother-in-law King George III. Penny's moral triplet, his trio of essays on exemplary military behaviour, have contiguous numbers in the catalogue for the show and were no doubt hung together.

Penny did not sell the *Death of General Wolfe* or *John Manners, Marquis of Granby, giving Alms* but in 1787 donated the pair to the Bodleian Library, by which time he had achieved a small measure of fame from

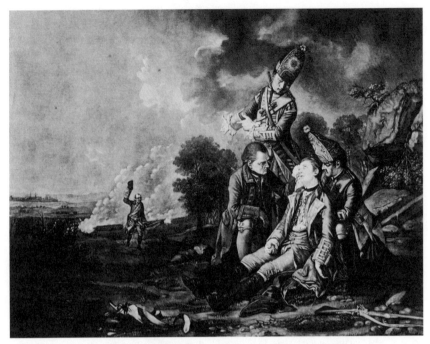

Fig. 6.5 Edward Penny, *The Death of General Wolfe.*
Engraving by Richard Houston, 1772
(Webster Canadiana Collection, New Brunswick Museum, Saint John)

the first. A mezzotint reproduction of the *Death of Wolfe* engraved by Richard Houston was published by Robert Sayer on 1 January 1772 (Fig. 6.5). The engraving did not reproduce Penny's 1763 painting but was taken from a simplified version of the composition, then in the possession of Sir John Denvers, Baronet of Swithland, who also owned a companion replica of *The Marquis of Granby giving Alms to a Sick Soldier.* These canvases, much smaller than the originals, were probably painted by Penny for the express purpose of serving as a models for the engraver.[29] In Penny's second and smaller *Death of General Wolfe* the British lines were pushed further back, landscape was added, and the officer who may have been intended as Monckton was deleted. (It is possible that Monckton was removed because Penny's version didn't resemble Wolfe's second in command and a good portrait of Monckton had been included in West's *Death of General Wolfe,* exhibited at the Royal Academy less than a year before the publication of the mezzotint after Penny's picture.) It is very likely that it was the popularity of West's *Wolfe* that motivated an enterprising publisher to remember

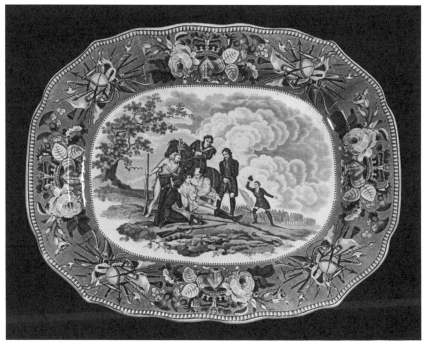

Fig. 6.6 Jones and Son, Blue-Printed Platter with the Death of General Wolfe.
1820s (McCord Museum of Canadian History, Montreal)

Penny's *Death of General Wolfe* and approach the artist with the propo-
sition to market the image through a reproductive print. Penny prob-
ably produced a modified replica of his original painting, then still in
his possession, turned it over to the engraver, and subsequently sold
the model to Denvers. The print apparently sold well, for a second
mezzotint, this one in a vertical format and cruder, was published by
Sayer and J. Bennett on 10 October 1779. It was reported that Penny
made the enormous sum of five hundred pounds from this second
print.[30] The second print seems to have been kept on the market for
quite some time. It served as a source for several late eighteenth- and
early nineteenth-century copyists who reproduced the image on canvas
and was used as a basis for the design on a blue printed platter made
by Jones and Sons at Hanley in the 1820s (Fig. 6.6).

Through Wolfe's military skill, courage, and sacrifice England won
peace. During this reign of peace, an era characterized by some as

conducive to unrestricted growth in arts, commerce, and wealth, Wolfe himself played a major role. His fame fertilized the fruits of peace and was itself increased by the efflorescence of arts, commerce, and wealth.

The Philadelphia poet Thomas Godfrey celebrated the end of the war by composing "A Cantata, On Peace 1763":

> Let Pleasure smile upon the plain,
> See Peace, with balmy wing,
> Now hither bends her flight again,
> To crown the joyful spring.
> Close by the fair One's side are seen,
> The **Arts**, with garlands drest,
> Gay **Commerce**, with engaging mein,
> And **Wealth**, with gaudy vest.[31]

Commerce and wealth were especially increased for those who memorialized in art the victory that permitted peace. This is demonstrated by the interest in the monument competition of 1759–60, the public exhibitions of Schaak's portrait of Wolfe in 1762, Romney's *Death of General Wolfe* in 1763, Benjamin West's portrait of Monckton and Edward Penny's *Death of General Wolfe* in 1764, and, finally, the profitable sale of reproductive prints after Penny's composition. But Wolfe as the source and subject of the garlands of art, engaging commerce, and gaudy wealth had yet to hit his stride.

7
Ardent for Fame

Among the multitude of literary and visual artists who attempted to gain fame, fortune, and immortality through rendering homage to the hero Wolfe, only Benjamin West succeeded in winning all three. His painting of the *Death of General Wolfe*, exhibited to the public at the Royal Academy exhibition of 1771, was elevated to the status of a national icon for the English, who saw it as a symbol of their right to dominion over North America, their military virtue, and the triumph of Protestant righteousness over Catholic perfidy. It came to symbolize as well the triumph of liberty over tyranny and immortalized Wolfe and its creator. Even today reproductions of it are ubiquitous in histories of art and of North America.

From the moment of his arrival in England in August of 1763, West diligently pursued the path of fame in the competitive English art world. He exhibited his paintings annually and obtained prestigious commissions. It was, however, through the *Death of General Wolfe* that he attained the position of England's foremost painter of histories. West's *Death of General Wolfe* became not only the single most reproduced work of art in eighteenth-century England but also precipitated a debate among a small group of artists and critics on the appropriate way to deal pictorially with historical events in the post-classical era. The picture, according to the artist and his apologists, caused a revolution in English art.

Benjamin West was born in Springfield, Pennsylvania, in 1738. He left America for Italy in 1760 and studied there for three years. For details about his life and training before he arrived in England we are dependant, for the most part, on a biography compiled by the Scottish journalist, later popular novelist and Canadian land speculator, John

Galt. The first instalment of Galt's life of West, published in 1816, was
based on reminiscences of the artist, who was then approaching his
eightieth year. Galt said that West "from time to time corrected the
manuscript," and that the book, was "as nearly as it possibly can be, an
autobiography."[1] The recollections of the geriatric West have been
severely criticized by almost all succeeding biographers of the Ameri-
can painter, who nevertheless, depend on them. Typical of the critics
was William Dunlap, frequently styled as the American Vasari, who
worked for a while in West's studio. He damned Galt's text as "a puer-
ile performance by an injudicious biographer [and] full of absurd
tales" but was compelled by the absence of other sources to repeat
many of the stories West had told Galt.

According to Galt, West obtained the rudiments of a classical edu-
cation from Reverend William Smith, provost of the College of Phila-
delphia. Although the painter could never write with facility nor spell
with any consistency, he seems to have absorbed the basics of history,
ancient mythology, and Protestant theology. West, by disposition and
innate talent inclined more toward artistic than literary pursuits,
moved in a circle of youthful literary lights at Smith's college, such as
Thomas Godfrey, Francis Hopkinson, and Nathaniel Evans, who were
all to achieve fame as pioneers in American poetry.[2]

The prodigious Thomas Godfrey, two years younger than West, had
a remarkable but lamentably short career. Among his posthumously
published juvenile poems was a pastoral, "To the Memory of General
Wolfe who was slain at the taking of Quebec." The young poet, credi-
bly imitating the Augustan masters of the *genre*, cast Wolfe in the role
of the shepherd Amintor. In Godfrey's poem Damaetas laments the
death of Wolfe as Amintor in a ponderous poetic dirge.

> E'er fond of danger, eager in the chase,
> With fearless mind he fought the savage race;
> Foremost to dare, he still with gallant pride
> First clomb the cliff, or rush'd into the tide;
> 'til smear'd in glorious horror with the gore,
> Of the fierce tiger or foaming boar.

The poem concludes with a description of the "sorrowing mother" at
the "mournful bier" whose grief leads one to contemplate the general
veneration of Amintor's memory.

> And hang your deathless ditties round his tomb,
> Here all around your flowr'y garlands throw,

And on his grave let short-liv'd roses blow.
Haste here, ye swains, here let your tears be shed,
Weep shepherds, weep, the brave Amintor's dead.
So sung the swains, 'til Phoebus' radiant light,
Chanced to her azure bed the Queen of Night.[3]

In another poem, entitled *Victory*, Godfrey celebrated the conquest of Canada by picturing a heavenly meeting between Britannia and the enthroned Victory. In reply to Britannia's plaint on the difficulties of the war against France, Victory addresses her "Oh! thou, my Joy and Pride! / Near to my heart, and fav'rite of my train." Victory reassures Britannia by predicting the conquest of Canada but at a great cost. "Soon Canada shall own thy pow'rful sway, / Yet bleeding Conquest here will ask the tear, / Like noble Decius, thy brave Chief must pay / His life a victim for his country here."[4]

Hopkinson's tribute to General Wolfe, printed in the *Pennsylvania Gazette* on 8 November 1759, was less ambitious. He eschewed the pastoral form, preferring instead an ode. Hopkinson's poem is a typical encomium to Wolfe, whose merits "transcend all human praise." It reaches a fever pitch when the poet turns to the last great heroic scene, which "should melt each Briton's heart" and "rage and grief alternately impart." In his last moment, Wolfe, according to Hopkinson, uttered, "my eye-sight fails! ... but does the foe retreat? / If they retire, I'm happy in my fate!" When told of his victory, the hero expired and "then wing'd his way, / Guarded by angels to celestial day. / An awful band! Britannia's mighty dead / Receives to glory his immortal shade!"

The third of West's poetic colleagues at the College of Philadelphia, Nathaniel Evans, wrote a panegyric ode to the memory of Wolfe. He depicted Wolfe as daringly leading the British troops "where the great St. Lawrence rolls its awful flood" and succeeding in his attack.

Soon Canada confess'd his warlike might,
If on the plain conspicuous he appear'd
Or gainst Quebec's aspiring tow'ry height,
His thund'ring arm all-dreadfully he rear'd.

On "Abram's purpled plain," Wolfe, "while superior to all fear," "drove, o'er heaps of slain, in full career."

A shaft, commission'd from above,
Full to his breast with fatal speed,
Took its unerring way,

Down fell great Wolfe amidst the dead,
And purpled where he lay –
"How goes the fight?" he cries,
(For round his head
Grim death was spread
And dim'd his rolling eyes.)[5]

It is likely that one or more of West's poetic colleagues had a hand
in the composition of the New Year's verses printed in a broadside and
distributed on 1 January 1760 by Philadelphia paper-boys. The annual
broadsides were composed by "such young bards as the printers lads
can make interest with."[6] The verse synopsis of the news of 1759 con-
cluded with the tale of Wolfe's late victory.

Great Wolfe is no more! thro' a fate most unkind
He has not on earth left his equal behind.
Pitt knew his true worth; and so did propose
This hero as fittest to humble our foes:
In which he succeeded, to all men's surprize
Beat haughty Montcalm, then flew to the skies!
Great honour to Britain, to the ruin of France,
He affected his scheme with strong pointed lance.[7]

West's poetically inclined fellow students were not alone in eulogiz-
ing Wolfe in the Philadelphia press. An unidentified writer from Mary-
land sent "Panegyrical Verses on the Death of General Wolfe" to the
Pennsylvania Gazette in March of 1760. For this poet, Wolfe was "Young
in th'account of time; of wisdom, old ... No crisis scaped his view, /
He seiz'd the conquering moment, as it flew." He was "ardent for
fame, yet not ambition's slave." Wolfe, the author urged, must be
remembered because;

His mercy humaniz'd barbarian breasts,
And sham'd to short remorse, the butchering priests,
Priests! who, themselves dragging Rome's Tyrant-Chain,
See alien freedom with invidious pain.[8]

In a letter to the editor published with the poem, its author apologized
for submitting his work so long after the event. The apology was
unnecessary. The newspaper continued to print material on Wolfe and
Quebec well into 1760. The 7 February issue of the *Pennsylvania*

Gazette reprinted the text of the *London Gazette Extraordinary* of 17 October 1759 announcing the victory at Quebec, accompanied by a poem, "To the Memory of General Wolfe," taken from an English newspaper and some lines from Addison's *Cato* headed "On the Death of Wolfe." While West may not have been in Philadelphia during this period – according to Galt it was at about this time that he spent some eleven months in New York trying to establish himself as a portraitist – he could not have escaped the broadcasting of Wolfe's virtues which reverberated throughout the colonies.

West arrived in Italy in June of 1760 and set out on the obligatory art student's pilgrimage to meditate upon and draw the monuments of ancient empire and probe the secrets of the old masters. Arriving in Rome in July he was befriended by a young Englishman, Thomas Robinson, later second Baron Grantham. Galt wrote that Robinson introduced his new friend to Cardinal Alessandro Albani, an exceptional connoisseur, dealer in antiquities, and spy for the English in Rome. Albani took West to see the *Apollo Belvedere*, the most famous piece of ancient sculpture on the Roman art tour. The American artist told his biographer many years later that on confronting the popular antique marble he said, "My God, how like it is to a young Mohawk warrior." The startled Italian *cognoscenti* present were mollified when West explained that the Indians of his homeland often stood in the same pose as the Greek god, "pursuing, with an intense eye, the arrow which they had just discharged from the bow."[9]

For his audience in Rome clustered around the *Apollo Belvedere*, West's special knowledge of the exotic aboriginal Americans would have compensated for his naive, rustic colonial ways and his obviously incomplete education. Whether or not his discourse on the *Apollo Belvedere* actually occurred as he remembered it many years later, the statue left a strong impression on him.

While West was in Rome, the resident English artistic community was astir with interest in a relief then being modelled by the French sculptor Luc-François Breton. Horace Mann wrote to Horace Walpole on 12 July 1760, mentioning a model of a relief he had heard was being produced for Wolfe's monument.

I would have them make haste that the Frenchman at Rome who is making the model for Wolfe's monument may know whom to call the conqueror of that place, or if he should still, as he has been ordered, put Wolfe's figure in, whether out of modesty he should not put Murray's there too, giving it back again to the French. The design, as I have been told by a person that has seen

it, is very rich and charged with figures: Wolfe expiring, with Americans and many others about him, is in the act of delivering his baton of command to General Townshend.[10]

Mann said that he thought the commission had come from Robert Adam or Robert Chambers. Walpole was astounded at the news. He replied to Mann that it was his understanding that Joseph Wilton, Adams, Chambers, and others had all presented their drawings for the Wolfe monument several months before and that as far as he knew the commissioners had already decided in favour of Wilton.

Such credence as the usually well-informed Walpole may have placed in Mann's statements concerning the relief of the expiring Wolfe being modelled in Rome was no doubt based on rumours circulating in England. It was believed by some that a foreigner had indeed been awarded the contract for the execution of the Wolfe monument. A chauvinistic letter to Tobias Smollett, the editor of the *British Magazine*, published at the beginning of February 1760, raised an alarm over the awarding of the Wolfe monument contract. "A foreigner, I am told," complained the correspondent, "is using his utmost interest to have the honour of executing the monument [to Wolfe] ... and in all probability, he will be successful." This rumour could be true according to the alarmist because, he said, it was a commonly held belief that, "Britons are utter strangers, or but slight proficients, in the art of sculpture." Such was, according to the booster of the national artistic ego, patently false as there are, "many excellent performances in statuary lately executed by our countrymen." He questioned "whether foreigners should be chosen to record our victories and successes, while Britons may be found equally, if not better, qualified for such a task?" In the end he recommended a fair competition and when the design was chosen "let the execution of it be trusted to a native of the most acknowledged merit."[11]

Walpole wrote back to Mann asking for more information on the relief being modelled in Rome. In response to this request he was sent an extract of a letter Mann had received from his informant in Rome, probably Cardinal Albani, who normally kept the British Consul in Florence up to date on Jacobite activities in the Vatican. Mann also sent to Walpole a "sketch of a bas-relief, done by one Berton [sic], a Frenchman, by order of Mr. Adams." He asked Walpole not to mention the relief publicly, "lest it might do him [Adam] a prejudice, though indeed Berton makes little difficulty to show it, and most of the English now here (and they are very numerous) have either seen

Fig. 7.1 Robert Adam, *Design for a Relief of the Death of Roger Townshend.*
Drawing, 1760 (Sir John Soane's Museum, London)

or heard of it at Rome. Among these English there is a Mr. Robinson,
Sir Thomas's son."[12]

The design for the relief being modelled by Breton and shown to
the English visitors in his studio was by Robert Adam. The character
of the drawing from which Breton worked can be inferred from
Adam's earlier study of the subject (Fig. 7.1) and was intended for a
monument commemorating not Wolfe but Lieutenant-Colonel Roger
Townshend. Breton's terra cotta was to be sent to England, where it
would be replicated by a marble carver and set into the face of a
sarcophagus on a monument in Westminster Abbey (Fig. 7.2). When
James Adam visited Breton's studio in Rome he reported to his
brother Robert in a letter of 7 March 1761 that Breton's relief "is
really magnificent and I imagine might cost as much to execute as half
the price of the whole monument. From the resemblance of the sub-
ject the English here explained it to Breton to be for General Wolfe
and consequently he thought he could not make it too magnificent."[13]
There is further confirmation that Breton thought he was modelling
a death of Wolfe as in 1761 the sculptor Richard Hayward recorded

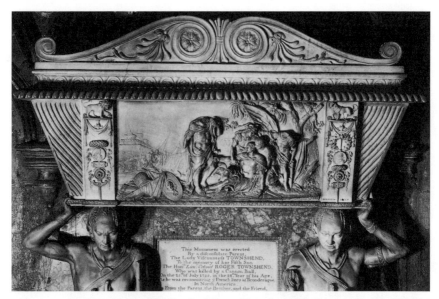

Fig. 7.2 Robert Adam, *The Death of Roger Townshend*. Marble, 1761, modelled
by Luc-François Breton, carved by John Eckstein (Westminster Abbey, London)

that he had heard that, "Britton a french studieant [had been]
employ'd by them [the brothers Adam] to model a Basso rilievo for
Genl. Woolf's monument," and "they found fault with it on which he
threw it down and broke it all in pieces after eight or ten months
labour."[14]

It is not hard to imagine how Breton, influenced by the comments
of uninformed patriotic English visitors, could misidentify the subject
of the relief he was modelling. As the earlier studies show the partici-
pants in the scene in quasi-Roman costume in a generalized antique
setting, it is understandable that difficulties would arise in differenti-
ating between a death of Wolfe and the death of any other military
hero. Adam's composition was in fact a slightly modified version of the
relief he had designed for his unsuccessful submission to the Wolfe
monument competition. Both his drawings for the relief of the *Death
of General Wolfe* and his preliminary or final plan for the relief of the
Death of Roger Townshend resemble images of the antique prototype for
the death of a military commander at the moment of victory, the death
of Epaminondas. The virtual identity of pictorial representation of the
death of Townshend with that of Epaminondas makes it almost impos-
sible to ascribe a single title to the relief. In modern literature Adam's
sculpture has been called both *The Death of Epaminondas* and *The Death*

of Roger Townshend. Breton's terra cotta relief was transferred to marble, probably in the summer of 1761, by John Ekstein, who had won a premium at the Society of Arts exhibition in the spring of that year for a relief of *The Death of Epaminondas,* – a fact which may have influenced Robert Adam in choosing him to execute the work.

The confusion in Breton's mind and in the minds of the English who came to look at his relief was exacerbated by the absolute pre-eminence of the death of Wolfe in the public sentiment. Further, any sculptor with a modicum of pride could have been easily convinced that he was producing a relief for the most important recent monument commissioned in England. The confusion may have been exacerbated by the coincidence that there were two famous Townshends serving at the same time in the English forces in America. Lieutenant-Colonel Roger Townshend was killed at Ticonderoga on 25 July 1759, on the eve of the fort falling to the British siege. Brigadier-General George Townshend served at Quebec in the same year, and, to the chagrin of some, survived. Breton may have thought he was carving the transfer of the baton of command from Wolfe to George Townshend as part of the Wolfe monument.

As Thomas Robinson is specifically mentioned as someone who had seen the putative relief of the *Death of General Wolfe,* it is probable that the young West also saw the work. He would certainly have paid attention to any rumours about it since, as an American colonial who had lived through the latest French and English war and had been close to the trans-Atlantic stage on which the two European imperial powers with their allied Indians struggled for continental domination, the subject would naturally have been of interest to him. If West had gone with Robinson to Breton's studio in Rome he might also have seen a terra-cotta head by Breton said to be of General Wolfe (now in the Musée des beaux-arts, Besançon). The head, however, has no physiognomic resemblance to any other "portrait" of Wolfe.

After three years of studying antique sculpture, copying old masters, and learning about the modern neo-classical style in Italy, West travelled overland to England. On his arrival he probably spent a few months setting up his studio, visiting established English artists, and seeking out potential patrons. One of these, General Robert Monckton, apparently came to him. According to William Carey, Monckton, who returned from service in North America in the summer of 1763, had "either seen or heard of Mr. West's brother, who had acted as captain in the Pennsylvania militia, under General Wayne, in 1757." He called on West and was so impressed with his work that he

commissioned a full-length portrait. West posed Monckton in the stance of the *Apollo Belvedere*. Monckton's friends were "pleased with the likeness and military spirit of the picture," and as a consequence "he pressed the artist to remain in England, and recommended him earnestly to his own circle." It was said that the portrait by the American "made a great noise."[15]

It is probable, considering West's habit of borrowing motifs and even entire passages from other artists and his recent spate of copying in Italy, that he saw, remembered, and reproduced Edward Penny's officer from the *Death of General Wolfe* in creating his portrait of Monckton. It would have been quite natural for him to visit Penny's studio soon after his arrival in England to see the painting of an event that had taken place in his homeland.

West's portrait of Monckton apparently attracted artists and connoisseurs to the artist's studio. Carey tells how the artist came to send his picture of Monckton to a public exhibition. "Artists and amateurs flocked to his apartments to inspect the works of a painter from the New World," among them George Romney. General Monckton took West to visit Joshua Reynolds, who in turn went to Monckton's house to inspect West's portrait. As the exhibition for 1764 was about to open, West was encouraged by Reynolds and the landscape painter Richard Wilson to send in the portrait of Monckton as well as two other works.

Exactly when West began to work on his *Death of General Wolfe* cannot yet be documented. One can imagine that Romney, on his visit to West's studio, might have engaged the knowledgeable colonial in conversation about the events of 1759 at Quebec. As Romney had exhibited his *Death of General Wolfe* only a few months before, he was undoubtedly interested in West's information on the American campaign. One can easily picture Romney inviting West to visit his studio to examine the *Death of General Wolfe* or, if it had already been turned over to its new owner, taking him to see it at Rowland Stephenson's house. If by some chance West did not see Romney's history, he would certainly have had access to Romney's sketches for the picture. It is tempting to suggest that the two secondary studies of heads from Romney's picture, sketches that are unlike Romney's other work in execution, are the work of West himself. However, even though the American painter was a practised copyist, there is insufficient pictorial evidence to substantiate such a hypothesis.

The environment in which West evolved as an artist in Pennsylvania, then in Italy, and finally in London was conducive to his decision to

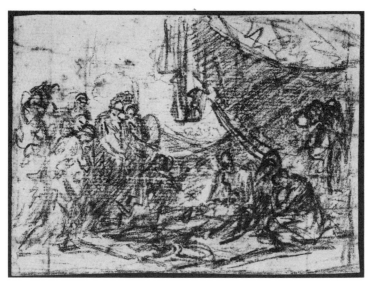

Fig. 7.3 Benjamin West, *The Death of General Wolfe*. Drawing, c. 1765
(Pierpont Morgan Library, New York 1970.11:76)

invent a pictorial commemoration of Wolfe's death. The poetic, jour-
nalistic, and oral accounts of Wolfe at Quebec, rife in America in the
months preceding the artist's departure; the excitement in Rome in
1760–61 over the supposed relief of the death of Wolfe; the contro-
versy over the prize awarded to Romney's picture of the subject in
1763; the appearance in 1764 of two similar Moncktons, one as a
subsidiary figure in Penny's *Death of General Wolfe* and one the subject
of a grand portrait by West himself; plus the close relationship between
Monckton and West lead one to surmise that the American artist
began to formulate plans for what was to be his major history painting,
if not in Italy then very soon after his arrival in England.

Only two of the drawings West made in preparation for his *Death of
General Wolfe* are extant. One was produced in the early stages of the
development of the composition and the other may have been his final
study before he began painting the grand canvas, which is dated 1770.
The earlier drawing is a very rough black chalk sketch. In it West
indicated the position of the generalized figures on the left and right
of the composition more or less as they would be placed in the fin-
ished work (Fig. 7.3). The seated figure with its head resting on its
hand on the right in the drawing would be transferred to the left and
become the Indian in the final composition and West reworked the

central part of the picture around the reclining Wolfe, adding more attendants and two men holding a huge flag. In this early drawing, which may have been a sketch for a death of Epaminondas, West used a large tent or drapery as a backdrop.[16] His use of this device is understandable as a similar curtain or tent appears in the monument to Wolfe then being carved in Joseph Wilton's studio and a tent even more like the one West was considering appears in Adam's drawing in his unsuccessful entry in the Wolfe monument competition. Wilton, Adam, and West drew from the same standard repertoire of forms for their work.

The second extant drawing for the *Death of General Wolfe*, a work in ink, chalk, and wash heightened with gouache on brown paper, is inscribed "Benj(m) West 1765" (Fig. 7.4). The inscription, which seems to be by the artist himself, is over traces of an earlier signature and has been shown convincingly to have been added to the drawing by the artist at a later date.[17] Whether this means that the date is wrong or not is a moot point. This drawing shows that West continued to use forms similar to those employed by Adam. In the extant drawing for the latter's relief, a prominent ensign is held by a soldier in a modified version of the pose of the *Apollo Belvedere*. West incorporated the concept of the prominent flag in his *Death of General Wolfe*. In the background of Adam's drawing are combatants whose legs are obscured by the rise on which their commander dies. West's drawing shows similar soldiers behind a knoll, perhaps representing Wolfe's Hill on the Plains of Abraham, where the hero is dying. The poses of the dying Townshend/Epaminondas and his attendants in Adam's drawing and his relief are like those employed for Wolfe and his concerned fellow soldiers in West's composition. Whether West actually studied Adam's drawings for his relief or the relief itself on the Townshend monument, unveiled in the fall of 1761, or whether both artists developed their compositions independently, guided by the standard form for an heroic death, it is certain that West began his thinking about the *Death of General Wolfe* with the idea that it was to be pictured like the *Death of Epaminondas*.

There are some borrowings in West's second drawing for the *Death of General Wolfe* which indicate that he studied Penny's earlier composition of the expiring Wolfe. Although West could have visited Penny's studio at any time, it seems unlikely that he would have done so as late as 1769 to look at and copy parts of a painting which the London artist had exhibited five years earlier. Penny's canvas was, however, exhibited publicly in the special show for the King of Denmark in 1768 and it

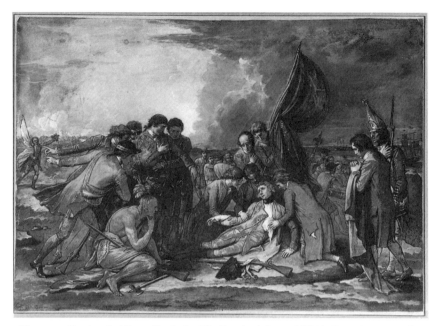

Fig. 7.4 Benjamin West, *Study for The Death of General Wolfe.* Drawing, c. 1769
(National Gallery of Canada, Ottawa. Purchased 1984 with the assistance of
a grant from the Government of Canada under the terms of
the Cultural Property Export and Import Act)

may have been then that West scrutinized it carefully, looking for inspi-
ration that might turn his essentially borrowed Wolfe as Epaminondas
into something new and different.

Apart from the image of Monckton, several other repetitions of
details show that West was familiar with Penny's *Death of General Wolfe.*
In the foreground of Penny's painting, strewn at Wolfe's feet, are a hat,
a musket, and a white belt with a bayonet in a scabbard. In West's
drawing these items, with the exception of the bayonet, are on the
ground below Wolfe. (The bayonet reappeared in the finished paint-
ing.) In the background of Penny's picture, news of the victory is
brought from the British lines by a runner holding his tricorn aloft.
The same figure, in approximately the same position, reappears in
West's drawing but in this case he holds a white flag and the opposite
hand raises the hat. The individual who holds a cloth to Wolfe's breast
in West's drawing is wearing a simple waistcoat of the same cut as that
worn by the individual identified as a surgeon's mate in Penny's paint-
ing. Only two individuals are shown in military uniforms in West's

drawing. One of these is the Louisbourg grenadier on the extreme right, whose uniform approximates those worn by the Grenadiers in Penny's picture. (There are errors in West's depiction of the uniform in the drawing but these were corrected in the finished painting.) The other individual who wears a vaguely military uniform is the soldier in the group on the left with his hand to his breast. In the finished picture this officer is Brigadier-General Robert Monckton. Common to both pictures is the distinctive black neck band or stock worn by Wolfe. Given the detailed similarities, it is not unreasonable to conclude that West studied Penny's *Death of General Wolfe* very carefully before or during the establishment of the form and details of his picture.

Comparing the sketch with the finished painting, it is clear that West was most comfortable with the details for the Monckton figure and the Indian. West had had some contact with Indians in his youth and he had already produced images of the natives of his homeland. The depiction of the other figures in his design would have required more of the painter's time. He could not draw the details of the uniforms and portraits of the participants, with the exception of Monckton, from memory. One can only guess at how long it took him to acquire the information necessary to begin painting his 1770 canvas. The amount of detail in his second drawing, in which the composition was worked out but the participants had indeterminate faces and civilian costume – recalling the "silk stocking" criticism of the absence of specific military dress levelled at Romney's picture – suggests that the drawing could well be from around 1765, as it is dated.

From the moment he arrived in England West found himself among people infatuated with their new hero and his stellar performance in North America. He was further reminded of the crucial aspects of the war in his homeland by visitors from home. Reverend William Smith was in England in 1763–64 on business for the Society for the Propagation of the Gospel. He certainly sought out his former student, who was then just beginning what he thought would be a temporary stay in London. Smith apparently carried news of West's accomplishments, undoubtedly derived from the artist himself, back to Philadelphia. West, who was prone to hyperbole in self-evaluation, was apparently paraphrased by Nathaniel Evans in a footnote in the 1765 posthumous publication of his friend Thomas Godfrey's works. West, so Evans said, had acquired "universal fame" in Italy and was now earning it daily in England, "perhaps beyond any other person of his profession of the present age."[18] Smith was so taken with his compatriot's progress that

he recommended him as an illustrator to the London publisher of his book on the 1764 expedition against the Ohio Indians.[19]

In England Reverend Smith publicized the success of that part of his work in Philadelphia devoted to establishing an academic and learned society in the community. He was proud of the growth of arts and letters in Pennsylvania and proud of his students. This pride led him to publish a poem read by Evans on commencement day at the College of Philadelphia in 1763 in the *Liverpool Advertiser*. Evans's ode painted a bright picture of the future of America after the end of the French and Indian War.

> Where the grim savage devastation spread,
> And drench'd in gore his execrable hand;
> Where prowling wolves late wander'd o'er the Dead,
> And repossess'd the desolate land:
> There beauteous villages and wealthy farms
> Now variegate the far-extended plain,
> And there the swain, secure from future harms,
> Delighted views fields of waving grain.[20]

Smith's confidence in the artistic, academic, and economic strength of American society, which he unapologetically promoted in the mother country, provided an example for West. With his mentor harbouring this positive attitude to American life, West would have felt no need to sublimate his pride in the political and military successes of William Penn and General James Wolfe. These heroes of the New World had importance equivalent to those of the Old World.

In 1766 West welcomed his fellow student Francis Hopkinson to London. In August Benjamin Franklin reported that he had tea with the Wests[21] and Hopkinson and in September the American poet wrote to his mother that he had gone on an outing to Greenwich with Benjamin West, his wife, and Benjamin Franklin.[22] One can imagine the conversation among the three expatriate Philadelphians as they cruised the Thames and walked around Greenwich. They might have passed Macartney House, the Wolfe residence since 1751, and stopped at St Alphege's Church to pay their respects at Wolfe's grave. They probably talked of poetry and politics, of art and America. No doubt they were in agreement on the theory that "the arts have always travelled westward." As Franklin was to state in a letter dispatched to the Philadelphia artist Charles Willson Peale shortly after West exhibited the *Death of General Wolfe*, the arts would flourish in America because

the number of wealthy patrons there would multiply and "from several instances it appears that our people are not deficient in genius."[23] The three countrymen may have ruminated on ways of promulgating knowledge of their native colony and its promise for artistic excellence among the English. Of the three men, one a polymath, one a poet, and one a painter, it was to be the latter who provided the English with a national monument created from an American subject. West was to prove to his compatriots that the brush was not only mightier than the sword but also mightier than the pen, at least in earning fame and fortune.

8

A Revolution in Art

West said later in life that the *Death of General Wolfe* (Fig. 8.1) was popular at the 1771 Royal Academy exhibition because it was innovative. In departing from the expected in contemporary art by showing the figures dressed in contemporary or modern costume rather than antique drapery, West created an image that had unprecedented appeal for an audience predisposed to idolize the virtuous hero of Canada.

What visitors to the Academy and, later, purchasers of reproductions of the image saw in it, what they understood by it, would have varied with their experience in artistic matters, their literacy, and their particular stance on affairs of state. The vast majority of individuals who, in the terms of Horace, were "delighted and instructed" by the composition were touched by its subject. They would have been oblivious to its modernism, that is to its "deviation from the ancient and classical manner" as Dictionary Johnson defined the term, or to West's adapting of "ancient compositions to modern persons or things," Johnson's definition of the verb to modernize. The few records of the reactions of the first viewers of the painting substantiate this idea, as does the fact that the picture was seldom remarked on in print or manuscript in an era of frenetic literary activity, suggesting that its popularity must have been owing to something other than its artistic novelty.

The gifted judge of art Horace Walpole did not question West's decision to abandon the cuirass, toga, and paludamentum. His revealingly bland annotation for the *Death of General Wolfe* in his exhibition catalogue reads, "Fine picture, tho' there is too little concern in many of the principal figures, and the grenadier on the right [is] too tall."[1]

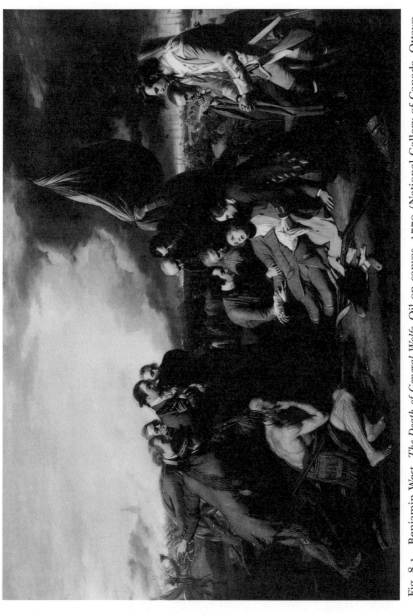

Fig. 8.1 Benjamin West, *The Death of General Wolfe*. Oil on canvas, 1770 (National Gallery of Canada, Ottawa. Transfer from the Canadian War Memorials, 1921, Gift of the 2nd Duke of Westminster, 1918)

The novelty in West's picture seems also to have escaped another knowledgeable connoisseur, the poet and dramatist Richard Cumberland, who saw the work in the artist's studio and wrote to his friend George Romney on 30 March 1771. For him the significance of the work lay not in the costuming but rather in the author's abstention from the habit of pictorializing poetry for "descriptive poetry has been frequently assisted by painting, but I think the latter art has seldom excelled when the pencil has copied after the pen." In support of his opinion Cumberland observed that West " did not take his *Death of General Wolfe* from the paltry poem called Quebec or the Conquest of Canada." He counselled Romney to ignore the poets and to give his figures "their natural titles in their own language."[2]

There are records of the opinions of two visitors to the Royal Academy who perhaps did not recall Romney's earlier composition as Walpole and Cumberland would have. William Pitt, Lord Chatham, the instigator of Wolfe's expedition to Quebec, on examining the painting carefully said that it "was well executed upon the whole" but he was of the opinion that "there was too much dejection, not only in the dying hero's face, but in the faces of the surrounding officers, who, he said, as Englishmen should forget all traces of private misfortunes when they had so grandly conquered for their country."[3] Chatham was not the only famous visitor to the exhibition who faulted facial expression in the *Death of General Wolfe*. England's foremost actor, David Garrick, went there one day soon after the doors were open so as to have a period of uninterrupted study of West's work. Unfortunately others had the same idea and a large crowd had already gathered in front of the canvas. Among them was a woman who was lecturing her companions on the painting. She liked the work but found Wolfe's expression unconvincing. Garrick, whose new and popular method of acting emphasized the coherent expression of emotion in all the muscles and parts of the body, agreed with her. Being prone to act off stage as well as on, he proceeded to show the woman and her friends what was wrong with West's Wolfe. He lay down on the floor in front of the painting and, supported by two men, reproduced the hero's pose and "displayed in his features the exact countenance depicted by the artist." He then moulded his face into what he considered to be an expression appropriate to the rapture Wolfe would have felt when, on the verge of death, he was informed of the defeat of the French. The performance earned him a round of applause.[4] It was perhaps this *ex tempore* impersonation that led later to the suggestion that he produce a dramatic interpretation of the subject in his theatre. Garrick declined,

saying that he would certainly make use of the idea "were we allow'd
to treat a subject so recent as the Death of Wolf [sic]."[5]

The criticism of the expression of the dying Wolfe is reminiscent of
comments on Romney's Wolfe, who was pictured as more dead than
dying. The demand for psychological realism, specifically a more
expressive mixture of rapture and pain in the face of Wolfe, was influ-
enced by what Edmund Burke characterized as the desire to be moved
by the sublime in imanent death. In his *Philosophical Enquiry* Burke
observed that "a man in great pain has his teeth set, his eye-brows are
violently contracted, his forehead is wrinkled, his eyes are dragged
inwards, and rolled with great vehemence, his hair stands on end ...
and the whole fabric totters."[6] This kind of pain or terror, perhaps like
that so ably shown by Garrick as mixed with ecstasy in the face of the
dying hero in his little dramatic tableau at the exhibition, was absent
in West's General Wolfe.

The four extant records of reaction to the *Death of General Wolfe* do
not support the notion that the apparent great public interest in the
picture was motivated by desire to see a work that had been censured
for ignoring tradition in the costuming of the figures but suggest
instead that it was the emotive effect of the picture which roused
public passion. The discourse on the propriety or impropriety of the
way West clad the men in his painting was restricted to a small circle
of art theorists. The protagonists in the debate were West and, it is
supposed, Joshua Reynolds. They were joined by their respective
friends, who acted as mouthpieces. The debate seems to have been of
little contemporary consequence in the world beyond the walls of the
Academy.

The earliest recorded comment on the subject of the soldiers' uni-
forms, and the first mention of the picture in a book is found in a
footnote of a work published in 1776 by the Scottish moral philoso-
pher James Beattie. Beattie said that a historical painting such as
West's *Death of General Wolfe* with portraits of individual heroes and
"dress according to the present mode, may be more interesting now,
than if these had been more picturesque" or antique and "expressive
of different modifications of heroism." But "in a future age," he said,
"when the dresses are become unfashionable, and the faces no longer
known as portraits, is there not reason to fear, that this excellent piece
will lose [sic] of its effect?"[7] Beattie could hardly deny the widespread
appeal of the picture and other subsequent histories like it by West.
So, as is often the case with critics of the popular, he used what was
even then a traditional tactic: he asked the irritatingly unanswerable

question "but will it last?" Ephemeral popularity is always suggested for widely accepted works, particularly those that seem to flaunt convention. In this case the suspicion that West's picture would lose its effect or appear ridiculous in the future because of its being fixed in time by the portraits and costume was particularly important for, in Beattie's opinion, an image capable of conveying timeless truths or immutable classical virtues must itself be framed in timeless terms to ensure perpetual comprehension of the message.

Beattie, a champion of classicism, was not a critical writer on visual art. What he knew about painting he gleaned from conversations with some of his more knowledgeable friends and his words on West's painting are probably those of Reynolds, whom Beattie visited in the autumn of 1771 and the summer of 1773 when he sat for a portrait by him. The wording of the footnote is very similar to that employed by Reynolds, without reference to West's picture, in one of his discourses on art.

The conflict between West and Reynolds over the proper way to clothe figures in a history painting is revealed in what both said and didn't say in a conversation that has come down to us in a prejudicially censored text. John Galt, in his second instalment of West's biography, published in 1820, recorded, probably verbatim, a story told him by the octogenarian West concerning Reynolds's conversion by *The Death of General Wolfe*. The aged painter's recollections were coloured by his pre-eminence among English artists, which he himself knew was in great measure attributable to the unprecedented popularity of his picture of Wolfe's death. West told Galt that King George III had been dissuaded from buying his *The Death of General Wolfe* because he had heard that the "dignity" of the subject had been lessened by putting the participants in contemporary dress. West recalled that he had told the king the story of how he had discussed the unfinished painting in his studio with Reynolds and Dr Drummond, the Archbishop of York, both of whom had objected to the costume worn by the soldiers. Reynolds, according to West, gave a "very ingenious and elegant dissertation on the state of the public taste in this country, and the danger which every attempt at innovation necessarily incurred of repulse or ridicule." Reynolds followed the warning, said West, by "urging me earnestly to adopt the classical costume of antiquity, as much more becoming the inherent greatness of my subject than the modern garb of war." West remembered his reply to Reynolds in great detail. He explained that the event he commemorated took place on 13 September 1759 "in a region of the world unknown to the Greeks

and Romans, and at a period of time when no such nations, nor heroes in their costume, any longer existed." The subject said West, was "a topic that history will proudly record, and the same truth that guides the pen of the historian should govern the pencil of the artist. I consider myself as undertaking to tell this great event to the eye of the world; but if, instead of the facts of the transaction, I represent classical fictions, how shall I be understood by posterity! ... I want to mark the date, the place, and the parties engaged in the event; [and] ... no academical distribution of Greek or Roman costume will enable me to do justice to the subject."[8]

The painter invited Reynolds and the Archbishop to return to his studio when the picture was finished. On seeing the painting for a second time Reynolds studied it carefully for about half an hour. "He then rose, and said to His Grace, 'Mr. West has conquered. He has treated the subject as it ought to be treated.'" The aged West told Galt that on that day fifty years ago Reynolds retracted his objections to the "introduction of any other circumstances into historical pictures than those which are requisite and appropriate." Sir Joshua, West alleged, then announced, "I foresee that this picture will not only become one of the most popular, but occasion a revolution in art."

West had apparently used the word revolution with respect to his artistic achievement prior to putting it into Reynolds's mouth. The poet Joel Barlow, West's first American literary apologist, in a long footnote on the painter in his epic poem *The Columbiad*, first published in 1807, said that West's *Wolfe* and his subsequent histories had "produced a revolution in art. So that modern dress has now become as familiar in fictitious as in real life; it being justly considered essential in painting modern history."[9] This statement was in all likelihood a paraphrase if not a direct quote of something West had said to his friend Barlow on their meeting in London in 1788.

West's story of the discussions with Reynolds in the presence of Dr Drummond was probably based on a grain of truth, but may have been somewhat elaborated, an accurate account being unnecessary as the other participants were, at the time of the publication of the biography, safely in their graves. It is improbable that Reynolds was seduced by the picture and West's argument or perspicacious enough as to forecast its immense popularity. In his own numerous writings, Reynolds never mentioned West's painting. In December of 1771, having seen West's picture twice in the making, if we are to believe West's biography, and several times at the Academy, Reynolds, in a discourse to the students

of the Academy, gave no indication of the coming "revolution in art" which he is said to have predicted. He told the students that "the great style", that is the classical style, "changes the dress from a temporary fashion to one more permanent, which has annexed to it no ideas of meanness from its being familiar to us." Reynolds proceeded to be more explicit in his demand for classical costuming.

It is the inferior style that marks the variety of stuffs. With (the historical painter) the clothing is neither woolen, nor linen, nor silk, satin, or velvet. It is drapery; it is nothing more ... Works ... which are built upon general nature ... live for ever; while those which depend for their existence on particular customs and habits, a partial view of nature, or the fluctuation of fashion, can only be coeval with that which first raised them from obscurity. Present time and future may be considered as rivals; and he who solicits the one must expect to be discountenanced by the other.

Reynold's "agenda for grand-style historical painting," as clearly shown in a recent study of commerce and painting in eighteenth-century England, demanded the "fusion of an elevated style with themes of ostensibly timeless significance." Nobility could be conferred on the painter only if his views "were morally, socially and intellectually superior to that part of mankind attached to more vulgar, material concerns."[10]

In spite of what West said Reynolds thought about the *Death of General Wolfe*, it is far more probable that the latter went to his grave in 1792 believing firmly that the message of a grand history, that is, its instructive content, virtue, and morality, being great and timeless, must be promulgated in a great and timeless style – a style co-temporal with the appearance of virtue as exhibited in its purest form. That style could only be derived from nature presented as classical art. Anything detracting from the unity of the picture – the unity of time and nature – the unity of style and message – should be avoided. West himself only deviated from these rules in *The Death of General Wolfe* in his rendering of costume, appurtenances of war, and topography. Otherwise his history is an acceptable, and indeed admirably executed work, in the eighteenth-century classical style.

Reynolds's observation, as recalled by West, that his picture would become "one of the most popular" proved to be accurate. However, if Reynolds really had observed this, he did not mean it to be the compliment West took it to be. Reynolds was very sceptical of popularity

in art. In his 1772 address to students of the Royal Academy he warned of the dangers of popularity. "Be ... select in those whom you endeavour to please," advised Reynolds, for the artist must temper his wish for celebrity. "Excessive and undistinguishing thirst" for fame will lead him to have "vulgar views." His style will be "degraded" and his "taste will be entirely corrupted." It was Reynolds's view that "the lowest style will be the most popular, as it falls within the compass of ignorance itself; and the Vulgar will always be pleased with what is natural, in the confined misunderstood sense of the word." A good artist must "not be tempted out of the right path by any allurement of popularity, which always accompanies the lower styles of painting." He further cautioned the students that public exhibitions have "a mischievous tendency, by seducing the painter to an ambition of pleasing indiscriminately the mixed multitude of people who resort to them."[11] The taste of the majority was highly suspect, as Lord Kames had made perfectly clear in his *Elements of Criticism* published in 1762: "those who depend for food on bodily labor, are totally void of taste, of such taste at least as can be of use in the fine arts. This consideration bars the greater part of mankind; and of the remaining part, many by a corrupted taste are unqualified for voting."[12] Popularity and vulgarity were synonymous according to Dictionary Johnson. Vulgar he defined as "suiting the common people, mean, low" and, most revealingly, "vernacular or national."[13] The kind of popularity Reynolds railed against was precisely that kind of vulgarity to be seen in West's picture of a vulgar hero – one who was nationally consumed.

The idea that innovation or revolution in art, or indeed any kind of substantial novelty in the practice of art, should be credited with causing popular acclaim evolved in concert with the growth of anti-classicism or modernism toward the end of the eighteenth century and into the following century. West was not untouched by the discourse on art which occurred subsequent to his presentation of *The Death of General Wolfe*. Struck by the undeniable public admiration for his picture, West used it not only to gain income but to ensure himself an enduring position in the world of art. He contributed to the lively discourse on art around the turn of the century through the polemical writing of a surrogate who was a necessary ally in a field of expression West could not hope to master. One thing is certain: West's revolution in art was promulgated in print very much after the fact. (To be fair one should recall that revolutions, particularly in intellectual and cultural realms, are frequently not recognized as such until confirmed by the passage of time.)

From the contents of a letter from George Washington to Thomas Jefferson dated 1 August 1786, we learn that comments on the appropriate costuming in history painting had by then crossed the Atlantic and at least one of the major contributors to the discussion, if not the instigator of the discourse on the subject, was West himself. Washington wrote, after having sat for the French portrait sculptor Houdon at Mount Vernon in 1784, that he would "scarcely have ventured to suggest [to Houdon] that perhaps a servile adherence to the garb of antiquity might not be altogether so expedient as some little deviation in favour of the modern costume, if I had not learnt from Colo. Humphreys that this was a circumstance hinted in conversation by Mr. West to Houdon. This taste, which has been introduced in painting by West, I understand is received with applause and prevails extensively."[14] Jefferson, although partial to classicism, apparently was convinced that a modern hero in antique garments was as "ridiculous as a Hercules or Marius in periwig and chapeau bras."[15]

In 1793, the year after Reynolds's death, the Reverend Robert Anthony Bromley published a book on the history of art and art theory which included a long, biased essay on West's *Death of General Wolfe*. He praised the painting for its "lively and impressive instruction," and its "dignity of sentiment which swells in its progress" and "enlarges the compass of our feelings."[16] The text implies that the debate which West claimed to have won in his "revolution in art" was more heated at the end of the century than it was three decades before. Bromley's book incensed a group of Royal Academicians whose egos were bruised because the author failed to mention them. Other Academicians may have considered the book loathsome because it was a bombastic, flattering apologia for West who, at the time, was far from universally popular among the members of the Academy over which he presided. The touchy Academicians voted not to subscribe to the second volume of Bromley's work.

Had the question of the proper mode of presenting history in art already been settled, Bromley would not have felt it necessary to offer an extensive defence of West's practice in the *Death of General Wolfe*. There is, however, a more plausible explanation for Bromley's extensive treatment of the picture. An undoubted sycophant of West, he acted as a proxy polemicist in the debate on art theory which West had a vested interest in continuing. To Bromley, the *Death of General Wolfe* was successful because "the first glance of the eye is met and satisfied by the greatest perspicuity ... We know it to be the out-scene of a battle in which the British nation marked by the dress of her army

is concerned." After complimenting West on the use of vessels in the background and the Indian to mark the overseas and American location of the battle, Bromley dealt with the issue of costume. "Equally just, but equally new to the historic pencil, is the character of dress in which those victorious men are exhibited. The pencil had never drawn a hero or a soldier in any country but in those habits, which the heroic ages and nations of antiquity had made in a manner peculiar to the field of battle."[17]

Bromley's enthusiasm for West's use of contemporary rather than antique dress suggests that he had read and agreed with the earlier art theorist Jonathan Richardson. Richardson, in his *Essay on the Theory of Painting* (1715), several editions of which were published in the eighteenth century, stated that a good painter of a historical subject "must be thoroughly informed of all things relating to it, and conceive it clearly, and nobly in his mind." The artist has to "possess all the good qualities requisite of an historian," and he must know "the forms of the arms, the habits, customs, buildings, etc., of the age, and country in which the thing is transacted" and in particular be cautious in the selection of the appropriate dress for figures for "those who, in representing ancient stories, have followed the habits of their own times, or gone off from the antique, have suffered by it."[18] It is implied that the same consistency in using contemporary dress in showing contemporary stories was also necessary.

The Reverend Bromley repeated Richardson's dicta in his passages on *The Death of Wolfe*. He may have reviewed Richardson's writing at West's insistence as a few years later the elderly painter would tell Galt that he had read Richardson in the period when he was beginning to try his hand at painting in Pennsylvania.

West's "revolution in art" occurred at a time when parallel changes were taking place in the theatre with a slow transformation toward temporal and geographical coherence. In 1772 the critic Thomas Jeffreys praised Garrick for the use of costumes in his theatre that were "no longer the heterogeneous and absurd Mixture of foreign and Antient Modes, which formerly debased our Tragedies, by representing a Roman General in full bottomed Peruke, and the Sovereign of an Eastern Empire in Trunk Hose."[19] In 1759 a writer had noted that an actor should choose his costume carefully "so that it may be adapted with sufficient exactitude to the age, time, and circumstances of his character" as it "may be called the last colourings and finishings of his picture; and in this case, very much will depend on his knowledge of antient history and historical paintings." If the actor were to

follow this advice he would be assisted in giving "his illusive representation of reality."[20] Slightly earlier a critic had observed that "Alexander and Cato were not masters of the snuff box, nor Greek woman of French heels."[21] The state of wardrobe in the English theatre in Richardson's day was such that for him the "sort of moving, speaking pictures" to be seen on the stage never represented things truly, "especially if the scene be remote and the story ancient." Richardson's disbelief was not suspended for an instant. "A man that is acquainted with the habits and customs of antiquity," he wrote, sees on the stage "a sort of fantastical creature, the like of which he never met with in any statue, bas-relief, or medal; his just notions of these things are all contradicted and disturbed."[22] The connection between history as seen on the stage and in art was also noted by Aaron Hill who wrote in 1724 in *The Plain Dealer* that in the theatre "upon occasion of some striking scene we should, as in a finished history-piece, the work of a great master, behold the stage as one living group of figures."[23] During the course of the latter half of the eighteenth century actors slowly gave up their assorted rag-tag collection of contemporary and near-contemporary stage clothes and began to adopt styles more appropriate to the period demanded by the scripts. This change allowed performers and audiences an increased illusion of reality in theatrical productions, particularly with respect to historical period. The Covent Garden production of *The Sorcerer* in 1762 was singled out for special praise by a reviewer who appreciated the appearance of Pluto "dressed in the mannier [sic] of the ancient Romans" and the simultaneous clothing of Proserpine "(an entirely modern lady), with a new fashioned cap, a handsome fan, and every other article of female decoration, necessary for a drawing room."[24] The transformation in the concept of costume occurred somewhat later in scenery. The taste for pictorial naturalism in setting grew under the influence of Philip James de Loutherbourg, who after 1771 worked for David Garrick at his Drury Lane Theatre.

West's use of contemporary military uniforms in his picture not only led to a change in matters pertaining to art theory in the late eighteenth century but also motivated a long line of historians in the nineteenth and twentieth centuries to use the work in their research to confirm details or add to the historical understanding of the conquest of Canada. West himself instigated this type of inquiry by telling his biographer that he wanted "to mark the date, the place, and the parties engaged in the event."[25] The 1776 publication of a key identifying some of the soldiers to accompany the engraving that reproduced the

Fig. 8.2 Anon. Key to Accompany the Engraving of
Benjamin West's *The Death of General Wolfe*. Engraving, published by
Woollett, Boydell and Ryland, 4 March 1776
(McCord Museum of Canadian History, Montreal)

picture suggested to historians that it was possible to find in the picture the kind of data with which they traditionally worked (Fig. 8.2).

Most historians, unable to find the kind of facts they expect in their mining of the canvas, have concluded their studies by vehemently attacking the *Death of General Wolfe* as unadulterated fiction. One modern author of an article on the names of the individuals in the painting was so distraught that he published the following note: "West's 'American mind' was so 'untrammelled' by considerations of veracity that he produced one of the most prodigious fakes in pictures that has ever been known – a most illegitimate piece of work and quite unworthy of the popularity which it has, unfortunately, achieved."[26] West was thus criticized in his day for situating the figures in his picture in a particular time period by showing the officers and others in the varied and colourful dress of the period and later by some modern writers for lack of this very historical accuracy and specificity.

Typically, modern analyses of the work by historians include disgruntled observations that this officer or that soldier who is said to appear in West's picture was not with Wolfe when he died. Monckton,

severely wounded, had already been removed from the field. Major Isaac Barré had been blinded and was resting some distance from Wolfe. Lieutenant-Colonel Simon Fraser had been wounded in an earlier attack on the French and was not in command of his regiment on the Plains of Abraham. And then there are those who point out that a particular flashing on a uniform is the wrong colour or that there were no Indians with the British at Quebec. First needing defence, or so the artist thought, against those who objected to its accuracy, in more recent times the painting has required defence against those who have damned it as fiction.

The key to the engraved reproduction of the *Death of General Wolfe* identifies six people in the composition. It indicates that Wolfe is supported on his left by the surgeon Mr Adair, who is titled director and 1st surgeon of the hospital. The man on Wolfe's right is said to be his aide-de-camp, Captain Hervey Smyth, and the staff-officer immediately behind is Major Barré, adjutant general. The soldier beside the officer holding the ensign is identified as Colonel Williamson, commander of the artillery. The most prominent figure in the group on the left side of the picture is identified as Brigadier-General Monckton, second in command, and behind him, to his right is labelled Captain Debbeig (misspelled Debbieg in the key), engineer.

Names for other soldiers in the painting have been suggested since the publication of the key. A seventh officer, the one in the uniform of a native regiment behind the Indian, was identified by John Young as Sir William Howe in the entry for the *Death of General Wolfe* in an 1821 catalogue of the pictures at Grosvenor House. Young may have obtained the name for this soldier from West himself as Galt says that one of the first people West met in London was General Howe who, seeing him skating in a park one winter's day, praised the young artist's proficiency on blades. In 1922 the Marquis of Sligo published a key to the picture. He identified the officer holding the colours behind Wolfe as Lieutenant Henry Browne, the officer behind Monckton and to his left as being possibly Colonel Napier, and the man between Monckton and Howe as Simon Fraser.[27] The Highland officer might indeed have been intended as Simon Fraser as his face looks similar to that in a contemporary engraved portrait.

Colonel C.P. Stacey, writing in 1966, rejects the identification of the American ranger as Sir William Howe. Stacey first dealt with the detail of the officer's powder-horn, on which is pictured a crude incised map of the Mohawk river and the inscription "S(r). W(m) Johnson." Stacey pointed out that Johnson was not at Quebec and that he was not a

Ranger. Nor was Howe a Ranger. "This figure" Stacey concluded, "was probably put in by West simply by way of local colour, along with the Indian. Johnson was not in England when the picture was being painted, and the face under the Ranger cap does not seem to be a portrait of him."[28] The reference to Sir William Johnson in the inscription on the powder horn was probably intended by West to commemorate his treaty negotiations when he was superintendent of Indian Affairs in New York.[29]

Stacey rejects Sligo's suggestion of Colonel Napier for the officer to Monckton's left as there was no officer by that name at Quebec. He concludes that "West was perhaps capable of including Major William Napier who appears in the contemporary Army List in the 68th foot – even though the 68th were in the Channel Islands."

This identification game, which seems to be treated as a kind of brain-teaser by military historians, is often quite amusing. In the case of Napier, the identification was rejected in an article published in 1925 in which the author cited for his authority what should have been an impeccable source, the Hon. George Napier. Napier, mistaking the soldier who had been picked as being his ancestor, wrote, "his person and countenance were very commanding, resembling so much the mourning grenadier in West's picture ... that it was thought to be a portrait, yet it was not so; the general resemblance is striking, but his figure was larger, grander in form, his eye still more falcon-like, his forehead less fleshy, showing finer blood, and his jaw more square and determined."[30]

The third problematical figure in the painting is that identified in the 1776 key as surgeon Adair. It has been pointed out that there were two surgeons by the name of Adair in the British Army at the time of the siege of Quebec.[31] One of them, Robin Adair, did not serve in North America and the other, John Adair, while having served as surgeon in North America from 25 June to 24 December, was not recorded as being at Quebec in 1759. (This does not, of course, preclude the possibility that he was there.)

West, in defending pictorial licence in his history paintings, said that he felt there was a purpose which superseded the requirement that truth "govern the pencil of the artist." For him there was "no other way of representing the death of a hero but by an epic representation of it." A picture of such a subject must "excite awe and veneration and that which may be required to give superior interest to the representation must be introduced." West was emphatic that a hero such as Wolfe should not be shown dying like "a common soldier under a

bush." "To move the mind there should be an spectacle presented to raise and warm the mind, and all should be proportioned to the highest idea conceived of the Hero."[32]

As this statement suggests, historians who have grumbled about the documentary worthlessness of West's painting have clearly misunderstood his intent. The painting's historical accuracy is indeed marginal, as one would expect in an epic representation. It shows what might have been or should have been and not necessarily what was, just as did the works of poets and dramatists who wrote on Wolfe at Quebec. Unfortunately the careful costuming and details in the props as well as West's proclamations of their accuracy for the period have seemed so convincing to many that they have suspended their disbelief, forgotten that art is a noble lie, and concluded that the image must have some relation to what actually happened at Quebec.

Of the soldiers who have been identified in the image only one, Lieutenant Henry Browne, can with some certainty be said to have been with Wolfe when he died as he wrote to his father telling him of the event. West not only included soldiers who were not present when Wolfe expired but seems to have omitted at least one who was. Lieutenant Samuel Holland, an engineer in the 4th Battalion of the Royal American Regiment at Quebec, claimed that he "lost his protector [Wolfe] whilst holding his wounded arm at the time he [Wolfe] expired, though for reasons [best known to Mr. West the painter] your memorialist was not admitted amongst the groups present by that artist as being attendant on the general in his glorious exit, but others are exhibited in that painting who never were in battle."[33] General James Murray, it is said, was asked by West to sit for inclusion in the *Death of General Wolfe* but refused, saying that he wasn't present at the death of his commander.[34] (A more likely reason for Murray's rejection of the artist's offer is that he wished to avoid being in the picture as he thoroughly disapproved of Wolfe's tactics at Quebec and intended to publish an exposé of the hero's faulty command.) Townshend, who because of his prominence at Quebec might have been in the painting, is not.[35] One of the oddest pieces of information regarding the absence of an officer in the picture is given in a letter written by the daughter of General Hale to the *Literary Gazette* in 1847. She said that her father, who as a lieutenant colonel was commander of the 47th regiment at Quebec, should have been in the print after West's painting. It was said that the mortally wounded Wolfe personally commanded Hale to take news of victory to England. "General Hale's portrait," said his daughter, "is not inserted in that fine print of Wolfe's

death, and why? Because he would not give the printer the sum of
£100, which he demanded as the price of placing on a piece of paper
what his own country knew so very well, viz.: that he [General Hale]
fought in the hottest of the battle of Quebec, whether the printer
thought fit to record it or not."[36] This statement has been taken by
most authors as evidence that West charged a fee to the individuals he
included in his picture, but Hale's daughter was not complaining
about West. Her anger was directed at the publisher of the print repro-
ducing West's painting. As the engraver would not, and did not,
change any of the faces in the image the general's daughter was prob-
ably objecting to the rapacity of the engraver or one of the publishers
of the key to the engraving. Her story casts doubt on the value of the
key, which is supported by the limited number of figures identified in
West's composition at a time when all of the soldiers represented in
the canvas were presumably alive and West himself could surely have
supplied a complete list of the men who sat for his painting.

From all the evidence it appears that West's painting should have
included Holland, could have included Murray, might have included
Hale, who refused to pay the fee to have his presence confirmed by
the key, and may or may not show Debbeig, Williamson, and surgeon
Adair, all of whom could have paid to be identified in the key but not
have sat to West for the painting. The well-known faces of Monckton
and Barré could hardly have been denied by the printer of the key
even if they refused to pay him. If we are to believe Holland's state-
ment that the painting included soldiers "who were never in battle,"
which is corroborated by the presence of Colonel Simon Fraser who
was recovering from a wound elsewhere, then the lists of candidates
for the unidentified soldiers and those with doubtful identification
could be very long indeed.

The question of who should have been in the picture becomes even
more difficult to resolve when one considers the very human desire to
have been near a martyr at his death. There were almost enough claim-
ants for the honour of attending Wolfe in his last moments to populate
another canvas. Among those who are reported in books, articles, and
archival documents to have attended Wolfe in one way or another
when he died are no less than four surgeons and a surgeon's mate.
Samuel Holland said that he found the wounded Wolfe being carried
off the field by Mr Browne of the 28th regiment of foot and a grena-
dier of the same regiment. Holland supported the general's wounded
arm while a "Mr. Treat, the surgeon's mate of the regiment, the only
medical person who appeared, endeavoured to offer assistance, but in

vain."[37] The surgeons said to have assisted Wolfe are Thomas Wilkins,[38] Wolfe's personal physician Dr Hinde, surgeon Tudor, and John Watson. Others who claimed to have been with the general at his passing include Drill Sergeant Donald McLeod, James Henderson, Alexander Campbell,[39] Grenadier Joseph Preston,[40] Orderly Sergeant Robert Sanderson,[41] Wolfe's servant Ligonier, James Lack,[42] a soldier named McDougal,[43] Francis Browne,[44] Colonel Alexander Murray,[45] John Honeyman, who later was a spy for George Washington, and Captain Isaac Eyles Warren.[46] If one accepts all these claims, the expiring Wolfe would seem to have been of more interest to a large contingent of soldiers, surgeons, and officers than the battle raging nearby. There was a least a battalion of veterans of the Quebec campaign who told their friends and relatives that they were with Wolfe or attended to his wounds when he died. Numbers of bloodstained handkerchiefs were passed from veterans to their sons: like bits of the true cross, they seem to have reproduced themselves on demand.

Writers who attempt to use West's painting as an illustration of history are bound to perpetual frustration: the work is inherently contradictory. It is fictional history, as the artist himself admitted. An example of the fiction is to be seen in the person of the artillery officer identified as Colonel Williamson. He would not have been present at the death of his commander as he was very busy elsewhere directing the cannon, specifically advancing victory by, as he reported, killing General Montcalm "with my grape shot from a light sixpounder."[47] In West's picture Montcalm is shown in the left background at the instant of his being blown off his horse.

There are some passages in the work which show that the painter did collect accurate information on the death of Wolfe. Wolfe has a bandage on his right wrist, a bleeding wound in his left calf, and a wound in his left breast is being stanched by the kneeling surgeon's mate. The first and the last wounds are accurate while the one in the leg is an invention of the artist. Wolfe's first two injuries are mentioned in an anonymous contemporary, and purportedly eyewitness, report: "A bullet from a Canadian marksman struck his wrist; he bound a handkerchief over the wound and his exertions were not relaxed. A few moments afterwards, another bullet passed into his groin, his manner was not changed, his exertions not relaxed."[48] James Henderson, a grenadier in the 28th foot, recorded the next wound. "And then the General came to me and took his post by me ... the great and ever memorable man ... was scarce a moment with me when he received his fatal wound."[49] A letter signed Charles Leslie aboard the *Medway*

off Quebec and dated 23 September 1759 mentions all three wounds. Presumably relaying information gleaned from an inspection of Wolfe's corpse, he said that the General "had 3 balls in diff'rent parts of his body, one in his Arm which was first, one in the belly, and one in the breast."[50] The grisly details were conveyed to the public through an article, said to be a report from an officer, printed in the December 1759 issue of the *Gentleman's Magazine*. Wolfe received his first wound "a musket ball thro' the right wrist," and then he was hit "in his belly, about an inch below the navel, and the third shot just above the right breast."[51] According to John Johnson, clerk and quartermaster-sergeant to the 58th Regiment "just … when we were on the point of gaining the victory, when the fatal shot took place… [Wolfe] sat down and leaned himself on an officer, who sat down by him for that purpose."[52] The identity of the marksmen who shot Wolfe was of no particular concern to the English immediately after the battle. However in 1788 a newspaper carried a story which may have been circulating as a rumour soon after the victory at Quebec. At least one of Wolfe's wounds, so the story went, was inflicted by an English sergeant who had been disciplined by Wolfe and deserted to the French. He was placed on the enemy's left wing and marked out Wolfe and shot him. Subsequently "the sergeant of whom we have been speaking was hanged for desertion, but before the execution of his sentence confessed the facts above recited."[53] That this story was repeated at all in the press is remarkable as reports of British military expeditions simply did not include mention of desertion, which was epidemic in the North American forces.

The final moments of General Wolfe were described over and over in the press in 1759 and early 1760, but these texts were unlikely to have been studied by West – not a great reader and not in England until 1763. It is likely that he got most of his information for his painting from patrons and friends. General Monckton's reminiscences would have been useful as would a passage in John Knox's account of the scene in his book *An Historical Journal of the Campaigns in North-America*, published in 1769. Monckton's name is on list of subscribers to this book. Knox attempted to set the record straight as "various accounts have been circulated of General Wolfe's manner of dying, his last words, and the Officers into whose hands he fell: and many, from a vanity of talking, claimed the honour of being his supporters, after he was wounded."[54] The author interviewed three eyewitnesses, Lieutenant Browne, Mr Henderson, a volunteer of the Louisbourg grenadiers, and an artillery officer whose name Knox forgot. There were

thirteen artillery officers at Quebec, among whom were Captain Debbeig, Captain Lieutenant (or colonel, as he styled himself) Williamson, and Captain Holland. Knox recreated the scene as follows:

After our late worthy General, of renowned memory, was carried off wounded, to the rear of the front line, he desired those who were about him to lay him down; being asked if he would have a Surgeon? he replied, "it is needless; it is all over with me." One of them cried out, "they run, see how they run." "Who runs?" demanded our hero, with great earnestness, like a person roused from sleep. The Officer answered, "The enemy, Sir; Egad they give way everywhere" ... Then, turning on his side, he added, "Now, God be praised, I will die in peace:" and thus expired.[55]

There was some discussion in West's lifetime concerning the accuracy of his picture which his defender, the Reverend Bromley, answered by pointing out that "no matter how far all or any of those incidents were true in fact, they are as fair in the supposition of the painter as if they had actually existed."[56] The notion that West presented the truth in his painting even though it may have contained incidents which had not happened agrees with an opinion held by Jonathan Richardson. Richardson wrote that a pictorial representation of a biblical story with imaginative refinements "makes a fine scene, and a considerable improvement, and probably was the truth, though the history says no such thing."[57] Because something is unrecorded in history does not mean that it did not happen. Richardson's notion that art could improve on history by imaginative recreation corresponded with the argument in another very popular text on art. Roger de Piles, in his *Abrégé de la vie des peintres*, printed in English editions in 1706, 1744, and 1750, said that a historical painter need not slavishly follow historical facts but he must know his history. If adherence to the facts detracted from the ideal harmony of art, the painter was entitled to depart from established facts and give a probable appearance or "vraisemblance" of historical truths.

In this sense West's recreation of Wolfe's death can be considered an accurate image and undeserving of the misguided attacks of historians who have forgotten the truism so ably put by William Ivins: "At any given moment the accepted report of an event is of a greater importance than the event, for what we think about and act upon is the symbolic report and not the concrete event itself."[58] West's report, like an historical novel, became the truth for those who consumed it.

9

It Was He Who Had Immortalized Wolfe

West's painting was a by-product of Wolfe's victory and death. The enormous consumption of West's image of the death of the hero was in fact due to the subject itself. The American-born painter was simply more successful than any of his contemporaries in employing the spirit of General Wolfe. His entrepreneurial use of his subject produced spectacular rewards for him both in financial gain and in the propagation of his reputation as an artist.

As Galt recounted the story told him by West, King George III was dissuaded by Joshua Reynolds, then president of the Royal Academy, from acquiring the *Death of General Wolfe*. This disparagement of the work preceded Reynolds' eventual appreciation of the composition, which led to his declaring it "a revolution in art." The failure of King George to buy *The Death of General Wolfe* may, however, have been due less to his having been influenced by Reynolds than to the fact that he was already committed to another picture by West, *The Oath of Hannibal*, the subject of which he had personally chosen from Livy.

Lord Grosvenor, who may already have owned paintings by West, bought the *Death of General Wolfe* for the princely sum of £400.[1] The king quickly regretted his decision and ordered a replica of *The Death of Wolfe*, which was painted by West in 1771 (now in the collection of Queen Elizabeth). The king paid £315 – a good savings from the price of the original. While, as West claimed years later, the king may have decided to commission the copy after being assured by Reynolds, who had rethought the matter, that the picture was a great work of art, it is more likely that its popularity at the Academy convinced him that he had made an error.

In the king's version West enlarged the composition by almost six inches on each side. He added another ship and additional troops disembarking on the right, thus giving more emphasis to the specific placement of the battle at Quebec. On the left, the soldier waving his cap and holding the French ensign was placed closer to the front, strengthening that part of the narrative referring to the announcement of the defeat of the French. The copy also varied from the original in the appearance of a more voluminous English ensign, which is brandished with greater concern and pride in an upright position.

West painted a number of other replicas of *The Death of General Wolfe*.[2] A third copy was painted for George Friedrich, Prince of Waldeck (now in Clements Library, University of Michigan, Ann Arbor). Waldeck probably commissioned the picture, dated 1776, when he was in London in the summer of 1775 negotiating terms for the supply of mercenaries to Britain for service in America.[3] There are several reasons why he might have wanted a copy. As a connoisseur he could well have responded to the purely pictorial quality of the work. However, if it was West's innovative style and accomplished technique that appealed to Waldeck, he could well have bought or commissioned an original work of another subject. It is more likely that it was the subject of West's painting that attracted him. He, like his fellow German princelings, was fondly disposed toward the British for their military service on the Continent during the Seven Years War, particularly the tactical skill exhibited by General Conway who, in 1762, despite a lack of ammunition for his troops, had used a ruse to liberate the prince's castle at Waldeck from the French.[4] Perhaps at some point Waldeck even talked with Conway about his one-time subordinate, the late General Wolfe. West's *Death of General Wolfe* could well have stood as a symbol of the martial potency of the English and as a reminder of the temper of the English Brunswick court. Commissioning an American artist to reproduce a painting hanging in Buckingham House might have had an even deeper meaning for the German prince: the canvas, a pictorial memorial of a past British victory in North America, could be seen as symbolic affirmation of eventual victory in the present overseas expedition to the American colonies in which Waldeck vicariously participated.

Waldeck would undoubtedly have agreed with many of the English at home and abroad who saw Wolfe's victory as a prototype for what would inevitably transpire in the suppression of the defiant Americans. British authority, British liberty, and British parliamentary rule would be preserved on the continent that Wolfe, while giving up his life, had

secured for Britain. The ungrateful, rebellious Americans, promoting political heresy, were behaving as the French once had in North America. The virtuous English would suppress the tyrannical and perfidious American mob just as Wolfe had reduced the French less than two decades before. While among the English and their European friends Wolfe symbolized the perpetuation of British authority in America, he was, as shall be shown later, accorded a contradictory role by the American revolutionaries. They considered Wolfe's struggle and eventual victory over French oppression in North America to be a model for their own conflict and eventual victory over the tyranny of the British crown.

Waldeck was delighted with his acquisition, so much so that he sent West a painting showing himself exhibiting his *Death of General Wolfe* to his principal history painter. This tribute to West was included in the artist's effects in his estate sale in 1829 but unfortunately has since disappeared.[5]

Waldeck's *Death of General Wolfe* is of the same dimensions as George III's replica and is virtually identical to it. The only substantive difference is the addition of a pair of moccasins in the lower left corner. According to one of West's American visitors, William Dunlap, who was presumably told the story by the artist himself, the moccasins were added on the advice of Henry Laurens.[6] Laurens, a Charleston merchant who was in London from 1771 to 1773, advised West that the natives of America never went into battle barefoot. Laurens would have considered himself an expert in such matters because he had served in the militia in action against the Cherokees in 1761.

West's fourth *Death of General Wolfe*, signed and dated 1779 (now at Ickworth House) and identical in size with the original, was acquired by the earl of Bristol,[7] first cousin of Captain Hervey Smyth, Wolfe's aide-de-camp, who is in the picture kneeling beside the dying general.

Another replica (last recorded in 1930 in the collection of Lady Gertrude Monckton, London), in this case a reduced version on panel, was in the collection of the family of General Monckton. While there is no evidence that the picture was ordered by the general himself or a relation, it is quite likely that this was a commissioned work. The Monckton family were not satisfied with a small *Death of General Wolfe* and subsequently acquired a full-size replica at West's estate sale for £577.10s. This picture (now in the Royal Ontario Museum) is signed and dated 1776 and is also inscribed "Retouched 1806." The date 1776, added in the retouching, is not necessarily an accurate indication of when the picture was painted. This version is the same

size as George III's and is identical with it in most details except that the Indian's moccasins are included and sails have been added to the vessels standing-by on the Saint Lawrence.

West's sale of five pictures of the *Death of General Wolfe* and his production of a sixth to keep in his studio gallery testifies to the popularity of the subject. The fact that the picture is in one sense a noble group portrait or grand conversation piece would have endeared it to a large audience, even those unrelated to the individuals portrayed, for the English had an abiding passion for portraits. Samuel Johnson criticized his countrymen for their limited taste in art. "It is vain," he grumbled, "to set before any Englishman the scenes of landscape, or the heroes of history – nature and antiquity are nothing in his eye. He has no value but for himself, nor desires any copy but of his own form."[8] A reviewer of the 1774 Royal Academy exhibition noted how with his *Death of General Wolfe* and other histories West had succeeded in changing English taste. "I have heard it frequently asserted," he wrote, "that if a good historical painter was to arise in this country he would not find sufficient encouragement, as the people here have no taste, except for Landscapes or Portraits. Mr. West has happily experienced the contrary."[9] In *The Death of General Wolfe* West combined the preferred genre of portraiture with the grand spectacle of history. Great moments in history as shown in this type of painting were the result of the actions of real and extraordinary people. The picture offered the public neither ancient soldiers nor the stereotyped attendants of some bygone heroic English king.

West engaged in an even more lucrative venture than painting replicas of his composition: on 17 November 1772 a partnership agreement was signed between the engravers William Woollett and William Ryland and the publisher John Boydell to publish in cooperation with West a print reproducing the *Death of General Wolfe*. They agreed to print what was at the time the enormous number of 1,200 impressions.[10] A month later, promising to publish the engraving on 4 March 1773, the partners advertised for subscriptions to the print at one guinea each.[11] In January of 1773 John Boydell promoted subscriptions by exhibiting in his shop the engraver's model for this print – a panel, the same size as the proposed print, which has since disappeared – as well as the model for an engraving by John Hall of West's *William Penn's Treaty with the Indians*.

Subscribers to the engraving after the *Death of General Wolfe* had to wait for a long time as it was not published until 1 January 1776. Publication was delayed for several reasons. William Woollett was a

notoriously meticulous and slow worker. West, rightly thinking that the important reproduction would increase his reputation and wealth, was no doubt fastidious in correcting the seven proofs of the print. West's thinking on the project is intimated in remarks by his newly arrived American pupil John Singleton Copley, who wrote to his brother on 15 July 1774, long before the print was published, saying, "I have seen Mr. West's Death of General Wolfe, which is sufficient of itself to immortalize the author of it. There is a fine print of it ingravening which when done you shall see."[12]

While the optimistic partners could have anticipated these holdups, they could not have foreseen two other delays in their publication schedule. The first of these occurred when the printer, Mrs Hocquet, left her young son alone in her shop after pulling only a few sheets. He apparently climbed on to the press plank, picked up a hammer and waved it in the direction of the plate, while, so it was said, muttering to himself, "I could soon be the death of Wolfe," and "General Wolfe is dying, and I'll be damned if I don't kill him quite." He smashed the hammer onto the plate, destroying Wolfe's face. On hearing of this disaster, the devastated William Woollett wept at having "his finest work destroyed."[13]

The plate was repaired and was back in the press by late November of 1775. Again the printing was halted after only a few impressions had been pulled. The interruption this time was caused by the fortuitous appointment on 27 November of William Woollett as "Engraver in Ordinary to His Majesty King George III." The royal patronage was potentially advantageous to the sale of the print, especially when combined with West's position as "Historical Painter to His Majesty," so the lettering was recut to include the parallel honorifics.

The print, when at last delivered to the patient subscribers and offered at a premium to those who had lacked the foresight to reserve one, was an instant success (Fig. 9.1). The partners increased their profit from the enterprise by publishing on 4 March 1776 an engraved key identifying six of the men in the print.

The profit Woollett, Boydell, Ryland, and West reaped from the sale of the engraving of *The Death of General Wolfe* was spectacular. In 1790 Boydell stated that receipts from it had reached 15,000 pounds.[14] The initial printing of 1,200 impressions was clearly an underestimation of their market. Based on receipts in 1790, if the post-subscription price of £1, 5s had been maintained, the total number of prints sold would have been in the range of 10,000. (This number is probably somewhat

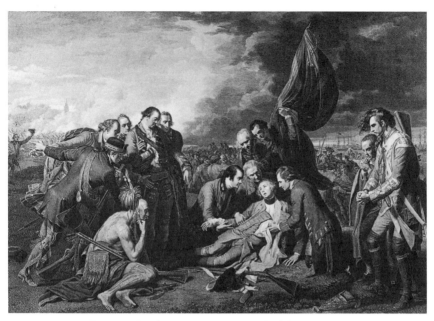

Fig. 9.1 Benjamin West, *The Death of General Wolfe.*
Engraving by William Woollett, published 1 January 1776
(Webster Canadiana Collection, New Brunswick Museum, Saint John)

high because, as the market remained firm, it would have been natural
for the price of the print to escalate.)

Woollett's engraving was by far the single most successful venture in
the burgeoning business of reproductive prints of works by English
artists. Such reproductions were extremely beneficial for the develop-
ment of English art as for the most part the prints would have been
purchased by individuals who by no stretch of the imagination could
be called collectors. Instead, the images were ideal for the decoration
of the homes of lesser gentlemen, shops, and inns. The sitting-room
in the fictional George Inn at Millcote described by Charlotte Brontë
in *Jane Eyre* in the mid-nineteenth century would have been similar in
appearance to many inns that might have been seen throughout
England in the late eighteenth century – "such a carpet, such furni-
ture, such ornaments on the mantlepiece, such prints, including a
portrait of George the Third, and another of the Prince of Wales, and
a representation of the death of Wolfe."[15]

Woollett's contribution to commerce in English art was commemo-
rated by his partner John Boydell, who commissioned one of West's

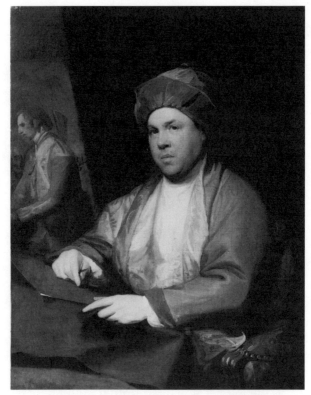

Fig. 9.2 Gilbert Stuart, *William Woollett.*
Oil on canvas, 1783 (Tate Gallery, London)

American students, Gilbert Stuart, to paint the engraver's portrait
(Fig. 9.2). Exhibited at the Society of Artists in 1783 and, following
the advice of a reviewer of the exhibition,[16] reproduced in an engrav-
ing by Caroline Watson published in 1785, the portrait served as an
advertisement for Woollett's most famous print. The engraver is seated
at a felt-covered table holding a plate and an engraving tool. Behind
him is Grosvenor's *Death of General Wolfe* which, as reflected in a mirror,
allowed Woollett to confirm the details in the reversed image he had
cut from the engraver's model.

Woollett died in May of 1785. He was predeceased by his partner
William Ryland, who was convicted of forging bills of exchange and
hung in August of 1783. Boydell thus became sole owner of the plate
for *The Death of General Wolfe.* He pulled prints as the market
demanded and periodically repaired the plate. In a satirical pamphlet,
published in 1791, an anonymous writer unmasked Boydell's avarice

through a letter from the ghost of Woollett from "the banks of the Stygian Lake" to John Boydell, Lord Mayor of London. Woollett's shade complained bitterly that his masterpiece had been destroyed.

The Death of General Wolfe. Ah! there's the cause of all my sorrows! ... the work on which I spent my health, to which I sacrificed all earthly comforts, and prematurely deprived myself of the light of the sun has, since my departure, been most basely butchered! That my unwearied efforts to rescue the arts in Britain from contempt and obloquy, and the beginning I made to a new and inexhaustible source of dignified commerce to my country, has been rewarded by having the humble sprig of bay, which I had gained by years of laborious industry, most barbarously torn away from my scarce cold corpse.[17]

The plate had "fallen into mercenary hands" and had been "retouched by a miserable botcher," and counterfeit proofs had even been printed. Woollett's shade appealed to the newly elected Lord Mayor, who as a scrupulous merchant and an official bound to uphold justice was, he said, obliged to ferret out the one who with unmitigated cupidity was pulling unauthorized prints from the badly reconditioned plate. While the satirist successfully exposed Boydell as an unconscionable profiteer, he conspicuously avoided attributing greed to West, who was also profiting from the constant printing of the image.

The shade of Woollett said that Boydell might better have spent the monies he had subscribed to a monument to the deceased engraver on the apprehension of the greedy man "who, by cruelly defacing the print of 'The Death of General Wolfe,' has destroyed for ever the only monument desired by the injured." (A monument to Woollett, eventually erected in Westminster Abbey, was a subject of vehement dispute among the engraver's cantankerous colleagues. A public committee formed in 1791 and headed by West, then president of the Royal Academy, had by June of 1795 raised sufficient funds to commission Thomas Banks to carve the memorial.[18] Acting on his own, West instructed Banks to inscribe below the bust specific mention of *The Death of General Wolfe*, which was, in West's mind, Woollett's claim to everlasting fame. The committee, when they heard of this, demanded that reference to the Wolfe print be deleted.)

Woollett's popular engraving put West's composition in the hands of anyone in England and abroad who could afford the moderate price. It was reported that Woollett himself made between £5,000 and £7,000 on foreign sales of the print.[19] A contemporary writer rightly concluded that entrepreneurial print publishers provided artists with

"the principal part" of their employment, "enabled them to live," and, through export duties, "also contributed, in no unimportant measure to the public treasury."[20] Evidence of the market abroad for the print can be surmised from the sales of proof states on the Continent. In a French guidebook for print collectors published in 1786 the price for an unlettered proof of *The Death of General Wolfe* was said to be 25 or 30 louis.[21] At a sale in 1796 in Leipzig a proof of the second state of Woollett's engraving sold for 640 francs.[22] West's foreign and domestic sales of prints, including the *Death of General Wolfe*, decreased during the Napoleonic Wars. Whereas it was reported in 1797 that before the war with France he had sold four or five hundred pounds worth of prints per annum, he now sold less than fifty pounds worth.[23]

West's foreign sales were also adversely affected by competition. European printmakers, unrestrained by the recently enacted British copyright laws, plunged into the lucrative market for reproductions of *The Death of General Wolfe*. Replicas of Woollett's engraving were produced for the German market by Carl Guttenberg, Theodore Falckeysen, Giovanni Balestra, and Johann Lorenz Rugendas. French shops carried copies of Woollett's print engraved by Robert De Launay, Augustin Le Grand, and Angelo Zaffonato. In France the ignominy of defeat in North America in 1759 seems to have been overshadowed either by good taste in art or by the notion that Wolfe's heroic death was an archetype for new sacrifices required in revolutionary America, revolutionary France, and the Napoleonic Wars.

The widespread dissemination of West's picture encouraged its use as a basis for pictures of the deaths of other contemporary military heroes. In France François-Louis-Joseph Watteau (Watteau of Lille) designed a print, *Mort du Général Montcalm* (1783), in which the message was amplified by pictorial reference to the *Death of General Wolfe* (Fig. 9.3). The equivalence between the deaths of the two combatants on the Plains of Abraham was further emphasized by the inclusion of a tiny reproduction of the central part of West's image in the background of the print. The printed announcement by Juste Chevillet for the engraving functioned much as did the key to Woollett's print. The composition was explained as showing "Montcalm dying of his mortal wounds in the arms of M. de Montreuil, maréchal de camp and his friend," and noted that "further away, [the bodies of] Mns. de Senzergne and Defontbonne, general officers who commanded both flanks of the French army, are carried away on a single stretcher."[24]

Watteau and his engraver may not have been the first French artists to borrow from West's image. Among the works of the printmaker

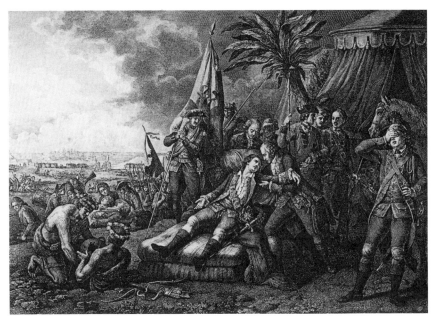

Fig. 9.3 François-Louis-Joseph Watteau, *Mort du Général Montcalm.*
Engraved by Juste Chevillet, 1783
(Webster Canadiana Collection, New Brunswick Museum, Saint John)

Gabriel de Saint-Aubin were drawings of a death of Wolfe and a death of Montcalm,[25] both almost certainly highly dependent on West's composition. Saint-Aubin also drew a portrait of Wolfe which may likewise have been based on a print.[26] Unfortunately all three drawings have disappeared.

In Germany the visual form of virtue and honour established by West and transmitted by Woollett's print or one of the replicas of it was adopted by Johann Christoph Frisch in a painting of the death of Fieldmarshal Schwerin at the Battle of Prague in 1757 and in two drawings of the same subject by Philipp Friedrich von Hetsch.[27]

Meanwhile in England, where the financial stakes were very high, Woollett's print was used by both ethical and unethical suppliers of the rapidly expanding consumer society. One of their products which, on the basis of the number of surviving impressions, sold very well was a singularly bad reduced replica of the print inscribed as engraved by "P. Somebody" and dedicated "To the Lovers of Little Things and Cheap-buyers." Another anonymous printmaker, in this case an out-and-out forger, published a facsimile of Woollett's engraving with minor variations in the lettering. Woollett's print also served as a

model for most of the abundant late-eighteenth-century painted copies of *The Death of General Wolfe*. Only a few of the many surviving examples seem to be based West's original or on any of his painted replicas.

Widespread familiarity with West's composition made possible through Woollett's print and facsimiles of it begged parody. Pictorial satirists also used it as a vehicle for thundering against behaviour contrary to that of the virtuous General Wolfe. In the print *General Black-beard Wounded at the Battle of Leadenhall*, published in 1784, John Boyne contrasted the meritorious demise of Wolfe with the deserved collapse of Charles Fox's anti-libertarian ministry (Fig. 9.4). Fox is surrounded by his friend Edmund Burke (dressed as a monk), Admiral Keppel, the fat Lord North, and Richard Brinsley Sheridan kneeling on the right. Fox is being given smelling salts by his erstwhile mistress, whose hand is being kissed by her former lover, the Prince of Wales. Understanding the point of the satire depended on understanding West's *Death of General Wolfe*: Boyne's caricature mocked the Whig hope that just as Wolfe died at the moment of victory so also could Fox wrest victory from his own loss of power in 1783 at the hands of William Pitt the younger. The Whigs, claiming to be the true reforming voice of the people, a political army dedicated to the restoration of English liberty, were cast in this print as absurd parodies of Wolfe and his brave patriotic soldiers.

The caricaturist James Gillray also used the *Death of General Wolfe* as a basis for one of his most successful political satires (Fig. 9.5). His print *The Death of the Great Wolf*, published 17 December 1795, was, like Boyne's, meant as a serious comment on politics, not art. He attacked those responsible for repressive new treason and sedition laws, replacing the virtuous military martyr with Prime Minister William Pitt, who was, according to a contemporary, trying to "extinguish the flame of liberty in England."[28] Pitt and his reprehensible political henchmen were, in contrast to Wolfe, promoters of unheroic, unvirtuous curtailment of individual liberty. Pitt is supported by, from left to right, Edmund Burke, Pepper Arden, Master of the Rolls, and Home Secretary Henry Dundas. The officer with the flag is the 2nd Earl of Chatham, Pitt's brother, and the man supporting him is Powys, noted for his propensity to tears. On the flag is the white horse of Hanover and a scroll inscribed "Magna Chart(a)." Lord Chancellor Loughborough is pictured as the stoic Indian, with the purse of the Great Seal, a mace, and a bloodstained headsman's axe. The other figures are caricatures of prominent men in Pitt's ministry, including, on the extreme right, the Duke of Richmond in a general's uniform

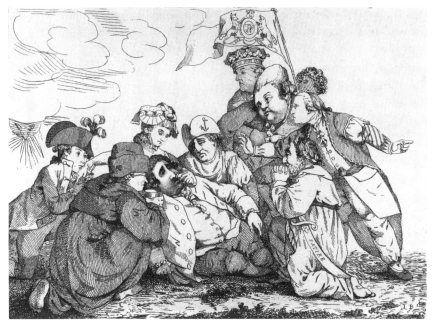

Fig. 9.4 John Boyne, *General Blackbeard Wounded at the Battle of Leadenhall.*
Engraving, 1784 (British Museum, London)

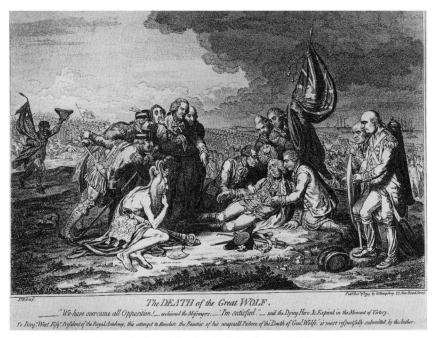

Fig. 9.5 James Gillray, *The Death of the Great Wolf.* Engraving, 1795
(Webster Canadiana Collection, New Brunswick Museum, Saint John)

with canon indicating his Mastership of the Ordnance. In the background of the print the ministerial cavalry, as *bonnettes rouges* carrying a standard with a crown, advance against a small body of naked and semi-nude *sans-culottes*. Gillray, using a famous image of England's last war with France, bitingly equated the new laws concerning treason and sedition with the brutal suppression by the *bonnettes rouges* of the *sans-culottes* who were fighting for liberty in the French Revolution. The strength of the satire stemmed from the absurd contradictory casting of the reactionary ministry in the roles of the brave and virtuous Wolfe and his faithful valorous companions.

Possibly the earliest use of Woollett's engraving as a source for work in another media was a needlepoint panel of *The Death of General Wolfe* exhibited by M. Ansell at the Society of Artists in 1776. Late-eighteenth-century needlepoint reproductions of West's image appear from time to time in the antique market, and there is one in Quebec House, in Westerham, Kent, the birthplace of General Wolfe.[29] Tole-work oval trays with reproductions of the *Death of General Wolfe* were produced in quantity and Wolverhampton iron tray-plaques manufactured around 1800 were decorated with the stirring scene.[30] Details of the *Death of General Wolfe* derived from Woollett's engraving, or replicas of it, were modified and transfer-printed on a variety of ceramic wares. Following his own dictum that "fashion is infinitely superior to merit in many respects," Josiah Wedgwood mass-produced ceramic jugs and teapots decorated with the *Death of General Wolfe* by the Liverpool printer Guy Green, perhaps from an engraving copied by Joseph Johnson from Woollett's print (Fig. 9.6). Surviving examples of these pottery wares have various scenes on the reverse, including an English pastoral landscape with ruins, a naval sloop, a sea-battle, or are inscribed "Success to the Independent Volunteer Societies of Ireland" or "Success to the Earl of Derby." What the patriotic Irish Volunteers were to understand by the *Death of General Wolfe* on the pottery was equivalent to the message revolutionary Americans received from the image: they were to emulate the selfless defender of liberty, who himself, it was widely known, had Irish relatives, in their own struggle for legislative independence. The pottery produced with the inscription to the Earl of Darby is devoid of political intent, as were those with innocuous and purely decorative scenes on the verso.[31]

Other manufacturers of transfer-printed ceramics competed with Wedgwood. Surviving examples showing the *Death of General Wolfe*, which probably represent only the tip of the iceberg, include pieces of Leeds creamware, jugs with purple on-glaze prints made at the pottery of Thomas Wolfe at Stoke-on-Trent,[32] a jug marked "R. Walker

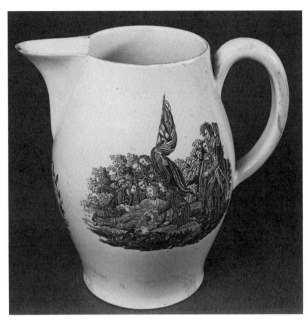

Fig. 9.6 Liverpool jug with *The Death of*
General Wolfe. Late eighteenth century
(Webster Canadiana Collection,
New Brunswick Museum, Saint John)

Sculp,"[33] a mug signed "Rothwell Sculp," and some unmarked ceram-
ics.[34] The image was also copied in relief on mass-produced consumer
goods such as a Pratt Ware plaque, a Herculaneum jug, an unmarked
tobacco jar,[35] and a Staffordshire sugar bowl.[36] The producers of
affordable goods decorated with the *Death of General Wolfe* were cer-
tainly not reckless speculators, as the market had been proven by the
success of Woollett's engraving.

On the Continent, although prints of *Death of General Wolfe* were
popular, the environment of industrial production and consumption
was not conducive to widespread use of the image on domestic ware.
The only known example is a cup made about 1795 at the Nyon
porcelain factory near Geneva. It is embellished with a hand-painted
and modified coloured copy of the central group of West's composi-
tion (Fig. 9.7). The painter of this cup may have used Woollett's print,
but it is more likely that he copied one of the several continental
replicas of the engraving.

In England and America West's composition was reproduced in the-
atrical as well as decorative art. The pantomime *The Soldier's Festival, or
The Night Before the Battle*, performed at Covent Garden on 3 May 1791,

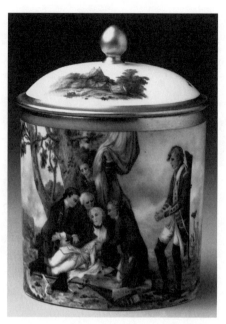

Fig. 9.7 Nyon porcelain cup with
The Death of General Wolfe. 1795
(Dépôt Fondation Jean-Louis Prevost,
Collection Musée Ariana, Geneva)

concluded with an "exact representation of the siege of Quebec, and the Death of General Wolfe."[37] The *dramatis personae* for these scenes closely parallels that of the print, including General Monckton, surgeon Adair, an aid-de-camp, a Grenadier, and an Indian chief. West must have been thrilled by London productions of the tableau vivant of *The Death of General Wolfe* for they would have enhanced the sales of his print and furthered his reputation. The *Soldier's Festival*, with the appended *tableaux vivants*, was staged in the north of England. In York, Pontefract, Leeds, Doncaster, and Hull, it was standard fare between 1792 and 1794.[38] In the cast list for a performance at York a Highlander was added, indicating dependence on the print. In America a production of a play entitled *The Siege of Quebec* – not the one of the same name by George Cockings – produced in Philadelphia in 1796 was followed by a *tableau vivant* of the death of General Wolfe in which the cast of characters was almost identical to that in West's picture.[39] Among those shown were Hervey Smyth, Simon Fraser, Major Barré, and Major Rogers. (Rogers' appearance may be the beginning of the tradition of identifying him as the individual in the uniform of a

ranger in West's painting.) A "serious pantomime" entitled *The Death of General Wolfe* was staged several times by the Philadelphia Company in their spring and fall seasons at their Holliday Street Theatre, Baltimore, in 1798 and 1799. The last scene of this piece was described as "exactly imitative of the celebrated picture by West."[40] The production of "a grand pantomimical ball [ballet]" *The Siege of Quebec or The Death of General Wolfe* produced at the New Hay Theatre at the Old Market in New York in 1797 is also likely to have included a scene based on West's image.[41] The print was also probably used by the entrepreneurs of a travelling wax museum which in 1802, in a visit to Montreal, was reported to include a scene of "the famous General Wolfe, who fell on the Plains of Abraham, supported by his attendants in his dying moments."[42]

The popularity of Woollett's print and the potential for the dramatic power of the scene of Wolfe's death as depicted by West were anticipated by the actor, playwright, and theatrical entrepreneur John Jackson, who seems in 1774 to have toyed with writing a play on the subject.

My nib can never rest – To-morrow's sun
Will view another Tragedy begun:
Quebeck's fam'd siege, with Wolfe's untimely fall;
Wolfe, England's glory, and the dread of Gaul.[43]

Jackson did not write his tragedy which, given the climate of the time, might well have earned him a measure of fame and a healthy income.

West's pride in his *Death of General Wolfe*, fed by its ubiquitous reproduction in decorative and theatrical art, was also nourished by the adoption of the composition as a visual formula for honouring subsequent martyrs in American history. Upon his arrival in England in 1784 the budding American painter William Dunlap showed his countryman his full-length portrait of General Washington at the battle of Princeton. In the background Dunlap had painted "General Mercer, dying in precisely the same attitude that West had adopted for Wolfe." West, said Dunlap, "smiled to see an awkward imitation of his own General Wolfe, dressed in blue, to represent the death of General Mercer; and the Yankees playing the part of the British grenadiers, and driving redcoats before them."[44] Dunlap, whose father had been wounded in the Battle of the Plains of Abraham, knew West's composition through Woollett's engraving. He had even made an ink and wash facsimile of the print.

Two of West's former students made use of the ideological content and formal structure of *The Death of General Wolfe* in histories of the deaths of modern heroes, showing martyrs expiring amid a group of supporters in a manner developed from West's composition. Contemporary understanding of John Singleton Copley's 1779–80 painting *The Death of the Earl of Chatham* depended in part on prior acquaintance with West's painting. Copley's essay on Chatham's stroke, which occurred in the midst of his zealous opposition to the Duke of Richmond's call for the removal of British troops from America, recalled Wolfe's heroic defence and death in preserving British interests in America. John Trumbull, who may have worked on West's own replica of *The Death of General Wolfe*, echoed his master's most famous composition in his first picture in a series of deaths of heroes of the American Revolution, painted in 1786. Trumbull's *Death of General Montgomery in the Attack on Quebec, 31 December 1775* depicted the martyrdom of the American commander of a tragically flawed attack on the British. The idea that Montgomery's death paralleled Wolfe's sacrifice was, at the time, a commonplace in contemporary American polemics.

Not only expatriate American artists fell under the influence of West's Wolfe – the Scottish painter John Graham, in *The Funeral of General Fraser, who was shot after the action at Saratoga, October 7, 1777*, repeated poses, gestures, and motifs from West's painting.[45] Lacking Copley and Trumbull's talent in transferring West's pictorial invention to another subject, Graham's work merited a reviewer's dismissal: "We should have been more pleased with the picture if we had not seen The Death of General Wolfe by West."[46]

West was not unaffected by the ubiquitous admiration for his *Death of General Wolfe*. His feeling of self-importance was noted after his death by the painter James Northcote, a Reynolds partisan, who held West in very low esteem. "[It] has often struck me in West," Northcote recalled, "how happy it was for him that he lived and died in the belief that he was the greatest painter that had ever appeared on the face of the earth. Nothing could shake him in this opinion, nor did he lose sight of it. It was always 'My Wolfe, my Wolfe.'" And, Northcote concluded, "I do assure you literally, you could not be with him for five minutes at any time without his alluding to the subject; whatever else was mentioned, he always brought it round to that. He thought Wolfe owed all his fame to the picture: It was he who had immortalized Wolfe, not Wolfe who had immortalized him."[47]

West may be excused for his talk, as another of his acquaintances said, being full "of his everlasting subject, himself,"[48] for others spoke about him with equal admiration. In the brief thaw in hostilities with France in 1803 West joined the invasion of curious English tourists to Paris where he was honoured at a banquet by his French colleagues. The poetic greeting given him confirms that the politically charged subject of the picture was not detrimental to French appreciation of the painting as an important work of art.

Célèbre West! allez, portez à l'Angleterre
L'affection, l'espoir, les vœux de notre terre.
Si la guerre jamais rallumait ses flambeaux,
Convoyez vos Bretons autour de vos tableaux;

Montrez, Peintre savant, à leur âme attendrie
Le sang que les combats coûtent à la Patrie;
Offrez à leurs regards ce Wolff, si jeune encor,
Frappé loin de leur bras au ciel du Labrador;[49]

West's success in commerce as well as art impressed the French. In 1800 Jacques-Louis David, in defence of the admission fee he charged for an exhibition of his painting of the Sabines, said, "in our own time this custom of showing the arts to the public is practised in England and is called *Exhibition*. The pictures of the death of General Wolfe and of Lord Chatham, painted by our contemporary, West, and shown by him, won him immense sums."[50]

West's pride in his accomplishment with the *Death of General Wolfe* would have been further elevated by the news that he was regarded as a star in the anticipated cultural ascendancy of the new United States. The American poet Joel Barlow heaped praise on the artist in his epic poem the *Columbiad*. Barlow's evaluation of West and his work was, as has been shown, similar to that of the Reverend Bromley but Barlow expressed himself in a much superior style.

West with his own great soul the canvas warms,
Creates, inspires, impassions human forms,
Spurns critic rules, and seizing safe the heart,
Breaks down the former frightful bounds of Art;
Where ancient manners, with exclusive reign,
From half mankind withheld her fair domain.

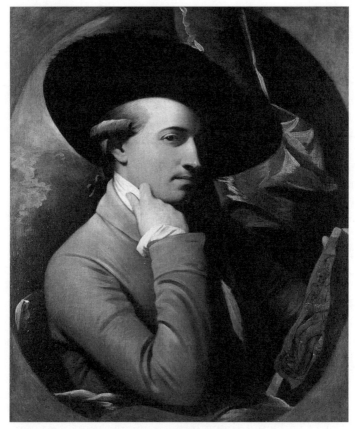

Fig. 9.8 Benjamin West, *Self Portrait.* Oil on canvas, c. 1776
(The Baltimore Museum of Art: Gift of Dr Morton K. Blaustein,
Barbara B. Hirschhorn, and Elizabeth B. Roswell, in memory of
Jacob and Hilda K. Blaustein BMA 1981.73)

He calls to life each patriot chief or sage,
Garb'd in the dress and drapery of his age.
Again her bold Regulus to death returns,
Again her falling Wolfe Britannia mourns.[51]

Given what we know of West's own feelings toward his work and his
famous painting of Wolfe it is hard not to conclude that Barlow
repeated in poetic form more or less what he had been told by the
painter himself. This supposition is supported by the long footnote
Barlow wrote for this passage in which he said that upon arriving in
England West "soon rendered himself conspicuous for the boldness of

his designs, in daring to shake off the trammels of the art so far as to paint modern history in modern dress." He astonished his fellow artists who "were surprised to find that the expression of the passions of men did not depend on the robes they wore."[52]

Reading Barlow one can understand how the elderly West could have been confused over whether he made Wolfe or Wolfe made him. West faced the conundrum of whether his image was so popular in England, on the Continent, and in America because it was a revolution in art or because it was a picture of the hero its various audiences so admired. West had brought this difficulty on himself as he had purposely set out to produce a picture with vulgar or common appeal. That his enterprise worked so well is a tribute to his understanding of human passion in his era. He himself predicted the popularity of his picture and that it would make his reputation and ensure for him an everlasting fame equivalent to that accorded its subject. It was not only in later life that West was full of his General Wolfe: he had earlier memorialized the fame he accurately predicted for his picture in a self-portrait painted around the time Woollett's print was published which shows the self-assured artist with a sketch for the *Death of General Wolfe* on his drawing board (Fig. 9.8). There is no hint in this optimistic self-portrait of the dilemma that West would face regarding Wolfe in his later life, the dilemma of whether a truly great work of art can be popular. West's predicament, caused by the vast fame of his picture, was a truly modern phenomenon that arose through the creation of a vast audience by the very revolutions in production and consumerism that had universalized the fame of Wolfe in the burgeoning industry of printed images and words. As a pioneer in the new consumer society, West was confounded by the fracture his work created in the art world – the split between the exclusive esoteric sphere of aesthetics, art theory and practice and the domain of mass consumption. Are quality and vulgar appeal mutually exclusive? West would have avoided this problem had he kept to the production of works illustrating heroic deeds with less mass appeal.

Although it may be unfair to use hindsight, there is something to be gained in seeing West's dilemma in light of the subsequent use of his picture. As West's *Death of General Wolfe* came to assume the role of "the picture of the event," whether accurate as history or not, it was adopted as the canonical illustration in history texts. The image, even today, is known less frequently as an important work of art, a turning point in the evolution of English art, than as an illustration of an historical event that represents the beginning of a new America.

Reproduced over and over in school texts and popular histories, in film and print, discussion of it in captions or commentaries deals primarily with its subject. Sometimes the author of the work is mentioned but more often he is not. His revolution in art is of no concern to those who use the image to animate history.

10

Lively and Impressive Instruction

About history painting Samuel Johnson said, "the event painted must be such as excites passion, and different passions in several actors, or a tumult of contending passions in the chief."[1] The excitation of passions in the audience of *The Death of General Wolfe* owed as much to the way the event was visualized as to the emotion inherent in the narrative itself. Elucidating what the eighteenth-century consumers could have seen in West's painting sheds light on how they were touched by the ghost of General Wolfe.

The expiring British military martyr's pose, which Garrick so skilfully imitated on the floor in front of the picture at the Royal Academy, would have been familiar to many of the more knowledgeable spectators. One source for it was the pose traditionally used in art showing Christ mourned by the Virgin. The pose of Benjamin West's Wolfe was probably based on the dead Christ in a replica in reverse of a lamentation by the Flemish seventeenth century painter Anthony van Dyck (Fig. 10.1). This small picture, considered at the time to be a van Dyck, likely captured West's attention as he strolled through the Gallerie de Luxembourg in Paris during public hours on a summer afternoon in 1763. The little painting in the French Royal collection may have caught his eye because he was already thinking of the problems he might encounter in composing a picture of the death of Wolfe.

Although most of those who saw West's picture at the Academy or bought copies and prints and other reproductions of it were not acquainted with the specific pictorial source for the body of Wolfe, many would have recognized it as coming from a lamentation. The parallel between West's dying Wolfe and the dead Christ is even more

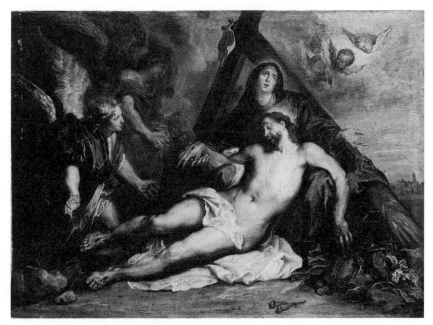

Fig. 10.1 After Anthony van Dyck, *Lamentation*. Oil on canvas
(Réunion des Musées Nationaux, Paris)

explicit if the wounds of the general are seen as modern stigmata.
Wolfe is shown as wounded in the wrist, in the calf, and in the breast.
West transferred Wolfe's wound in the groin or belly, recorded in the
eye-witness accounts, to the leg to emphasize the relationship between
Wolfe and the Christ of the lamentation.

Other borrowing from Christian iconography further enhanced the
religious character of the picture.[2] The grouping of kneeling and
standing mourners was based on Baroque paintings of the deposition
and entombment. This borrowing is clearest in the two foreground
figures on the right. Each has his hands clasped – a gesture close to
one of prayer and adoration. The wild appearance of the grenadier to
the extreme right, the only major figure not impeccably groomed,
recalls the traditional placement of the hermetic, rustic St John the
Baptist in traditional pictures of the crucifixion. The other wild figure
in Christian art, frequently pictured as present at the crucifixion and
deposition, is St Mary Magdalene, who is often shown on the ground
swooning in grief. Her place in West's composition is taken by a noble
Indian who, in Apollonian self-restraint, is a mute spectator to the
result of the white man's natural war-like nature.

West, however, invested his canvas with meaning well beyond that implied in the recapitulation of Christian iconography. His representation of an epic moment in history, a summation of the past and a prognosis for the future, was presented within a neo-classical framework. The allusion to pre-Christian morality intrinsic in neo-classicism would have escaped only the most insensitive in West's audience. His frieze-like, clear composition capturing the crucial moment in the narrative of the conquest of Canada could be read with facility by those accustomed to the many similar death scenes on ancient and contemporary sepulchral monuments, which involved "genuine historic spirit," "lively and impressive instruction," and "dignity of sentiment."[3] It spoke, as did Joseph Addison's *Cato*, of valour that "soars above what the world calls misfortune and affliction." West's Wolfe, like Cato, accepted his pain and death gladly, neither of which were to be interpreted as ills, "else would they never fall on heaven's first fav'rites, and the best of men."[4]

Understanding the meaning of Wolfe's death as pictured by West is aided by consideration of the Indian, the second most important person in the composition. This figure had a greater purpose than merely indicating the overseas location of the battle at Quebec. For the eighteenth-century English the potency of the idea of the Indian, based on fact and fiction, emanated from what was believed to be his paradoxical nature. On one hand he was thought to be an arch savage, an uncivilized being who required redemption. On the other hand he was seen as noble, moral, and virtuous – the archetypical uncorrupted man. He belonged outside history because he straddled the continuum of time. He was regarded sometimes as a primeval creature, sometimes as an ancient man, and sometimes as an inhabitant of the contemporary world.

In *The Death of General Wolfe* the potential for the resolution of the paradox of the Indian is explicitly stated. The semi-nude warrior humbly seated on the ground at the great white warrior's feet takes the role of the tamed and newly civilized wild-person in the traditional drama of Christian crucifixion, deposition, and lamentation pictures. It suggests that through Wolfe's sacrifice the barriers to the Christianization of Native Americans were breached and they were granted the potential of redemption in its broadest sense. Those who were already Christian were freed to cast off their misdirected Catholic faith and embrace the true religion. Reverend William Smith, West's mentor in Philadelphia, summarized the religious benefits of Wolfe's defeat of the French: "The Protestant interest in America has now received such

signal advantages, and obtained such sure footing, that we trust neither the machinations of its inveterate enemies, nor even the gates of hell itself, shall ever prevail against it."[5] Those still pagan were now offered Protestant redemption and all the consequent benefits of English civilized society. Until the American natives abandon "their miserable heathenish state," wrote the missionary Charles Beatty, until they "are acquainted with the nature of the glorious gospel of Jesus Christ, and the immense advantages accruing thereby to their precious immortal souls, they will pay little regard to the arguments made use of in favour of a civil state." In summary, Beatty said, "as soon as any of them become true converts to Christianity, they then, but not till then, begin to see the necessity and benefit of a civil government."[6]

The secular advantages of civilization extended to the "savage" American through the martyrdom of Wolfe were the same as those to which the African King Juba II of Numidia in Addison's *Cato* aspired. In the popular play, Juba fawns at the feet of Roman civilization. To him, Rome tames "the rude unpolished world" through the gift of law. This law allows the cultivation of "the wild licentious savage with wisdom, discipline, and liberal arts ... Virtues like these," says King Juba, "make human nature shine, reform the soul, and break our fierce barbarians into men."[7]

The idea that Wolfe's martyrdom opened the way for polish and civilization among North American Natives is explicitly stated in one of the epitaphs to Wolfe submitted to the Society at Almacks. It seems likely that the composer of this piece was directly inspired by Benjamin West's painting.

> To the memory of General Wolfe
> His Character, by Tradition, will be handed down
> among the savage Indians
> 'Till they become a polished People
> And a Homer shall arise amongst them,
> To realize in him
> The Fables of the Ancients.[8]

The belief in the potential for the salvation of the "savage" American was predicated on the conviction that beneath the veneer of wildness dwelt an innately good soul. But this view was not held by all. While missionaries and their allies sought to Christianize, civilize and tame the Native Americans, a greater number of the English preferred to ponder their savagery. They consumed quantities of books and

pamphlets that related in tantalizing, grisly detail real and imagined horrors of scalping, torturing, rape, and pillage. Typical of this genre of literature, which served both as lurid entertainment for the masses and propaganda for the missionary movement, is Peter Williamson's account of his abduction by Indians in Pennsylvania. In his sensational story he told of barbarities that were so "terrible and shocking to human nature," that they were "not to be paralleled in all the volumes of history."[9] Most of Williamson's narrative consists of a litany of skull splitting, protracted human incineration, disembowelling, flaying and so on – all practised by the Indians on their enemies, who were mostly white settlers. Indian fury and violence against their brothers, while not pictured as quite so horrific, served to confirm their innate barbarity. Another example of the English appetite for gore in describing Indian habits is to be found in an appendix added by John Johnson, Quartermaster Sergeant of the 58th Regiment of Foot, to his memoir of the siege of Quebec. In spite of its title, "a short sketch of the Barbarous and Inhuman Art of Scalping," the addendum, in tune with the expectations of its audience, was neither short nor a sketch.[10]

The English had a rapacious appetite for works such as *The Cruel massacre of the Protestants in North America; shewing how the French and Indians join together to scalp the English and the manner of their scalping*, a second edition of which was published in London in 1761. Only a few observers considered the possibility that the Native Americans might have been schooled in savagery by Europeans. James Gibson, a naval chaplain, wrote from Quebec in 1759 that the Indians "scalp all they kill, and have even quarter'd many." Gibson theorized that the Indians might do this naturally but, he added, they are encouraged in such barbarities by the Europeans. The English, the cleric reported, "use 'em just the same (as the French), except quartering, which all the discipline of the commanders can scarcely prevent."[11] What constituted savage behaviour depended, as it always does in war, on the perspective of the moralist. Wolfe himself issued an order to his English troops forbidding "the inhuman practice of scalping except when the enemy are Indians, or Canadians dressed like Indians."[12]

The potential of the English themselves for uncivilized behaviour is revealed in a tale told without so much as a whiff of moral censure by the sensitive poet Thomas Gray. The celebrated author of *An Elegy Written in a Country Churchyard* reported that General Townshend brought home an Indian boy with the intention of giving him to Lord George Sackville. The gift being refused, Townshend kept the youth at his home, where dressed in his native costume, he was exhibited on

social occasions. At one such party Townshend showed his guests a box of scalps and other ethnological souvenirs. When the guests had departed, Townshend's Indian "got to the box and found a scalp which he knew by the hair belonged to one of his own nation. He grew into a sullen fury (tho but 11 years old) and catching upon one of the scalping knives made at his master with intention to murther him, who in his surprise hardly knew how to avoid him".[13] The lad was eventually disarmed much to the chagrin, one might suppose, of the ghost of General Wolfe.

Many commentators on the traits of the Indians of North America were, with good reason, in agreement with Voltaire, who observed that "the example of our nations has made the savages almost as wicked as we."[14] This theory, that the Indians learned their wicked ways from the Europeans, was based on the paternalistic assumption that they were pliant and unsophisticated, lacking their own culture, and was almost as ubiquitous in literature as the savage butcher. An example of such an Indian was the hero of John Cleland's unproduced play *Tombo-Chiqui: or, The American Savage*, published in 1758, who is depicted as an innocently righteous, benign, and amusing rustic, much like other "lesser" races such as the Scots or Irish. Another anecdote about the Indian Townshend had brought with him illustrates the English love of presenting the Indian as an unsophisticated primitive. It was said that when bonfires in celebration of Sir Edward Hawke's victory were lighted, the boy "concluded that they were kindled to roast him alive, a-la-mode de Canada, and began to sing his death song with a very dismal face."[15]

There were, however, instances in which the Indian appeared as other than rustic bumpkin or ignorant savage. In 1766–67 many received a different picture when the Reverend Samson Occom, a redeemed Mohegan, preached over 300 sermons around the country soliciting aid for the propagation of the gospel overseas. And Chief Joseph Brant (Thayendanegea) became a social celebrity on his visit to England at the time Woollett's print of *The Death of General Wolfe* was put on the market.

Some saw Native Americans as superior in behaviour to Europeans. A newspaper writer who noted that many white captives immediately returned to their captors upon their release concluded that "the Indian way of life is not so distasteful as may be thought."[16] One school of thought maintained that in his natural and uncorrupted state the Indian was equal "if not superior to either the antient [sic] Greeks or Romans, for generosity, integrity, justice, policy in government, firmness

of mind and courage; particularly intrepidity and contempt of death."[17] Even the former captive Peter Williamson, after his titillating recitation of the horrors committed by the Indians, admitted that civilized nations might benefit from copying some of the customs of native Americans. "No people," he wrote, "have a greater love of liberty, or affection to their relations."[18] He particularly recommended to his English readers that the nation would do well to follow the Indian practice of selecting "war-captains" on the basis of wise conduct, courage, and personal strength. (This pointed remark would undoubtedly have elicited agreement from readers embarrassed by the succession of well-publicized military inquiries and trials dealing with incompetent and cowardly English "war-captains.")

The Indian dwelling in a natural uncivilized world, a pre-Christian Eden or Arcadia, was thought to possess an a-Christian morality that manifested itself in virtues equivalent to those characteristic of ancient Greeks and Romans. This good Indian, this noble, innocent, and pure creature of God, embodying all that the Europeans had lost in the process of civilization, was in need neither of instruction in Christianity nor lessons in civics. While West positioned his Indian in such a way as to recapitulate traditional Christian iconography, he made reference to the pre-Christian aspect of the Indian by deriving the trunk of the body from a well-known classical sculpture, the *Belvedere Torso*. Contemporary English connoisseurs would have recognized this quotation and appreciated its meaning as the *Belvedere Torso* was one of the major works on the Roman art tour and was well known in England through plaster facsimiles. (In 1780 Joshua Reynolds told the students of the Royal Academy to study the *Torso*, which glowed with "a warmth of enthusiasm, as from the highest efforts of poetry.") West, in a self-portrait commemorating his succession to the presidency of the Academy in 1792, included among the symbols of his new office and his continuing commitment to his craft a plaster of the *Belvedere Torso*.[19]

Not only were the English able to reflect on the appearance of the *Belvedere Torso* through facsimiles, they were provided with a description and interpretation of the fragment by the German antiquarian Johann Winckelmann, who had studied the original closely. Winckelmann, in his essay translated into English and published in 1765, said the sculpture was "the sublimest in its kind, and the most perfect offspring of art among those that have escaped the havock [sic] of time." The shoulders of the figure, which he identified as portraying Hercules, were "like two mountains," and as for the breast, "no chest of an Olympian Pancratiast, no chest of a Spartan victor, though

sprung from heroes, could rise with such magnificence." Winckel-
mann extolled the elasticity of the muscles, their balance between
action and inaction, undulating like waves on the sea. The sculptor
had eschewed embodying base passions, recreating rather "the calm
repose of the parts," from which "the grand and settled soul appears."
The heroic torso thus portrayed "the man who became the emblem of
virtue; who, from his love of justice alone, faced every obvious danger;
who restored security to the earth, and peace to its inhabitants."[20]

West's picturing the Indian as a Greco-Roman hero had a precedent
in his work. In 1760 he had employed an ancient sculpture, the *Apollo
Belvedere*, as a model for an Indian in the painting *Savage Warrior Taking
Leave of His Family*. His biographer also reports a conversation in the
presence of Cardinal Albani in which he compared the *Apollo Belvedere*
to a Mohawk warrior.[21] Whether this is a fiction concocted by West in
his old age or not, it is evidence that the artist saw a strong physical
relationship between the male Indian and the ancient sculptural rep-
resentation of gods and heroes. West's insistence on a parallel between
the Indian and ancient man was a manifestation of a widely accepted
theory that the two species possessed identical virtues.

Since the discovery of the New World Europeans had struggled to
insert the strange peoples of the new region into the existing catego-
ries of race and culture. Indians were variously classified as descen-
dants of the Jews, Scythians, Tartars, Phoenicians, Carthaginians,
Vikings, Greeks, and Romans. A cultural genealogy that led back to
any of these ancient peoples meant that Indians, living idyllic lives in
an uncorrupted Edenic state, could in fact be more civilized than
Europeans. The novelist Frances Brooke described Indians near
Quebec as "the happiest people on earth; free from all care, they enjoy
the present moment, forget the past, and are without solicitude for the
future."[22] Combining this view of Indians with the savages who peo-
pled so much of the literature of the time produced a strange hybrid,
the noble savage, a self-contradictory prelapsarian sinner. This anthro-
pological invention was at the apogee of its popularity in the period
when West painted his Indian seated on the ground at the feet of
Wolfe.

The noble savage made one of his first appearances in a published
but unproduced play entitled *Ponteach, or the Savages of America* (1766)
traditionally held to be the work of Major Robert Rogers. (Rogers, who
was in England from 1765 on, may have served as a model for West's
ranger in the *Death of General Wolfe*. This is suggested by the reuse of
West's Indian as a supplicant in an anonymous portrait print of Rogers

in his ranger uniform.[23]) The noble savage surfaced regularly at the beginning of George Stevens's immensely popular and continuously staged entertainment, the *Lecture on Heads*. Stevens's show began with the presentation of the head of a Cherokee chief, "Sachem Swampum-Scalpo-Tomahawk, ... a great hero, warrior, and man-killer lately." The next head held up was that of Alexander the Great. Both noble heroes were then contrasted to a quack doctor who was accused of being a greater killer than either the Cherokee or Alexander the Great. Stevens's Cherokee Sachem was modelled on Ostenaco who, with two companions, had visited London in 1762. The presence of these Cherokees in English society had elicited a comment in the newspaper regarding the superiority of their system of government. According to the writer, while the noble Indians might be thought to be savage, they were in fact superior to the European in that they had "the utmost respect for constitutional liberty." These noble people have chiefs who are given power to lead them in time of war, advise in time of peace, but who have no "authority or pre-eminence, except in such circumstances as the good of the community requires." The Indian, according to those who admired their absolute liberty, should be revered as worthy models for the English rather than savages in need of penitential prostration before the English constitution.[24]

The belief that "no people on the face of the earth are fuller of the idea of liberty, than the North-American Indians,"[25] was quite common in polemical writing on the virtuous Indian. "Their whole constitution breathes nothing but liberty," observed James Adair. Their egalitarian society produced "such a cheerfulness and warmth of courage in each of their breasts as cannot be described."[26] Thomas Mante, who wrote the best contemporary history of the war in America, advised the English conquerors to follow the example of the French and sublimate their prejudices "conceived against an innocent, much abused, and once happy people, who, with all their simplicity, are no strangers to the first principles of morality."[27]

The physical appearance of the noble savage matched his character. For a Eurocentric artist such as West and his equally prejudiced audience, placing the Native American in a racial category was not difficult – he was equivalent to the ancient Greeks and Romans. A contemporary of West's observed that one could consider the Indians "in their present condition" and "behold as in a mirror, the features of our own progenitors."[28] Looking at an Iroquois chief, Cadwallader Colden claimed in his *History of the Five Nations* (1727) that he was reminded of a bust of Cicero. He characterized the Iroquois as noble savages. "A

poor, generally called barbarous people, bred under the darkest igno-
rance; and yet a bright and noble genius shines through those black
clouds. None of the greatest Roman heroes have discovered a greater
love of their country, or a greater contempt of death, than these
people called barbarians have done, when liberty came in competi-
tion." But Indians committed barbarous atrocities in war. Colden man-
aged to turn this around so that even in vice the Indian has
counterparts in the ancient world. "But whoever reads the history of
the so-famed ancient heroes, will find them, I'm afraid, not much
better in this respect. Does Achille's behaviour to Hector's dead body,
in Homer, appear less savage?"[29]

The Iroquois hero of John Shebbeare's novel *Lydia: or, Filial Piety*
(1755) was a paragon of nobility.

His person was as straight as the arrow which his hands directed from his fatal
bow. His face was animated with features that spoke sensibly of soul, high and
open was his forehead, from his eyes flashed forth the beams of courage and
compassion. His heart beat with honest throbbing for his country's service.
Ample were his shoulders, yet falling off with easy grace, his body all distinctly
muscular, his hips united his upper and lower parts with perfect symmetry, his
thighs and legs complete formed for strength and agility.

Shebbeare's description fits both the *Belvedere Torso* and the Indian in
Benjamin West's *Death of General Wolfe*. Shebbeare even anticipated
West's comparison of the appearance of the American Indian to the
Apollo Belvedere. "The air, attitude, and expression of the beauteous
statue of Apollo, which adorns the Belvedere Palace at Rome, were
seen animated in this American the instant he had discharged his
deadly shaft" and the "perfection of his form and the expression of his
visage were such that the Grecian sculptors of the famed Laocoon, or
the fighting gladiator, might have studied him with instruction and
delight."[30] In thinking of West's Indian in relation to the *Belvedere Torso*
and as the descendent of the Greek hero and demi-god Hercules, the
contemporary viewer would have recognized in this figure the embod-
iment of the contradictory traits ascribed to the noble savage.

West's symbolic Indian, who carries the baggage of contemporary
European thought, is, like everything else in his picture, a shrewd
blend of fiction and fact. The American artist, drawing on his own
memories of his youth in Pennsylvania, could claim to be more knowl-
edgeable about the appearance of the Natives of North America than
any of his fellow artists in England.[31] Before painting *The Death of*

General Wolfe he had used his special ethnological knowledge in his painting of *Savage Warrior Taking Leave of His Family*, in the designs for two engravings illustrating William Smith's *An Historical Account of the Expedition Against the Ohio Indians*, published in London in 1766,[32] and in *General Johnson Saving a Wounded French Officer from the Tomahawk of a North American Indian*, painted in the period 1764–68. In the latter work, showing Johnson humanely preventing the scalping of his prisoner Baron Ludwig August von Dieskau, an event from 1755, the Indian's tonsure and costume are similar to those of the Indians in the *Savage Warrior* and *The Death of General Wolfe*.

In West's major works his Indians are idealized reincarnations of ancients with a sufficient overlay of exotic body colour and pattern, beaded costume, and unique tonsure to signify their New World origin. The generalized warrior in *The Death of General Wolfe* has, unlike his companions in the picture, virtually escaped being identified. Only Necha, chief of the Cherokees has been suggested.[33] West apparently intended the warrior to be anonymous and a-historical, connecting the contemporary classicism of the picture with the ancient world. But in seeking to create historical verisimilitude, to accurately mark the place in which the contemporary martyrdom occurred, he made use of authentic ethnographic material. Sometime in the late 1760s he acquired some Indian artifacts, perhaps from Sir William Johnson, the individual whose name appears in the inscription on the powder horn worn by the ranger in *The Death of General Wolfe*.[34] With these in hand he was able to improve on the generalized costume accessories in the earlier pictures of Indians and add details lacking in the second extant preliminary drawing. His new acquisitions are used in the Indian's pouch and the quill-wrapped knife handle. Other Indian artifacts were used for his Roger's Ranger. The soldier's hat quill-strip, sash or shoulder strap, and beaded garters reproduce items in West's possession.

Modern historians who delight in pointing out the historical inaccuracy of West's painting have noted that the artist's inclusion of a Native American in *The Death of General Wolfe* is yet another sign of the fictional nature of the work. There is no historical evidence, they say, that any Native Americans fought with the British at Quebec. The Reverend Gibson's statement that the British "use 'em [Indians]" just as the French do, should be sufficient to put paid to this theory. Whether West meant his Indian to illustrate native alliance with the British is a moot point. His Indian carries so much cultural baggage – not his own but European and English – that he seems to serve more as a foil to Wolfe, expanding and amplifying the meaning of the hero's death,

than as a representative visual document providing the kind of evidence sought by historians.

Further light is shed on the meanings West intended his picture to convey through consideration of his choice of subjects for companions to the composition. The first ensemble of paintings that includes *The Death of General Wolfe* was created for King George III. The artist painted two vertical compositions, *The Death of Chevalier Bayard*, dated 1772, and *The Death of Epaminondas*, dated 1773, to flank his painting of Wolfe in the Warm Room of Buckingham House. The first painting shows the penultimate gasps of the French General Bayard during a campaign in 1524 when, mortally wounded and having asked his retreating soldiers to leave him behind, he receives the homage of his successful adversaries, the soldiers of Emperor Charles V. It was, according to Galt, West himself who suggested this subject as a parallel to *The Death of General Wolfe*. The similarity between the deaths of Wolfe and Bayard does not lie in their ultimate sacrifice in victory for Bayard, like Montcalm at Quebec, succumbed to wounds won in defeat. It may be reading too much into the pairing of these deaths but it is possible that West and the king considered Bayard as a stand-in, by way of being a prototype, for the losing yet heroic Montcalm.

The pairing of Wolfe and Bayard makes sense in that their lives were to some degree analogous. Both had, according to their canonical biographies, led impeccable lives of courage and virtue. One of the events in Bayard's life had already been recorded in English art: in 1768 Edward Penny exhibited at the Society of Artists his painting *The Generous Behaviour of Chevalier Baiard*, a modest didactic canvas showing the magnanimity of the general after one of his victories. Penny's picture was hung later in 1768 in a special exhibition with his *Death of General Wolfe*. His invention of a pictorial parallel between the virtuous Bayard and the virtuous Wolfe surely influenced West in his suggestion to the king of a companion for his *Death of General Wolfe*.

West's *Death of Chevalier Bayard* is the earliest known picture of this subject, which was later to become popular in French painting. What lead West to paint a death of Chevalier Bayard? Where did he obtained the necessary historical information to support his pictorial invention? The poet William Hayley in 1778 criticized the English habit of painting foreign histories, saying:

> Shall BAYARD, glorious in his dying hour,
> Of Gallic Chivalry the fairest Flow'r.

Shall his pure Blood in British colours flow,
And Britain, on her canvas, fail to shew
Her wounded SIDNEY, BAYARD's perfect peer.[35]

In a footnote to this passage the poet observed that Bayard's "glory has of late received new lustre from the pen of Robertson and the pencil of West."[36] William Robertson's *History of the Reign of Emperor Charles V,* which included the tale of Chevalier Bayard, was immensely popular from the moment it was published in London and Philadelphia in 1770. If West had not read the best-selling history, he may have been informed of its contents from one of his learned friends from whom he was in the habit of acquiring "a general knowledge of the passing literature of the day."[37] In the unlikely event that Hayley was incorrect in pairing West and Robertson, another source for the story might have been Pierre Laurent Buyrette de Belloy's play *Gaston et Bayard; tragedie,* first published in 1770, which was the kind of book likely to have been owned by one of West's more erudite friends. The play was produced in 1771 in Paris and a second edition of the drama with historical notes was published soon after.[38] The playwright's introduction to the tragedy describes Bayard in ways which invite comparison with Wolfe. Bayard's life is described as filled with incredible exploits and magnanimity whose glory had not faded with time. "Si tant d'héroïsme a droit d'étonner notre siècle, si ce siècle a le droit malheureux d'être incrédule sur la vertu, qu'il respecte au moins le témoignage de l'histoire, qu'il ne juge point du passé par le présent, & qu'au lieu de rabaisser la grandeur de nos aïeux jusqu'à notre soi blessé, il cherche à élever jusqu'à eux leurs descendans."[39]

West would not have needed to consult his learned friends to recognize the analogy between the deaths of Epaminondas and Wolfe. He himself had first conceived of *Wolfe* as a pictorial equivalent to a death of Epaminondas and had only to look at the forms he had drawn on earlier, in this case maintaining the classical fiction.[40] The pictorial identity between the death of the ancient and modern heroes was confirmed by their ideological correspondence. The Theban general, fatally wounded at the battle of Manitea in 326 B.C.E., had asked, as he lay dying, who won. When told that victory was his, he said, "I have lived long enough for I die unconquered." This story was well-known in Augustan England, having gained its widest audience through the extremely popular English translation of the French historian Charles Rollin's *Ancient History.* Rollin's theme, underlying his chronicle of

ancient empires, was that their growth and decline was caused by the rise and descent of morals. History was presented as being theologically didactic.[41]

The story of Epaminondas not only served as an archetype for moral behaviour, it also stood as a shining example of the kind of human perfection upon which an honourable national dignity could be based. This was the theory espoused by Johann Georg Zimmermann, physician in-ordinary to his Britannic majesty at Hanover, in his *Essay on National Pride*, first published in English in 1771. In the chapter "Reflections on some advantages and disadvantages of National Pride as founded upon real Excellencies" Zimmerman retold the story of the death of Epaminondas in an account almost identical to the one so often repeated about the death of Wolfe.[42] Captain John Knox, in his history of the war in America, a book that listed General Monckton among its subscribers, gives essentially the same account of the death of Wolfe. "Wolfe's resignation and greatness of soul," calls to mind for him the "almost similar story of Epaminondas who said at the instant of his death 'this is not the end of my life, my fellow soldiers, it is now your Epaminondas was born, who dies in so much glory.'"[43]

West could have arrived at the idea of pairing the deaths of Epaminondas and Wolfe from any number of sources. The similarities were often remarked on in writing celebrating Wolfe's heroic death. For example, the author of the poem "On the Death of General Wolfe at Quebec," first printed in the *Public Advertiser* on 20 October 1759 and then in *The London Magazine* for October, compared Wolfe to Epaminondas and to the Swedish King Gustavus Adolphus, who had died in similar circumstances.

> The virtuous Theban, and the mighty Swede
> For freedom fought, and conquered as they bled;
> England shall claim her WOLFE, and mourn his fate,
> In life as virtuous, and in death as great.

As well as having won Cadmean victories, the three heroes represented the constancy of virtue in three historically distinct periods and three distant nations.

> Three heroes in three distant ages born
> Greece, Sweden, and Great Britain
> ...

A signal victr'y each by death procur'd
And to himself immortal fame secur'd[44]

The notion of Gustavus Adolphus's death as a counterpart to Wolfe's was easily accessible to literary minds. Henry Brooke's 1739 play "Gustavus Vasa, the Deliverer of His Country," republished in 1761, was a perennial favourite and the tale of the valiant Swede was standard fare in the popular press.[45]

Parallels between the deaths of Epaminondas and Wolfe abound in poetry of the time. One verse began with the line "The great Epaminondas conqu'ring, dy'd; / Hist'ry, brave Wolfe! shall place thee by his side." The poem first appeared in the *London Chronicle* on 20 October 1759 and, like most popular writing of the time, was reprinted in a monthly, in this case *The Scots Magazine*.[46] A poetaster from Glasgow wrote "For WOLFE, who, like the gallant Theban, died / In the arms of victory – his country's pride."[47] Jacob Belham in his Latin *Canadia Ode* of 1760 recalled that Epaminondas died in circumstances similar to Wolfe's, as did the anonymous author of an ode published in the same year:

So fell of old the famous Theban Chief,
Whelming victorious troops in noble grief:
Like his Wolfe's fate, like his, Wolfe's deathless name
Swells the loud Trump of everlasting fame.[48]

The coupling of Wolfe, Epaminondas, and Adolphus recurred in the second round of poems on Wolfe. One of the contributors to the epitaph competition for the monument in Westminster Abbey wrote in 1773,

By Victory crown'd, fame shall for ever tell,
Epaminondas, and Gustavus fell.
Great Britain's Wolfe shares the same glorious fate,
And now completes a grand triumvirate![49]

A letter from George Hardinge to Horace Walpole, dated 21 June 1771, reads in part, "Upon the death-bed indeed of Epaminondas, Adolphus or General Wolfe, one may conceive this heroism; but the enthusiasm of action and pride through the noblest birth, were great helps to the real virtue of those immortal men."[50]

West's paintings of the deaths of Epaminondas, Bayard, and Wolfe represent three heroic deaths, ancient, "medieval," and modern. In

each the epoch is revealed by the apparel of the figures. Hanging the pictures together emphasized the temporal sequence of the events and highlighted the historical continuity of bravery, enhancing the recognition of Wolfe's courage by placing it in the context of two undoubted heroes of past times. The desire to present heroism in three distinct eras precluded use of the obvious parallel of Gustavus Adolphus. The Swede's death in 1632 was to West and his contemporaries an event in modern history and thus in the same epoch as the death of Wolfe.

West did not feel that he had exhausted the potential for enhancing the meaning of the *Death of General Wolfe* in the companion paintings done for the King. The entrepreneurial artist approached Lord Grosvenor with the idea of painting a companion piece to the original *Death of General Wolfe*. He proposed the singularly strange theme of the discovery of the bones of General Braddock's army, in particular the episode in which Major Sir Peter Halket finds the skeletons of his father and brother, who had perished with their commander in the ill-conceived attack on Fort Duquesne. The macabre scene of the discovery of the bones during General Forbes's 1764 expedition was, so Galt said, known to West because his brother had observed it as a captain in the militia. It is more likely that West got the idea for this picture from his mentor Reverend Smith, whose book on the expedition in which the bones were discovered he had illustrated in 1766.

West described for Grosvenor the sight he intended to paint: "the gloom of the vast forest, the naked and simple Indians supporting the skeletons, the grief of the son on recognizing the relics of his father, the subdued melancholy of the spectators and the picturesque garb of the Pennsylvanian sharpshooters."[51] The artist and Grosvenor agreed that the contemporary subject was superior to its classical prototype, the search for the remains of the army of Varus. But, according to Galt, Grosvenor decided that because the theme suggested by West was not recorded in any histories it would not be of interest to the public. Grosvenor, more learned and possibly with more sense of propriety than West, may also have understood that except for the fact that both events occurred in North America there was no connection between the scene of Halket contemplating the bones of his father and brother and the death of General Wolfe.

In proposing the Halket subject, West revealed his inclination to think of his Wolfe picture as one in a series of compositions recording the history of his native land. In 1775 he published a print reproducing his painting *William Penn's Treaty with the Indians*. This print was the same size as the print then being engraved after *The Death of General*

Wolfe. It can be assumed that it was his intention that both prints of events in colonial America be treated as companions.

West did eventually get a commission from Grosvenor. It is not clear whether the ideas for the subjects came from the patron or the artist. Two scenes from modern history were chosen: the battle of La Hogue, a naval engagement between the allied English and Dutch fleets against the French in 1692, and the 1690 battle of the Boyne. The undated painting *La Hogue,* and the *Boyne,* dated 1778, were exhibited at the Royal Academy in 1780. Considered in the context of these two paintings, *The Death of General Wolfe* would be understood less as a statement on individual heroism and ideal national virtue than as yet another event in the succession of modern victories of the English nation or of Protestantism. In 1781 West, in partnership with John Hall and William Woollett, published prints of *The Battle of the Boyne* and *The Battle of La Hogue.*[52] These reproductions were the same size as the 1776 print of *The Death of General Wolfe.*

Two other companions were subsequently added to Grosvenor's ensemble of modern histories, but in this case the artist departed from the theme of military supremacy over French and Catholics. In 1782 West painted *Oliver Cromwell Dissolving the Long Parliament* and *General Monk Receiving Charles II on the Beach at Dover.* Both were reproduced in engravings published in 1789 by West, Hall, and Woollett.

West also obtained a replica of Grosvenor's *The Battle of La Hogue,* inscribed "1776 – Retouched 1806," to serve as a companion to the enlarged copy of *The Death of General Wolfe,* inscribed identically, that he retained in his studio. John Trumbull, West's one-time student and assistant, was responsible for the replica of the *La Hogue.* A note in his account book describes his work. "The Battle La Hogue, copied for Mr. West from his original picture. – the Same Size, but on a cloth – 12 inches longer & 6 inches higher: – this extra size left equally on every side, with a view to enlarge the composition for a companion to the copy of Wolfe. – This copy was painted up entirely at once, and will only be retouched and harmonized by Mr. West."[53] In his autobiography Trumbull states that he finished the replica in the summer of 1785.[54] The improvement or retouching of the replicas in 1806 coincided with their exhibition in the artist's studio gallery in that year with yet another companion, *The Death of Lord Nelson.* This trio of pictures of British victories in three modern wars with France would undoubtedly have deeply moved West's anti-French clientele.

By 1806 Wolfe's death had itself become a historical precedent. The transformation of Wolfe from contemporary hero to historical archetype

can also be seen in the literature of the time. For example Coleridge in his *Ode to Addington* of 1801 compared the death of Sir Ralph Abercromby from wounds sustained in a victorious battle against Napoleon's armies near Alexandria (21 March 1801) with Wolfe's earlier victory and death against the French. "Hence British valour wins the coast, / Where their lov'd Chief, the soldier's boast, / Conquer'd like Wolfe and bled."[55] The idea that Wolfe's death was a prototype for that of Abercromby is evident in Philippe Jacques de Loutherbourg's painting *The Battle of Alexandria* 1802 (National Portrait Gallery, Edinburgh) which was loosely based on West's *Death of General Wolfe.*[56]

If we are to believe a story West told an American visitor to his studio, the artist himself had something to do with Nelson's following in Wolfe's footsteps. At a dinner party at William Beckford's Fonthill Abbey in April 1801, Nelson admitted to the American artist that he was not a connoisseur of art.

"But," said he, turning to West, "there is one picture whose power I do feel. I never pass a printshop where your 'Death of Wolfe' is in the window, without being stopped by it." West, of course, made his acknowledgements, and Nelson went on to ask why he had painted no more like it. "Because, my Lord, there are no more subjects." "D———n it," said the sailor, "I didn't think of that," and asked him to take a glass of champagne. "But, my lord, I fear your intrepidity will yet furnish me such another scene; and if it should, I shall certainly avail myself of it." "Will you?" replied Nelson, pouring out bumpers, and touching his glass violently against West's – "will you, Mr. West? Then I hope that I shall die in the next battle." He sailed a few days after and the result was on the canvas before us.[57]

In 1811 West, in partnership with an engraver, published a print reproducing his picture *The Death of Lord Nelson.* The engraving was the same size as those published earlier reproducing Grosvenor's *The Death of General Wolfe* and its companions. Those inclined toward displays of patriotism in a domestic setting could now add a print of Nelson to a gallery already containing images of the battle of the Boyne, the battle of La Hogue, and the death of Wolfe, and episodes in English history concerning Cromwell and General Monk.

West's great skill in creating *The Death of General Wolfe* is to be found less in his modification of some traditional aspects of the neo-classical style than in his ability to reflect the passions and beliefs of the English. The image did not challenge contemporary civic faith but confirmed the essential righteousness of the beliefs already held by its

vast audience. Seen simultaneously as a group portrait or epic conversation piece, as historical narrative, and as commemorative moral exemplar or symbol of the doctrine of divinely ordained supremacy of English liberty over tyranny and savagery, *The Death of General Wolfe* was, like the death of the hero himself, an icon of everything right about English civilization. The remarkable image became a visual national anthem – a silent summation of the passionate patriotic songs popular during and after the Seven Years War and of the hortatory urgings of preachers, poets, and didactic essayists, sculptors and painters, and sublime dramaturges and parliamentary homilysts.

11

The Front Face Is No Likeness at All

The author of an obituary of General Wolfe struggling to compose appropriately laudatory prose prefaced his literary portrait by declaring that the delineation of the hero's magnificent character required "a Raphael's pencil."[1] The same tool was called for in the pictorial rendering of the great man, but a pencil even remotely like Raphael's was unfortunately rarely to be found in the studios of most artists who attempted to capture Wolfe's likeness. These portraitists could have benefited from an ability to emulate not only Raphael's exquisite line but also his imagination, as only a very few had any idea what Wolfe looked like.

The first portrait of Wolfe recorded as having been exhibited publicly was a small full-length of Wolfe by J.S.C. Schaak shown at the first exhibition of the Free Society of Artists in 1762. An engraving of the picture was included in the *Grand Magazine* of 1760, so the portrait must have been painted sometime shortly after the news of the victory at Quebec reached England.[2] Schaak's picture was engraved a second time by Richard Houston. Judging by the number of surviving impressions of the various editions of Houston's mezzotint, the portrait print was exceedingly popular. The first edition of Houston's print, showing the hero full-length standing before the cliffs at Quebec, was published between 1762 and 1764 by a consortium of printsellers that included the partners E. Bakewell and H. Parker, the partners John Bowles and son, and the independent dealers T. Bowles and Robert Sayer.[3] The inscription on the first edition states that the print reproduced a portrait of Wolfe by Schaak that was "in the possession of Hervey Smith Esqr." (The reference here is probably to Hervey Smythe, Wolfe's aide-

Fig. 11.1 J.S.C. Schaak, *Major General James Wolfe.*
Engraved by Richard Houston, 1766–67
(Webster Canadiana Collection,
New Brunswick Museum, Saint John)

de-camp and a run-of-the-mill topographical draughtsman, some of whose drawings of the Quebec campaign were published in 1760.)[4] What was probably the second edition of this print was published before 1767 by Robert Sayer on his own (Fig. 11.1).[5] Its inscription says that Hervey Smith [sic] drew the design and Schaak painted the picture reproduced in the mezzotint. Smyth's role in the printmaking project probably consisted of making a small copy, or printer's model, of Schaak's portrait. The mezzotint was published twice more by different combinations of the publishers of the original edition and the plate was run through the press a final time for John Bowles's second son, Carrington.

Except for his painting of Wolfe, Schaak merits less than a footnote in the history of English eighteenth century art. He was one of a

multitude of mediocre painters historically eclipsed by the several greater stars of his era. His place in the history of art is equivalent to that in the history of literature of those many amateur poetasters who bent their quills in praise of Wolfe.[6]

The extant pencil profile sketch of Wolfe attributed to Smyth, previously referred to as a possible source for Wilton's portrait bust (Fig. 5.3), appears to be a tracing or copy of another drawing. It is thus unclear whether Schaak's source for Wolfe's physiognomy was the Smyth drawing or the drawing from which it was copied. The original version of Schaak's picture has disappeared, although there are eighteenth-century replicas that might be from the artist's studio. Among these is a partial copy, now in the National Portrait Gallery, of a bust-length Wolfe said to have been in the collection of Princess Charlotte, who may have got it from her father, George III.[7] There is record of another replica whose provenance strongly suggests that it was by the portraitist himself. This is an unlocated full-length portrait of Wolfe, signed and apparently dated 1766, that was sold from the collection of the Duke of Richmond and Gordon in the 1930's.[8] It may have been that shortly after its public showing Schaak disposed of his first portrait of Wolfe to Smyth, then, encouraged by the mass sale of the print, painted a full-size replica portrait either on speculation or on commission for the Duke of Richmond, who as friend of General Wolfe had a particular interest in souvenirs of his likeness.

The publisher/printseller Sayer apparently did well with his Wolfe portrait print for in 1772 he added Houston's engraving of Edward Penny's second version of *The Death of General Wolfe* to his stock. This print also produced a steady income. Five years after establishing their partnership Sayer and J. Bennett published a second print reproducing the same picture.

The market for the print based on Schaak's full-length portrait of Wolfe was sufficiently large to attract unscrupulous publisher/printsellers. A mezzotint copy that reverses Houston's print, inscribed only with the words "Corbut fecit," appeared on the market. Corbut was a pseudonym used by the corrupt engraver and printseller Purcell. Judging from the number of extant examples, the pirated print, although lacking lettering indicating the portraitist's name, did well in the market place. Another print, of which there are fewer surviving examples, which reproduces the head and shoulders of Wolfe from Houston's mezzotint was engraved by Killingbeck of London in 1783.[9] The inscription on Killingbeck's print misrepresents the image as being after a sketch made by John Montresor. The name of John Montresor,

a sub-engineer at Quebec in 1759, would have added an air of authenticity to the plagiarized image. A third unauthorized and undated copy of Houston's mezzotint portrait was printed and sold by Cluer Dicey in his shop in Aldermary Churchyard.

The pirating of images was not uncommon at the time. In 1734 a group of concerned engravers published a pamphlet describing the corruption rife in their industry. "The printsellers, when they find a popular print, arrange to have copies made for sale and none of the profits from this sale go to the artist of the original. One artist having it in his power to copy the designs of another is, therefore, the true source of all these grievances."[10] Although the Engravers Act of 1735 was intended to end these practices, it was ignored by many who were tempted by the lucrative market for such works as portraits of Wolfe. One of the boldest thefts of Houston's image was perpetrated by an entrepreneurial French engraver, Jean-Baptiste Barbié, who was immune from prosecution for violation of the English copyright. In his print, which includes not only the borrowed bust of Wolfe but also West's *Death of General Wolfe* pictured as a relief, the credit for painting the ensemble was given to J. Reynolds.[11] This claim was, of course, preposterous, but it certainly must have enhanced the appeal of the print to the more gullible of Barbié's Continental customers.

A small half-length portrait of General Wolfe shared the market with the grander and more heroic folio-size image by Houston. This smaller portrait was engraved twice. The first engraving, scraped by Charles Spooner, was, so the inscription said, after a work by Hervey Smyth and was published by John Bowles and son. The print was republished with the "and son" excised after the dissolution of the Bowles's partnership in 1764 (Fig. 11.2) and the plate was modified for a third printing in which the portrait of Wolfe was set in a circular frame and the publisher's line in the lettering omitted altogether.

A second mezzotint of the half-length Wolfe was scraped by Richard Houston. In his print, made for the same group of firms that had published the first edition of his full-length portrait, thus dating it between 1762 and 1764, he set the portrait in an oval frame resting on a ledge. The inscription on the print says that the portrait was based on a work by Schaak. Neither Spooner's nor Houston's half-length mezzotints seem to have been based on the same picture as the full-length portrait print as the half-lengths show the general hatless with his hair curled above his ear. His right arm is by his side, his torso is turned more toward the front, the fusil and strap are absent, and the opened coat reveals a silk vest.

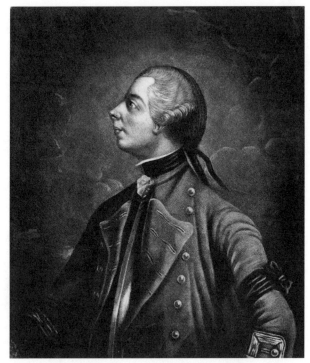

Fig. 11.2 J.S.C. Schaak, *Major General James Wolfe.*
Engraved by Charles Spooner, after 1764
(Webster Canadiana Collection,
New Brunswick Museum, Saint John)

The epidemic of pirated portrait prints of Wolfe, which flourished
in the new English shopocracy, was further expanded by copies of the
half-length portrait engraved by Houston and Spooner. Copies of the
image were engraved by T. Chambers, Philip Audinet (published by
Harrison and Co. 2 Feb. 1795), and an anonymous book illustrator.
The "rage" for portrait prints among the English, a phenomenon iden-
tified by Horace Walpole in 1770,[12] reached a frenzy in the mania for
pictures of the late hero of Canada.

Richard Houston's full-length mezzotint portrait served as a source
for a number of artists. A bow ware figurine based on the print was
manufactured in the 1770's (Fig. 11.3).[13] The image was also a natural
for tavern signs. The designs of two of these are known, one with the
bust of Wolfe produced for the Quebec veteran William Davenport's
Wolfe Tavern in Newburyport, Massachusetts, established in 1762,[14]
and another with the full-length Wolfe (now in the Connecticut

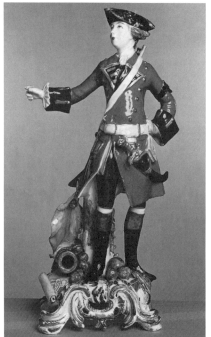

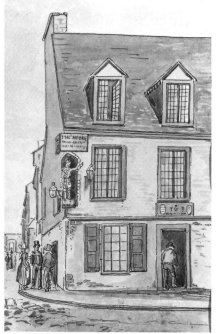

Fig. 11.3 General Wolfe. Bow ware figurine. Late eighteenth century (Victoria & Albert Museum, London)

Fig. 11.4 John Pattison Cockburn, *The House at Wolfe Corner, Quebec City, with the Statue of General Wolfe* (detail). Drawing, n.d. (Sigmund Samuel Collection, Royal Ontario Museum, Toronto)

Historical Society Collection, Hartford), for Israel Putnam's Wolfe's Tavern, which he opened about 1767 after serving in the war with Rogers' Rangers. The limners of these signs presumably had in hand prints recently imported from England.

Considering the potential for the sale of portrait prints of General Wolfe in the American colonies, one could reasonably suppose that they made up a good proportion of the trade in engravings between the mother country and her trans-Atlantic possessions. Sayer, the prime publisher of the Houston mezzotint, exported nearly £100 worth of prints to the Williamsburg, Virginia printer Joseph Royale between 1764 and 1766.[15] Sayer supplied print dealers in the other American colonies as well. In Boston the engraver Nathaniel Hurd reproduced the half-length print as an engraved medallion watch-paper which he advertised in December of 1762.[16]

Houston's full length mezzotint portrait of Wolfe was most likely the source for a wooden statue of Wolfe carved by Hyacinthe and Yves Chaulette which in about 1780 was placed in a niche on the second story of George Hips's house at the corner of rue Saint-Jean and Rue du Palais in Quebec City (Fig. 11.4).[17] The story of the Quebec Wolfe statue is indicative of the demand in North America for visual memorials of the hero. Hips commissioned two French sculptors, the brothers Chaulette (or Cholette), to make the statue and asked James Thompson, who had come to Quebec with Wolfe's troops as an engineer and was reputed to have been the last survivor of the siege, to advise the carvers on the appearance of the late General. "The Cholettes tried to imitate several sketches I gave them," said Thompson, "but they made but a poor job of it after all; for the front face is no likeness at all, and the profile is all that they could hit upon. The body gives but a poor idea of the General, who was tall and straight as a rush. So that after my best endeavors to describe his person, and I knew it well, for which purpose I attended every day at their workshop ... I say that we made but a poor 'General Wolfe' of it."[18] The sculptors seem to have had sources for the appearance of Wolfe other than Thompson's memory: in 1847, in the course of renovations of the house at Wolfe's Corner, a hand-coloured mezzotint of the full-length Wolfe by Richard Houston's was found in the dwelling.[19]

Not only did Houston's full-length Wolfe serve as a source for artists who needed an easily recognizable image but the half-length portrait print or the one by Spooner showing the hatless Wolfe with queue were also widely used. The profile portrait of Wolfe appeared on a transfer-printed porcelain mug made at William Ball's pottery in Liverpool, printed by the company of Sadler and Green from a transfer engraving attributed to Jeremiah Evans (Fig. 11.5). The mug is inscribed "J. Sadler Liverpool" and "August 1763."[20] Either the print by Houston or the one by Spooner was copied in relief on cast iron firebacks known from a few surviving examples apparently manufactured in the American colonies. The portrait of Wolfe is surrounded by an oval frame inscribed "In Mem of Maj Genl JAMES WOLFE at Quebec" with the date of Jan 1, 1779.[21]

In some editions the portrait of Wolfe in Houston's and Spooner's mezzotints was authenticated by reference to its derivation from a work connected with Wolfe's aide-de-camp, the artist Hervey Smyth. Assurance of a first-hand source for images of Wolfe, while of some concern, did not seem to overly affect consumers. In 1759 and 1760

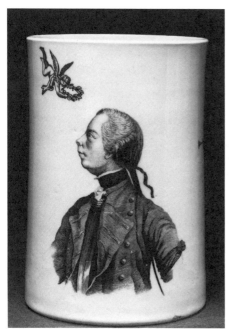

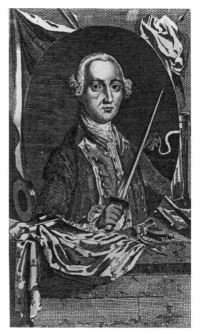

Fig. 11.5 Sadler and Green, transfer-
printed porcelain mug with portrait of
Wolfe, 1763
(Victoria & Albert Museum, London)

Fig. 11.6 Anonymous,
Major General Wolfe. Engraved for
The Royal Magazine, 1759 (Webster
Canadiana Collection, New
Brunswick Museum, Saint John)

the illustrators of magazines printing obituaries of Wolfe solved the
problem of their ignorance of Wolfe's physiognomy by the simple
expedient of drawing generalized military gentlemen and labelling
them as Wolfe. The round-faced, wigged Wolfe holding a sword
engraved for the *Royal Magazine* in 1759 (Fig. 11.6) was the first in a
series of pseudo-portraits showing a well-fed Wolfe. One of the prog-
eny in this family of portraits was a stout-faced Wolfe modelled by the
sculptor Isaac Gosset. Typical of the ingenious capitalist artists of his
era, Gosset had invented a system to multiply his relief portraits. His
novel technique involved the casting of the relief in a wax compound
that mimicked ivory. In 1760 he advertised his latest creation.

Mr. Gosset having finished a model of the late General Wolfe in a composition
that imitates ivory, the likeness of which has been approved of by the later
General's family and friends, proposes to publish it on the following terms: –

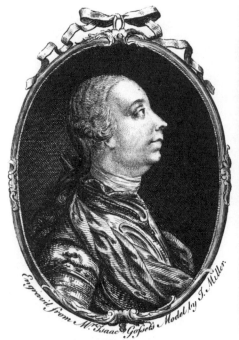

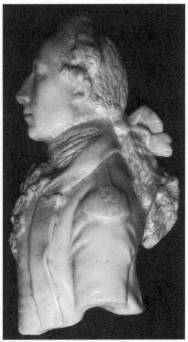

Fig. 11.7 Isaac Gosset, *General Wolfe.*
Engraved by John Miller, 1760–64
(Webster Canadiana Collection,
New Brunswick Museum, Saint John)

Fig. 11.8 John Charles Lochee,
General Wolfe. Wax, late eighteenth
century (Royal Ontario Museum,
Toronto)

viz. a guinea to be paid at the time of subscribing and half a guinea more on
the delivery of the model, which will be two months after the subscriber gives
in his name. Subscriptions are taken at Mr. Gosset's in Berwick Street, Soho
(where the original model may be seen).[22]

Gosset's bold assertion that his portrait was authentic had some effect.
His beaky and fleshy Wolfe in antique armour and drapery was repro-
duced by the medallist John Kirk on a medallion commemorating the
conquest of Quebec[23] and the design of the relief was reproduced
in an engraving by John Miller, who sold the print in his shop at
Maiden Lane, Covent Garden, which he operated between 1759–64
(Fig. 11.7). Miller's engraving was in turn re-used as an illustration in
Tobias Smollett's contemporary *Continuation of the Complete History of
England.*
 Another specialist in the manufacture of multiple relief portraits, the
sculptor John Charles Lochee, had in his stock an image of Wolfe.

Lochee, who exhibited at the Royal Academy between 1776–90, sold
relief portraits of Wolfe in contemporary military costume. These
reliefs, cast in wax, could be had in either painted or unpainted ver-
sions (Fig. 11.8). It is difficult to estimate Lochee's success in the Wolfe
market as the small number of surviving examples of these fragile
reliefs cannot be taken as evidence of the numbers originally produced.

Considering the size of the market for Wolfe portraits, it is not
surprising to discover that portraits of just about any military person
were passed off as the national hero to an unsuspecting or, more to
the point, indiscriminate public. The most outrageous fraud in the
group of round-faced Wolfes was a mezzotint printed for Bakewell and
Parker from a plate engraved by Richard Purcell (whom we have
already encountered under the alias of C. Corbut), after a painting by
F. Turin (Fig. 11.9). This "portrait of Wolfe" shows a wigged gentleman
in an elaborate coat. In the background is a castle on a hill and a
cavalry skirmish. On a table to the left of the putative Wolfe is a plan
of a fortified town on a meandering river. The inscription "QUEBEC"
on the plan was clearly cut as a later addition to the print, which was
obviously tampered with as evidenced by the careless and incomplete
effacing of the original oval frame. The print has been identified as
pulled from a plate originally made by the engraver Faber as a portrait
of General L. Dejean after a painting by Mercier.[24]

Another family of false Wolfe portraits began with an engraving to
accompany an obituary. The portrait of "James Wolfe, Esq" printed in
The London Magazine in 1759 shows a man with a triangular face,
rounded chin, and large nose (Fig. 11.10). This portrait print was
copied in Germantown, Pennsylvania, by the printer and woodcut spe-
cialist Christopher Sower Jr and sold there as a portrait of General
Wolfe.[25] In England, *The London Magazine* portrait was repeated in a
folio-size mezzotint. The inscription on this print does not include the
name of the engraver, the name of the publisher, or that of the painter
of the portrait – and for a good reason: the print was pulled from a
reworked plate of a portrait of Prince Charles (Bonnie Prince Charlie)
by Robert Strange. The engraver for *The London Magazine*, faced with
the task of producing a portrait of someone of whom he lacked phys-
iognomic data, took an expedient course and simply copied the image
of Prince Charles. Once this had been done, it was easy for the owner
of the plate, perhaps the magazine illustrator himself, to recut the
name of the sitter and print and market the fraudulent portrait. The
price of the print, indicated in the lettering as one shilling, would have
made the item very attractive to even the most parsimonious patriot.

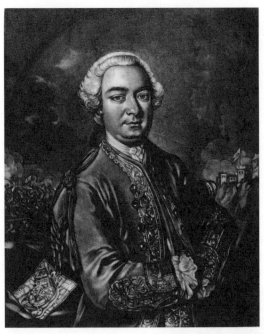

Fig. 11.9 F. Turin, *Major General Wolfe.* Engraved by R. Purcell, n.d. (Webster Canadiana Collection, New Brunswick Museum, Saint John)

Fig. 11.10 Anonymous, *James Wolfe Esq.* Engraved for *The London Magazine,* 1759 (Webster Canadiana Collection, New Brunswick Museum, Saint John)

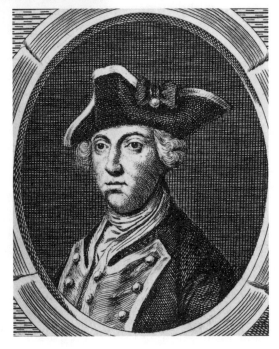

As the unnamed publisher of this print was not obliged to share the income from its sale with either a painter or an engraver, the profitability of the project may have been quite spectacular. It is tempting to attribute this printmaking enterprise to Purcell/Corbut, who was active in the sale of "borrowed" and forged images of Wolfe, but it must be remembered that there were dozens of other equally capable contemporary forgers in London, among them Benjamin West's one-time partner William Ryland.

While the accuracy of portraits of Wolfe was of minor concern to the eighteenth century consumer, interest in the actual appearance of the hero of Quebec has increased and the few potentially authentic portraits have become the object of some veneration. Apart from the supposed drawing by Smyth, there are three extant portraits that, in all probability, were taken from life. None of these were engraved and they seem to have had no influence on the production of the mass-marketed images of Wolfe in the eighteenth century. The earliest life portrait of Wolfe shows him in the uniform of a gentleman volunteer, his role prior to his commission as second lieutenant in his father's regiment of marines in 1741 (Fig. 11.11). The painting has a later inscription on the back which reads:

This picture was painted about the year 1744 for his friend Geo Warde, of Squerryes, ... but the painter's name has not been preserved ... The picture is an undoubted original and tho' not a good painting was stated to have been a good likeness. It was painted in a powdered wig. A young friend of Genl. Warde's painted red hair over the wig in water colours, which was afterwards partially removed. The natural colour of Wolfe's hair was red.

The portrait, dated incorrectly in the inscription, shows Wolfe, at about fourteen years of age. He is represented as a having a cleft in his chin, a broad forehead, large nose, and triangular face.

Another portrait of Wolfe, this one attributed to Joseph Highmore, shows Wolfe in the same pose, with the same lighting and identical facial features[26] (Fig. 11.12). A nineteenth-century inscription on the back of this picture says that it was painted by Highmore in about 1742. Wolfe, according to the note, sat for the portrait "for the express purpose of presenting it to his much esteemed Tutor and Friend, the Rev.'d S.F. Swindon." The inscription claims that this was the only picture Wolfe ever sat for. He is shown, says the author of the description, in his uniform of ensign in the 20th regiment, "when he was preparing to join that Corps, on getting his first commission." The

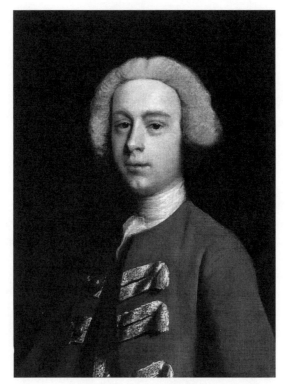

Fig. 11.11　Anonymous, *James Wolfe as a Youth*.
Oil on canvas, before 1741
(Squeryes Court, Westerham)

inscription goes on to say that all other pictures of Wolfe are copies of a miniature which was itself drawn from "this Picture by the desire, and for Mrs. Wolfe, the General's mother, after his lamented but glorious death." That Highmore painted a portrait of Wolfe is substantiated in his obituary, which gives a different date for the work. The notice of the artist's death states that in 1745 Highmore painted "the only original of the late Gen. Wolfe, then about 18."[27] The striking similarity (they are virtually identical) between the Highmore portrait of James Wolfe and the anonymous, supposedly earlier, picture leads to the inescapable conclusion that one is a copy of the other or both are copies of another picture.

The third portrait taken *ad vivam* is a watercolour sketch by George Townshend, who presented it to his colleague Isaac Barré (Fig. 11.13). This picture, painted at Quebec, shows Wolfe much as he appears in the Highmore and the earlier anonymous portrait. It has been

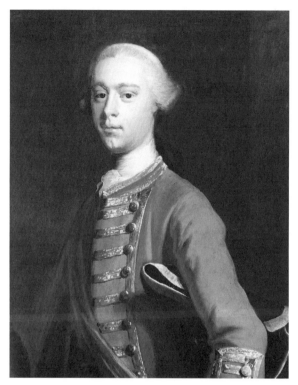

Fig. 11.12 Joseph Highmore, *James Wolfe.*
Oil on canvas, 1745 (National Archives of Canada,
Ottawa, Neg. no. C3916)

suggested that Townshend's portrait of Wolfe was reproduced by Francis Hayman in his now-lost *Britannia Distributing the Laurels* (1764), installed at Vauxhall Gardens. This would have been possible, since Townshend apparently sat for Hayman in the production of Hayman's grand allegory, which showed the Marquis of Granby, Albemarle, Coote with the Quebec generals, Wolfe, Townshend, and Monckton and could have made his likeness of Wolfe available to be copied.[28]

There exist three other likenesses of Wolfe for which he may have sat. A half-length miniature in the McCord Museum of Canadian History in Montreal shows Wolfe full-face, dressed in a red coat with yellow lapels, white waistcoat, and white stock. The miniature is signed "A.C." and inscribed "Blackheath" and dated 1758. In the same collection there is a silhouette of Wolfe with the inscription "Done at Bath. Dec. 28, 1758."[29] A last candidate is a small pen, ink, and wash drawing on the flyleaf of a copy of Humphrey Bland's *Treatise on Military*

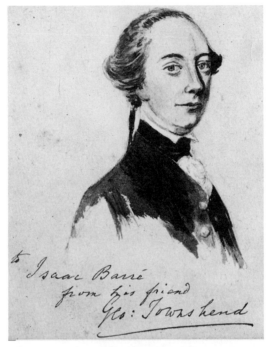

Fig. 11.13 George Townshend, *General Wolfe*.
Drawing, 1759 (McCord Museum of
Canadian History, Montreal)

Discipline (1727).[30] The copy of Bland's book, which contains notes
and annotations by Wolfe and William DeLaune, has an inscription
recording that it was given by James Wolfe to DeLaune in 1752. The
drawing on the fly-leaf, perhaps by DeLaune, looks as if it were a copy
of another work. Perhaps both this drawing and the pencil sketch
attributed to Hervey Smyth had a common source.

The possibility that there was a now-lost profile life sketch of Wolfe
in circulation among artists showing him hatless and with a long queue
is indicated by the appearance of such an image in a satirical print
published in early 1760 (Fig. 11.14). The draughtsmanship of the car-
icature of Wolfe and the composition of the print look very much like
the work of George Townshend. He cannot, however, have been the
author of the print, for he was, if we may believe his defenders, a great
supporter of Lord George Sackville[31] and the print, *A Living Dog is Better
than a Dead Lion,* is a strong statement on the cowardice of Sackville at
the battle of Minden on 1 August 1759, where he refused to comply
with Prince Ferdinand's order to command the British cavalry to charge.

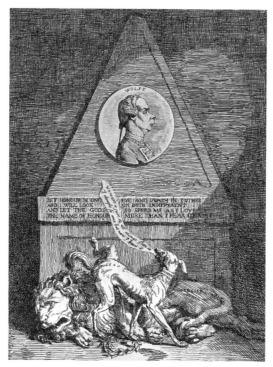

Fig. 11.14 Anonymous, *A Living Dog is Better
than a Dead Lion.* Engraving, 1760
(Webster Canadiana Collection,
New Brunswick Museum, Saint John)

In the print a dog with the word "Minden" on its collar urinates on the
British lion in front of a monument to the brave Wolfe. (The competi-
tion for the commission for Wolfe's monument was, at the time when
this print was published, an event of widespread interest.) The talking
dog, representing Sackville, utters John Gay's famous epitaph in West-
minster Abbey, substituting the word "honour" for "life."

 Sackville's contemptible behaviour was the very antithesis of Wolfe's.
The dead hero and the living coward both elicited strong emotions in
England. In November 1759 John Warde wrote to his brother George,
"I sincerely condole with you on the loss of poor Wolfe, but as I know
you always foresaw some such calamity from his too great intrepidity,
conclude you received the fatal event, with the less surprise." He then
changed the subject saying that he was worried about their neighbour
Sackville, who had been in residence for sometime at his home at
Knole. "Clamour runs hard against him," said Warde, who wished that

Sackville could be vindicated. He said that he did not "like the prece-
dent of a man's fame being blasted without the opportunity of defend-
ing himself. His friends here complain vehemently of his barbarous
treatment, & make no doubt but he will convince mankind."[32] Sack-
ville was not vindicated. In 1760 a court-martial found him guilty and
unfit to serve king and country in any military capacity.

The passions aroused by the scandal, exemplified by the self-
righteous satirical print, focused the fury of those disheartened over
the recent string of strategic and tactical errors and outright incompe-
tence by England's leaders both in and out of uniform. Sackville's
court-martial was the last in a celebrated trio of trials during the Seven
Years War dealing with military behaviour that insulted the national
ego. In 1757 Admiral John Byng, who had lost a naval battle with the
French off Minorca in 1756, was court-martialled and executed for
criminal negligence.[33] General Mordaunt, who failed in the attack on
Rochefort, was brought before a court-martial but acquitted because
of his age in 1757. Sackville's cowardice was for many the last straw in
the sequence of incompetencies displayed by aristocratic military lead-
ers. Wolfe, who had achieved command through honest experience
and innate ability rather than hereditary right or purchase, had the
role of hero, with all its attendant exaggerations, conferred upon him
in some measure as a response to the sentiment which simultaneously
cast Sackville in the part of villain. Sackville, whether deserving of it
or not, served as a focus for the national rage that burst forth in an
environment of accumulated frustrations. Many English, unlike the
Wardes who were bound by friendship to both hero and villain, simul-
taneously vented their spleen by damning Sackville and flaunted their
joy by venerating Wolfe. "The irresolution and timidity, which ener-
vated our national strength," a newspaper writer explained, was with
Wolfe "revenged and replaced with victories, activity and courage."[34]
Or, as a poet wrote,

> Of Britain's glory envious, spread their lure,
> Bid Wolfe, "Be cautious – live at home secure:"
> Bid him, "Remember Britain's late disgrace;"
> ...
> In that blessed moment Britain's genius reared
> Her awful head, and brighter days appeared
>
> Again Britannia lifts her arm on high,
> Again the lightning flashes from her eye!

Once more her all-enlivening voice is heard,
Her arms are dreaded, and her fleets revered.[35]

One repercussion of Wolfe's popularity and the resulting incredible production and consumption of mostly simulated portraits was to saddle almost every significant late eighteenth-century English portraitist with authorship of a likeness of him. If we are to believe the claims of picture dealers and catalogue writers over the years, much of Wolfe's short life must have been spent in the studios of portraitists. He is supposed to have been painted by Joshua Reynolds,[36] Allan Ramsay,[37] Nathaniel Hone,[38] Thomas Hudson,[39] Thomas Gainsborough,[40] John Copley,[41] William Hogarth,[42] Johann Zoffany,[43] and David Martin.[44] None of the purported portraits were exhibited publicly as pictures of Wolfe in the eighteenth century.[45] Further, none of the putative likenesses look anything like Wolfe as he appears in the few life portraits. They were, however, passed down from generation to generation as authentic images of the hero and when from time to time they were sold, even if both parties in the transaction knew better the fiction of the sitter's identity was maintained.

An appreciation of the environment which stimulated the sale of so many images of Wolfe can be gained through consideration of the popular theatrical entertainment *A Lecture on Heads* by George Alexander Stevens. Stevens's innovative one-man show was first staged in 1764 and was thereafter performed regularly in London, in the provinces, and in North America, where it was produced in the last quarter of the century from Augusta to Halifax.[46] The performance consisted of the sequential exhibition of modelled stereotypical heads, some made of wood and some in papier mâché, with a running satirical commentary by the monologist.[47] The performer satirized such types as the cuckold, the Frenchman, the Cherokee chief, the laughing philosopher, the connoisseur, and the lady of the town. The immense popularity of this show reflected contemporary interest in the head as an embodiment of traits of race, culture, and character and the performance was well received by a people who had elevated a portraitist, Joshua Reynolds, to the pinnacle of social fame.

In Stevens's show one of the major scenes was the "Head of a British Hero." Stevens gave a long speech, in this case devoid of satire, on the typical English hero. Such a hero, naturally military, was ardently valourous in youth, "which ripened into the wisdom and cool intrepidity of the veteran." The hero entered military service "with the true principles of a soldier and a patriot, the love of fame and the love of

his country." He had an active and vigorous mind which meant that no military expedition was either too difficult or impossible. "Fortune seemed enamoured of his valour ... Though he cannot stretch out an arm without showing an honourable testimony of the dangers to which he was exposed, he has still a hand left to wield a sword for the service of his country." There is nothing too great to be expected of Stevens's hero: "he resembles the immortal WOLFE in his fire and fame."[48]

With this kind of popular lecture in the presence of a head which probably looked vaguely like Wolfe's as known through engravings, it is not surprising that passionate consumers were blinded to the truth of the adage *caveat emptor* in their rush to acquire an image of their hero. With portraits of heroes and martyrs it is not a matter of whether the image is a likeness but whether the audience believes it to be. Images of heroes and martyrs have a symbolic presence which transcends the mundane criteria applied to images of less godlike personages. The propensity to identify pictures of just about any unknown eighteenth-century military gentlemen as Wolfe, no matter how preposterous, is a habit still far from extinct.[49]

As well as acquiring images said to be of Wolfe from print sellers and possibly from famous painters, eighteenth-century patriots cherished pseudo-portraits of their idol even without attribution. Several of these anonymous images are recorded to have a provenance that included someone connected with the Battle of the Plains of Abraham. In effect they obtained their validity by having been touched by someone who had touched the subject. An example of such a transference of the power of the hero through images – akin to the present day autographed photograph of a sports, entertainment, or political hero – is a nineteenth-century report by an owner of two pictures said to be of Wolfe. The pictures, one an unfinished sketch showing Wolfe tying a handkerchief around his wounded wrist and the other showing him dying in the arms of a soldier, were, according to family tradition, painted immediately after Wolfe's death by one of his aides-de-camp or an officer. Verification of the "sacred" images was felt to be effectively settled by their being accompanied by "a portion of the sash said to have been worn by him at the time of his death, and saturated with his blood."[50]

One portrait, *General James Wolfe as a Boy*, painted by West in 1777 for George Warde, has never masqueraded as a life portrait.[51] The circumstances of its commissioning are preserved in a note dating from the period between 1822 and 1851 affixed to the back of the anonymous "life" portrait of Wolfe at Squerryes Court. It says that

Warde sent the Squerryes Court Wolfe, which he owned, to West in about 1775 so that he could use it as a source for a commissioned portrait of the young Wolfe. West's posthumous portrait of Wolfe was to serve as a companion to an earlier portrait of Warde himself by West. Warde, however, rejected West's picture and returned the painting to him as it showed someone quite unlike the Wolfe in the anonymous Squerryes picture. West apparently dug in his heels and sent his portrait of Wolfe back to Warde uncorrected, explaining, so the note says, that he regretted not having seen Warde's anonymous portrait of Wolfe before he had produced his *Death of General Wolfe* but as his grand history piece had been reproduced in a print it would be unfair to the engraver, and one can assume to West himself, to paint a portrait of Wolfe in which "no likeness could be traced to Wolfe as represented in the engraving."[52] West may have been disinclined to use the Squerryes portrait for another reason as he may have believed he had in his possession a more accurate depiction of the hero. In the catalogue of the sale of the contents of his studio in 1829 there was an item listed as "Portrait of Wolfe when a Boy, presented to West by the General's family, to assist him in forming the likeness of the hero as represented in the celebrated picture of the Death of General Wolfe. Said to be unique." There is no other information relating the catalogued portrait to the *Death of General Wolfe* and West seems to have obtained his knowledge of the physiognomy of the dying General from the abundant prints on the market or from Wilton's Monument. The portrait of the youthful Wolfe in West's estate cannot be identified with any existing true or false portrait of Wolfe.

The commissioned portrait of the young Wolfe by West shows a lad with a face that is in fact derived, at least in part, from the earlier anonymous portrait also in the possession of George Warde. The ambitious youth is seated at a table with the plan of the Battle of Blenheim unrolled before him while he holds in his right hand the plan of the fortifications of Bergen op Zoom. On the table behind him are three volumes, one entitled *History of England*. This book might represent the first of Tobias Smollett's multi-volume history, which, although unwritten when Wolfe was a boy, was to contain the story of Wolfe's heroic exploits. (West, Wolfe, and Smollett were connected in the nineteenth century through the use of the *Death of General Wolfe* in a modified form on the title page of the last volume of a new edition of Smollett's popular history.)

As one would expect of West, he did not let the opportunity pass to use the new image more than once. He painted a replica of *General*

James Wolfe as a Boy for Lord Grosvenor, the owner of the first *Death of General Wolfe*. Grosvenor and Warde would have wanted to have an image of Wolfe as a boy for they would have felt strongly that all the requisite characteristics of the hero, the mature General Wolfe, were to be seen in the boy. The belief that the genius of the man springs from seeds present in the youth was even stronger in eighteenth-century England than it is today.

12

Wolfe Now Detached and Bent on Bolder Deeds

The role of General James Wolfe as a symbolic presence in English and American life did not remain static. As political passions evolved in England and her trans-Atlantic colonies Wolfe was conjured up to provide spiritual generalship in situations that were well beyond his terrestrial imaginings. In the 1770s Wolfe as the heroic achiever was supplanted by his achievement, that singular spectacular illuminating moment where the meaning of his existence was clarified.

Many profited from the growing market for images of Wolfe's martyrdom. Benjamin West's enterprising reproduction of his painting in five replicas and the print of 1776, the publication of a reproduction of Edward Penny's *Death of General Wolfe*, the interest in Joseph Wilton's monument expressed through the highly popular competition for the epitaph are evidence of this demand. Pictures of Wolfe's death were exhibited by James Williams at the Free Society of Artists in 1774, by James Barry at the Royal Academy in 1776, and by Robert Henry Morland at the Free Society in 1782. (Morland's and Williams' pictures have disappeared.)

A death of Wolfe also thought at one time to be the work of James Williams has recently been reattributed to the American novelist and painter William Williams[1] (Fig. 12.1). William Williams knew the young West and had lent him books on painting by Jonathan Richardson and Charles Alphonse Du Fresnoy. He was a scene painter for the American Theatre Company in Philadelphia when it produced George Cockings, *Siege of Quebec* and later, while in England, was said to have sat for one of the figures in the boat in West's *Battle of La Hogue.*

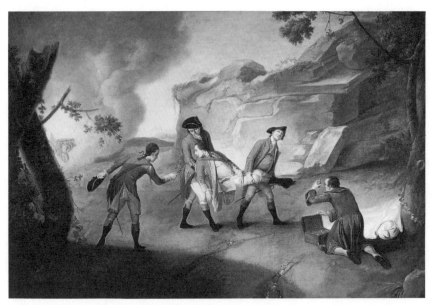

Fig. 12.1 Attributed to William Williams, *The Death of General Wolfe.*
Oil on canvas, c. 1777
(Department of Collections, Colonial Williamsburg, Inc., Williamsburg)

William Williams's painting of about 1777 does not deal with the crucial moment of Wolfe's last breath but shows the preceding, less glorious episode in the narrative when the almost lifeless General was carried to the rear of the British lines. A surgeon in civilian dress preparing to treat Wolfe has just opened his medical box. A soldier on the left offers a leafy branch, perhaps a symbolic laurel of victory, to the general.[2]

James Barry painted Wolfe in 1776. His picture began as a commission from the Duke of Richmond. The Irish-born artist probably received the order from Richmond to paint a picture of the death of his military colleague around the time West's painting was shown at the Royal Academy. Richmond may have been encouraged to engage Barry by his friend Edmund Burke, who had taken his countryman Barry on as a protegé.

A final sketch for the proposed death of Wolfe was sent to Richmond in 1772. He returned it to the artist, advising that work on the picture cease until a particular figure was changed. The temperamental and quarrelsome painter, who was "always unpleasing, harsh and repulsive,"[3] probably balked at modifying his sketch, which led to the termination of the commission. After an hiatus of three years the eccentric artist returned to the composition. When it was shown in

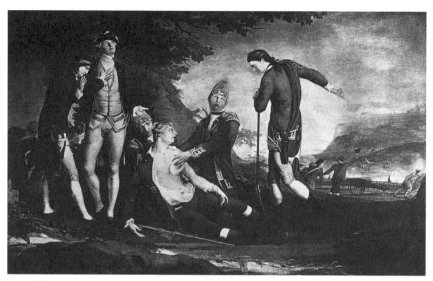

Fig. 12.2 James Barry, *The Death of General Wolfe.* Oil on canvas, 1776 (Webster Canadiana Collection, New Brunswick Museum, Saint John)

1776 Barry's *Death of General Wolfe* (Fig. 12.2) did not receive the kind of praise its author expected. It was "so unfavourably received by the public" that Barry "was much disgusted and never afterwards sent any performance to the exhibition."[4] One critic said that all the people in the picture looked too young[5] and Horace Walpole noted curtly in his catalogue of the exhibition that it was bad.[6] Another critic complained, "the position of General Wolfe's legs and thighs is meant, we suppose, to give us an idea of the pliancy of human limbs when life is at her lowest ebb; but Mr. Barry, to effect this, has bow'd them out in so awkward a manner, as must disgust the eye of every observer."[7]

The artistic flaws in Barry's work were balanced somewhat by his diligence in pursuit of bettering West's accuracy picturing the event. A critic commented on "the ingenious and pathetic Manner in which this heroic fact is painted," and noted that in spite of this "the Truth of History is not in the least departed from."[8] The artist had researched his subject well. In his notes he recorded what he had learned about the topography of the location of the battle:

Quebeck is composed of two towns, upper & lower, ye lower is washed by ye sea, ye upper is very high upon a rock –higher than ye plains of Abram about 7 1/2 miles from ye place [of] engagement – ye pursuit was given over at ye windmill about 3/4 of a mile from ye town – ye plains were ye engagement

was — is swampy and most wild & uncultivated & interspersed with spruce & pine – when Wolfe received his mortal wound he remained behind upon ye heights of ye plains of Abram as the troops were advancing down hill upon ye French.[9]

Barry got his information for his picture in interviews with Lieutenant Browne and others. From his sources he discovered that West had not kept to historical fact. Barry's diary entry for 1 November 1775 reads, "Mr. Adair the surgeon told me that he was not present at the Death of General Wolfe, that when he arrived he found him lying dead under a tree, where Mr. Browne related to him those memorable words with which Wolfe expires." Apparently as a result of this information, in Barry's composition surgeon Adair is absent from the group around Wolfe. Two Grenadiers support the dying general who is informed of victory by Lieutenant Browne, shown pointing to the British lines in the background. However the gestures of grief by the midshipman and naval officer on the left, the pose of Wolfe, the use of an elevated tricorn to signal victory, and the Indian on the ground in the foreground all point to the influence of West's painting.

Barry did not succeed in bettering his predecessor's essay on the subject. Historical accuracy unaccompanied by an adequate demonstration of talent in the grand historical style rendered the picture ineffectual. It was neither reproduced in a print nor shown to the public again in the artist's lifetime. After his death it disappeared until rediscovered in the present century when a historian attempted to remove the work from obscurity by writing that it "is much more worthy of commendation than West's production, yet it has been completely ignored and forgotten by artists and historians, while West's picture has enjoyed continual admiration for a hundred and fifty years."[10] As the person who wrote this was in the process of negotiating the purchase of the picture for its value as a historical illustration and not its aesthetic merit, he can be forgiven for overlooking the fact that its wooden figures and unsettling composition failed to capture the heroic pathos of the subject.

In completing and publicly exhibiting his painting Barry had a second and loftier motive than bettering his predecessor's treatment of the subject. In returning to work on the composition in the fall of 1775 he was almost certainly influenced by the wish to make an emphatic pictorial statement on his hopes for the outcome of the current violent dispute over liberty in North America. Unlike the expatriate American West, Barry was not circumspect in expressing his

opinions on matters of state. He unashamedly voiced a pro-American stance, reflecting the opinions of his patron, mentor, and fellow Irishman Burke, who in March 1775 spoke in Parliament on his hopes for conciliation with the American colonies. Barry's unorthodox opinions on the happenings in North America – opinions he would have expressed in distinctly un-Burkeian syntax – no doubt contributed to the public's disinterest in his *Death of General Wolfe.*

Current events at the time James Barry recommenced work on his picture would have confirmed in his mind the rightness of his support for the American cause. The Americans, to him, were not only pursuing an ideologically just crusade but, more importantly, they showed every sign of being successful. Their gains seemed to follow the pattern of the British successes late in the Seven Years War. They had captured Ticonderoga, Crown Point, St Johns, Fort Chambly (surrendered 18 Oct. 1775), Montreal (surrendered 12 November 1775), and, most symbolic of all, laid siege to Quebec in November of 1775. Barry undoubtedly believed that, as before, conquest of Quebec would ensure the rescue of the entire continent from subservience to a tyrannical overseas government.

At Quebec in December of 1775 the opposing sides were led and manned by veterans of the American campaign in the Seven Years War. Guy Carleton, governor of Quebec, had seen action at Louisbourg and then served as lieutenant-colonel under Wolfe. In his will Wolfe left Carleton one thousand pounds and all his books and papers, both in Canada and in England. The American commander, Richard Montgomery, had had a military career similar to his opponent's. He had participated in the siege of Louisbourg and served at Lake Champlain and Montreal. But, as the Reverend William Smith said, "little did he foresee the scenes which that land had still in reserve for him! Little did those generous Americans, who then stood by his side, think that they were assisting to subdue a country, which would one day be held up over us, as a greater scourge in the hands of friends, than ever it was in the hands of enemies."[11] At the end of the war Montgomery returned with his regiment to England where he sold out of the army and emigrated to America, settling down to the quiet life of a country gentleman. His retirement was terminated in 1775 when on the urging of his countrymen at the first provincial congress of New York he agreed reluctantly to take up the sword again. Montgomery's career in America was typical. Many of those who had most vigorously opposed the French became leaders in the struggle against England that began shortly after declaration of peace in 1763.

General Montgomery at Quebec, said Reverend Smith in a commemorative oration, "approached those plains which the blood of Wolfe hath consecrated to deathless fame." He "seemed emulous" of Wolfe's glory and was "animated with a kindred spirit."[12] That kindred spirit is evident in Montgomery's letter to Carleton demanding capitulation in which, as if he was conscious of emulating Wolfe in word as well as in deed, he blustered that the ramparts of the citadel were "in their nature incapable of defenses" and that they were manned by "a motley crew of sailors, the greatest part our friends ... citizens who wish to see us within their walls, and a few of the worst troops who ever styled themselves soldiers." He boasted that his own patriotically charged men were "accustomed to success," and so "so highly incensed" at British "inhumanity, illiberal abuse, and ungenerous means employed to prejudice them in the minds of Canadians," that it was only with difficulty that he could restrain them.[13]

Montgomery's demand for surrender had no effect. The well-supplied and professionally managed garrison held out successfully. Realizing that the only way to breech the walls was by surprise attack, Montgomery, whose own troops were in fact ill-supplied amateurs, led an assault on the Lower Town in a snowstorm on the evening of 31 December 1775. At a barricade on a road into the city the troops of the Continental Army were cut down and repulsed and Montgomery himself "received the fatal stroke, which in an instant released his great spirit, to follow and join the immortal spirit of Wolfe."[14] At dawn on New Years Day the British investigated the snow-covered lumps on the street in front of their barricade and discovered the frozen corpses of Montgomery and his unfortunate men.

It is not known whether news of Montgomery's death at Quebec arrived in England before or after Barry finished his painting. In any case he would have certainly seen the parallel between the ultimate virtuous behaviour of Montgomery and that of Wolfe and would undoubtedly have stressed the similarity of the two deaths if asked. His audience would have been small; the majority of Londoners equated Wolfe's bravery and military skill with that of Governor Carleton rather than Montgomery. A poem published in the *St. James's Chronicle* on 16 July 1776 illustrates this.

Dying, heroic Wolfe this conquest gain'd
Which Carleton living, sav'd and fame obtained;
Both great in council, glorious in the field,
What fruits their conduct and courage yield.[15]

Barry's verbal and pictorial backing of the American cause as well as his limited ability as a history painter did earn him recognition in some quarters. In 1782 the *Morning Herald* reported that he "had been invited by Congress to America, to paint the actions in the Revolution of General Washington. Mr. Laurens had the commission to engage those whom he thought fit, and viewed all the works of the great painters now in London, after which he fixed on Mr. Barry; who, it is said, has refused the offer."[16] Laurens, captured by the British off Newfoundland, had been imprisoned in the Tower and, after gaining his release through the petitioning of Burke and Franklin, spent the next year and half in London acting as an unofficial representative of the American Congress. It was probably Burke who recommended the sympathetic artist Barry to Laurens. When Barry refused the commission, it was given to an expatriate veteran of the Revolutionary War, John Trumbull.

The un-spectacular, even pathetic death of Montgomery was subsequently transformed by Trumbull in a fictional pictorial memorial of what his patriotic American audience considered a signal event in the history of their struggle for independence. In its undisguised dependence on the composition of West's *Death of General Wolfe* Trumbull's *Death of General Montgomery in the Attack on Quebec 31 December 1775* of 1786 (Yale University Art Gallery, New Haven, Connecticut, Trumbull Collection) served to confirm ideas of a parallel between the deaths of two heroic generals dedicated to the liberation of America from the tyrannies of the old world. In anticipation of a large market for the image, Trumbull had his work engraved in England (Fig. 12.3), but the image, which for the British was clearly a commemoration of disloyalty if not treason, not surprisingly sold very poorly. Its compositional similarity to an accepted national pictorial memorial to a genuine hero would have been particularly irksome to a public surrounded by visual reminders of the battles at Quebec. In 1776 Carleton's workmanlike defence of Wolfe's hard-won gift to the Empire was celebrated by a new thoroughfare in the city of London being called New Quebec Street. When the war of revolution or independence was over, and England with her Canadian colonies still held sway over a considerable part of the continent of North America, the object of Wolfe's victory and Carleton's defence was yet again memorialized through the building of the Quebec Chapel in 1787 by the wealthy Portman family.[17]

The parallel between the death of General Wolfe and that of General Montgomery was noted over and over again in contemporary

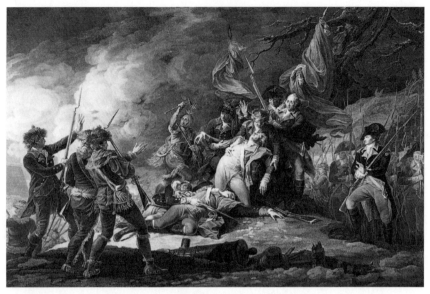

Fig. 12.3 John Trumbull, *The Death of General Montgomery*. Engraved by
Johan Frederick Clemens and published in 1798 by A.C. de Poggi in London
(Webster Canadiana Collection, New Brunswick Museum, Saint John)

writing. The meanings to be found in the two deaths varied, of course,
depending on the politics of the writer. The loyalist Thomas Anburey,
on seeing the remains of Montgomery's camp on the Plains of Abra-
ham, "could not help contrasting those who have so lately abandoned
that place with the possessors of it when the brave Wolfe fell!" He
found it impossible "to suppress a sigh" for General Wolfe who,
although young, "had acquired the esteem and admiration of all man-
kind." Wolfe "in the very arms of death ... added glory and conquest
to the British Empire." Anburey uttered a fainter sigh for Montgomery
who, even if an enemy, was an officer of some merit "possessed [of]
all the fire of military ardour ... [who] rushed with impatience in the
front of every danger, and ... fell a sacrifice to mistaken principles,
unnatural rebellion, and the ambitious views of a few designing men.
His courage and death would have done honour to a better cause."[18]

For writers who supported the revolutionary cause in America, the
similar deaths of Montgomery and Wolfe at Quebec were connected
by more than arbitrary fate. The significance, meaning, and purpose
of Montgomery's heroic demise was illuminated through reference to
its prototype, the death of Wolfe. For example the American poet John
Trumbull wrote:

Ye plains, renown'd by many a hero's tomb,
 Whence Wolf's [sic] immortal spirit took its flight,
A soul as brave, with like relentless doom,
 Stepped to the attack and tempts the embattled height!
Ah, stay, Montgomery! In the frowning wall
 Grim Death lies ambush'd![19]

To the propagandists of the revolution, Wolfe and Montgomery died in similar circumstances, fighting for identical causes. A memorial verse to Montgomery ran:

When Cato fell, Rome mourn'd the fatal blow
Wolfe's death bid streams of British tears to flow.
Why, then, should freemen stop the friendly tear,
Or ever blush to weep for one so dear.[20]

Americans were well prepared to see the martyrs of their revolution as emulators of the brave Wolfe. Following the first rash of literary memorials in the colonies, Wolfe's virtue in victory was repeatedly lauded in print. For example, in 1770 William Livingston in *America*, a poem "addressed to the friends of freedom and their country," concluded the tale of Quebec and Wolfe with, "May this blest land with grateful praise adore / Such boundless goodness, and such boundless power."[21] Colonial adoration of the hero of Quebec also motivated the editor of the *Virginia Gazette* to fill the first two pages of the New Years Day edition of 1773 with a reprint of an obituary of Wolfe from the November 1759 issue of the *London Magazine* and several long epitaphs from the British press. There was a passionate readership for lines such as,

O matchless Chief! still shall thy praise be told,
Wise in the council, in the battle bold.
Applauding Senates reverence thy name,
Raise this grav'd marble to thy deathless fame;

Virginians were exhorted, as were their English cousins, to "see how, on Abram's heights, the warrior stood," and consider the wisdom, valour, and discipline of his troops – their "little band well order'd ranks display." One of the poems spoke of Wolfe's fame as eternal: "Ages unborn thy merits shall proclaim, / And not ev'n nature's wreck shall bound thy fame."

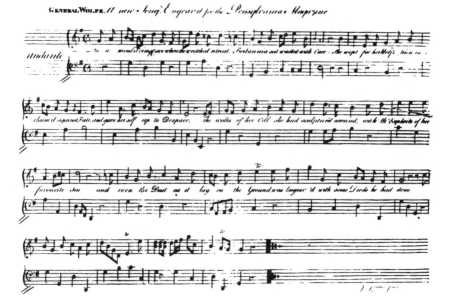

Fig. 12.4 Thomas Paine, *In a Mouldering Cave.*
From *The Pennsylvania Magazine*, March 1775
(Webster Canadiana Collection, New Brunswick Museum, Saint John)

The English immigrant Thomas Paine chose as one of the first dem-
onstrations of his poetic talent to the diminutive yet ambitious Phila-
delphia literary circle a work on the death of Wolfe (Fig. 12.4). He
included his allegorical verse set to music in the March 1775 issue of
the *Pennsylvania Magazine* of which he was editor. It was perfectly in
tune with the taste of his audience. The sentiment of the poem is so
close to the slightly earlier medley of epitaphs in England that it has
been supposed by some that Paine wrote his verses for presentation to
his friends at a social club at the White Hart in Lewes prior to his
departure for America in 1774.[22]

Paine's poem on the death of Wolfe became popular on both sides
of the Atlantic. It reiterated for the loyal English or independence-
minded American alike the fact that the death of Wolfe had set the
course of history and that if this path was to remain uninterrupted
many of their number would have to emulate the martyr of Quebec.
The poem was published in London as the song "On the Death of
General Wolfe." Set to a different tune than the American version, it
was marketed with the blurb "as sung at the Anacreontic Society by

Mr. Sedgwick."[23] The song was reprinted on a broadside published in Edinburgh, perhaps in about 1780,[24] and was included in the book *A Garland of New Songs* of about the same date.[25] It was reprinted in the United States in 1786 and 1788 and frequently thereafter.[26]

Paine's poem is, like so many of its predecessors in the genre, intended less as a verbal picture than as a rhetorical text wrapped in poetic diction. Paul Fussell has written that "for all the eighteenth-century chatter about Horace's *ut pictura poesis*," the sister art of poetry was not painting, nor was poetry close to meditation. The closest relative of poetry was public speaking. In support of this contention, Fussell cited George Campbell's *The Philosophy of Rhetoric* (1776) in which the author stated unequivocally that, "poetry indeed is properly no other than a particular mode or form of certain branches of oratory." The two are similar, said Campbell, because they both depend on the medium of language and use the same rules of composition, description, and argumentation and "the same tropes and figures, either for beautifying or invigorating the diction."[27]

Paine's poem or musical oration was not the first rhetorical text he had written on Wolfe for his American audience. In *The Pennsylvania Journal and Weekly Advertiser* of 4 January 1775 he published *A Dialogue between General Wolfe and General Gage, in a wood near Boston*. Gage, like Wolfe, had apprenticed in the art of modern warfare under the Duke of Cumberland in Scotland. In America he served in Braddock's disastrous expedition to Fort Duquesne in 1755 and under Amherst at Montreal. He replaced Amherst as commander-in-chief of the British forces in America in 1763 and from 1774 was governor of the Massachusetts Bay colony, where he displayed a style in dealing with the restive Americans that was only slightly more humane than that he had learned in the suppression of insurrection in Scotland. Gage's administration in America earned him a reputation among revolutionary colonials that was diametrically opposed to that of General Wolfe.

In Paine's dialogue the shade of Wolfe announces that he has been sent back to earth by a group of British heroes to convince Gage that his mission in America, to deprive his fellow subjects of their liberty, is "a business unworthy [of] a British soldier, and a freeman." Gage replies that he is following the orders of his Sovereign "sanctified by the Parliament," an august assembly in which is collected "all the wisdom and liberty of the whole empire." General Wolfe, who seems on the evidence of his post-mortem conversation to have been wiser in death than in life, informs Gage that assemblies are subject to error. "The greatest ravages which have ever been committed upon the liberty

and happiness of mankind have been by weak and corrupted republics … The American colonials," Wolfe says magnanimously, "are entitled to all the privileges of British subjects." According to Gage the inhabitants of Massachusetts had thrown off any allegiance to the crown, refused to obey his proclamations and, against his orders, had armed themselves and begun military training. Paine's proto-republican Wolfe observes that the inhabitants of Massachusetts have been disaffected by the mistakes of royal ministers, which have even upset the heroes in Elysium. "It was once the glory of Englishmen," he tells Gage, "to draw the sword only in defence of liberty and the protestant religion, or to extend the blessings of both to their unhappy neighbours. These godlike motives reconciled me to all the hardships of the campaign which ended in the reduction of Canada." The dead Wolfe, touched with amnesia on the matter of his treatment of British troops at Quebec, continues, "British soldiers are not machines, to be animated only with the voice of the Minister of State." They "disdain those ideas of submission which precluded them from the liberty of thinking for themselves, and degrade them to an equality with a war horse, or an elephant." Wolfe exhorts General Gage to resign his commission if he values "the sweets of peace and liberty," if he has regard for "the glory of the British name" and if he prefers "the society of Grecian, Roman and British heroes in the world of spirits."

Paine's use of Wolfe's ghost as his alter ego failed to convince General Gage to desist from his misguided and evil course. Gage soon found his troops fired on at Concord and routed at Lexington, and later, even with reinforcements commanded by General William Howe, staunchly resisted at Bunker Hill. In August of 1775 the invasion of Canada under Philip Schuyler, Richard Montgomery, and Benedict Arnold had begun and in October a disheartened Gage resigned his governorship and returned to England. His successor, General Richard Howe, was, so a loyalist wrote, "a man almost adored by the army and one that with the spirit of a Wolfe possesses the genius of a Marlborough."[28] According to an American patriot poet, Howe, who had commanded an advance unit in Wolfe's assault on the Plains of Abraham at Quebec, was also visited by the ghost of Wolfe. Wolfe was depicted as having been sent from Olympus by Jupiter to convince Howe not to fight the American rebels.[29] But, as with Gage, Wolfe's ghost was not persuasive enough.

On May Day 1776 the Philadelphia Society of the Sons of Saint Tammany toasted "the pious and immortal memory of General Wolfe" immediately before honouring radical revolutionaries.[30] Philadelphians

had clarified their feelings toward Wolfe after a mid-February 1773 lavish production by Louis Hallam's American Company of George Cockings's play on the siege of Quebec during which some patriots in the audience, unprepared to accept Wolfe as a truly American hero, jeered the players for being Loyalists.[31] One can understand the confusion in the audience, for the hero saluted by the Sons of Saint Tammany would also animate the Loyalists. Cockings's play was staged in the British garrison in New York on 4 October 1783 on the eve of their evacuation. One can imagine the desperate zeal that permeated the performance by the soldiers of "'A Tragedy, called the Siege of Quebec. The Conquest of Canada, or the Death of General Wolfe,' with the original prologue, by a Gentleman of the Army. Characters by Gentlemen of the Army."[32] The play would later have given solace and inspiration to those in Quebec who had remained loyal to the crown. In this case the audience and the actors would have understood the text quite differently for it was the American Company troop of Allen, Bentley, and Moore who on 19 October 1786, presented the play to the inhabitants of the city where not only Wolfe had fallen but, more recently, Montgomery's siege had terminated with his death.[33]

The influence of the memory of Wolfe on politics of the time is indicated by a poem published in London in 1766 on the repeal of the Stamp Act which the Boston author said rendered Wolfe's success "a short-liv'd triumph," and lamented Wolfe's "unfortunate death in victory."[34] Without Wolfe's victory and sacrifice the Americans might well have found it more difficult to revolt against any measures, tax or otherwise, needed by England to protect her American colonies, even though these might have infringed upon their liberty as they perceived it. The validity of this supposition is supported by Thomas Hutchinson, governor of Massachusetts, who wrote "there were men in each of the principal colonies who had independence in view before any of those taxes were laid or proposed ... their design of independence began soon after the reduction of Canada."[35]

The spirit of Wolfe was conjured up among the American revolutionaries not only as a referee but also as a standard to spur his successors in the struggle for liberty to reach for the loftiest level of virtuous selflessness. At the Princeton commencement on 25 September 1771 the young Hugh Henry Brackenridge recited a poem he had written with his colleague Philip Freneau entitled "The Rising Glory of America." The poetic paean to the fulfilment of the destiny of America included praise of the Indians who had fought earlier with the English and the hero of America, General Wolfe. They suggested

that the rising glory of America had taken a giant leap forward with
the defeat of the French.

> Here, those brave chiefs, who, lavished their blood,
> Fought in Britannia's cause, in battle fell! –
> What heart but mourns the untimely fate of Wolfe,
> Who, dying, conquer'd – or what breast but beats
> To share a fate like his, and die like him.

For Brackenridge and Freneau, America's continued rise and glory
required more sacrifices like that of Wolfe. But fortunately not all
heroes were dead. There were individuals of virtue amongst the colo-
nials and these people should be praised.

> But why alone commemorate the dead,
> And pass these glorious heroes by, who yet
> Breath the same air, and see the light with us?[36]

The resurrection of Wolfe as a mouthpiece for political wisdom or
ideological propaganda reached a new high in the book *Dialogues in
the Shades, between General Wolfe, General Montgomery, David Hume, George
Grenville and Charles Townshend*, published in London in 1777. In this
text, which has been attributed incorrectly by some to Hume himself,
Wolfe is again shown to have acquired considerable acumen in politi-
cal and philosophical matters in his eighteen years in Elysium. In the
first dialogue the novice shade of General Montgomery asks his
mature predecessor why he has treated him so coolly since his arrival
in the other world. The ghost of Wolfe, in a burst of spiritual profun-
dity, replies that his feelings toward Montgomery are not based on his
understanding of valour but of cause. The shade of Montgomery
points out that the cause for which Wolfe fought and died was only
some insignificant French breaches of ancient treaties. Wolfe counters
that he was a champion of his country against its natural and inveter-
ate enemy while Montgomery was a leader of seditious men who were
morally bound to England by filial duty. Montgomery defends his posi-
tion by saying that filial duty and alliance are based on mutual advan-
tage and when such ceases to exist the people may withdraw their
delegation of power. It is only because Britain instituted liberty in the
American colonies, says Wolfe, that Montgomery can even talk this
way. Montgomery asks Wolfe if his troops would have fought as valor-
ously if they had been harangued before the battle with a speech such

as, "Here, my friends, we are to support, at the hazard of our lives, some interest of commerce and the glory of our arms against men who have the very same reasons to fight against us, and who upon the whole, are neither better nor worse than ourselves. Believe not the absurdities related in regard to the persons, sentiments, and design of the French, but attack them, spurred only by honour and patriotic jealousy of fame?"[37] The debate between the recently deceased American general and Wolfe ends in an impasse, Wolfe claiming that he died not for glory but for benevolence and Montgomery asserting that his cause was justice for the enslaved.

The ethical standoff between the two shades is resolved by the spirit of Hume, who interrupts to suggest that both generals "mistook passionate prepossessions for equitable sentiments," and that accordingly they are "punished only by the continuation of [their] blindness." War, according to Hume, operates under the standard of envy and avarice for the economic success of other nations. Mankind's natural horror of blood should lead to the substitution of peaceful commerce for "reciprocal rapines and murder."[38] This leaves an opening for Montgomery to claim that there should be no arbitrary taxes and that the fruits of labour should be reaped by the labourers. Hume agrees, but Wolfe asks whether, if such a system were opposed by men filled with malice, it would not then be justified? Hume allows that Wolfe is right. He cautions that one should beware of councils of the ambitious and those with vested interest. Wolfe observes that generals, not usually part of such councils, can claim innocence in war. To Hume this argument is correct only so long as the generals remain ignorant and hence do not knowingly fight for fraud, slaughter, desolation, and treasure. George Grenville joins the debate, proposing that in the civilized world submission to and the exercise of authority is necessary: "From the time they preferred the amiable tie of society to their savage freedom," people have "submitted to the yoke of subordination, without which there can be neither liberty nor safety."[39]

Charles Townshend M.P. appears on the scene. The younger brother of Wolfe's brigadier-general George Townshend, he was first an opponent and then supporter of colonial taxation through the Stamp Act. Montgomery damns him for gilding "the bitter pill" and defends the American cause as it "impossible to reconcile passive obedience with freedom, as infamy with honour." Townshend says things would have been different if the French had not been conquered. Wolfe, obviously pleased, interjects, "You will soon find among you that I have been instrumental to this odious war."[40]

American poets were soon to be supplied a dead hero whose hero-
ism could be emphasized by comparison to Wolfe. The Boston poet
John Trumbull's "The Genius of America; an ode," composed in 1777,
tells of Montgomery's attack on Quebec, where "Toil, famine, danger,
bar their course in vain / To proud Quebec's high walls, and Abra-
ham's hapless plain." On the plain outside Quebec where Wolfe's
"spirit took its flight," Montgomery, who was no less courageous than
Wolfe, pushed his siege against the city and tempted fate.[41]

The ghost of General Wolfe is one of the major characters in Hugh
Henry Brackenridge's play *The Death of General Montgomery in Storming
the City of Quebec,* published in Providence and Philadelphia in 1777.
The drama is typical of the kind of republican propaganda produced
during the revolution. Brackenridge sacrificed any claims to literary
standards in order to demonstrate to even the most dullwitted Amer-
ican yeoman the contrast between the blackhearted English and the
righteous Americans. The play commences on "Those plains where
mighty Wolfe in triumph bled" and where "Thy sons, America, with
cheerful heart, / In all her conflicts took a willing part." But the
circumstances of the latest loss of blood at Quebec are different. In
Wolfe's time "For Britain's glory, flow'd the purple vein / Warm from
the heart to prop a Brunswick's reign." But now says Brackenridge,
"How changed the scene! no more with friendly hand / To aid thy
power, we leave our native land." At the end of the play, when Mont-
gomery has been slain, the ghost of Wolfe appears to ruminate on the
meaning of this latest heroic death before the walls of Quebec.

> From realms celestial and sweet-fields of light;
> I come once more to visit this sad spot,
> New-ting'd and red'ning with a hero's blood;

Wolfe states that Montgomery had his life cut short not in contest with
France but rather with cruel Britain, led by a "False – council'd king
and venal Parliament!." He asks rhetorically whether he lost his own
life so that Britain could enact laws denying liberty to her American
citizens and continues;

> Have I then taught, and was my life-blood shed,
> To lay foundation for such dire event,
> That you my friends should bleed alas! today,
> In opposition to the unrighteous aim
> Of British power by my achievement, rais'd?

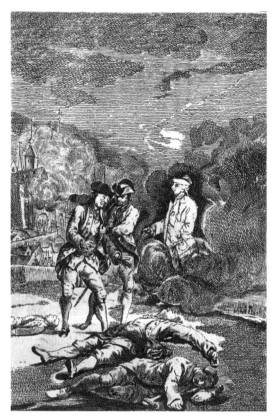

Fig. 12.5 *The Death of General Montgomery*. Engraved by John Norman
for Hugh Henry Brackenridge's *The Death of General Montgomery in Storming the
City of Quebec*, Philadelphia, 1777 (American Antiquarian Society)

Wolfe concludes that Montgomery's death will help America gain an
empire, independence from the "step-dame," "self-balanced power,
each province independent yet reigned in by one great council," and
this new empire "will yield golden commerce and literature."[42]

The edition of Brackenridge's play published in Philadelphia con-
tained a frontispiece (Fig. 12.5). The image was explained in a long
note which has the same function as the key published to accompany
the engraving of West's *Death of General Wolfe* and was probably written
by someone familiar with that key. Montgomery is shown "stretched at
full length, in the casual manner in which one slain in battle may be
supposed to have fallen," and nearby are the bodies of Macpherson
and Captain Cheeseman. Major Burr, Montgomery's aide-de-camp, is
seen addressing his fallen comrades "in the language of funeral
eulogium." To Burr's left is Colonel Campbell, who is pointing to the

city and imploring Burr to move away from danger. The ghost of Wolfe is shown half enveloped in cloud with "his left hand on the wound he received in his breast, and his right hand the wrist of which appears to be bound up, addressed to Major Burr, while he laments with him the tragic scene before them, but foretells the happy resentment and opposition to the British tyranny which it will naturally produce in the minds of the Americans." The prescient Wolfe, according to the text, "anticipates the pleasing view of certain overthrow of the British arms, and the final glory of an Independent Empire in America."[43]

The Yale-educated poet Timothy Dwight wrote a patriotic epic with a powerful section on the first hero of the protracted struggle to rid the continent of tyranny. In his work *America or a Poem on the Settlement of the British Colonies Addressed to the Friends of Freedom, and their Country*, published in New Haven in 1780, he painted the French as dupes of their priests, "clothed in Virtue's garb," who spread destruction by inciting the Indians. To stop the "pious fury," which "heaped the fields with dead ... E'en Heaven itself approv'd a war so just" against the Gallic tyrant. The devastation of the continent, however, went unchecked "'Till Wolfe, appear'd and led his freedom bands / Like a dark tempest to yon Gallic lands." The British then, "rushed fearless on and swept their foes away." For Dwight the new empire, this "blest land" which arose thanks to Wolfe's humbling of the haughty Gaul, should remember the hero and "with grateful praise adore / Such boundless goodness, and such boundless power."[44]

A revealing transformation of the British hero into a proto-hero of the American revolution occurred in the work of the poet and medical doctor Benjamin Young Prime. In 1762 Prime visited England, where he published a collection of his poems, *The Patriot Muse, or Poems on Some of the Principle Events of the Late War* (London 1764). Among his verses celebrating the end of French power in America was a Pindaric ode on the victory at Quebec, "Britain's Glory or Gallic Pride Humbled." The sentiments expressed in this poem and indeed in all the poems in *The Patriot Muse* were identical with those held by many in England. Following the passage of time and a revolution in his political thinking, Prime was inspired to rework his highblown praise of the righteousness of the British cause as exemplified by the life and death of Wolfe. In 1791 he published privately in New York *Columbia's Glory or British Pride Humbled; A Poem on the American Revolution*. Part of this work was a parody of his earlier work "Britain's Glory." Wolfe was replaced by another hero, one of whom fortune did not require the ultimate sacrifice in battle.

O Washington, thou dear illustrious chief,
Thou ornament and blessing to mankind,
The soldier's glory and thy country's pride.

The Christian, patriot, hero or the man,
Devout and humble, affable, sincere,
Religion's friend, to vice alone a foe,
Kindly susceptive of another's woe.[45]

Wolfe's ghost might have approved of Washington replacing him in Prime's poem. According to some he looked fondly on the American general. A patriotic American camp song, sung to the tune of "The British Grenadiers" included the lines "And Wolfe 'mid hosts of heroes, superior bending down, / Cry out with transport, 'Well done brave Washington.'"[46]

In the poetics and rhetoric of the American revolution Wolfe's spirit was generally summoned forth not so much as a shade of an identifiable individual, a person with a significant biography, but rather as one who had a single claim to fame – an exemplary death. For many Wolfe's death was the crucial fact of his existence. In his oration to the Continental Congress in memory of General Montgomery the Reverend William Smith distinguished between adoration and emulation. For Christians and pagans, he said, eulogy was intended to inspire the living to imitate the dead, not to worship or deify the deceased. It was the deed and not the doer of the deed that held precedence. As the act of imitating was easier than the act of being instructed, he considered that "eminent characters" had "a stronger influence than written precepts" over human behaviour.

Despite his adoption in America, Wolfe's preeminence in England in the pantheon of modern heroes was not challenged. As the Americans saw Montgomery as an emulator of Wolfe, so the British saw their heroes as followers in his footsteps. For example, according to the poet William Cowper Lord Chatham was not immune to the influence of the prototypical death of Wolfe. In the poem "The Task" (1785) Cowper equated the deaths of Chatham and Wolfe.

They have fallen
Each in his field of glory; one in arms,
And one in council – Wolfe upon the lap
Of smiling victory that moment won,
And Chatham heart-sick of his country's shame!

They made us many soldiers. Chatham, still
Consulting England's happiness at home,
Secured it by an unforgiving frown,
If any wronged her. Wolfe, where'er he fought,
Put so much of heart into his act,
That his example had a magnet's force,
And all were swift to follow, who all loved.

As Wolfe had died in the British annexation of Canada so Chatham, the genius who had orchestrated the conquest of Canada, had died in his struggle as first minister to keep all of British North America loyal to the crown. Both martyrs were, to Cowper, irreproachable patriots whose deaths warranted juxtaposition as both were the result of passionate interest in Britain's transatlantic colonies.

During debate on the second reading of the American Prohibitory Bill in December of 1777, Chatham, who proposed dealing with the Americans through conciliation not capitulation, was opposed vehemently by the Duke of Richmond. Richmond called for the withdrawal of troops from America and the recognition of the United States as a new nation. It was Richmond's belief that the resistance of the colonists was "neither treason nor rebellion but ... perfectly justifiable in every possible political and moral sense."[47] Richmond's radicalism precipitated an apoplectic seizure in Chatham that led to his death a few days later. Cowper's parallel between the death of Wolfe and the death of Chatham was particularly powerful for those who knew that the Duke of Richmond, whose "traitorous" opposition had led to the first minister's death, had been a friend of General Wolfe and an active champion of the preservation of his memory. Cowper recorded his feelings toward contemporary events and their historical precedents in a letter he wrote in 1782. He said "suppose not however that I am perfectly an unconcerned spectator, or that I take no interest at all in the affairs of my country. Far from it – I read the News – I see that things go wrong in every quarter ... But nothing could express my rapture when Wolfe made the conquest of Quebec. I am not therefore I suppose destitute of true Patriotism."[48] Cowper's passage on Wolfe and Chatham in *The Task* ends in a melancholic observation on the state of a nation which becomes mired in yesterday's glories and gives birth to no new heroes. The lights of history, Wolfe and Chatham, are no more.

Those suns are set. O rise some other such!
Or all that we have left is empty talk
Of old achievements, and despair of new.

The importance of General Wolfe's achievement, the influence his death had had on patriots on both sides of the Atlantic, its service as a model for emulation broadcast through books, newspapers, prints, paintings, and assorted other consumer goods depended on a mass market which in turn was part of an economic system protected and expanded by his sacrifice. According to some writers, in defending and promoting liberty Wolfe had bequeathed to the world economic prosperity, for such was the natural consequence of breaking the shackles of tyranny. Not all would agree with this. There continued to be some in England who did not see Wolfe's triumph as having produced financial reward. They thought that if indeed he had made America fertile ground for the seed of revolution, then his martyrdom had led only to an unwanted drain on the treasury.

Many of those living in the transatlantic colonies saw the economic gains from Wolfe's victory quite differently. Quebec resident Thomas Cary, in his poem *Abram's Plains* published in 1789, treated General Wolfe, now three decades in the grave, as a symbol for the propriety of the British system of commerce. The poem is a topographical encomium on the economic importance of the St Lawrence watershed from Quebec to Gaspé. According to Cary the future for trade and resource extraction in Canada was great. It was Wolfe who wrested the rich territory from the French and in doing so demonstrated the superiority of the English not just in military matters but in commerce. Because English mercantilism was necessarily right, proper, and justly rewarding, Cary concluded that the French should accept the blessing of defeat, accept British magnanimity, and by abandoning their culture and language reap the benefits of the new commercial order.

Although what Cary made of the death of Wolfe and the conquest of Quebec was coloured by his own ambitions as a budding Quebec entrepreneur, his narrative of the events of 1759 was traditional. He told the old story well, perhaps reminded of the event by witnessing the first re-enactment of the battle presented for the visiting Prince William Henry on 29 August 1787.[49] Cary wrote;

When up the heights, great Wolfe his veterans led,
Panting, the level lawn they dauntless tread:
As bold they rise the broad battalion forms,
The gained ascent, for fight, their bosom warms;

Then with "ardour glowing" Wolfe draws his "hostile sword" and leads his troops in "inspiring cheers ... The battle rages, bullets, charged

with fate, / The hungry soil, with human victims, sate." In the struggle, "Too sure, alas! the leaden vengeance flies, / And on the chief its force repeated tries." Wolfe hides "the purple flood," his courage "kindling with the loss of blood." As the ebb of the General's life is slowed he hears the shout of victory, then dies content. "Whilst death exulting triumphs o'er his clay, / His name fame echoes through the realms of day.[50]

It was not only the loyal subjects of the British crown who saw in Wolfe's death a symbol of the necessary prerequisites for the commercial growth of the continent. The new United States, free from the strictures of imperial control, would enjoy unbounded growth as its inhabitants could turn to peaceful harvest of the bounties of the limitless land. The death of Wolfe stood for the end of the French and Indian despoliation of the efforts of frontier entrepreneurs. To him were owed thanks for removing the first barriers to continental economic growth.

The poet Joel Barlow in *The Vision of Columbus*, published in America and England in 1787, sang of the history of America from which was born a new nation bursting with energy, free to develop an unfettered commerce. In his poem, which he began writing in 1778, he put forth the theory, shared by many of his countrymen, that the wealth expected to accrue to the United States would create an environment for the limitless growth of culture. The flowering of the arts in America would be spectacular. History had created the present and set the direction for the commercial and cultural maturation of the new nation. Columbus's vision for America would become a reality, and that reality depended in part upon the magnificent historical event which had transpired in 1759. Barlow's presentation of Wolfe at Quebec is novel only in the use of the spiritual guide Columbus.

> While, calm and silent, where the ranks retire,
> He [Columbus] saw brave Wolfe, in pride of youth expire.
> So the pale moon, when morning beams arise,
> Veils her lone visage in her midway skies,
> Required no more to drive the shades away,
> Nor waits to view glories of the day.[51]

Barlow revised his epic and republished it as the *The Columbiad* in 1807. In the final version he expanded the narrative of the conquest of Canada. Following his vision of the raising of Acadia by Amherst and Wolfe, he described the siege of Quebec.

Wolfe, now detacht and bent on bolder deeds,
A sail-born host up sea-like Laurence leads,
Stems the long lessening tide, till Abraham's height
And famed Quebec rise frowning into sight,
Swift bounding on the bank, the foe they claim,
Climb the tall mountain, like a rolling flame,
Push wide their wings high bannering bright the air
And move to fight, as comets cope in war.
The smoke falls folding thro the downward sky
And shrouds the mountain from the patriarch's eye.[52]

Barlow's picture of the events at Quebec, although superior in quality to many of its predecessors, portrays what had become common in the telling of the tale. What Barlow added to the subject was a new context: Wolfe's victory and death were now a stunning moment in the moral-nationalistic-progressive chronicle of America in which one could see preordained commercial and cultural prosperity. It was this commercial and cultural prosperity that nourished the poets and artists of the nation, who in turn celebrated in their works the death of General Wolfe.

How post-revolutionary America saw the martyrdom of Wolfe is indicated by William Dunlap. The death of Wolfe, he said, was one of the most appropriate subjects for a history painting because it was "one of those events which has produced incalculable good to the human race." It was no exaggeration to state that the benefits enjoyed by America in his day could be ascribed to Wolfe's victory at Quebec. Wolfe and his troops had rendered to America, said Dunlap, "the blessings we enjoy under our unparalleled constitution, the effects of example upon the existing civilized world, and upon millions on millions yet unborn." He explained his claim:

It may appear, at first sight, wild to attribute such mighty consequences to a battle gained in Canada by a few English over a few French soldiers; but when we recollect that the power of France, under a despotic government, had been exerted successfully to extend her armies and her fortresses, from Hudson's Bay and the St. Lawrence to the Mississippi and the Gulf of Mexico; that an enslaving and soul-debasing government was extending, link after link, a chain made stronger day after day with systematic perseverance and admirable skill, and was inclosing, as in a net of steel, all the descendants of the English republicans who has sought refuge on the shores of this continent; a net which would have made all this fair territory a province of a

despotic monarchy instead of what it is now is – the greatest republic the world ever saw.[53]

What Dunlap saw in the death of General Wolfe was invisible to the English audience. There, in images such as West's, the public saw symbols of the inherent justness of the English cause and the inevitability of their control over all of North America. As Wolfe had succeeded in terminating French tyranny, so also would the British triumph over the tyranny of the ungrateful independence-minded colonials. It was this interpretation of Wolfe's political role, one that fed and in turn was nourished by West's image of his death, that led James "Athenian" Stuart to create a "design for a medal in honour of General Wolfe." The design was exhibited at the Society of Artists in the spring of 1775, fifteen years after one might have expected it to appear but only a few months after the skirmish at Lexington. Wolfe, who exemplified the highest form of civic duty, had sacrificed himself, as had the entire nation, to free the American colonials – who now were rejecting the very ideals for which the hero had died.

When the struggle against the revolution in America ended, the symbol of Wolfe was held aloft to protect the nation from renewed threats of French tyranny – first the tyranny of revolutionary anarchy and then the tyranny of Napoleon. To transform Wolfe into a guiding light in purely European disputes one only had to modify his part in the national drama by de-emphasizing the geographical context of his martyrdom. Far from being expunged from the national historical consciousness after the end of hostilities in America, Wolfe continued to thrive as a symbol of unending British military superiority over the French and as a paragon of selflessness.

William B. de Krifft's composition *Siege of Quebec. A Sonata for the Harpsichord or Pianoforte with Accompaniments for a Violin, Violincello and Tympano ad Libitum,* published by J. Bland in London about 1791, played to English national sentiment. The sonata, begun by Franz Kotzwara, the composer of the popular *Battle of Prague* and completed after his untimely death in 1791 due to overdone asphyxia erotica or breathless love in a bordello, starts with the song "How Stands the Glass Around." According to legend this ditty was composed by Wolfe and sung by him the night before the final assault on Quebec. Modern assailants of Wolfe myths have shown that the origin of the song predates the general's short life.[54] It is, however, in keeping with Wolfe's character to suppose that he might have delighted in singing such a jaunty song while preparing for victory and possible death. One verse of the song runs:

Behold this sword of mine
Which has stood many a cut, my boys,
Behold this sword of mine,
So boys don't decline;
But boldly clear your way, my boys
So let the armies join,
And break the enemy's line;
But before you go to fight, my boys,
Drink of your wine.[55]

The sonata proceeds with a slow march of trumpets and drums giving the signal for attack. The soldiers are then uplifted by the patriotic song from Purcell's *Bonduca*. The attack is sounded. Canon boom. Running fire is heard. The composition resonates with the ascending of the heavy artillery up the rocks followed by a cannonade. Amidst fighting with swords more canon boom. The wounded are lamented. A party of the enemy retire with the sound of heavy cannonade. Another skirmish is followed by the capitulation in *andante moderato*. An *allegro* movement leads to an *adagio* lamentation of Wolfe and his fallen men. A march of victory and general rejoicing in *allegro molto* conclude Krifft's musical picture of Wolfe's success at Quebec.

The immanence of Wolfe's ghost in the British conscience in the 1790s is exemplified by the publication of an ambitious and interminable epic poem, well over 300 pages in length, by the Irishman Henry Murphy. Murphy dedicated *The Conquest of Quebec* to the retired Lord Lieutenant of Ireland, George Townshend, whom he refers to throughout as "godlike Townshend." The narrative combines a love story of two Indians, a history of the New World, and the story of Wolfe at Quebec, where at the instant victory was within his grasp,

... a foul vengeful Gaul
Aimed at the hero's breast a ponderous ball
Heaven from its destined course the fate swift threw,
And thwart his sinewy wrist with rage it flew,
Flesh, veins and sinews, in its flight it tore,
And all the hand leaves downward in tides of gore.

Following a drawn out death scene, Wolfe's soul rises to heaven where God thunders the question. "Why thou should'st here in endless raptures glow, / Rather than groan in misery below?" Wolfe answers satisfactorily, avoids hell and is enrolled among the immortals. Hearing the news of Wolfe's victory the nation is impelled to joyous raptures.

Swift at the word bright joy expanding wide
Pours through the land her all-o'erwhelming tide,
At her loud call huge bellowing cannons roar,
Their shouts in thunders o'er the echoing shore,
Bells with wide warbling clang dance nimbly round,
And chime the raptures in harmonious sound.[56]

Toward the end of the eighteenth century the market in England
and abroad for pictures of the death of General Wolfe was of such
magnitude that it could not be saturated even by the thousands of
reproductions of West's picture or the smaller number of prints of
Edward Penny's painting. Several other artists of lesser talent tried to
make money from prints of the subject. Samuel Wale drew heavily on
Penny's composition to produce a death of Wolfe cut by Grignon for
Temple Sydney's *New and Complete History of England* (London 1775).
The engraving was also published independently for those who wanted
the image more than the book (Fig. 12.6). Wale's decorative rococo
design drains Wolfe's death of its pathos and grand national signifi-
cance.[57] An equally unimaginative image was designed by the engraver
of gems and cameos Nathaniel Marchant and reproduced around the
turn of the century in an engraving by Luigi Schiavonetti (Fig. 12.7).[58]
Marchant's intaglio consisted of slightly disguised borrowings from
Wilton's Wolfe monument and West's painting. The Indian is a variant
of West's noble savage.[59] Because West's *Death of General Wolfe* had
become the standard and most widely recognized depiction of the
event, illustrators, even if we assume them to have had the best of
intentions, found it almost impossible to avoid relying heavily on the
much-reproduced work. One such designer, one Dodd, produced a
variation of West's picture for Charlotte Cowley's *The Ladies History of
England from the descent of Julius Caesar, to the summer of 1780.*[60] Dodd's
borrowing of his image is in keeping with the text, which was not the
original work of Charlotte Cowley.[61] A slightly more original but
equally bad attempt at illustrating the death of General Wolfe was
made by Robert Smirke in a design engraved and published in 1810.
By the end of the Napoleonic wars, however, the production of new
images of the death of Wolfe was confined to a very few book illustra-
tions. For the most part publishers' requirements were met through
reproduction of old designs, particularly West's composition.

In the last quarter of the eighteenth century the increased interest
in literature and a change in reading tastes resulted in the publication
of a profusion of novels, some good, more indifferent, and many
rather bad. General Wolfe, as the archetypal hero of the age, made

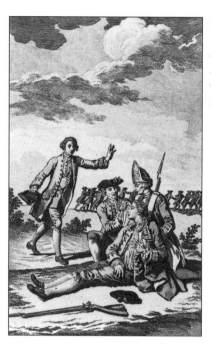

Fig. 12.6 Samuel Wale, *The Death of General Wolfe*. Engraved for Temple Sydney's *New and Complete History of England*, London, 1775 (Webster Canadiana Collection, New Brunswick Museum, Saint John)

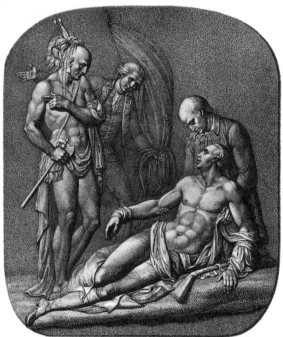

Fig. 12.7 Nathaniel Marchant, *The Death of General Wolfe*. Engraved by L. Schiavonetti, 1790–1800 (Webster Canadiana Collection, New Brunswick Museum, Saint John)

brief appearances in several of these tales.[62] William Beckford in his satire *Modern Novel Writing*, published in 1796, poked fun at the by then hackneyed use of Wolfe as the paragon of military virtue. One of his characters reads a long and florid ode he had written in imitation of Horace which includes the lines:

Wolfe rushed on death in manhood's bloom,
Paulet crept slowly to the tomb;
Here breath, there fame was given;
And that wise power who weighs our lives
By contras and by pers contrives
To make the balance even.

Beckford provided footnotes for the piece in which he said that "breath" means length of days, "which has the recommendation of novelty." "Fame" he notes sarcastically "instead of breath is a grand conception" and the line "by contras and by pers contrives," the author tells us "is surely one of the finest … in the English language."[63]

Beckford was satirizing the use of Wolfe in cameo roles by contemporary novelists such as Sir Herbert Croft. In *Love and Madness. A Story Too True in a Series of Letters*, published in 1780, Croft included the heavy-handed hortatory poem "On the Love of our Country." In this case readers were instructed that it was in freedom's cause that Britannia "rul'd the main, or gallant armies led, / With Hawke who conquer'd or with Wolf who bled." Those unlike Wolfe who draw "the sword for empire, wealth, or fame" will be disowned by virtue. Their glories will fade. They will receive no prayers, no paeans, and no blessings.[64]

"The Clergyman's Tale," one of Harriet and Sophia Lee's stories in *The Canterbury Tales*, published in 1799, includes the character Henry Pembroke who, unhappy in love, goes to Canada and volunteers for military service. At Quebec he meets General Wolfe. As the boats proceeded to the foot of the cliffs below Quebec, each eye of the invaders, "having first besought its God, was turned with awe and admiration towards the dauntless leader, who, with circumspect mein, but sublime determination, marshalled the silent soldiery." Pembroke stood by the valorous and virtuous general and "had the envied honour of being bade to do so in the field of battle."[65] Such an honour involved considerable danger and Pembroke was seriously wounded. When news of the victory at Quebec reached England there was, according to the authors of this tale, "one universal burst of joy, of sorrow, of generous ennobling tears" for "Wolfe, even in the arms of victory, had fallen,

and each man seemed to lose in him a son – a brother – a friend: ah! each had lost even more, when the adored object of national gratitude lived not to enjoy its rapturous effusions." Having "embalmed the lost hero" with generous tears, Pembroke's father and sister anguished over the fate of Henry who, being a volunteer, was not in the War-Office list of killed and wounded. Eventually they talked with the officer who brought the dispatches from Canada. He recalled only that he had seen Henry by the side of General Wolfe at the beginning of the battle. This did not bode well, for it indicated to Mr. Pembroke "a pre-eminence so glorious" that "might easily become fatal." It explained the lack of news of Henry for it was quite possible that his fate was "overlooked when Wolfe expired," though under other circumstances his wounds might not have been mortal, or his death unmentioned."[66]

Harriet and Sophia Lee's use of Wolfe is symptomatic of the aging of the shade of the hero and martyr. The spirit, now rather long in the tooth, was called upon now and then to add local colour or to provide an aura of historical veracity in a story. The shade of Wolfe was consulted less and less in matters of urgent import to the nation. That the lustre of his previously omni-present model of virtue had tarnished from disuse is indicated by his pictorial decline: fewer and fewer new images of his death appeared and these, moreover, were not displayed on the walls of grand exhibition halls but tucked into histories where they contended with pictures of less remarkable mortals such as the several Henry's, Edward's and George's who peopled the national chronicle.

13
Postscript:
The Realism Was Overpowering

Wolfe underwent another metamorphosis after his late eighteenth-century transformation from heroic achiever to symbol of a spectacular deed. In the nineteenth century he changed from a symbolic martyr and ideological standardbearer into a canonical historical archetype as he was promoted by a new generation to that part of Elysium in which dwelt the likes of Epanimondas, Cato, Julius Caesar, and others who had once served him as models. New heroes, living and dead, created in England and the new United States, men such as Montgomery,[1] Chatham, Washington, Major-General Simcoe,[2] Nelson, Lieutenant-General Sir John Moore,[3] and their successors, were seen as patterned on Wolfe.

Wolfe's "eternal" light dimmed in the mists of history as he was promoted from heavenly executive to figurehead. He lost his ability to command universal respect even among military types. His statue on George Hipps house at Quebec, which had been pulled from its perch and broken several times by indignant French Canadians, suffered its worst indignity at the hands of presumably patriotic Englishmen who considered neither Wolfe nor his wooden image sacred. In 1838 the statue was dislodged by a group of sailors who took it aboard the H.M.S. *Inconstant.* Wolfe was set up, as a kind of mascot, first in Bermuda and then in Portsmouth. Eventually he was put in a packing case with his sawn-off arm by his side and shipped to Halifax where he was restored and dispatched to Quebec to be reinstalled in his niche. At the same time that the ghost of Wolfe was being promoted in Elysium, his statue suffered a similar removal from day-to-day life by also being propelled upwards. The demolition and replacement of the house at

Wolfe's Corner in 1846 allowed Wolfe to be placed in a new niche, this time on the third storey where it was hoped he would "continue to flourish for many years yet." "By his elevation," it was observed, Wolfe appeared "closer to heaven ... and therefore safer from the attacks of practical jokers, middies, etc."[4]

As the spirit of Wolfe was awarded a more elevated position among the national heroes his earthly appearance was treated with less reverence. In Thackeray's *The Virginians*, serialized between 1857 and 1859, the brave and virtuous Wolfe was pictured as a historical figure who did not always command august respect. It is not that Thackeray intentionally set out to disparage General Wolfe. He merely wrote what seemed at the time natural and potentially believable about the man. "There was little of the beautiful in his face. He was very lean and very pale, his hair was red, his nose and cheekbones were high." However Wolfe was so courteous that one tended "to forget, even to admire his homely looks."[5] One of the livelier characters in the book on seeing Wolfe asks "Who is that tallow-faced Put with the carroty hair?" On being informed that it is Wolfe he replies, "Never saw such a figure in my life!"[6] Thackeray's picture of Wolfe is like that painted by the Canadian-born novelist Gilbert Parker in *Seats of The Mighty* (1896). Parker's hero questions how Wolfe's "flaming, exhaustless spirit" could be "in a body so gauche and so unshapely?" He is described as having straight red hair, a face "defying all regularity, with the nose thrust out like a wedge and the chin falling back from an affectionate sort of mouth." His tall "straggling frame and far from athletic shoulders, all challenged contrast with the compact, handsome, graciously shaped Montcalm." It was Wolfe's burning and searching eyes that "carried all the distinction and greatness denied him elsewhere" in his physiognomy.[7]

In *The Virginians* Wolfe, on the eve of the Quebec campaign, confesses to the hero of the novel that glory and honour were once his dreams but his "desires are much more tranquil". He says that he would prefer "quiet, books to read, a wife to love me, and some children to dandle on my knee." For, concludes Wolfe, "true love is better than glory, and a tranquil fireside with the woman of your heart seated by it the greatest good the gods can send us."[8]

Thackeray's wistful Wolfe who preferred books and a lover to death and glory was an invention of the nineteenth century. This unbellicose general was created in an environment in which evolved the tale of his reading Gray's *Elegy* on the eve of his death. The anecdote was a frequent postprandial entertainment in the home of the distinguished professor of natural philosophy at Edinburgh, John Robison, who in

his youth had been at the siege of Quebec as midshipman aboard the *Royal William*. It was only in 1815 that the professor's story was transmitted to the public in print. He said that on the eve of the battle, as the general was rowed to the foot of the cliffs of Quebec, he repeated nearly the whole of Gray's *Elegy* and on concluding said that he would rather have been the author of the poem than have the glory of beating the French the next day.[9] Sir Walter Scott reported to the essayist and poet Robert Southey that he had heard Robison tell the story repeatedly and felt that Wolfe's comment "was a strong way of expressing his love of literature."[10] Southey, who was attempting to edit some of Wolfe's correspondence, replied that he had difficulty in accepting the story as Wolfe's letters were "utterly devoid of any allusion to literature or any indication that the writer took any delight in it," and he suspected that Wolfe never looked into a book.[11] The story is verified, however, at least in part in that Wolfe did own a copy of Gray's *Elegy*. The book, now in the Fisher Rare Book Library, University of Toronto, is inscribed K.L., suggesting that Wolfe did not buy it himself but that it was presented to him by his fiancé, Katherine Lowther.[12]

Historians have also quibbled with the tale of Wolfe's recitation of Gray's *Elegy*. They have not objected to the story on the grounds that the theme of the poem contradicts the accepted picture of Wolfe's character but instead because Wolfe would not have broken his own order to proceed in stealth by reciting a poem and he could not have referred to beating the French "tomorrow" when he had embarked with his troops in the pre-dawn hours of 13 September, the same day as the battle on the Plains of Abraham.

The yarn of Wolfe and his favourite poem expanded with the telling. In a mid-nineteenth-century biography, the general is delightfully pictured reciting the poem in the most dramatically romantic of circumstances.

As in death-like stillness they were borne along, Wolfe, in whispers only audible to the officers who accompanied him, repeated Gray's Elegy. With thoughts of his betrothed and his mother ... his feelings may be imagined as he recited the lines: –

The boast of heraldry, the pomp of power,
And all that beauty, all that wealth e'er gave,
Await alike th'inevitable hour.
The paths of glory lead but to the grave.

When in the poet's words, he had spoken of his merits and his frailties alike in trembling hope, reposing in the bosom of his Father and his God, "Now gentlemen," he added in a low, but earnestly emphatic tone, "I would rather be the author of that piece than take Quebec."[13]

The legend affirms Wolfe's confidence in his immanent victory. The author's selection of the verse quoted by the biographer, including the observation underlined in Wolfe's own copy of the poem, "The paths of glory lead but to the grave," emphasized the brave soldier's awareness of having embarked on a course which would lead to a glorious death. The equanimity with which Wolfe, according to this rendering of the anecdote, approached his inevitable doom and his wistful envy of a great poet are indeed the stuff of eternal national legends. Here is a man who clearly saw his impending death in the cause of national good, yet, simultaneously, envied Gray's great understanding of the meaning of death and coveted the poet's ability to convey this in words. Through this story Wolfe's death is elevated to stand as a timeless example for cogitation on the meaning of life. Thomas Carlyle gave an even more explicit meaning to the tale by having Wolfe say of the *Elegy*, "Ah, these are tones of Eternal Melodies, are not they? A man might thank Heaven had he such a gift; almost as we might for succeeding here, Gentlemen."[14]

The absence of the tale of Wolfe and Gray's *Elegy* in eighteenth-century literature is significant: the story did not conform to the image then being created of the defunct commander. His grand gesture for liberty was unrelated, indeed antithetical, to Gray's ruminations on "the short and simple annals of the poor" who "kept the noiseless tenor of their way," and "for who, to dumb forgetfulness a prey," destiny was obscured like a flower "born to blush unseen, / And waste its sweetness on the desert air." These lines, never quoted in the narration of Wolfe's last hours, were not useful in heightening the meaning of Wolfe's sacrifice.

In the era of humanizing Wolfe by broadcasting his supposed admiration for Thomas Gray's poetics he was shorn of his monopoly on the glory of the battle at Quebec. Political pragmatists of the era decided that the laurels should be given to Montcalm as well. The first abortive project for a Wolfe monument in Canada, proposed for the Anglican Cathedral in Quebec City, elicited a suggestion for an epitaph in which its author tried "not to reflect on the nation Wolfe opposed" as this "might not only hurt feelings" but detract from the monument's

projected elegance.[15] Wolfe and Montcalm began to be seen as "joint runners in the race that leads to glory," as "the only men whom death could not divide, / A monument indeed for earthly pride."[16] In 1827 when Governor Lord Dalhousie erected an obelisk at Quebec City to the two generals, the blessing offered by Reverend Dr Mills, chaplain to the Forces, fit the political realities of the time. He asked the Lord to let the monument transmit the fame of the two generals to subsequent generations uninjured by flood, flame, lightning, earthquake, or harm from foreign foes. He implored the God of armies to give the soldiers in his audience divine protection and encouraged them "even amidst the severest struggles of expiring Nature," to emulate Wolfe and Montcalm assuming "the same heroic Resignation ... the same loyal devotedness to ... King, and glowing attachment to ... Country which blazed forth – like the Sun's last flash before its setting – with inextinguishable lustre, in the breasts of these departed Warriors."[17] The Quebec poet Louis Fréchette later expressed the same sentiment regarding the meaning of the obelisk in his *Victor and Vanquished*. "Underneath the granite slab both receive equal fame / Winner blesses by fortune and looser without blame."[18]

Two other monuments appeared in Quebec. The first, an imaginary one based on Richard Houston's full-length mezzotint portrait of Wolfe, was created in about 1840 by the politically involved antiquarian and painter Joseph Legaré in his *Landscape with Wolfe Monument* (Musée du Quebec). Legaré pictured a Wolfe monument in a dramatic landscape where the hero took on a role like that ascribed to him by a writer in 1759: "Like a radiant taper, placed on the highest pinnacle of the temple of fame," where he "directs his followers to tread the paths of virtue and honour."[19] In the painting it is clear that the general is to be seen as a statue, a monument, a memorial, as history in a romantic, untended setting, not as a living guide. The same casting of Wolfe as a historical personage occurred at the end of the century at Quebec when a bronze statue of him by Philippe Hébert, also derived from Houston's engraving, was installed in a niche on the facade of the Legislative Assembly. (Other niches contained statues of other individuals conspicuous in the history of the province.) It is one of the ironies of history that today this prominent statue of Wolfe is often seen in the background of newscasts of political demonstrations at Quebec, most of which are still connected with the events of September 1759.

The first statue at Quebec of Wolfe, that on George Hipps house, was retired in 1898 and replaced by a new wooden Wolfe carved in

1901 by Louis Jobin. Jobin, in the interests of historical realism, updated his Wolfe by adding a brace of pistols and a sword hanging from the general's belt. The modern statue, placed beyond human reach, for many years suffered only from the vicissitudes of climate. It was prudently removed to the safety of a museum in 1964 when the owner of the house received threats of fire from people incensed over the symbol of English imperialism in their midst. A recent writer cleverly summed up the tale of the statue of Wolfe and its predecessor on the house, a figure of Saint John, by observing that the "climate of secular and religious iconoclasm has led to a situation where it is now very unlikely that either Saint John the Baptist or Wolfe will ever return to their original place."[20] It was in this environment, euphemistically described as one of "secular iconoclasm," that in 1963 the Front de libération du Québec destroyed the monument over the spot where it is believed Wolfe died. The shattered column has since been restored.

The promotion of General Wolfe and General Montcalm to positions of rank in the history of the young nation of Canada, their roles in the propaganda of heritage, was confirmed in the celebrations of the tercentenary of Quebec that occurred one year before the sesquicentennial of the battle of the Plains of Abraham. On 14 July 1908 the largest-ever muster of troops of the Dominion of Canada passed in review before the Prince of Wales on the site of the battle. The prince presented the Government of Canada with the deed to the Plains and a donation for the perpetual preservation of the battlefield. This was followed by the largest demonstration of fireworks in North America until the bicentennial of the American Revolution. A Canadian commemorative seven-cent postage stamp was issued with "portraits" taken from old engravings of Wolfe and Montcalm.[21]

At the beginning of this century a proposal was drawn up in Quebec for the construction of a Wolfe Memorial Church. With the blessing of the bishop of Quebec, an emissary was sent to England to raise money. In a pamphlet the Quebec City resident William Wood asked why the memorial should be an Anglican church, why the site chosen should be in Ste-Foy, and why the memorial should be a church at all as Wolfe was a secular hero. In concluding his argument against the church he stated the obvious, that francophones would not like the idea. Either the power of Wood's pamphlet or lack of money resulted in the abandonment of the unreasonable and incendiary plan for the chapel.[22]

Some influential and energetic patriotic citizens of the young Dominion of Canada urged their English cousins to commemorate

Wolfe. What for reasons of sensible politics could not be done in
Canada could be done in England with impunity. In 1908 Sir Gilbert
Parker unveiled a mural tablet on Wolfe's one-time residence in
Bath.[23] In the same year a tablet by Adolphus E. Rost was unveiled at
Saint Alfege, Greenwich.[24] Rost, according to the notes in the souvenir
programme of the event, was inspired in his work by a letter from Miss
Edith Harper the author of "The Hero of Quebec" published in *the
Kentish Mercury*, 18 September 1908. The service preceding the unveil-
ing of the tablet on 20 November, the anniversary of Wolfe's inter-
ment, included the processional hymn "Fight the good fight" and a
lesson from Ecclesiastes, "Let us now praise famous men." Sir George
White, in unveiling the tablet, said that Wolfe was "a great soldier and
a singleminded gentleman, the single aim of whose short but brilliant
career was the path of duty, and who fell – as he himself would have
wished to fall had he known that his time was come."[25] Sculptural
commemorations of Wolfe, more substantial than the tablets, soon
appeared in England. A statue by Derwent Wood, set up on the Green
at Westerham, was unveiled in 1911 and a monument by the Canadian
sculptor R. Tait McKenzie was erected at Greenwich Park in 1927. In
design both owed something to the form of Wolfe as seen in Houston's
mezzotint. The last statue of Wolfe was erected in Canada. Carved by
the New York firm of Messrs. Piccirrilli, a large Wolfe having no rela-
tionship to any of the pre-existing images was installed on the west
entrance of the Legislature Building in Winnipeg in 1922.

Around the turn of the century great collections of Canadiana were
formed by nationalistic Canadians. They served the youthful nation as
it sought, like the United States more than a hundred years before, to
preserve a heritage. This heritage, if demonstrably magnificent, could
be considered to foretell the spectacular economic, political, and, to
a lesser extent, cultural growth of the nation. Materials relating to
General Wolfe formed the nucleus of these collections, items from
which have been used to illustrate this book.[26] For the Canadian col-
lectors of material on General Wolfe, Wolfe stood not so much as a
prototype of valour or as a symbol of the achievement of Empire but
as an affirmation of the existence of a genuine and heroic history
which proved the antiquity and confirmed the virtuous future of the
new Dominion of Canada. The acquisition of material relating to
Wolfe in Canada and elsewhere was not restricted to eighteenth-
century literature and images. There was a passion for all those things

the hero had sanctified by touching in his short life – his hair, books, dispatch case, chess set, chair, pistols, and so on. As the great man did not have the foresight to leave a physical imprimatur on all his possessions, hunters of relics in England and Canada frequently ascribed to him ownership of things that looked appropriately old with unverifiable provenances pointing in his general direction. The collections of relics is symptomatic of the firm consignment of Wolfe to the rank of a fully dead historical personage. He had lost the ability he possessed in the eighteenth century to transcend history. He was shorn of his immanence in everyday life. If one wanted to commune spiritually with Wolfe it now had to be done through touching or looking at the things he had touched, visiting the places, now marked with plaques, where he had lived, fought, and died, or getting close to his mortal remains at St Alfege. In 1993 an English political party called New Britain, dedicated to a complete revival of the nation and promoting freedom and democracy in opposing British participation in European union, sponsored a Canada Day commemoration at Wolfe's tomb in Greenwich. In addressing the congregation at this event the Reverend Basil Watson said that Wolfe did not live to know what he had really done: "His victory had set in process a loyalty which was to make Canada such a jewel in the British crown and to lead on to that development which now enables her to play such a significant role in international affairs."[27]

Wolfe's transformation from living spirit to historical personage was hastened by the imperialist popular author of boys' stories G.A. Henty. He made Wolfe a minor character in his novel *The Winning of a Continent*, later titled *With Wolfe in Canada*, published in several editions from 1887. In this novel the jaunty hero of Canada is shown as a pale wraith of the classical virtuous spirit of the eighteenth century. He was demoted from service as an inspiration for the eighteenth-century adult to functioning as one of many historical moral examples in the literary propaganda intended to mould the young males of the Empire, youths being prepared for the eventual call to exercise Wolfe-like valour in fields of battle from Africa to Hong Kong.

One of the most illuminating examples of the transformation of General Wolfe into an historical figure suiting twentieth-century needs is the film *Wolfe, or The Conquest of Quebec* of 1914. No copies of this grand historical spectacle survive but the outline of its plot is preserved in promotional synopses. The Kalem Company movie began, as did George Cocking's eighteenth-century play, with General James Wolfe bidding farewell to his mother and his sweetheart, Katherine

Lowther. This sets the stage for the romantic plot which involves the vicissitudes of two lovers in Quebec, a French-Canadian beauty named Mignon Mars and a dashing British soldier, Lieutenant Arleigh. Their tension-filled adventures end when they are reunited at the end of the film as momentous events are shown taking place on the Plains of Abraham. Wolfe was seen dying in victory and Montcalm, "spared the humiliation of surrender," expired. The film ends "as the sun sets. Mignon and Arleigh, now married, watch as a departing vessel bears Wolfe's body to England."[28]

The moving picture, like West's *Death of General Wolfe*, was in large measure intended to be instructive and, like the painting, at least in some aspects, its didactic content depended on its historical accuracy. A reviewer quoted in advertisements said that history literally repeated itself on the screen. "There is no flaw that I was able to detect," he wrote as if reflecting West's apologists. "I sat enthralled by the spectacle. At times the realism was overpowering."[29] The realism, like that in West's picture, depended on what was at the time considered to be historical accuracy of costume, location, and sequence of events. The film was commended for its use of authentic locations and the large cast of extras, about a thousand men, who "were drilled for three weeks before being judged competent to take the part of the soldiers or to wield the firearms." The costumes were spectacular and accurate, for they were those used at "an historical pageant a year before of the same subject, and correct, both English and French, to the last helmet plume."[30] Unfortunately it is not known how Kenean Buel, the director, staged the death of General Wolfe. It was probably based on the "historically accurate" painting by West.[31]

Buel's sweeping historical epic was marked by the same realism and attention to detail of time and place that animated antiquarians and historians of period. They, like Buel, had interests in recreating the history and demonstrating the heroic and romantic heritage of the New World. The era of the conquest of the French in North America was the golden or heroic age of the continent. Buel and antiquarians, like their creative ancestors in eighteenth-century England and America, looked back in time and saw archetypes essential for their world – a world coloured to a great extent by civil, colonial, and global war.

The role of the dead General Wolfe has undergone yet another transformation, which probably isn't his last. What this latest metamorphosis means is difficult to say because we are denied the advantage of

hindsight in considering it. Not until the advent of the present icono-
clastic generation has anyone dared to poke fun at the entire story of
Wolfe, his life, death, and subsequent adoration and emulation by his
contemporaries. Nancy Mitford, howver, does just that in *Wigs on the
Green* (1935) where she describes an amateur theatrical whose first
episode is introduced by an officer announcing "the victory of Wolfe
over the French Pacifists at Quebec." The scene following has Wolfe
reading Gray's *Elegy* to his troops. He is "hit by a stray bullet and dies
in a heap of straw," while a brass band plays the "Death March in Saul."
The success of this comedic scene depends upon a widespread knowl-
edge of the usual presentations of Wolfe's death. Mitford's audience
was familiar with the event, now firmly situated in the historical past,
through recollections of it absorbed in adolescence. What Mitford
counted on their remembering in order to make the scene amusing
is not what the school texts recounted but rather what West's ubiqui-
tous illustration told of the event.[32] The picture and the well-known
anecdote of his recitation of Gray's *Elegy* have become the "real" facts
of Wolfe's death. Wolfe himself, replaced by these two shop-worn signs,
has now become the brunt of jokes and a source of satire.[33] The real
Wolfe is separated from the barbs of wits by the intermediary of one
canonic picture and one canonic literary anecdote. On this generous
reasoning it can be supposed that it is not Wolfe himself who is the
object of comedic derision but rather the well-known images of his
dying and reciting Gray's *Elegy* that are parodied and ridiculed. It is
the idea of Wolfe, long-separated from the real Wolfe, that is used to
produce laughter. In Margaret Atwood's comic novel *The Robber Bride*
(1993), the office of one of the characters, a military historian, is
graced with a "bad reproduction" of West's *Death of General Wolfe*. The
print shows "Wolfe white as a codfish belly, with his eyes rolled piously
upwards and many necrophiliac voyeurs in fancy dress grouped
around him." The historian keeps the print in her office, we are told,
"as a reminder, both to herself and to her students, of the vainglory
and martyrologizing to which those in her profession are occasionally
prone." Also on display in her office is a student's work – a cartoon
entitled "Wolfe Taking a Leak."[34]

A recent essay by Simon Schama entitled "The Many Deaths of Gen-
eral Wolfe" confirms Wolfe's longevity.[35] In this piece, an admirable
mixture of fact and believable fiction, the historian cleverly recapitu-
lated the thought processes of writers and artists who dealt with Wolfe
in the eighteenth century. His approach to the subject follows Jonathan
Richardson's advice to painters at the beginning of the eighteenth

century. Richardson wrote that it was perfectly legitimate to enhance a historical painting with imaginative refinements that were probably the truth "though the history says no such thing."[36] This theory was repeated by West's apologist, the Reverend Bromley, who wrote that no matter how much of what the artist showed in his painting was in fact true, everything "was as fair in the supposition of the painter as if [it] had actually existed."[37] Schama presented his readers with an essay which in form and intent completes the cycle between our era and the eighteenth century. Youth has been restored to the shade of Wolfe. He has been released from the bonds of nineteenth-century historicism. The obvious co-mingling of fact and fiction in Schama's essay permits Wolfe to die in many ways. How we perceive his death and the meaning we find in it is limited only by our imagination.

The shade of Wolfe is still active in the politics of the world. In our struggle to deal with the rise of a global community driven by transnational business, nationalism is springing up everywhere with a vehemence equivalent to that in eighteenth-century England. In Quebec and the rest of Canada, debate on the aspirations of many Québecois to live in their own sovereign nation frequently involves the invocation of the hero or villain Wolfe and the meanings to be found in his victory more than two hundred years ago. The power of Wolfe's ghost to haunt current debate is clear in the recent film *Le Sort de l'Amérique* by Jacques Godbout.[38] In this documentary the Québecois filmmaker grapples with the problems of the historical event that occurred on the Plains of Abraham in 1759. He asks, who won? who lost? who was a hero? who was a villain? But, more importantly, he asks whether the facts of history matter – assuming, of course, that we can indeed know the facts. One might conclude from the film that the value of history is to be found in its use to us as evidence of whatever we want it to mean. Our images of historical events and personages have a life independent of "facts." For Godbout, the English and French in Canada "have kept on trying to invent a country where they can live side by side,"[39] while living with the myth of the founding of Canada on the Plains of Abraham. Further, he believes, the erosion of the independence of both the English and French cultures in Canada in the face of the dominance of the United States is a result of the English victory at Quebec. While Montgomery died in a failed attempt to recapitulate Wolfe's conquest of Quebec and Canada, his countrymen today are succeeding in a similar venture with no loss of blood.

The evidence suggests that Wolfe's first biographer was right when he said that the dead general would "live in the memory of future ages, 'til that duration comes when time shall be no more."[40]

Appendix
Birth and Death Dates of Individuals
Mentioned in the Text

Adam, James (1732–1794)
Adam, Robert (1728–1792)
Adams, Amos (1728–1775)
Adams, President John (1735–1826)
Addison, Joseph (1672–1719)
Albani, Cardinal Alessandro (1692–1779)
Amherst, General Jeffrey (1717–1797)
Arnold, Benedict (1741–1801)
Audinet, Philip (1766–1837)
Ayrton, Edmund (1734–1808)
Balestra, Giovanni (1774–1842)
Ball, William (fl. c.1755–1769)
Banks, Thomas (1735–1805)
Barbié, Jean-Baptiste (fl. 1755–1779)
Barlow, Joel (1754–1812)
Barré, Col. Isaac (1726–1802)
Barry, James (1741–1806)
Beard, John (c.1716–1791)
Beattie, James (1735–1803)
Beatty, Charles (?1715–1772)
Beckford, William (1760–1844)
Bedford, John Russell, Fourth Duke of (1710–1771)
Belloy, Pierre Laurent Buyrette de (1727–1775)
Belsham, William (1752–1827)
Bland, Humphrey (1686?–1763)
Board, Rev. Richard (1792–1859)
Bougainville, Jean-Pierre (1722–1763)

Bowles, Carrington (d.1792)
Bowles, John (fl. 1754–1764)
Boydell, John (1719–1804)
Boyne, John (c.1750–1810)
Brackenridge, Hugh Henry (1748–1816)
Braddock, Gen. Edward (1695–1755)
Brant, Joseph (Thayendanegea) (1742–1807)
Breton, Luc-François (1731–1800)
Brewster, Martha (fl. 1757)
Bromley, Rev. Robert Anthony (1735–1806)
Bronte, Charlotte (1816–1855)
Brooke, Francis (?1724–1789)
Brooke, Henry (c.1703–1783)
Burke, Edmund (1729–1797)
Burt, Rev. John (1716–1775)
Byng, Admiral John (1704–1757)
Campbell, George (1719–1796)
Carey, William (1759–1839)
Carleton, Sir Guy (1724–1808)
Carlini, Agostino (c.1735–1790)
Carlyle, Thomas (1795–1881)
Carter, Elizabeth (1717–1806)
Cary, Thomas (1751–1823)
Chambers, Robert (1710–1784)
Chatham, William Pitt, Earl of (1708–1778)
Cheere, Sir Henry (1703–1781)
Chesterfield, Philip Dormer Stanhope, Earl of (1694–1773)
Chevillet, Juste (1729–1790)
Cleland, John (1709–1789)
Cockings, George (d.1802)
Colden, Cadwallader (1688–1776)
Coleridge, Samuel Taylor (1772–1834)
Conway, Gen. Henry Seymour (1721–1795)
Cooke, Rev. William (1725–1783)
Cooper, Rev. Samuel (1725–1783)
Coote, John (d.1808)
Copley, John Singleton (1738–1815)
Coverly, Nathaniel (c.1775–1824)
Cowper, William (1731–1800)
Croft, Sir Herbert (1759–1806)
Cumberland, Richard (1732–1811)

Cumberland, William Augustus, Duke of (1721–1765)
David, Jacques-Louis (1748–1825)
Dawson, Rev. Eli (fl. 1760)
De Launay, Robert (1754–1814)
Delaune, Captain William (d.1761)
Denvers, John, Baronet of Swithland (c.1722–1796)
Dicey, Cluer (fl. 1763–1780)
Dodsley, James (1724–1797)
Dodsley, Robert (1703–1764)
Doughty, Sir Arthur George (1860–1936)
Duché, Jacob (1737–1798)
Dunlap, William (1766–1839)
Dwight, Timothy (1752–1817)
Eckstein, John (1735–1818)
Edgcumbe, Richard, 2nd Baron (1716–1761)
Edwards, Edward (1738–1806)
Eliot, Rev. Andrew (1718–1778)
Evans, Nathaniel (1742–1767)
Falckeysen, Theodore (c.1768–1814)
Ferguson, Adam (1723–1816)
Fergusson, Robert (1750–1774)
Fitler, James (1758–1835)
Franklin, Benjamin (1706–1790)
Fraser, Simon Lieutenant Col. (1726–1782)
Fréchette, Louis (1839–1908)
Frederick II, King of Prussia (1712–1786)
Freneau, Philip (1752–1832)
Frisch, Johann Cristoph (1738–1815)
Gage, General Thomas (1721–1787)
Gainsborough, Thomas (1727–1788)
Galt, John (1779–1839)
Gardiner, Richard (1723–1781)
Garrick, David (1717–1779)
Gaudry, Joseph I. (d.1782)
George II (1683–1760)
George III (1738–1820)
Gibson, Patrick (1720–1831)
Gillray, James (1757–1815)
Gilpin, William (1724–1804)
Godfrey, Thomas (1736–1763)
Goldsmith, Oliver (1728–1774)

Gosse, Edmund (1849–1928)
Gosset, Isaac (1713–1799)
Graham, John (1754–1817)
Granby, John Manners, Marquis of (1721–1770)
Gray, Thomas (1716–1771)
Green, Guy (fl. 1780–1794)
Griffiths, Ralph (1720–1803)
Grignon (d.1787)
Grosvenor, Richard, First Earl (1731–1802)
Grove, Joseph (d.1764)
Guttenberg, Karl (d.1790)
Hallam, Louis (1740–1808)
Hardinge, George (1741–1797)
Hawley, General Henry (?1697–1759)
Hawthorne, Nathaniel (1804–1864)
Hayley, William (1745–1820)
Hayman, Francis (1708–1776)
Hayward, Richard (1728–1800)
Hébert, Philippe (1850–1917)
Henty, George Alfred (1832–1902)
Hetsch, Philipp Friedrich von (1758–1839)
Highmore, Joseph (1692–1780)
Hill, Aaron (1685–1750)
Hogarth, William (1697–1764)
Holland, Lieutenant Samuel (1728–1801)
Hone, Nathaniel (1718–1784)
Hopkinson, Francis (1737–1791)
Horn, John (1837–1926)
Houdon, Jean-Antoine (1741–1828)
Houston, Richard (1721–1775)
Howard, Middleton (b.?1747)
Howe, Gen. William, Fifth Viscount (1729–1814)
Hudson, Thomas (1701–1779)
Hume, David (1711–1776)
Humphreys, Col. David (1752–1818)
Hurd, Nathaniel (1730–1777)
Hutchinson, Thomas (1711–1780)
Jackson, John (1730–1806)
Jeffereys, Thomas (?1695–1771)
Jefferson, Thomas (1743–1826)
Jobin, Louis (1845–1928)

Johnson, Joseph (fl. 1789–1808)
Johnson, Samuel (1709–1784)
Johnson, Sir William (1715–1774)
Johnstone, Charles (?1719–1800?)
Johnstone, James chevalier de (1719–1800?)
Kames, Henry Home, Lord (1696–1782)
Kearsley, George (d.1790)
Keppel, Admiral Augustus, Viscount (1725–1786)
Kirk, John (1724–1776)
Knox, John (d.1778)
Kotzwara, Franz (c.1750–1791)
Krifft, William B. de (b.?1765)
Langdon, Samuel (1723–1797)
Laurens, Henry (1724–1792)
Lee, Sophia (1750–1784)
Lee, Harriet (1757–1855)
Légaré, Joseph (1795–1855)
Le Grand, Augustin (1765–c. 1815)
Livingston, William (1723–1790)
Lochée, John Charles (1751–after 1795)
Loutherberg, Philip James de (1740–1812)
Lowe, Thomas (c.1719–1783)
Lyttleton, George, Baron (1709–1773)
McCord, David Ross (1844–1930)
Mahon, Philip Henry Stanhope, Lord (1805–1875)
Mann, Sir Horace (1701–1786)
Manthe, Thomas (c.1719–1783)
Marchant, Nathaniel (1739–1816)
Martin, David (1737–1797)
Maudit, Israel (1700–1787)
Mayhew, Jonathan (1720–1766)
Mellen, Rev. John (1722–1807)
Mercier, Philip (?1689–1760)
Millan, John (d.1784)
Monckton, Brig. Gen. Robert (1726–1782)
Montagu, Elizabeth (1720–1800)
Montcalm de Saint-Véran, Louis-Joseph, Marquis de (1712–1759)
Montgomery, Gen. Richard (1736–1775)
Montressor, John (1736–1799)
Moore, Lt. Gen. Sir John (1761–1809)
Mordaunt, Gen. John (1697–1780)

Morland, Robert Henry (?1719–1779)
Mortimer, John Hamilton (1740–1779)
Murray, Gen. James (1721–1794)
Nelson, Admiral Horatio (1758–1805)
Norman, John (c.1748–1817)
Northcote, James (1746–1831)
Occom, Rev. Samson (1723–1792)
Ogden, James (1718–1802)
Paine, Thomas (1737–1809)
Parker, Sir Gilbert (1862–1932)
Parkman, Francis (1823–1893)
Peale, Charles Willson (1741–1827)
Penny, Edward (1714–1791)
Piles, Roger de (1635–1709)
Pitt, William, The Younger (1759–1806)
Pratt, Samuel Jackson (1749–1814)
Prime, Benjamin Young (1733–1791)
Pringle, Sir John (1707–1782)
Purcell, Richard alias Corbut, C. (fl. 1763–1766)
Putnam, Israel (1718–1790)
Pye, John (1782–1874)
Ramsay, Allan (1713–1784)
Rapin de Thoyras, M. (Paul) (1661–1725)
Reynolds, Sir Joshua (1723–1792)
Richardson, Jonathan (1665–1745)
Richmond and Lennox, Charles Lennox, Third Duke of (1735–1806)
Rickson, Capt, William (1719–1770)
Robertson, John Ross (1841–1918)
Robertson, William (1721–1793)
Robinson, Thomas Second Baron Grantham (1738–1786)
Robison, John (1739–1805)
Rogers, Major Robert (1731–1795)
Rollin, Charles (1661–1741)
Romney, George (1734–1802)
Roubiliac, Louis François (1705–1762)
Rugendas, Johann Lorenz (1775–1826)
Ryland, William Wynne (1732–1783)
Rysbrack, John (1694–1770)
Sackville, George, First Viscount, (later Germain) (1716–1786)
Sadler, John (1720–1789)
Saint-Aubin, Gabriel de (1724–1780)

Sayer, Robert (1725–1794)
Schaak, J.S.C. (fl. 1760–1770)
Schiavonetti, Luigi (1765–1810)
Schwerin, Field Marshal Kurt Christoph, Count von (1684–1757)
Scott, Sir Walter (1771–1832)
Shaftesbury, Anthony Ashley Cooper, Earl of (1671–1713)
Shebbeare, John (1709–1788)
Shenstone, William (1714–1763)
Simcoe, John Graves (1752–1806)
Smirke, Robert (1753–1845)
Smith, Charlotte (1749–1806)
Smith, Nathaniel (c.1741—after 1800)
Smith, Rev. William (1727–1803)
Smollett, Tobias (1721–1771)
Smyth, Captain Hervey (1734–1811)
Southey, Robert (1774–1843)
Sower, Christopher Jr. (d.1784)
Spooner, Charles (d.1767)
Stair, John Dalrymple, Second Earl of (1673–1747)
Stevens, George Alexander (1710–1784)
Strange, Sir Robert (1721–1792)
Strutt, Joseph (1749–1802)
Stuart, Prince Charles Edward (Bonnie Prince Charlie) (1720–1788)
Stuart, Gilbert (1755–1828)
Stuart, James "Athenian" (1713–1788)
Talbot, Catherine (1721–1770)
Tassie, James (1735–1794)
Temple, Richard Grenville-Temple Earl (1711–1779)
Temple, Sir William (1628–1699)
Thackeray, William Makepeace (1811–1863)
Thomson, James (1700–1748)
Thompson, James (?1732–1830)
Townsend, Rev. Jonathan (1721–1776)
Townshend, Charles (1725–1767)
Townshend, George First Marquis (1724–1807)
Trumbull, John (painter) (1756–1843)
Trumbull, John (poet) (1750–1831)
Turner, Thomas (1729–1793)
Tyler, William (d.1801)
Vattel, Emerich de (1714–1767)
Vaudreuil, Pierre de Rigaud, marquis de (1698–1778)

Verelst, Harry (d.1785)
Voltaire (1694–1778)
Waldeck, Prince George Friedrich (1743–1814)
Wale, Samuel (1721–1786)
Walpole, Horace (1717–1797)
Warde, Gen. George (1725–1803)
Warren, Sir Peter (1703–1752)
Washington, General George (1732–1799)
Watson, Caroline (1761–1814)
Watteau, François-Louis-Joseph (Watteau of Lille) (1758–1823)
Webb, Daniel (1718–1798)
Webster, John Clarence (1863–1950)
Wedgwood, Josiah (1730–1795)
West, Benjamin (1738–1820)
Whitehead, William (1715–1785)
Williams, James (fl. 1763–1776)
Williams, William (d.1791)
Williamson, Peter (1730–1799)
Wilson, Richard (1713–1782)
Wilton, Joseph (1722–1803)
Winckelmann, Johann Joachim (1717–1768)
Wolfe, Col. Edward (1685–1759)
Wolfe, Gen. James (1727–1759)
Wolfe, Thomas (1751–1818)
Woollett, William (1735–1785)
Young, John (?1750–1820)
Young, Thomas (1732–1777)
Zaffonato, Angelo (d.1835)
Zimmerman, Johann Georg, Ritter von (1728–1795)
Zoffany, Johann (1733–1810)

Notes

PREFACE

1 J. Clarence Webster, *Wolfe and the Artists* (Toronto: Ryerson Press 1930); *Wolfiana* (Privately Printed 1927); and "A Study of the Portraiture of Major-General James Wolfe," *Transactions of the Royal Society of Canada.* 3rd Ser. 19 (1925), 47–67; "Pictures of the Death of Major-General James Wolfe," *Journal of the Society for Army Historical Research.* 6 (1927), 30–6. J.F. Kerslake, *Wolfe Portraiture and Genealogy* (Westerham: Quebec House 1959) and *Some Portraits of General Wolfe* (London: National Portrait Gallery 1959).

CHAPTER ONE

1 Anonymous, *A Dialogue Betwixt General Wolfe and the Marquis of Montcalm in the Elysian Fields* (London: Rivington and Fletcher 1759 and Coventry: E. Jopson 1759). A critic faulted the pamphlet for the weakness of the intended wit and for its unprofound irony, specifically the "smart sarcasms on the principal officers, who have foolishly lost their lives in their country's cause" *London Magazine* 28 (November 1759): 632.
2 George Alexander Stevens, *A Lecture on Heads* (Dublin: William Porter 1788), 174–5.
3 Thomas Wright, *Caricature History of The Georges* (London: John Camden Hotten n.d.), 210.

CHAPTER TWO

1 John Johnson, clerk and quartermaster-sergeant to the 58th regiment, manuscript journal, National Archives of Canada (NA), MG18 N18, vol. 3: 53–4.

2 Anonymous, *Genuine Letters from a Volunteer in the British Service at Quebec* (London: H. Whitridge 1759) reprinted in Arthur G. Doughty and G.W. Parmelee, *The Siege of Quebec and the Battle of the Plains of Abraham*, 6 vols (Quebec: Dussault 1901), 5:13–14.

3 Horace Walpole, *Memoirs of the Reign of King George II*, edited by John Brooke, 3 vols (New Haven: Yale University Press 1985), 3:74–5.

4 *London Chronicle*, 27–9 November 1759, 522.

5 J[ohn] P[ringle], *The Life of General James Wolfe, The Conqueror of Canada: Or, The Elogium of that Renowned Hero, Attempted according to the rules of eloquence, with a Monumental Inscription, Latin English, to perpetuate his memory* (London: G. Kearsley 1760), 25. Other editions: Boston: Fowle and Draper 1760 and Portsmouth, New Hampshire: Daniel Fowle 1760. Authorship is attributed to John Pringle by J.C. Webster in "The First Published Life of James Wolfe," *Canadian Historical Review* 11 (1930): 328–32.

6 Montagu to Lady Bute, 9 November 1759. *The Complete Letters of Lady Mary Wortley Montagu* edited by Robert Halsband, 3 vols (Oxford: Clarendon Press 1965–67), 3: 226.

7 "The humble address of the knights, citizens, and burgesses in Parliament assembled," *London Gazette*, 12 November 1759.

8 *Annual Register for the Year 1759* (London: J. Dodsley 1760), 41.

9 "Lines Occasioned on the Death of General Wolfe," *Scots Magazine* 22 (April 1760): 203.

10 Anonymous, "On courage, particularly that required in the military profession," *Universal Magazine* 25 (October 1759): 242. As was common with the journals of the time, this magazine was published at the end of the month; the article cited was reprinted from an earlier source.

11 Tobias Smollett, *The History of England from the Revolution to the Death of George the Second*, 5 vols (London: T. Cadell 1823), 5:169.

12 Oliver Goldsmith, *Busy Body* 6 (20 October 1759): 32–5.

13 *The Monitor*, 22 December 1759, 1394.

14 Quoted in *Wolfe: His association with Bath* (Bath: Bath Chronicle Offices [1908]), 10.

15 Letter from J. Lowell to anon, 19 October 1759, New Brunswick Museum, Webster Papers, pkt. 16.

16 *The Diary of Thomas Turner 1754–1765*, edited by David Vaisey (Oxford and New York: Oxford University Press 1985), 191.

17 Transcript of ms. letter in Warde Collection, NA, MG18 L5, vol. 3: 522.

18 *A Form of Prayer and Thanksgiving to Almighty God to be used at morning and evening service after the general thanksgiving for the defeat of the French army in Canada and the taking of Quebec by His Majesty's forces and for the other successes and blessings of the year* (London: By order of His Majesty 1759).

19 *The Diary of Thomas Turner,* 194.

20 James Johnson, *A Sermon Preached before the Lords ... November 29 ...* (London: Hawkins 1759).

21 [Richard] Dayrell, *A Sermon Preached before the Honourable House of Commons, at St. Margaret's Westminster ...* (London: J. Walter [1759]).

22 James Townley, *A Sermon Preached before the Right Honourable the Lord Mayor, the Court of Aldermen and the Liveries of the Several Companies of the City of London, in the Cathedral Church of St. Paul on Thursday, November 29, 1759* (London: H. Kent, T. Field, J. Walter 1759).

23 At Buckland's were Nathaniel Ball, *The Divine Goodness of Human Gratitude ... a sermon preach'd at West-Horsley ...* (London: J. Buckland 1759); Robert Gilbert, *Britain Revived, and under the Smiles of Mercy, Summoned to the Work of Praise ... a sermon preached at Northampton,* (London: J. Buckland 1759); J. Hogg, *A Thanksgiving Sermon preached to a Congregation of Protestant Dissenters, at Dismouth in Devonshire ...* (London: Buckland 1759); and Edward Hitchin, *A Sermon (on Ephes V 20) preached at the New Meeting, in White-Row Spital-Fields ...* (London: J. Buckland, T. Field, E. Dilly and G. Keith [1759]). At Griffith's the stock included J. Williams, *The Favours of Providence to Britain in 1759 ... a sermon preached at Wokingham ...* (London: C. Henderson, R. Griffiths, and S. Blackman [1759]) and Richard Price, *Britain's Happiness and the proper improvement of it, represented in a sermon ... preached at Newington Green, Middlesex,* (London: A. Millar and R. Griffiths 1759). Robert and James Dodsley sold Anonymous, *A Sermon (on Exod xv, 9, 10) preached on Thursday the 29th of November, 1759 ...* (London: R. and J. Dodsley [1759]). Other thanksgiving sermons probably sold by their authors include the following: John Harris (Rector of Greensted, Essex), *A Thanksgiving Sermon (on Deut. xxii 29) ...* (London: n.p. 1759); Edward Picerking Rich, *A Sermon (on Ps. xxvii 3) ...* (London: n.p. 1759); Thomas Scott, Rev. of Ipswich, *The Reasonableness, pleasure and benefit of National Thanksgiving,* (Ipswich: n. p. [1759]), and Richard Winter, *A Sermon (on Chron. xx, 27) ... preached ... November 29, 1759,* (London: n.p. 1759).

24 *A Sermon Preached at the Sunday Morning Lecture in the Parish Church of St. Giles, Cripplegate and afterwards at Stratford-Bow, November 29, 1759* (London, Printed by the author [1759]).

25 Rev. Eli Dawson, *A Discourse delivered at Quebec in the Chappel [sic] belonging to the Convent of Ursulines, September 27th, 1759* (London: R. Griffiths 1760).

26 Samuel Cooper, *Mr Cooper's Sermon Occasioned by the Reduction of Quebec* (Boston: Green & Russel and Edes & Gill 1759). The *London Chronicle*, 18–20 March 1760, 275–7 printed a correspondent's summary of Cooper's sermon so that the readers could see "what sentiments the people there entertain of the mother-country [sic] and its government, and the consequences of our late conquests."

27 Amos Adams, *Songs of victory directed by human compassion and qualified with Christian benevolence; in a sermon delivered at Roxbury, October 25, 1759* (Boston: Edes & Gill 1759).

28 Jonathan Townsend, *Sorrow turned into Joy. A Sermon delivered at Medfield, October 25, 1759* (Boston: S. Kneeland 1760).

29 Jonathan Mayhew, *Two Discourses delivered October 25th, 1759 Being the Day Appointed by Authority to be observed as a day of public thanksgiving for the success of his majesty's arms more particularly in the reduction of Quebec, the Capital of Canada* (Boston: Richard Draper and Edes & Gill 1759).

30 Andrew Eliot, *A Sermon Preached October 25, 1759. Being a Day of Public Thanksgiving appointed by authority for the success of the British arms this year; especially in the reduction of Quebec, The Capital of Canada* (Boston: Daniel and John Kneeland for J. Winter 1759).

31 For example Samuel Langdon, in *Joy and Gratitude to God for the Long Life of a Good King and the Conquest of Quebec. A Sermon Preached in the First Parish of Portsmouth in New Hampshire, Saturday, November 19, 1759 ...* (Portsmouth: Daniel Fowle 1760) said that the "indefatigable resolute" Wolfe, "has at length bro't us into the strong city, the capital of a country which to us has been like Edom to Israel." Samuel Chandler, in *A Sermon Preached at Gloucester Thursday November 29th, 1759, Being the Day of the Provincial Anniversary Thansgiving* (Boston: Green & Russell [1759]), concluded a colourful history of the war with an evangelical evocation of the conflicting emotions elicited by Wolfe's victory and death through which "the grand scheme which engaged the attention of the grasping Monarch of France and his sage statesmen, is disconcerted."

Among sermons the following year which mention Wolfe were those of Eliphalet Williams, *A Sermon Preached at East-Hartford, March 6, 1760. Being the Day of Public Thanksgiving for the Signally Favourable Appearances of Almighty God, in prospering his majesty's arms. Particularly by the defeat of*

the French army in Canada and the taking of Quebec (New London: Timothy Green 1760) and John Mellen, *A Sermon Preached at the West Parish in Lancaster, October 9, 1760 on the General Thanksgiving for the Reduction of Montreal and Total Conquest of Canada* (Boston: B. Mecom 1760).

32 *Boston Evening Post,* 27 October 1760, quoted in Kerry A. Trask, *In the Pursuit of Shadows. Massachusettes Millenialism and the Seven Years War* (New York and London: Garland 1989), 265.

33 *Pennsylvania Gazette,* 25 October 1759.

34 *Pennsylvania Gazette,* 15 November 1759.

35 John Burt, *The mercy of God to His People, in the Vengeance he renders to their Adversaries, the Occasion of their Abundant Joy,* (Newport, R.I.: J. Franklin [1759]), 11.

36 *London Chronicle,* 20–2 November 1759, 495, and *Public Advertiser,* 27 November 1759. Robert E. Pike, in "Voltaire: Le Patriot Insulaire," *Modern Language Notes* 57 (1942): 345–55, suggests that the play was *Tancrède.* H.T. Mason, who kindly drew the above reference to my attention, has written me saying that he thinks it wildly improbably that Voltaire would have applauded the victory of the English, especially as he had cause to suffer a loss of his personal investments at sea thanks to the British navy.

37 Oliver Goldsmith, article on Voltaire's *Universal History* in the *Monthly Review* (August 1757), quoted in *Collected Works of Oliver Goldsmith,* edited by Arthur Friedman, 5 vols (Oxford: Clarendon Press 1966), 2:73n1.

38 John Adams, *The Works of John Adams, Second President of The United States,* 10 vols (Boston: Little Brown and Co. 1850–56), 10: 284.

CHAPTER THREE

1 "Extract of a letter from Bristol," *Pennsylvania Gazette,* 20 October 1759.

2 *The Monitor,* (London) 27 October 1759: 1333–4.

3 6 September 1759, printed in *11th Report of the Historical Manuscript Commission,* pt. 4, 309, 316.

4 *London Chronicle,* 30 October – 1 November 1759, 413 and *Public Advertiser,* (London) 2 November 1759 and in contrast see letter to the *London Chronicle,* 1–3 November 1759, 432, stating Townshend "was the least of the living who had not been given due honour in need of vindication."

5 *London Chronicle,* 20 October 1759, 382 quoting the *Public Advertiser.* "General Monckton died of the wound he received in the battle with the French before Quebec a few days after the said action."

6 Anonymous, *A Letter to the Honourable Brigadier-General, Commander-in-Chief of His Majesty's Forces in Canada*, published in October 1760 by R. Stevens. Reprinted in full in Lt.-Colonel C.V.F. Townshend, *The Military Life of Field-Marshal George First Marquess Townshend 1724–1807* (London: John Murray 1901), 253–61.

7 Anonymous, "An Officer's Address to the Publick," *London Chronicle*, 27–30 October 1759, 412; reprinted in the *Royal Magazine* 1 (November 1759): 236.

8 *Correspondence of Thomas Gray*, edited by Paget Toynbee and Leonard Whibley, 3 vols (Oxford: Clarendon Press 1971), 2: 656–7.

9 *London Chronicle*, 8–11 December 1759, 560.

10 Horace Walpole, *Memoirs of the Reign of George II*, edited by John Brooke, 3 vols (New Haven: Yale University Press 1985), 3: 230.

11 *A Refutation of the Letter to an Honble. Brigadier General, Commander of his Majesty's Forces in Canada*. The text is reprinted in Townshend, *The Military Life of George Townshend*, 262–74.

12 *London Magazine* 29 (October 1760): 560. A more complimentary notice of the pamphlet was given in the *Monthly Review* 22 (October 1760): 326.

13 NA, MG23, G11, vol 1, f 3. Published by C.P. Stacey in "Quebec 1759; Some New Documents," *Canadian Historical Review* 47 (1966): 352.

14 Six of them illustrate Lieutenant Colonel Ian McCulloch, "Pratfalls on the Paths of Glory," *The Beaver* 73 (1994): 14–19.

15 Horace Walpole, *Correspondence*, edited by W.S. Lewis, 48 vols (New Haven: Yale University Press 1937–83) 3: 317.

16 Typescript copy of letter, Murray to Townshend, 5 November 1774, New Brunswick Museum, Webster Papers.

17 Richard Gardiner, *Memoirs of the Siege of Quebec ... from the Journals of a French officer on board the frigate Chezine ... compared with the accounts transmitted home by Major General Wolfe and Vice-Admiral Saunders, with occasional remarks by Richard Gardiner Esq* (London: R. & J. Dodsley 1761), 6, 7, 10.

18 Townshend to Amherst, 29 October 1774, New Brunswick Museum, Webster Papers. See extracts from Murray's letters in the hand of Marquis Townshend, Hist MSS. Comm, II, report pt. iv.

19 Horace Walpole, *Memoires of the Reign of King George the Third*, 4 vols (London: Lawrence 1894), 3: 222.

20 Townshend to Amherst, 29 October 1774.

21 *The Letters of Philip Dormer Stanhope, Earl of Chesterfield*, edited by John Bradshaw, 3 vols (London: George Allen Unwin 1926) 3: 1260.

22 William Cavendish, *The Devonshire Diary: Memoranda on State of Affairs 1759–1762*, edited by Peter D. Brown and Karl W. Schweizer. Camden 4th series, vol. 28 (London: Royal Historical Society 1982): 26.

23 Anonymous, *A Letter to a Great M———r. On the Prospect of Peace* (London: G. Kearsley 1761).

24 *London Chronicle*, 25–7 December 1759, 616–17. Published in *The Papers of Benjamin Franklin*, edited by Leonard W. Larabee, 22+ vols (New Haven: Yale University Press 1959-), 8: 450–1. George Augustus Howe was killed at Ticonderoga on 6 July 1759.

25 *A Detection of the False Reasons and Facts, … by a Member of Parliament* (London: Thomas Hope 1761) quoted in William L. Grant, "Canada versus Guadeloupe, An Episode of the Seven Years War," *American Historical Review* 17 (1912): 740. For the pamphlet war, see also Clarence Walworth Alvord, *The Mississippi Valley in British Politics*, 2 vols (Cleveland: A.H Clark Co. 1917) and C.E. Fryer, "Further Pamphlets for the Canada-Guadeloupe Controversy," *Mississippi Valley Historical Review* 4 (1917): 227–30.

26 Frederick George Stephens, *Catalogue of Political and Personal Satires Preserved in the Department of Prints and Drawings in the British Museum*, 10 vols (London: British Museum, 1870–1954) 4: 225–6, no. 4001.

27 Charles Holmes, letter dated 18 September 1749, British Museum, Ms Add 32, 895f.449. A transcript is available at NA, MG18 N18, vol 4, book 1.

28 *Pennsylvania Gazette*, 1 November 1759, dateline, Boston, 23 October; "Yesterday morning arrived a ship 16 days out from Quebec – carrying a passenger eyewitness to the battle." The details correspond to those given in the anonymous "An Account of the Action Which Happened Near Quebec, 13th September, 1759," copy in the Cumberland Papers, held in the Archives of Windsor Castle and printed in *Military Affairs in North America 1748–1765, Selected Documents from the Cumberland Papers in Windsor Castle*, edited by Stanley Pargellis (Hamden, Conn.: Archon Books, n.d. reprint of 1936 edition), 437–9.

29 *The Grenville Papers*, edited by William James Smith, 4 vols (London: Murray 1852) 1: 326.

30 "Anecdotes relating to the Battle of Quebec," *The British Magazine* 1 (March 1760): 148.

31 Walpole, *Memoirs of the Reign King George II*, 3: 230.

32 The page of the register with Wolfe's baptism in reproduced in A.E. Wolfe-Aylward, *The Pictorial Life of Wolfe*, (Plymouth: W. Brendon [1924]), 49. The question of Wolfe's birthplace and his genealogy surfaced for a

second time in the mid nineteenth century. See *Notes & Queries*, ser 1,
4 (1851): 271, 322, 393, 438, 459, 503 5 (1852): 34–5, and 8 (1853):
587. Regarding a printed and framed statement once hung in the now-
demolished Black Swan, Peaseholme Green, York, which stated that Wolfe
was born in that house see *Notes & Queries*, 171 (1936): 6. In spite of the
inaccuracy of the message it continues to cloud the issue. The question is
discussed in *The Beaver* 70 (Feb/March, 1990): 63 and 70 (June/July,
1990): 62. Further St. Cuthbert's, York, which may have been the parish
church of Wolfe's parents, is sometimes referred to as the "cradle of
Canada" thus furthering the erroneous belief that General James Wolfe
had some personal connection to York.

33 *London Chronicle*, 25–7 October 1759, 406; and the *Public Advertiser*,
27 October 1759. In contrast in the *London Chronicle*, 30 October–1
November 1759, 418, it was reported, "we hear that General Wolfe was
a man of Kent."

34 *London Chronicle*, 5 November 1759, clipping, NA, Horn Collection,
MG18 N51.

35 *Gentleman's Magazine* 29 (December 1759): 593 and *Edinburgh Magazine*
4 (January 1760): 35.

36 Wolfe to Rickson, quoted in J.A. Brendon, "True Love Stories of Famous
People, no. 35. Two Warriors in Love – Wellington and Wolfe," *Every
Woman's Encyclopaedia*, clipping in NA, Horn Collection, MG18 N51.

37 Wolfe to Rickson, 9 June 1751. Printed in J.T. Findlay, *Wolfe in Scotland
in the '45 and from 1749 to 1753*, (London and New York: Longmans,
Green 1928), 201.

38 The letter was first published in *Tait's Edinburgh Magazine* 19 (1849).
The owner of the letter noted the deletion of the printed version but
remained steadfast in his resolve to protect the reputation of Wolfe. "I
do not feel at liberty to break the seal of confidence under which this
information was communicated in Wolfe's letter, though at a distance of
one hundred years." *Notes & Queries*, ser. 1, 4 (1851): 439.

39 Anonymous, "Memoirs of the Life of Major-General James Wolfe," *Royal
Magazine* 1 (December 1759): 311.

40 Wolfe to Rickson, 9 June 1751, Arthur G. Doughty and G.W. Parmelee,
The Siege of Quebec and the Battle of the Plains of Abraham, 6 vols. (Quebec:
Dussault 1901) 4: 12.

41 Wolfe to his mother, 29 February 1755. Doughty and Parmelee, *Siege of
Quebec*, 4: 32.

42 Ibid., 4: 34.

43 The Rochefort fiasco temporarily tainted the reputation of the second in
command, Brigadier Henry Conway. Among the writers who came Conway's

defence was the political critic Israel Mauduit. In 1765, long after the botched Rochefort raid, Maudit, who about this time was nominated to replace his brother Jasper as the representative of Massachusetts-Bay colony in London, published a diatribe entitled *An Apology for the Life and Actions of General Wolfe, against the misrepresentations in a pamphlet, called, 'A Counter Address to the Public with other Remarks on that Performance.'* In spite of its title Mauduit's essay is not primarily an apology for the conqueror of Canada but rather a lively and detailed defence of Conway. The success of Wolfe at Quebec is discussed briefly as an example of military brilliance of no less import than that exhibited by Conway at Rochefort. Mauduit's almost impenetrable argument in the pamphlet was pointless in 1765, by which time Wolfe's reputation required no defence and Conway had been rehabilitated and regained Prime Ministerial confidence.

Another piece on Wolfe published in the same year, "A Dialogue between the Earl of Stair and General Wolfe" (*London Chronicle*, 12–14 February 1765, 156) deals with the injustice of heroic behaviour in the afterlife. John Dalrymple, second earl of Stair, a twelve-year veteran in Elysium, complains to the recently arrived shade of Wolfe that there are more Indian Sachems than old Romans in heaven. Even the Romans, says Stair, are rude, they having told him that he should sit below them and that he was a barbarian. Stair praises Wolfe, saying that the "tenderest boldest notes" would be raised in his praise and "some future Homer ... shall transcribe their heavenly warblings, and send down thy name triumphant to remote ages."

44 Wolfe at Blackheath to Rickson at Edinburgh, 17 January 1759, Doughty, 4: 25. *Tait's Edinburgh Magazine*, 16 (1849): 13.

45 8 November 1755, Doughty 4: 35.

46 Philip Henry Stanhope, Lord Mahon, *History of England*, (London: J. Murray), 228. Lord Mahon's source for the story was the Rt Hon. Thomas Grenville, from whom W.J. Smith also heard the anecdote. *The Grenville Papers*, edited by William James Smith, 3 vols (London: Murra 1852–1953), 3: lxxxix n1.

47 First printed in *Rivington's New York Gazetteer*, 5 May 1774. Also in Louis Winstock, *Songs & Music of the Redcoats*, (London: Leo Cooper 1970), 60 and Edith Fowke and Alan Mills, *Singing Our History*, (Toronto: Doubleday 1984), 37.

48 Doughty and Parmelee, *Siege of Quebec*, 4: 37.

49 John Warde to his brother George Warde, received 16 November 1759. Transcript, NA, MG18 L2, vol 3, 525.

50 J.H. Wynne, *A General History of the British Empire in America*, 2 vols (London: W. Richardson & L. Urquhart 1770), 2: 107–8.

51 Anonymous, "A Journal of the Expedition up the River St. Lawrence," *New York Mercury* no. 385, (31 December 1759) reprinted in *The Siege of Québec in 1759: Three Eye-Witness Accounts* (Quebec: Ministère des affaires culturelles 1974), 36.

52 Sister Marie de la Visitation [Marie-Joseph Legardeur de Repentigny], *Relation du siege de Québec en 1759*, in *The Siege of Québec in 1759: Three Eye-Witness Accounts*, 16.

53 Wolfe to his mother from the banks of the St Lawrence, 31 August 1759, Doughty and Parmelee, *Siege of Quebec*, 4: 37.

54 Wolfe to Col Burton, printed in a clippling on Wolfe dated 24 January 1788, NA, Horn Collection, MG18 N51.

55 Manuscript copy, early nineteenth century, New Brunsick Museum, Webster Papers, pkt 15.

56 *Idler* 20 (26 August 1758) reprinted in *Idler* 1 (London: Hodges, Millar et al. 1790): 81–2.

57 J.G. Zimmermann, *Essay on National Pride*, (New York: H. Caritat 1799), 69. This is a translation of Zimmermann's *Von dem Natinalstolz*, first published in Zurich in 1758. The first English translation was published in London in 1771.

58 Guy Frégault, *Canada: the War of Conquest* translated by Margaret M. Cameron (Toronto: Oxford University Press 1969), 244 quoting Wolfe to Sackville, undated; Doughty and Parmelee, *Siege of Quebec*, 4: 82 and Proclamation of 27 June, 1759, A.R. Casgrain *Lettres et pièces militaires* (Quebec: L.J. Demers 1891), 274.

59 Ibid., 244.

60 Thomas Carlyle, *The History of Fredrich the Second, Called Frederick the Great*, 6 vols (N.Y.: Harper 1962–1874), 5: 448.

61 Nicolas Renaud d'Avene Des Meloizes, *Journal militaire 1756–1759* (Quebec: n.p. 1930), 51.

62 "The Family Physician of General Wolfe," *Boston Medical & Surgical Journal* 2 (1829): 620.

63 J. C. Webster, *Wolfiana* (Shediac, New Brunswick: Privately Printed, 1927), 9.

64 Wolfe to his mother 28 September 1755, Doughty and Parmelee, *Siege of Quebec*, 4: 34.

65 *London Magazine* 28 (November 1759): 569 and paraphrased in *Scots Magazine* 21 (October 1759): 554.

66 *London Chronicle*, 1–4 December 1759, 533.

67 First published in the *London Chronicle*, 27–30 October 1759, 412; reprinted in the *London Magazine* 28 (November 1759): 578 and in

John Entick, *The General History of the Late War*, 5 vols (London: E & C. Dilly and J. Millan 1775–1776), 4: 117, 119 n b.

68 Quoted in Francis Jennings, *Empire of Fortune*, (New York: Norton 1990), 220–1.

69 Undated newspaper clipping, NA, Horn Collection, MG18 N51, vol.1, file 5. Also printed in Mrs. N. Deverell, *Miscellanies in Prose and Verse* (London: Printed for the author 1781) and quoted in *Notes & Queries*, Ser. 1, 12 (1855): 312.

70 Doughty and Parmelee, *Siege of Quebec*, 3: 236 quoting Walpole from his *Memoirs of the Reign of King George the Third.*

71 Tobias Smollett, *The History of England from the Revolution to the Death of George the Second*, 5 vols (London: T. Cadell 1823) 5: 166.

72 Montagu to Lyttleton, 23 October 1759, Emily J. Climenson, *Elizabeth Montagu, The Queen of the Blue-Stockings. Her Correspondence from 1720 to 1761*, 2 vols (New York: E.P. Dutton & Co. 1906), 2: 172.

73 *Royal Magazine* 1 (December 1759): 314.

CHAPTER FOUR

1 Publication announced in the *Public Advertiser* (London), 20 October 1759, and the *London Chronicle*, 20–3 October 1759, 389. Extracts printed in the *London Chronicle*, 23–5 October 1759, 398.

2 *Public Advertiser*, 24 October 1759. The letters were rightly dismissed as unauthentic by the *Monthly Review* 21 (October 1759): 367.

3 *Monthly Review* 21 (November 1759): 455.

4 *London Magazine*, 27 (December 1759): 688.

5 Review, probably by Tobias Smollett, in the *British Magazine* 1 (February 1760): 96.

6 *Gentleman's Magazine* 27 (December 1759): 590.

7 J. Grove, *A Letter to a Right Honourable Patriot*, (London: J. Burd 1759), 17ff.

8 A copy of this is in the library of the National Archives of Canada, I-274.

9 *Le droit des gens* by Emerich de Vattel was published in 1758 in Leiden and London. An English translation was published as *The Law of Nations; or Principles of the Law of Nature Applied to the Conduct and Affairs of Nations and Sovereigns*, 2 vols (London: J. Newbery 1759–60).

10 For a partial listing of the poems see Marlin Kallich, *British Poetry and the American Revolution: A Bibliographical Survey* (Troy, N.Y.: Whitston 1988).

11 Alexander Pope, *The Dunciad Variorum* (London: A Dod 1729), 20.

12 Oliver Goldsmith, "Citizen of the World," letter 106, the *Public Ledger,* 4 March 1761, in *Collected Works of Oliver Goldsmith,* edited by Arthur Friedman, 5 vols (Oxford: Clarendon Press 1966), 2:412.

13 *Scots Magazine* 21 (October 1759): 536.

14 *Notes and Queries,* ser. 1, 4 (1851): 322–3. The lines were said by the contributor to have been given to him by a lady who got them from the lady to whom they were addressed.

15 *London Chronicle,* 18–21 October 1759, 377 and *Public Advertiser,* 19 October 1759.

16 Undated broadside, New Brunswick Museum, Webster Papers, pkt. 187. A variant of the ballad is printed with music in Edith Fowke and Alan Mills, *Singing Our History. Canada's Story in Song,* (Toronto: Doubleday 1984), 44–5. A broadside, dated 1799 at Norwich, Connecticut, containing the song is in the J. Carter Brown Library, Brown University.

17 By chance this ingredient in the fictional Wolfe corresponded to a then unknown aspect of his character. The young soldier wrote about love to his mother saying that, "this passion has one main objection to it, that it is almost accidental where it fixes, sometimes without knowledge, often without considering whether the person deserves any degree of affection or esteem, and what is worse, beauty in a woman works stronger effects, than modesty or good sense." Wolfe to his mother, dated at Inverness, 6 March 1752, copy NA, MG18 L5 vol. 3, 188.

18 *Scots Magazine* 21 (October 1759): 528.

19 "Letter from an Officer at Quebec, Sept. 20," *Scots Magazine* 21 (October 1769): 554.

20 *Naval and Military Gazette,* 11 May 1850.

21 *London Chronicle,* 10–13 November 1759, 463; *London Magazine* 28 (November 1759): 613; *Scots Magazine* 21 (November 1759): 585; and *Annual Register for the Year 1759* (London: J. Dodsley 1760), 451–2.

22 "Lines occasioned by the death of Gen. Wolfe," *Scots Magazine* 21 (October 1759): 527.

23 *London Chronicle,* 25–7 October 1759, 401 and *Scots Magazine* 21 (October 1759): 528.

24 *Royal Magazine* 1 (December 1759): 313.

25 Poem on the back of Anon. *Portrait of Wolfe* in Squerryes Court, Westerham. See *Notes & Queries,* Ser. 1, 5 (1852): 98.

26 Jacobus Belham, *Canadia Ode E inikio* (London: J. Clark, J & R Dodlsey, J Buckland 1760), 7.

O quam decoro pulvere Wolfius
Persusus ensem fulmineum rotat!

Irrumpit, hostiles catervas

Caedit, agit, rapit, urget instans!

27 *London Chronicle*, 3–5 January 1760, 21. The author of these lines, like many of his fellow poets, drew on imagery found in popular works of a distinctly higher order. In this case the poetic idea was derived from Addison's *Cato* where Caesar was shown to have overcome similar physical obstacles. "In vain has nature form'd / Mountains and oceans to oppose his passage; / He bounds o'er all, victorious in his march." In the ballad *Bold General Wolfe*, the French are pictured as being on mountains high.

28 See note 25.

29 Broadside printed by Nathaniel Coverly, Printer, Milk St., Boston. Coverly was active as an independent printer from 1796.

30 Daniel Webb, *An Inquiry into the Beauties of Painting and Into the Merits of the Most Celebrated Painters, Ancient and Modern* (London: R. & J. Dodsley 1760), 13.

31 *London Chronicle*, 3–5 January 1759, 21.

32 "An Essay to an Epitaph on the truly great and justly lamented Major General Wolfe, who fell victoriously before Quebec, Sept. 12 [sic], 1759," *Annual Register for the Year 1759* (London: J. Dodsley 1760), 452. The poem by Valentine Nevill was sent in manuscript form to General Robert Monckton in October 1759 with a letter that said, "I admired him [Wolfe] living, I am desirous to express, at least my private respect to him dead," Arthur G. Doughty and G.W. Parmelee, *The Siege of Quebec and the Battle of the Plains of Abraham*, 6 vols (Quebec: Dussault 1901), 4:70–1, quoting from papers in the Viscount Galway Collection.

33 Signed J.D. *London Chronicle*, no month, 1760, handwritten copy in New Brunswick Museum, Drysdale notebook, 151.

34 *Public Advertiser*, 12 December 1759.

35 Jonathan Mayhew, *Two Discourses delivered October 25th 1759 ...* (Boston: Richard Draper and Edes & Gill 1759), appendix.

36 *London Chronicle*, 10–13 November 1759, 463.

37 *British Magazine* 1 (March 1760): 213, reprinted in the *Scots Magazine* 22 (April 1760): 203.

38 "An Elegy, On the Death of General Wolfe," *Annual Register for the Year 1763* (London: J. Dodsley 1764), 240 reprinted from *Scots Magazine* 21 (October 1759): 526.

39 "Epitaph for General Wolfe," *Scots Magazine* 21 (December 1759): 641.

40 *Scots Magazine* 21 (October 1759): 526.

41 Oliver Goldsmith, "The Citizen of the World," 2: 413.

42 *London Magazine* 28 (November 1759): 631.

43 *Gentleman's Magazine* 29 (November 1759): 544.

44 Anonymous, *Daphnis and Menalcas: A Pastoral to the Memory of the Late General Wolfe* (London: R. & J. Dodsley & J. Scott 1759).

45 *Correspondence of Thomas Gray*, edited by Paget Toynbee and Leonard Whibley, 3 vols (Oxford: Clarendon Press 1971), 2: 656.

46 *Monthly Review* 26 (April 1762): 316.

47 James Ogden, *The British Lion Rous'd or Acts of the British Worthies*, Manchester: R. Whitworth 1762, 167.

48 Florence May Anna Hilbish, *Charlotte Smith Poet and Novelist (1749–1806)* (Philadelphia: n.p. 1941), 19, 35.

49 Dodsley to Shenstone, 1 December 1759, in *The Correspondence of Robert Dodsley 1733–1764*, edited by James E. Tierney (Cambridge: Cambridge University Pess 1988), 432.

50 *The Busy Body* 7 (22 October 1759): 42. *Collected Works of Oliver Goldsmith*, ed. Arthur Friedman, 4: 413–14. Friedman suggests that "in the second stanza of the poem the importance of the loss of Wolfe is evaluated much as it was later by Goldsmith in *An History of England, in a Series of Letters from a Nobleman to his Son* (1764), II, 241." Goldsmith's authorship of the poem is considered doubtful by Roger Lonsdale in *The Poems of Thomas Gray, William Collins, and Oliver Goldsmith* (London: Longmans 1969), 768.

51 Wolfe's aunt married a Goldsmith of Limerick who was a first cousin of Reverend Charles Goldsmith (the model for the Vicar of Wakefield) and uncle to Oliver Goldsmith.

52 Middleton Howard, *The Conquest of Quebec: A Poem* (Oxford: J. Fletcher, 1768), 7.

53 *Critical Review* 27 (June 1769): 468. *The Conquest of Quebec. A Poem*, by the Reverand William Cooke, A.B. (London: Davis and Reymers, n.d.).

54 *Monthly Review* 40 (June 1769): 515.

55 *Critical Review* 27 (June 1769): 470. Joseph Hazzard of Lincoln College, Oxford, *The Conquest of Quebec. A Poem* (London: Fletcher 1769).

56 Martha Brewster, "A Final Conquest of Canada or, God Reigning over His and Our Enemies," printed in W.T. Waugh, *James Wolfe, Man and Soldier* (Montreal: L. Carrier 1928), 320.

57 [Thomas Young], "Poem Sacred to the Memory of James Wolfe," printed by James Parker and Co., New Haven [1761], 4.

58 The story of Wolfe is included in the first part of the novel published in 1760. Johnstone wrote it while a house guest of Richard, 2nd Baron Edgcumbe (1716–1761) an inactive major general, friend of Horace Walpole and participant in the creation of the first posthumous portrait of Wolfe.

59 Charles Johnstone, *Chrysal; or The Adventures of a Guinea*, 4 vols (Dublin: T. Becket 1761) 2: 106–8.

60 Frances Brooke, *The History of Emily Montague* [1769], edited by Mary Jane Edwards (Ottawa: Carleton University Press 1985), 5.

61 Tobias Smollett, *The History and Adventures of an Atom*, edited by O.M. Brack, Jr (Athens and London: The University of Georgia Press 1989), 90–1.

62 George Cockings, *War: An heroic Poem From the taking of Minorca by the French, to the raising of the Siege of Quebec, by General Murray* (Boston: S. Adams 1762), xiii.

63 Ibid., 85–6.

64 David Erskine Baker, *Biographica Dramatica, or A Companion to the Playhouse*, 2 vols (London: Rivington, Payne and Son, et al. 1782), 2: 65 n188.

65 George Cockings, *The Conquest of Canada: or The Siege of Quebec. An Historical Tragedy of five acts* (Albany: A. & J. Robertson 1773), v.

66 Ibid., 9.

67 Ibid., 11.

68 Ibid., 67.

69 Ibid., 69.

70 Ibid., 75.

71 George Winchester Stone Jr, *The London Stage 1660–1800*, 5 vols (Carbondale: Southern Illinois University Press 1960–73), 2, part 4: 806.

72 *Universal Magazine* 26 (February 1760): 93. Song by Paul Whitehead (1710–1774), printed in Sigmund Samuel, *The Seven Years War in Canada 1756–1763* (Toronto: Ryerson Press 1934), 143.

73 Stone, *London Stage*, 812.

74 *Egerton's Theatrical Remembrancer* (London: T. & J. Egerton 1788), 230, no. 11. Stone, *London Stage*, 795–6.

75 *London Magazine* 28 (November 1759): 631.

76 *A Monody on the Death of Major-Gen.l James Wolfe* (London: Thrush 1759).

77 *Monthly Review* 21 (November 1759): 456.

78 *Public Advertiser*, 20 October 1759.

79 *Public Advertiser*, 2 November 1759.

80 *Universal Magazine* 27 (July 1960): 40–1.

81 *Public Advertiser*, 1 January 1760.

CHAPTER FIVE

1 Patrick Gibson's story is recorded in an undated, printed commentary for an engraved portrait of Gibson published by J. Moyes, Castle Street, Leicester Square. New Brunswick Museum, MS. 109.

2 Autograph note by Capt. W. DeLaune on fly-leaf of a copy of Humphrey
Bland's *Treatise on Military Discipline* given to him by James Wolfe. New
Brunswick Museum Library. A lock of Wolfe's hair passed through
Maggs Auction House, London, "General Wolfe's Hair £ 30 & his own
copy of *The Trial of Admiral Byng*," October 1904. "Genuine" locks of
Wolfe's hair are in the McCord Museum, Montreal, acc. no. 253, and
the New Brunswick Museum.

3 *London Chronicle*, 17–20 November 1759, 485 and *London Magazine* 27
(November 1759): 580 reprinted in *Annual Register for the Year 1759*
(London: J. Dodsley 1760), 282–3.

4 Bell's journal, NA, MG18M, Ser.3, item 24. Funeral noted in *Universal
Magazine* 25 (December 1759).

5 In the will Delaune and Bell, Wolfe's other aide-de-camp Hervey Smyth,
Colonel Isaac Barré, and two others were bequeathed one hundred guin-
eas each to buy swords and rings in remembrance of their friend.

6 Beckles Willson, *The Life and Letters of James Wolfe* (London: Heinemann
1909), 193.

7 P.L. Carver, "Wolfe to the Duke of Richmond; Unpublished Letters," *Uni-
versity of Toronto Quarterly* 8 (1938–9): 20–1. This letter is printed also in
R.H. Whitworth, "Some Unpublished Wolfe Letters 1755–58," *Journal of
the Society for Army Historical Research* 53 (1975): 82. There are fifteen let-
ters from Wolfe to Richmond, 1755–57, in the Goodwood Papers, box
29 bundle 9, Goodwood House, Sussex.

8 Wolfe to Richmond, 19 January 1757, Carver, "Wolfe to the Duke of
Richmond."

9 Horace Walpole, *Anecdotes of Painting in England*, edited by F.W. Hilles and
P.B. Daghlian, 5 vols. (New Haven: Yale University Press 1937), 5: 156.

10 National Portrait Gallery, London, no. 4415.

11 Letter from Simcoe to his wife Elizabeth Posthuma, dated 8 March
1784, in Mary Beacock Fryer, *Elizabeth Postuma Simcoe 1762–1850, A Biog-
raphy*, (Toronto and Oxford: Dundurn Press 1989), 134. The bust,
which has disappeared, is recorded in a photograph in the J. Ross Rob-
ertson Canadian Historical Collection, Toronto Public Library, no. 2123.

12 Anthony, Earl of Shaftesbury, *Sensus Communis* (1709) in *Characteristics of
Men, Manners, Opinions, Times*, edited by Rev. Walter M. Hatch (London:
Longmans, Green, and Co. 1872), 167.

13 The currency of this notion is confirmed by Edmund Burke's objection
to it in *A Philosophical Enquiry into the Origin of our Ideas of the Sublime and
Beautiful*, 1757. In the passage on "How far the idea of Beauty may be
applied to Virtue" (part 3, Section 11), he wrote: "the application of
beauty to virtue ... has given rise to an infinite deal of whimsical theory;

as the affixing the name of beauty to proportion, congruity, and perfection … This loose and inaccurate manner of speaking, has … misled us both in the theory of taste and of morals."

14 *Five Miscellaneous Essays by Sir William Temple*, edited by Samuel Holt Monk (Ann Arbor: University of Michigan Press 1963), 93.

15 Ibid., 98–9.

16 Signed E.D., *London Chronicle*, 18 August 1774.

17 Undated street ballad without imprint, quoted by Roy Palmer, *The Sound of History* (Oxford: Oxford University Press 1988), 275.

18 Anthony, Earl of Shaftesbury, "Soliloquy," in *Characteristics*, edited by Hatch, 243–5.

19 David Hume, *An Enquiry Concerning Human Understanding* (La Salle, Illinois: Open Court 1907), 85.

20 Joshua Reynolds, *Discourses*, edited by Pat Rogers (London, N.Y., Toronto: Penguin Books 1992), 232–3.

21 Ibid., 241.

22 Ibid., 246.

23 Ibid., 133.

24 Ibid., 148.

25 The complete inscriptions are given in John Kerslake, *National Portrait Gallery: Early Georgian Portraits* (London: H.M. Stationery Office 1977), 316. The first inscription reads in part, "this sketch belonged to Lt Col Gwillim, A.D. Camp to Genl Wolfe when he was killed – It is supposed to have been sketched by Hervey Smith." Captain Gwillim was major of Brigade at Quebec and not an aide-de-camp with Hervey Smyth and Thomas Bell. Gwillim, who died in 1762, was the father of Elizabeth Posthuma, wife of John Graves Simcoe.

26 *Public Advertiser*, 1 November 1759.

27 The address to the King (parliamentary motion) regarding the monument was printed in the *London Chronicle* (25–6 November 1759), 506. Horace Walpole, in *Memoirs of King George II*, edited by John Brooke. 3 vols (New Haven: Yale University Press 1985), 3:80, reported that William Pitt, in speaking on the resolution, let loose his enthusiasm for his successful deceased general, overstating the case "in a low and plaintive voice." His speech, "a kind of funeral oration," was according to Walpole "perhaps the worst harangue he ever uttered." Pitt had admitted his oratorical conundrum, concluding that even by ransacking ancient history and throwing "ostentatious philosophy into account" it was impossible to find an episode to rank with Wolfe's heroic death.

28 *Scots Magazine* 12 (December 1759): 641; also printed in *The Royal Magazine* 1 (December 1759): 320.

29 Anonymous, "Daphnis and Menalcas, a pastoral, sacred to the memory of the late Gen Wolfe," *Scots Magazine* 12 (December 1759), 641–2.

30 For the money bill see *Journals of the House of Commons* 28: 643. Wilton, Chambers, and Adam are mentioned as competitors by Horace Walpole in a letter to Horace Mann, *Correspondence*, edited by W.S. Lewis, 48 vols (New Haven: Yale University Press 1937–1983), 21: 428. See Katherine Ada Esdaile, *The Life and Works of Louis Francois Roubiliac* (London: Oxford University Press 1928), 161, no. 1; *Rococo Art and Design in Hogarth's England* (London: Victoria & Albert Museum 1984), 305–6, nos. S42 and S.43; and David Bindman, *Roubiliac and the Eighteenth-Century Monument* (New Haven: Yale University Press 1995), 336–9, no. 16. H. Cheere, "Sketch for General Woolfe's [sic] monument" is no. 5 in his sale, 26–7 March 1770. William Tyler (Society of Artists, 1760, no. 99), *A design for General Wolfe's Monument.*

31 Carlini exhibited at the Society of Artists in 1760 a "Design for General Wolfe's Monument." It was catalogued, perhaps in error, as being for a monument "near Buckingham Gate." A work entitled "The Death of Wolfe" was among the models in Carlini's estate sale. A drawing for Wolfe's monument by Agostino Carlini is in the Victoria and Albert Museum, London: Bindman, *Roubiliac*, fig. 279.

32 Taken from drawings sent by Charles Theomartyr Crane, the owner of Roubiliac's maquette, to the *Gentleman's Magazine*. The drawings, he said, were "by Roma and also one by another hand more accurate."

33 By Nathaniel Smith, Roubiliac's apprentice, in the National Gallery of Canada. The drawing shows the death of Wolfe behind a large drape-enshrouded arch with a cartouche inscribed "Britannia Posuit." It also shows a canon on a carriage in the background.

34 Charles Theomartyr Crane, the owner of Roubiliac's maquette, quoting a letter from Mr Brigden, the former owner of the model, who in turn acquired it from the sculptor. *Gentleman's Magazine*, 58 (1788): 668–9.

35 Illustrated in John Harris, *A Catalogue of British Drawings for Architecture, Decoration, Sculpture, and Landscape Gardening 1550–1900 in American Collections* (Upper Saddle River, NJ: Gregg Press 1971), plate 327.

36 Montreal Book Auctions, 19 January 1977, no. 126. A drawing by Wilton for his submission was sold by E. Parsons & Sons, London, cat. no. 40, lot no. 456, said to have been an original design.

37 Rupert Gunnis, *Dictionary of British Sculptors* (London: Odhams Press n.d.), 78.

38 Horst W. Janson, "Observations on Nudity in Neo-Classical Art," *Stil und Uberlieferung in der Kunst des Abendlands. Akten des 21. Internationalen Kongresses fur Kunstgeschichte in Bonn, 1964*, 3 vols. (Berlin: Mann 1967), 1: 203.

39 *Public Advertiser,* 2 February 1760.

40 Anonymous, *Memoires of the Life and Gallant Exploits of the Old Highlander, Serjeant Donald McLeod, who, having returned wounded, with the Corpse of General Wolfe, from Quebec, was admitted an out-pensioner of Chelsea Hospital in 1759; and is now in the CIII.d year of his age,* (London: n.p. 1791), 73. Reprinted with portrait by Blackie and Son, London and Glasgow, 1933. Wolfe may not have died in a plaid cloak; the American writer Nathaniel Hawthorne, on his visit to the Tower in 1855, saw "the cloak in which Wolfe died, on the plains of Abraham; a coarse, faded, threadbare, light-coloured garment, folded up under a glass case." *The English Notebooks by Nathaniel Hawthorne,* edited by Randall Stewart (New York: Russell & Russel 1962), 214–15.

41 "A Tour Through Part of England, by Mary Shackleton, in the year 1784," *The Pennsylvania Magazine of History and Biography,* 40 (1916): 141.

42 Margaret Whinney, *Sculpture in Britain 1530–1830* (Harmondsworth: Penguin Books 1964), 139.

43 Edmund Gosse, "An Essay on English Sculpture from Roubiliac to Flaxman," in John Thomas Smith, *Nollekens and His Times,* edited by Edmund Gosse (London: R. Bentley & Son 1895), 7.

44 J.T. Smith, *Nollekens and His Times,* 2 vols. (London: J Lane), 2: 110. For Nathaniel Smith see also *Gentleman's Magazine,* 102, pt. 1 (1833): 641.

45 *Gentleman's Magazine* 43 (1773): 524, 526.

46 *St. James's Chronicle,* 19 September 1772.

47 *The Works of Robert Fergusson,* (London, Edinburgh, and Dublin: A. Fullarton 1879), 214. The poem was originally published in *Bingley's Weekly Journal,* 15 August 1772; *London Evening Post,* 11 August 1772; and *Public Advertiser,* 14 August 1772.

48 *St. James's Evening Chronicle,* 26–8 November 1772.

49 J[ohn] P[ringle], *The Life of General James Wolfe … with a Monumental Inscription, Latin English, to perpetuate his memory,* (London: G. Kearsley 1760), 35–6. Reprinted in *Annual Register for the Year 1760:* 99.

50 See *Gentleman's Magazine,* 29 (November 1759): 539. Letter also published in *Annual Register for the Year 1759:* 452 and *Edinburgh Magazine* 3 (November 1759): 591.

51 [Miss Anne Christian Penny], *Poems* (London: J. Dodsley, and P. Elmsly 1780), 180.

52 *London Chronicle,* December 1772, clipping in NA, Horn Collection, MG 18 N51, vol. 1 file 2.

53 By J.M. in Caledonia, *London Chronicle,* 26 September 1772, clipping in NA, Horn Collection, MG18 N51.

54 The Late Rev. Ryan, *Reliques of Genius* (London: Edward and Charles Dilly 1777), 22.

55 NA, Horn Collection.

56 Ibid.

57 Unlocated music manuscript of six pages formerly in the collection of F. Sabin, London, titled "Epitaph on General Wolfe."

58 NA, Horn Collection.

59 Ibid., file 5.

60 *A Series of Letters between Mrs. Elizabeth Carter and Miss. Catherine Talbot,* edited by Rev. Montagu Pennington, 2 vols (London: F.C. & J. Rivington 1809), 2: 304.

61 *Gentleman's Magazine,* 20 (April 1750): 184. See also Thomas Wright, *Caricature History of the Georges* (London: J. Camden Hotten n.d.), 233.

62 It unleashed a flood of helpful texts such as *Prayers for a time of Earthquakes, Reflections Physical and Moral on Earthquakes,* and *The Earth's Groans, and her Complaints against Man. In Heroic verse* published in 1756. A general fast was proclaimed in England for 6 February 1756 through which the citizens, by atonement, might seek to avoid suffering the fate of the Portuguese.

63 *War: An Heroic Poem* (London: J Cook 1760), 89. A second edition was published by T. Leverett, Edes & Gill and D. & J. Kneeland, Boston 1762, and another edition was printed in London in 1762 for Daniel Fowle's shop in Portsmouth, New Hampshire.

64 *Gentleman's Magazine* 42 (December 1772): 588.

65 NA, Horn Collection, cutting from an unidentified newspaper dated 18 September 1772.

66 Lewis, *Walpole Correspondence,* 38: 110.

67 *Gentleman's Magazine,* 42 (November 1772): 517–18.

68 NA, Horn Collection. Letter cut from an unidentified newspaper, 18 September 1772.

69 Reprinted in *Three Early Poems from Lower Canada,* edited by Michael Gnarowski, (Montreal: McGill University 1969), 52.

70 *Public Advertiser,* 12 July 1762, and *Daily Advertiser,* 12 July 1762.

71 *Annual Register for the Year 1760* (London, J. Dodsley 1761), 69.

72 Chevalier James de Johnstone, "A Dialogue ...," published in *Manuscripts relating to the Early History of Canada,* (Quebec: Dawson 1886), 47.

73 De Bougainville's letter, Pitt's reply of 10 April 1761, and the Latin inscription with an English translation were printed in the *Annual Register for the Year 1762:* 266–8.

CHAPTER SIX

1 Verelst returned to England in 1770 and lived for a time at Aston Hall near Sheffield. Convicted of assault and bankrupt, he fled to the continent,

where he died in 1785. It is unlikely that Verelst had Romney's painting in England or on the continent, for he surely would have made it known, if only to dispose of it in the heady market for pictures of Wolfe's death that arose after West's treatment of the subject was presented to the public in 1771.

2 The canvas is painted right up to the edges. There were nail holes, now filled and overpainted, around the perimeter. The absence of selvage and the nail holes, anomalies in a preliminary working sketch or study, suggest that Romney cut this head out of a prior failed attempt at the composition, nailed it to a board or on a stretcher, and used it as a source for work on his second effort. The head is published in Jennifer C. Watson, *George Romney in Canada* (Waterloo, Canada: Kitchener-Waterloo Art Gallery 1985), 35-5, no. 1.

3 Another possible study for Romney's *Death of General Wolfe* shows a much less than life-size soldier standing below a rocky cliff next to what might be the St Lawrence. Holding a musket or fusil by the barrel, he gestures with his left arm toward the background, perhaps indicating the defeat of the French. The difficulty in ascertaining whether this picture has anything to do with Romney's *Death of General Wolfe* is compounded by the fact that the picture, unlocated at present, is known only through a poor photograph printed in an advertisement for the Talbot Art Gallery in *Connoisseur* 86 (November 1931).

4 Daniel Webb, *An Inquiry into the Beauties of Painting and into the Merits of the Most Celebrated Painters, Ancient and Modern* (London, R & J. Dodsley 1760), 13, 198.

5 On 16 August 1796 Edwards read some of his lives of modern painters to Joseph Farington. Farington said that Edwards did not intend to have the lives published during his lifetime.

6 Edward Edwards, *Anecdotes of Painters who have resided or been born in England* (London: Leigh and Sotheby 1808), 277.

7 Brian Allen, *Francis Hayman* (New Haven: Yale University Press 1987), 67–8.

8 *Universal Magazine* 26 (July 1760): 32. See also John Sunderland, "Samuel Johnson and History Painting," *Journal of the Royal Society for the Encouragement of Arts, Manufactures and Commerce* 134 (November 1986): 834–41.

9 Mrs Montagu to Mrs Carter, 1 July 1762, in *Letters from Mrs. Elizabeth Carter to Mrs. Montagu*, edited by Rev. Montagu Pennington, 2 vols (London: F.C. & J. Rivington 1817), 1: 166–7.

10 *General Evening Post*, 4–6 June 1761.

11 "An Account of Winkelman's [sic] History of the Fine Arts," *London Chronicle*, 11–13 April 1765, 356.

12 William Hayley, *Memoirs of The Life and Writings of William Hayley*, edited by John Johnson (London: Colburn, Simpkin & Marshal 1823), 172.

13 William Hayley, *The Life of George Romney, Esq.* (London: T. Payne 1809), 40. Romney, as described in *Memoirs of Richard Cumberland*, 2 vols (London: Lackington Allen & Co. 1807), 2: 211, was "of a habit naturally hypochondriac" and possessing "aspen nerves, that every breath could ruffle." As a very sensitive man and a novice in the politics of art in London, Romney seems to have been willing to politely accept the critical remarks of his detractors.

14 Transcribed and edited by Hugh Gatty, "Notes by Horace Walpole, Fourth Earl of Orford, on the Exhibitions of the Society of Artists and the Free Society of Artists, 1760–1791," *The Walpole Society* 27 (1938–9): 77.

15 Francis Haskell and Nicholas Penny, *Taste and the Antique* (New Haven: Yale University Press 1981), 134–5.

16 Richard Cumberland, "Memoirs of Mr George Romney," *The European Magazine and London Review* 43 (June 1803): 420–1.

17 Gatty, "Notes by Horace Walpole," 77.

18 William Hayley, *Poetical Epistle to an Eminent Painter* (London: T. Payne, J. Dodsley, Robson 1778), 40.

19 [Edward Young], *Conjectures on Original Composition* (London: A. Millar and R. & J. Dodsley 1759), 87–8, 94–5.

20 Samuel Johnson, *Rasselas, Poems, and Selected Prose*, edited by Bertrand H. Bronson, (New York: Holt, Rinehart and Winston 1958), 471.

21 Edmund Burke, *A Philosophical Enquiry into the Origin of our Ideas of the Sublime and Beautiful*, edited by J.T. Boulton (London: Routledge and Kegan Paul 1958), Part 1, Section 7, 39–40.

22 Ibid., Sec. 5.

23 Ibid., Sec. 14.

24 Walpole quoted in William T. Whitley, *Artists and Their Friends in England 1770–1799*, 2 vols (New York: B. Blom 1928), 2: 371.

25 *Annual Register for the Year 1759* (London: J. Dodsley 1760), 282.

26 For this portrait see Helmut von Erffa and Allen Staley, *The Paintings of Benjamin West* (New Haven: Yale University Press 1986) no. 665.

27 J.C. Webster, "Pictures of the Death of Maj. Gen. James Wolfe," *Journal of the Society for Army Historical Research* 6 (1927): 31, and Christopher Lloyd, *The Capture of Quebec* (London: B. T. Batsford [1959]), caption to fig. 36, p. 37. Samuel Holland, in his eyewitness account of the death of Wolfe, does not identify the messenger: "On a wounded Grenadier's coming towards us and crying out the French run, he [Wolfe] was near his last moments, and on my repeating it he closed his eyes and

breathed his last without a groan." Holland says that Wolfe did not say anything from the moment of his fatal wounding to his death: A.G. Doughty, "A New Account of the Death of Wolfe," *Canadian Historical Review* 4 (1923): 54.

28 *Gentleman's Magazine* 24 (May 1764): 223.

29 Private collection. Reproduced in David H. Solkin, *Painting for Money. The Visual Arts and the Public Sphere in Eighteenth Century England* (New Haven: Yale University Press 1993), 206. A reduced copy on panel in the collection of Mrs F. H. Craichlaw, England, inscribed "Atken pinx" and dated on the back 1783.

30 Edwards, *Anecdotes of Painters*, 180.

31 Thomas Godfrey, *Juvenile Poems on Various Subjects with the Prince of Parthia, a Tragedy* (Philadelphia: Henry Miller 1765), 74.

CHAPTER SEVEN

1 John Galt, *The Autobiography*, 2 vols (London: Cochrane and M'Crone 1833), 2: 235–6.

2 John Galt, *The Life and Studies of Benjamin West, Esq., President of the Royal Academy of London, Prior to his Arrival in England: Compiled from Materials Furnished by Himself* (London: T. Cadell and N. & W. Davies 1816), 38–9. Galt says that Smith introduced West to four fellow students. He mentions only three of them by name: Francis Hopkins [sic], Thomas Godfrey, and Jacob Duchey [sic]. West's friendship with Godfrey was mentioned by Nathaniel Evans in his introduction to the posthumous publication of Godfrey's work, *Juvenile Poems on Various Subjects with the Prince of Parthia a Tragedy* (Philadelphia: Henry Miller 1765), x.

3 Godfrey, *Juvenile Poems*, 33–4.

4 Ibid., 70–1.

5 Nathaniel Evans, *Poems on Several Occasions with some other compositions* (Philadelphia: John Dunlap 1772), 12 ff.

6 Ibid., 55 note.

7 Broadside, *The New-Year Verses of the Printers Lads, who Carry about the Pennsylvania Gazette* (Philadelphia: B. Franklin and D. Hall 1760), in Charles Evans, *American Bibliography*, 13 vols (Chicago: for the author 1903–34), 3: no. 8709.

8 The contributor of the verses published in the *Pennsylvania Gazette* on 13 March 1760 wrote from Kent, in Maryland, that he had penned the poem on 18 November 1759. The poet identified himself as the author of "An Epitaph on Lord Howe," published in the *American Magazine*.

9 Galt, *Life of Benjamin West*, 105.

10 Horace Walpole, *Correspondence*, edited by W.S. Lewis, 48 vols (New Haven: Yale University Press 1937–83), 21: 421–2.

11 *British Magazine* 1 (February 1760): 207.

12 John Fleming, "Robert Adam, Luc-Francois Breton and the Townshend Monument in Westminster Abbey," *Connoisseur* 179 (October 1972): 166.

13 Ibid., 168.

14 Lindsay Stainton, "Hayward's List: British Visitors to Rome 1753–1775," *The Walpole Society* 49 (1983):12.

15 William Carey, "Memoirs of Benjamin West, Esq. Late President of the Royal Academy of Painting, Sculpture, and Architecture, in London," *New Monthly Magazine* 13 (1820): 518.

16 Ruth S. Kraemer, *Drawings by Benjamin West and His Son Raphael Lamar West* (New York: Pierpont Morgan Library 1975), 7–8, no. 7.

17 Michael Pantazzi, "A Preliminary Study for Benjamin West's 'Death of General Wolfe,'" *Drawing* 7 (1985): 4.

18 Nathaniel Evans, introduction to Godfrey, *Juvenile Poems*, x note.

19 William Smith, *An Historical Account of the Expedition against the Ohio Indians in the year 1764* (London: T. Jefferies 1766), first published in Philadelphia by Bradford in 1765. West's illustrations are titled "The Indians giving a talk to Colonel Bouqet" and "The Indians delivering up the English captives to Colonel Bouquet."

20 *Liverpool Gazette*, 21 July 1763, in Albert Frank Gegenheimer, *William Smith Educator and Churchman* (Philadelphia: University of Pennsylvania Press 1943), 329.

21 Letter to Deborah Franklin, 5 August 1767, in *The Papers of Benjamin Franklin*, edited by Leonard W. Larabee, 22+ vols (New Haven: Yale University Press 1959–), 14: 224.

22 Gegenheimer, *William Smith*, 118.

23 Franklin to Peale, 4 July 1771, *The Papers of Benjamin Franklin*, 18: 163.

CHAPTER EIGHT

1 Algernon Graves, *Royal Academy of Arts. A Complete Dictionary of Contributors*, (London: n.p. 1906).

2 *The Letters of Richard Cumberland*, edited by Richard J. Dircks (New York: AMS Press 1988), 72. The "revolution in art" went unrecognized by Mary Granville, an amateur artist and one knowledgeable about contemporary taste, who was certainly shown the picture on her visit to West on the fourth of February 1771. She was apparently insufficiently impressed to mention his masterpiece in a letter reporting on her visits to West's and Angelica Kauffmann's studios. *The Autobiography and Correspondence*

of *Mary Granville, Mrs. Delany*, edited by the Rt. Hon. Lady Llanover, 6 vols (London: R. Bentley 1862), 2nd ser, 1: 329. Peter Canon-Brookes has found evidence that West charged an admission fee to his studio in 1770; see his entry in *The Painted World. British History Painting 1750–1830* (Woodgridge, Suffolk: Boydell Press, 1991), no. 18, in which he refers to a statement in Jean Jacques Barthélemy, *Voyage du jeunes Anacharsis en Gréce* (Paris: Didot L'an 7 [1798/9]).

3 *Gazeteer and Daily Advertiser*, 20 May 1771, 2, quoted in William T. Whitley, *Artists and Their Friends in England 1770–1799*, 2 vols (New York and London: Benjamin Blom 1928), 1: 282.

4 Ibid. Alan T. McKenzie, *Certain, Lively Episodes. The Articulation of Passion in Eighteenth Century Prose* (Athens and London: University of Georgia Press 1990), 1 n1, identifies what may have been the first appearance of this anecdote in print. It is told in an article in *La Belle Assemblée; or Bell's Court and Fashionable Magazine*, 2 (April 1807), 148.

5 Garrick to Fountain, 7 October 1772. *The Letters of David Garrick*, edited by David M. Little and George M. Kahrl (Cambridge, Mass.: The Belknap Press 1963), 821.

6 Edmund Burke, *A Philosophical Enquiry into the Origin of Our Ideas of the Sublime and the Beautiful* (Montrose 1803), pt 4, sec. 3.

7 James Beattie, "On Poetry & Music, as they affect the Mind," in *Essays on the nature and immutability of Truth, in opposition to Sophistry and Scepticism* (Edinburgh: William Creech 1776), 432n.

8 John Galt, *The Life, Studies, and Works of Benjamin West, Esq, subsequent to his arrival in this country* (London: T. Cadell and W. Davies 1820), 2: 48–9.

9 Joel Barlow, *Columbiad* (Washington: Joseph Milligan 1825), 417 n45.

10 David H. Solkin, *The Visual Arts and the Public Sphere in Eighteenth Century England* (New Haven: Yale University Press 1993), 273. For an excellent analysis of Wolfe and the commerce in art of the period see pages 207–18.

11 Sir Joshua Reynolds, *Discourses* (London and Toronto: Penguin Books 1992), 149–50.

12 Henry Home, Lord Kames, *Elements of Criticism* (London: G. Cowie & Co. 1824), 444.

13 Samuel Johnson, *A Dictionary of English Language* (London: Knapton 1755). See under "vulgar."

14 *The Writings of George Washington*, edited by John C. Fitzpatrick, 39 vols (Washington: U.S. Government Printing Office [1931–1944]) 28: 504.

15 Marie Kimball, *Thomas Jefferson, the Scene of Europe 1784–1789* (New York: Coward-McCann 1950), 61, quoted in Irma B. Jaffe, *Trumbull: The Declaration of Independence* (London: Allen Lane 1976), 62.

16 The Reverend Robert Anthony Bromley, *A Philosophical and Critical History of the Fine Arts, Painting, Sculpture, and Architecture* (London: Printed for the Author 1793), 56.

17 Ibid.

18 Jonathan Richardson, *An Essay on the Theory of Painting*, in *The Works of Mr. Jonathan Richardson* (London: n.p. 1773), 4, 5, 9, 10, 22, 28, 29, 106.

19 [Thomas Jefferys], *A Collection of The Dresses of Different Nations* ... 4 vols (London: Thomas Jefferys 1757–72), 2: xiii.

20 Thomas Wilkes [Samuel Derrick], *A General View of the Stage*, (London: J. Coote 1759), 144.

21 [Roger Pickering], *Reflections upon Theatrical Expression in Tragedy*, (London: W. Johnston 1755).

22 Richardson, *An Essay*, 3

23 Quoted in Janet Todd, *Sensibility; An introduction* (London & New York: Methuen 1986), 34.

24 *The Court Magazine* 2 (November 1762): 704.

25 John Galt, *The Life, Studies and Works of Benjamin West, Esq. subsequent to his arrival in this country* (London: T. Cadell and W. Davies 1820), 49.

26 J. Clarence Webster, "Pictures of the Death of Major-General James Wolfe," *The Journal of the Society for Army Historical Research*, 6 (1927): 33.

27 Marquis of Sligo, "Some Notes on the Death of Wolfe," *Canadian Historical Review* 3 (1922): 275. Sligo's main purpose in writing the article was to identify Browne, whom he identifies as Henry Browne of the 22nd regiment and Louisbourg grenadiers and not, as Samuel Holland had said, of the 28th Regiment.

28 Col. C.P. Stacey, "Benjamin West and 'The Death of Wolfe,'" *The National Gallery of Canada Bulletin* 7 (1966): 1.

29 In his youth in Pennsylvania West would have heard a great deal about Johnson's work. Before painting *The Death of General Wolfe* West produced an unremarkable history showing *General Johnson Saving a Wounded French Officer from the Tomahawk of a North American Indian* and what may have been a portrait drawn from memory of Sir William Johnson with an Iroquois in the background.

30 J. Clarence Webster ("A Study of the Portraiture of James Wolfe," *Transactions of the Royal Society of Canada*, 3rd ser. 19 (1925): 61) quoting from the *Life of Gen. Sir Charles Napier* by Lieut. Gen. Sir William Napier (1: 48) with reference to Col. the Hon. George Napier, son of Francis, 6th Baron Napier.

31 Archibald Malloch, "Robin and John Adair," *Bulletin of the New York Academy of Medicine* 13 (1937): 576–96. There exists a miniature of an individual said to be an Adair, but this portrait looks not to have been

taken from life but to be derived from the figure in West's painting. N.B.M. Webster Canadiana Collection.

32 Entry for 10 June 1807, Joseph Farington, *The Farington Diary*, edited by James Grieg (London: Hutchinson & Co. 1924), 151.

33 From E. Alfred Jones, "The History of a Picture," *The Canadian Magazine* 56 (December 1920): 108 quote of an autograph document by Holland in the Public Record Office, London. See also a letter from Samuel Holland to Lieutenant Governor Simcoe, dated "near Quebec, June 10th, 1792," in A.G. Doughty, "A New Account of the Death of Wolfe," *Canadian Historical Review* 4 (1923): 45–55.

34 Robert Wright, *The Life of Major-General James Wolfe* (London: Chapman and Hall 1864), 604.

35 Townshend's exclusion is historically accurate: "General Townshend who was on the left knew nothing of this, [the death of Wolfe] until he sent his aid-de-camp to let the Genl. know that he had but one battalion left" Doughty transcript, NA MG18 N18, vol. 4, bk 1, from a notebook apparently in Townshend's own writing entitled "Journal of the Voyage to America and the Campaign against Quebec, 1759," Sept. 13.

36 Arthur G. Doughty and G.W. Parmelee, *The Siege of Quebec and the Battle of the Plains of Abraham*, 6 vols (Quebec: Dussault 1901), 3: 222, quoting a letter sent to the *Literary Gazette*, 11 December 1847.

37 A.G. Doughty, "A New Account", *Canadian Historical Review* 4 (1923): 53–4.

38 *Annual Register for the Year 1814* (London: J. Dodsley 1815), 141, Obituary, "Thomas Wilkins, M.D., Galway, Ireland, 102. General Wolfe died in his arms."

39 *Notes & Queries*, Ser 11, 2 (1910): 37.

40 Ibid., Ser. 10, 5 (1906): 518.

41 Ibid., 6 (1906): 113, 173.

42 *Annual Register for the Year 1807* (London: J. Dodsley 1808), 601. Died "at Hackney, James Lack, aged 105 years. He served as a private soldier ... and attended Wolfe in his last moments."

43 *Notes & Queries*, Ser. 10, 7 (1907): 17 and *Notes & Queries*, Ser. 1, 1 (1856): 422, identified as Grenadier James M'Dougal.

44 *Notes and Queries*, Ser. 10, 12 (1909): 308.

45 Ibid., 2 (1909) 308.

46 V.H., "Note 156," *The Journal of the Society for Army Historical Research* 6 (1927): 249. Tombstone at Warham, All Saints, states that Captain Isaac Eyles Warren was a volunteer at Quebec "and it was his solemn task to support on the rock and witness the last moments of the Immortal Wolfe." Also cited here *Monthly Magazine* 28 (1809): 642, obituary of

Warren. It included the statement, "he was presented with one of the rifle balls which gave the great soldier his death wound."

47 20 September 1759, transcript of letter in F. Sabin Collection, London, from Co. Williamson to the Right Honourable and Honourable the Lieutenant General and rest of the Principal Officers of His Majesty's Ordnance, NA, MG18, L5, vol. 4.

48 Manuscript quoted by Arthur G. Doughty and G.W. Parmelee, *The Siege of Quebec and the Battle for the Plains of Abraham*, 6 vols (Quebec: Dussault 1901), 3: 205–6. Horace Walpole, *Memoirs of the Reign of King George II*, edited by John Brooke, 3 vols (New Haven: Yale University Press 1985), 3: 76. "He received a wound in the head, but covered it from his soldiers with his handkerchief. A second ball struck him in the belly: that too he dissembled. A third hitting him in the breast, he sunk under the anguish, and was carried behind the ranks."

49 James Henderson, letter dated 7 October 1759, to his uncle. Printed in *Notes & Gleanings* 2 (15 April 1889).

50 Transcript of a letter in the F. Sabin Collection, London, NA, MG18, L5, vol. 4.

51 *Gentleman's Magazine* 29 (December 1759).

52 Manuscript journal in the possession of G.F. Parkman, transcribed for Arthur G. Doughty, NA, MG18, N18, vol. 4, file 4, bk 2: 53.

53 *London Chronicle*, 16–19 August 1788. Reprinted in *Notes & Queries*, Ser. 1, 7 (1853): 127. According to the anonymous author of "Anecdotes relating to the Battle of Quebec," *The British Magazine* 1 (March, 1760): 147–8, a contingent of burghers of Quebec who were sharpshooters hid in a field of corn to the right of the British and it was from this group that Wolfe received both his wounds.

54 John Knox, *An Historical Journal of the Campaigns in North-America for the years 1757, 1758, 1759, and 1760* (London: printed for the author 1769), 114 note.

55 Knox, *Journal*, 114.

56 Bromley, *A Philosophical and Critical History of the Fine Arts*, 58–9.

57 Richardson, *An Essay*, 24.

58 William Mills Ivins, *Prints and Visual Communication* (London: Routledge & Kegan Paul 1953).

CHAPTER NINE

1 Grosvenor may have visited West's studio shortly after the completion of *The Death of Wolfe*. A portrait of Grosvenor as mayor of Chester, an office he held from 1759 to 1760, and a companion portrait of his younger

brother Thomas, his successor as Mayor of Chester, seem to have been painted by Benjamin West at about this time. Grosvernor owned *The Death of General Wolfe* by 10 August 1771. See letter from Edward Jennings to Charles Willson Peale noted in *The Selected Papers of Charles Willson Peale and His Family*, 3 vols (New Haven: Yale University Press 1983), 1: 203–4.

2 Various sequences for the production of these pictures are given in Galt's biography and lists of West's works drawn up in his lifetime. A chart of the lists of West's paintings is printed in John Dillenberger, *Benjamin West: The Context of His Life's Work*, (San Antonio: Trinity University Press 1977), 136–90. The most plausible order, with one exception corroborated by the dates inscribed on the canvases, is that given in a list of the artist's works printed in *Public Characters of 1805* (London: R. Phillips 1804). Contrary to the title the volume was published in 1804.

3 The Hanoverian Minister in London, C.H. Hinueber, wrote to Waldeck's secretary on 3 September 1776 and enclosed West's bill for £250. Hinueber said West was concerned over the safe arrival of the picture in Waldeck and the prince's opinion of it (Archives of Waldeck, Acts of the Cabinet, no. 2796, published by Webster, 1930, photostat of document in files of William L. Clements Library, The University of Michigan, Ann Arbor.)

4 Lieut-General Sir Reginald Savory, *His Britannic Majesty's Army in Germany During the Seven Years War* (Oxford: Clarendon Press 1966), 380–2.

5 Robins, London, 20–2 June 1829, lot 162. See discussion in Helmut von Erfa and Allen Staley, *The Paintings of Benjamin West* (New Haven: Yale University Press 1986), no. 95.

6 William Dunlap, *History of the Rise and Progress of the Arts of Design in the United States*, 2 vols (New York: George P. Scott and Co. 1834), 1: 64.

7 The painting is recorded in the 1804 list as in the possession of Frederick William Hervey (1769–1859), fifth earl and first marquis of Bristol. It is not known whether the replica was commissioned by the third earl (d. 1779) or his successor, who died in 1803. Both were cousins of Hervey Smyth.

8 *The Idler* 45 (24 February 1759).

9 "Review of R.A. exhibition by Dilettante," *Public Advertiser,* 30 April 1774, under no. 312.

10 Manuscript of the agreement in possession of William B. Hector, Tijeras, New Mexico.

11 Unidentified newspaper, 18 December 1772, printed in Louis Fagan, *A catalogue raisonné of the engraved works of William Woollett* (London: The Fine Art Society 1885), 41.

12 "John Singleton Copley Correspondence, 1762–1775," *American Art Review* 2, no. 3 (1975): 51.

13 Fagan, *Woollett*, xi, quoting a manuscript in the Department of Prints and Drawings, British Museum.

14 John Pye, *Patronage of British Art* (London: Longman, Brown 1845), 244 n54.

15 Charlotte Bronte, *Jane Eyre*. edited by Beth Newman (Boston and New York: St Martins Press 1996), 101.

16 *St. James's Chronicle*, 25–7 May 1783.

17 Fagan, *Woollett*, xii.

18 Invitation to the inaugural meeting, *St. James's Chronicle*, 22–4 March 1791. The story of the monument is told in Robert C. Alberts, *Benjamin West. A Biography* (Boston: Houghton Mifflin 1978), 217.

19 Earl of Suffolk, address to the House of Lords, 13 March 1804, quoted by Fagan, *Woollett*, ix.

20 Pye, *Patronage*, 160.

21 C.F. Joullain, *Réflexions sur la peinture et la gravure, accompagnées d'une courte dissertation sur le commerce de la curiosité et les vents en général* (Paris: Calude Lamort 1786), 135.

22 In England impressions of the print were sold at auction for £20, 9s, 6d in 1824, for 17 guineas in 1825, for £21 in 1827, and for 18 guineas in 1830. West's small oil on panel which served as the engraver's model of *The Death of General Wolfe* was sold at auction in 1791 for £29 8s while the model for the print of *Penn's Treaty* fetched £25 4s.

23 Joseph Farington, *The Farington Diary*, edited by James Greig, 8 vols (New York: George H. Doran 1923), 1: 225.

24 *Journal de Paris* 184 (July 3 1783), translated in *Master Drawings from the National Gallery of Canada* (Washington: National Gallery of Art 1988), 193, no. 61 n8.

25 Emile Dacier, *Gabriel de Saint-Aubin*, 2 vols (Paris and Brussels: Givan Oest 1931), 2: 9, no. 66.

26 Dacier, *Saint-Aubin*, 45, no. 246.

27 A print dated 1790 by Daniel Berger after Frisch's painting is illustrated in Hans-Martin Kaulbach, "Abschied, Krieg und Trauer," in *Schwäbischer Klassizismus zwischen Ideal und Wriklichkeit 1770–1830* (Stuttgart: Staatsgalerie 1993), fig. 148. The two drawings by von Hetsch are reproduced in Ulrike Gauss, *Die Zeichnungen und Aquarelle des 19. Jahrhunderts in der Graphischen Sammlung der Staatsgalerie Stuttgart* (Stuttgart: Staatsgalerie 1976), nos. 572 and 573.

28 Charles James Fox quoted in William Belsham, *Memoirs of the Reign of George III*, 6 vols (London: G.G. & J. Robinson 1801), 5: 144–8, 253, 374–81.

29 Silk embroidery with Guthman Americana (Westport, Connecticut) illustrated in *Maine Antique Digest* (February 1984): 37-C. Another is in the collection of the National Trust, England (Acc. no. Que/T/).

30 The Wolverhampton tray manufactury was established by Benjamin Mander about 1792. A tray with the *Death of General Wolfe* is illustrated in W.D. John and Jacqueline Simcox, *English Decorated Trays (1550–1850)* (Newport, England: Ceramic Book Company 1964), 121–2.

31 These wares were likely produced to commemorate the second marriage of Edward Stanley, 12th Earl of Darby to his second wife, the actress Eliza Farren, on 1 May 1797. Derby was the lord lieutenant and custos rotulorum of Lancaster county in which the pottery manufactory was located.

32 One is illustrated in M. McSherry Fowble, *To Please Every Taste. Eighteenth-Century Prints from the Winterthur Museum,* (Alexandria Va.: Art Services International 1992), 199, ill. 198. For attribution to Thomas Wolfe, Stoke-on-Trent, see Cyril Williams-Wood, *English Transfer-Printed Pottery and Porcelain* (London, Boston: Faber and Faber 1981), 174.

33 Williams-Wood, *English Transfer-Printed Pottery,* 126, pl. 57.

34 Elizabeth Collard, *The Potters' View of Canada* (Montreal: McGill-Queen's University Press 1983), 14, nn9, 10, 11.

35 *A Pageant of Canada* (Ottawa: National Gallery of Canada 1967), nos. 119, 120, and 118.

36 Brian Musselwhite, "'Death of Wolfe' on English Sugar Bowl," *Canadian Collector* 13 (March–April 1978): 45. The central part of West's composition was also reproduced in relief in a late eighteenth-century carnelian intaglio seal (Alan D. McNairn, "Benjamin West and the Death of General Wolfe," *The Magazine Antiques* (November 1996): 150, 681 pl. vii) and the right side of the composition was reproduced in a carved gem possibly by William Barnett, preserved in a cast by James Tassie. The American native from the picture was also cut in a gem, perhaps by Barnett (*British Art Treasures From Russian Imperial Collections in the Hermitage,* edited by Brian Allen and Larissa Dukelskaya (New Haven: Yale University Press, 1996), 149 figs. 130 and 131). The Tassie medallions were brought to my attention by Richard Margolis of Teaneck, New Jersey, who owns an un-attributed late eighteenth-century oval blue and white jasperware medallion on which the centre of West's composition is reproduced.

37 Production information on the *Soldiers Festival* is given in George Winchester Stone Jr, *The London Stage 1660–1800,* 5 vols (Chicago: Southern Illinois University Press 1960–73), 2: part 5.

38 Linda Fitzsimmons and Arthur W. McDonald, eds., *The Yorkshire Stage,* (Metchuen, N.J., and London: Scarecrow Press 1989).

39 The handbill, (copy in the New Brunswick Museum, Saint John, Canada) is dated 9 November 1796. It does not indicate a place for the production but Mr and Mrs John Darley listed in the cast were working at the time for the Chestnut Street Theatre Company in Philadelphia.

40 *A Guide to the Baltimore Stage in the Eighteenth Century*, compiled and edited by David Ritchey (Westport, Connecticut: Greenwood Press [1982]), 262. Ritchey lists productions for 8 June, 10 October, and 10 December 1798 and 7 June and 1 November 1799. The dramatis personae includes Wolfe, Monckton, Townshend, Adair, a grenadier, and an Indian chief.

41 C.D. Odell, *Annals of The New York Stage*, 15 vols (New York: Columbia University Press 1927–49), 2: 60.

42 *Montreal Gazette*, 26 April 1802.

43 Epilogue to *Eldred; or the British Freeholder*, quoted in *Henry MacKenzie Letters to Elizabeth Rose of Kilravok*, edited by Horst W. Drescher (London and Edinburgh: Oliver & Boyd Ltd 1967), 155 n5.

44 Dunlap, *Rise and Progress of the Arts of Design*, 1: 301, 303.

45 Copy in the Army Museum, London, acc. no. 6012–200. Engraved by W. Nutter, key published by John Jeffryes, March 1794.

46 Anon., "An Account of the Exhibition of the Royal Academy for 1791," *St. James's Chronicle*, 3–5 May 1791.

47 *The Complete Works of William Hazlitt*, edited by P.P. Howe, 15 vols (London: J.M. Dent 1932), 10: 356. Printed in Michael Pantazzi, "A Preliminary Study for Benjamin West's 'Death of Genal Wolfe,'" *Drawing* 7, no. 1 (May-June 1985): 1.

48 Abraham Raimbach, *Memoires and Recollections* (London: Privately printed 1843), 50 n67.

49 *Vers lu au dîner donné par l'administration du Musée central des arts de le 7 vendémiaire an XI à Monsieur West, directeur de l'Académie royale de Londres par Joseph Lavallée* (Paris: Imprimerie des Sciences et Arts vendémiaire an XI), 3. (Bibliothèque Nationale. Cab. Est. Yd. 2609/8 o), reference found by Laurier Lacroix.

50 *Catalogue de la Collection de Pièces sur les Beaux Arts* (Paris: George Duplessis 1881), 21, reprinted in Elizabeth Gilmore Holt, *From the Classicists to the Impressionists*, (Garden City: Doubleday & Co 1966), 5.

51 Joel Barlow, *Columbiad* (Washington: Joseph Milligan 1825), lines 587–96.

52 Barlow, *Columbiad*, 417–18 n45.

CHAPTER TEN

1 *The Idler* 45 (24 February 1759).

2 Peter Cannon-Brookes in *The Painted World. British History Painting 1750–1830*, (Woodbridge, Suffolk: Boydell Press 1991), 17, proposes that West's conception of his picture as a kind of religious *tableau vivant* may have been based on his memories of the *presepe* of Naples and Genoa and the *sacri monti* of Piedmont and Lombardy.

3 The Reverend Robert Anthony Bromley, *A Philosophical and Critical History of the Fine Arts, Painting, Sculpture, and Architecture* (London: Printed for the Author 1793), 56.

4 Joseph Addison, *Works*, 6 vols (London: George Bell & Son 1893), 1: 194.

5 William Smith, *A Discourse Concerning the Conversion of the Heathen Americans and the Final Propagation of Christianity and the Sciences to the Ends of the Earth* (Philadelphia: W. Dunlap 1760), 20.

6 Charles Beatty, *The Journal of A Two Months Tour; with a view of promoting religion among the frontier inhabitants of Pennsylvania* (London: William Davenhill and George Pearch 1768), 101.

7 Addison, *Works*, 1: 180.

8 *St. James's Chronicle*, 17 September 1772.

9 *French and Indian Cruelty; Exemplified in the Life and Various Vicissitudes of Fortune of Peter Williamson* (London: N. Nickson 1757), 10. The book was published for the benefit of "the unfortunate author" in York in 1757, in Glasgow in 1758, in London in 1760, and in Edinburgh in 1762. Williams, dressed as an Indian, gave performances on the street at which he presumably peddled his book.

10 Printed in Arthur G. Doughty and G.W. Parmelee, *The Siege of Quebec and the Battle of the Plains of Abraham*, 6 vols (Quebec: Dussault 1901), 5: 155–6.

11 Paul G.M. Foster, "Quebec 1759: James Gibson, Naval Chaplain, Writes to the Naturalist, Gilbert White," *Journal of the Society for Army Historical Research* 64 (1986): 221.

12 Doughty and Parmelee, *Siege of Quebec*, 2: 121–2.

13 Thomas Gray to Thomas Warton, London, 23 Jan. 1760. *Correspondence of Thomas Gray*, edited by Paget Toynbee and Leonard Whibley, 3 vols (Oxford: Clarendon 1971), 2: 657.

14 Voltaire to Jean-Jacques Rousseau, 30 August 1755, in *The Selected Letters of Voltaire*, edited and translated by Richard A. Brooks (New York: NYU Press 1973), 179.

15 G. Lyttelton to W. Lyttelton, 4 December 1759, in George Lyttelton, *Memoirs and Correspondence from 1734 to 1773*, edited by Robert Phillimore, 2 vols (London: James Ridgway 1845), 2: 623.

16 *London Chronicle*, 28 February – 2 March 1765, 214.

17 Anonymous, *The State of the British and French Colonies in North America* (London: A. Millar 1755), 82.

18 Williamson, *French and Indian Cruelty*, 25.

19 The *Belvedere Torso* appeared in a self-portrait by the painter James Barry dated 1767. He likely encountered a plaster cast of the *Torso* in the Duke of Richmond's study collection. Another cast was given to the Royal Academy by the sculptor Joseph Nollekins, who probably brought it to England from Italy in 1770 as a souvenir. This cast of the *Belvedere Torso* with casts of the *Laocoon* and the *Apollo Belvedere* appears in Henry Singleton's group portrait *The Royal Academicians* of 1795.

20 "A description of the famous marble trunk of Hercules, dug up at Rome, commonly called the Torso of Belvedere; wrought by Apollonius the son of Nestor, and universally allowed to have been made for a statue of 'Hercules spinning.' Translated from the German of the Abbe Winckleman [sic], librarian of the Vatican, and antiquary to the Pope, etc., by Henry Fussle [sic]," *Annual Register for the Year 1765* (London: J. Dodsley 1766), 180–2 reprinted from *Universal Museum* 1 (January 1765): 16–18. Winkelmann's *Reflections on the Painting and Sculpture of the Greeks*, translated by Henry Fuseli, was published by Andrew Millar in April 1765 and again in 1767. See Marcia Allentuck, "Fuseli's Translations of Winckelmann: A Phase in the Rise of British Hellenism with an Aside on William Blake," *Studies in the Eighteenth Century II. Papers presented at the Second David Nichol Smith Memorial Seminar Canberra, 1970*, edited by R.F. Brussenden (Toronto: University of Toronto Press 1973).

21 John Galt, *The Life and Studies of Benjamin West, Esq., President of the Royal Academy of London, Prior to his Arrival in England: Compiled by Materials Furnished by Himself* (London: T. Cadell and N&W Davies 1816), 105.

22 Frances Brooke, *The History of Emily Montague*, edited by Mary Jane Edwards (Ottawa: Carleton University Press 1985), 11.

23 Print from an unknown late eighteenth-century periodical in the William L. Clements Library, University of Michigan, reproduced in S.H.P. Pell, *Fort Ticonderoga. A Short History* (Fort Ticonderoga Museum 1957), 4.

24 *London Chronicle*, 3–5 June 1762, 18.

25 Thomas Mante, *The History of the Late War in North-America, and the Islands of the West Indies* (London: W. Strahan and T. Cadell 1772), 481,

26 James Adair, *The History of the American Indians* (London: E. and C. Dilly 1775), 379.

27 Mante, *History of the Late War*, 479.

28 Adam Ferguson, *The History of Civil Society* ([1767] London: Basil 1789), 123.

29 Cadwallader Colden, *The History of the Five Nations of Canada* (London: T. Osborne 1747), 5.

30 John Shebbeare, *Lydia or Filial Piety*, 4 vols (London: J. Scott 1760), 1: 3.

31 They could have had their notions of the character and life of the imaginary American Indian confirmed at theatres with such entertainments as the pantomime *The Choice of Harlequin; or, The Indian Chief* produced at Covent Garden in 1782, William Richardson's tragedy *The Indians*, performed in 1790 at the Theatre-Royal, Richmond, or James Cobb's comic opera *The Cherokee*, produced at Drury Lane in 1794. An antidote to these frivolous and fanciful depictions of the Amerindian was to be obtained in the serious description of the Native American compiled from a number of sources by the Scottish historian William Robertson in his *History of America*, first published in 1777.

32 1766 London edition of the Reverend William Smith's book *An Historical Account of the Expedition against the Ohio Indians in the year 1764*. If West read the text of what he was illustrating, published in Philadelphia in 1765, he would have found the description of the appearance of the Native Americans written by his Philadelphia educational benefactor Provost Smith remarkably similar to the one he had written himself to accompany the engraving of his painting *Savage Warrior Taking Leave of His Family* which was used as frontispiece in the Italian edition of Edmund Burke's revised version of William Burke's *Account of the European Settlements in America* published in 1763.

33 Joseph Burke, *English Art 1714–1800* (Oxford: Clarendon Press 1976), 246.

34 J.C.H. King, "Woodlands Artifacts from the Studio of Benjamin West 1738–1820," *American Indian Art Magazine* 17, no. 1 (Winter 1991): 35–47.

35 *Poetic Epistle to an Eminent Painter* (London: T. Payne, J. Dodsley, Robson 1778), 41. West later painted a *Death of Sydney*, *Death of Epaminondas*, and a *Death of Bayard* in a single frame.

36 Ibid., 73.

37 John Galt, *The Life, Studies and Works of Benjamin West, Esq., subsequent to his arrival in this country* (Toronto: T. Cadell and W. Davies 1820), 74.

38 *Gaston et Bayard, tragédie, par M de Belloy … suivi de notes historiques*, (2d edition, Paris: Duschesne 1771). It is interesting to note that there was a flurry of writing on Bayard at this time. Guyard de Berville's *Histoire de Pierre Terrail dit le chevalier Bayard sans peur et sans reproche* was published in Paris in 1760, 1765, 1768, and 1772, and M. Combes' *Eloge de Pierre Terrail, dit le chevalier Bayard* was published in Dijon in 1769.

39 *Œuvres complettes du M de Belloy*, 6 vols (Paris: n.p. 1779), 3: 59.

40 West based his *Death of Epaminondas* on the frontispiece, engraved by Hubert Gravelot, to the fourth volume of an illustrated edition of Charles Rollin's *Ancient History*. In his youth he had based a painting of the death of Socrates on engraving illustrating another volume of the same text. Peter S. Walch, "Charles Rollin and Early Neoclassicism," *Art Bulletin* 99 (1967): 123.

41 William Gribbin, "Rollin's Histories and American Republicanism," *William and Mary Quarterly* 29 (1972): 617.

42 Johann Georg Zimmerman, *Von dem Nationalstolz*, first published in 1758. Quotation from edition N.Y.: Caritat 1799, 278.

43 Captain John Knox, *An Historical Journal of the Campaigns in North America for the years 1757, 1758, 1759 and 1760* (London: Printed for the author 1769), 114–16.

44 *London Chronicle*, 1–7 November 1759, 430.

45 For example Mr Raymond's *The History of Gustavus Ericson King of Sweden* (London: Millar 1760).

46 *The Scots Magazine* 21 (October 1759): 527.

47 Newspaper clipping dated 7 October 1759. NA, Horn Collection, MG18 N51, file 4.

48 Anonymous, *An Ode in Two Parts, Humbly Inscrib'd to the Right Honourable William Pitt* (London: John Hart 1760), 16.

49 *Gentleman's Magazine* 43 (February 1773): 94.

50 Horace Walpole, *Correspondence*, edited by W.S. Lewis, 48 vols (New Haven: Yale University Press 1937–83), 35: 556.

51 John Galt, *The Autobiography*, 2 vols (London: Cochrane and McCrone 1833), 1: 67.

52 The publication in 1781 of companion prints after *The Battle of La Hogue* and *The Battle of the Boyne*, engraved by William Woollett and John Hall respectively, by the partnership of West, Hall, and Woollett would have spurred the sales of *The Death of General Wolfe*. The market for these companions was very good. West told John Trumbull that he had made 1,500 guineas from the La Hogue print, which sold for one guinea. If it is assumed that the artist, publisher, and engraver were equal partners, the total profit earned on the print may have been in the range of 4,500 guineas. From this one could estimate that about 4,000 impressions of *The Battle of La Hogue* were sold. Such figures are astounding for the English market, where even popular titles in the book trade rarely reached a few hundred in sales.

53 Irma B. Jaffe, *John Trumbull: Patriot-Artist of the American Revolution* (Boston: New York Graphic Society 1975), 316.

54 John Trumbull, *Autobiography, Reminiscences and Letters of John Trumbull* (New York and London: Wiley Putnam 1841), 92.

55 *The Collected Works of Samuel Taylor Coleridge*, edited by David V. Erdman, 3 vols (Princeton: Princeton University Press 1978), 1: 267.

56 See Fintan Cullen, "The Art of Assimilation: Scotland and Its Heroes," *Art History* 16, no. 4 (December 1993): 612. An engraving of the painting by Anthony Cardon (1739–1822) was published in 1806. Arthur William Devis's (1762–1822) *The Battle of Waterloo*, exhibited at the Royal Academy 1816 and engraved by John Burnet (1784–1868) and published in 1819, also depended on West's *Death of General Wolfe* implying a connection between the ends of the Napoleonic War and the Seven Years' War.

57 George Ticknor, quoted in *Life, Letters and Journals of George Ticknor*, edited by George S. Hilliard, 2 vols (Boston: R. Osgood & Co. 1876) 1: 63.

CHAPTER ELEVEN

1 Anon, "An Officer's Address to the Public," *Royal Magazine* 1 (November 1759): 236.

2 John Kerslake, in *National Portrait Gallery Early Georgian Portraits*, 2 vols (London: H.M.Stationery Office 1977), 1: 316, identifies the magazine as either the *Grand Magazine of Magazines*, which ceased publication in 1759, or the *Grand Magazine of Universal Intelligence*, which was discontinued in 1760. The former advertised its November 1759 issue as "adorned with the head of General Wolfe, finely engraved." *London Chronicle*, 29 November–1 December 1759, 525.

3 The location of Bakewell and Parker's shop is designated in the lettering on the print as "opposite Birchin-Lane in Cornhill." They opened this shop in 1762. John Bowles and his eldest son, John Jr, dissolved their partnership in 1764.

4 *Six views of the Most Remarkable Places on the Gulf and River of St. Lawrence*, engraved and published by Thomas Jeffereys in 1760.

5 A watercolour copy of this print signed M. Richardson and dated 1767 is in the New Brunswick Museum, Webster Collection, no. 1865.

6 Even his contemporary Edward Edwards could only say of him; "A portrait painter. Of his abilities, no just estimate can be formed." Edward Edwards, *Anecdotes of Painters who have resided or been born in England* (London: Leigh and Sotheby 1808), 17.

7 Kerslake, *Early Georgian Portraits*, 1: 315.

8 Reproduced in J. Clarence Webster, *Wolfe and the Artists* (Toronto: Ryerson Press 1930) pl. 28, and in *Journal of the Society for Army Historical Research* 15 (1936), 1 pl. 1.

9 Webster, *Wolfe and the Artists*, pl. 7.

10 *The Case of Designers, Engravers, Etchers & etc.* (London: 1734), 3, quoted by Herbert M. Atherton, *Political Prints in the Age of Hogarth* (Oxford: Oxford Uiversity Press 1974), 40.

11 The print was a pendant to Barbié's *Montcalm*, after J.-B. Massé, with a relief of his entombment, and his print of Lieutenant-general Chevert, after Tischbein, with a relief of one of his battles. Roger Portalis and Henri Béraldi, *Les graveurs du dix-huitième siècle*, 3 vols (Paris: Damascène Morgand et Charles Fatout 1880–1882), 1: 95, no. 14.

12 Horace Walpole to Horace Mann, 8 May 1770. Horace Walpole, *Correspondence*, edited by W.S. Lewis, 48 vols (New Haven: Yale University Press 1937–83), 23: 465.

13 Peter Bradshaw, *18th Century English Porcelain Figures 1745–1795*, (London: Antique Collectors' Club 1981), 58, 161, where dated before 1765.

14 Davenport's tavern was destroyed by fire in 1811. A second Wolfe tavern was established in Newburyport in 1814. Its sign, a copy of the original Wolfe Tavern sign dated 1762 and said to have been painted by Jacques Moyse Dupré, afterwards known as Moses D. Cole, is in the Massachussetts Historical Society. John J. Currier, *History of Newburyport, Mass. 1764–1905*, 2 vols (Newburyport: published by the author 1906), 2: 350, ill. 1, 29.

15 Kenneth Silverman, *A Cultural History of the American Revolution* (New York: T. Y. Crowell 1987), 12.

16 Dorothea E. Spear, "American Watch Papers: With a Descriptive List of the Collection in the American Antiquarian Society," *Proceedings of the American Antiquarian Society* 61 (1951): 327, and pl. opp. 298. M. McSherry Fowble, *To Please Every Taste. Eighteenth Century Prints from the Winterthur Museum* (Alexandria, Va.: Art Services International 1992), 86, ill. 87.

17 The statue formerly in the niche, a St John the Baptist, had been taken to General Hospital nunnery for safekeeping because "the inhabitants, feared that the introduction of so many heretics in Sept. 1759, might subject the statue to slight." J. M. LeMoine, *Picturesque Quebec* (Montreal: Dawson Brothers 1882), 504 note. The statue is now in the collection of the Literary and Historical Society of Quebec. For the story of the Chaulette statue see Jean Trudel, "A propos de la statue de Wolfe," *Vie des arts* 59 (été 1970): 35 and note 3, transl. 76–8, and John R. Porter et Jean Bélisle, *La Sculpture Ancienne au Québec* (Montreal: Editions de l'homme 1986), 91–2.

18 Trudel, "A propos de la statue de Wolfe," 35, transl. 77.

19 P.-B. Casgrain, "The Monument to Wolfe on the Plains of Abraham, and the Old Statue at 'Wolfe's Corner,'" *Transactions of the Royal Society of Canada*, ser. 2, 10 (1904): 213–22.

20 In August 1763 Sadler wrote to Wedgwood that he did not have a copper-plate of Wolfe. For a brief note on the business see Bernard Watney, *Longton Hall Porcelain*, (London: Faber and Faber n.d.), 42–3.

21 Peter Herbert and Nancy Schiffer, *Antique Iron, Survey of American and English Forms* (Atglen, Pennsylvania: Schiffer Publishing Ltd 1979), 152, fig. A.

22 *Public Advertiser*, 1 April 1760, and reprinted in William T. Whitley, *Artists and Their Friends in England 1700–1799*, 2 vols (New York and London: Benjamin Blom 1968), 2: 246.

23 The first medal celebrating the conquest of Canada was struck by Thomas Pingo after a design by Michael Harry Sprang. It was exhibited in 1761. The medal has a head of Britannia with two crossed standards representing the army and the navy and with a laurel wreath. It is inscribed "Wolfe" and "Saunders." The reverse has a winged Victory placing a laurel wreath on a tree hung with armour. A naked boy is bound to the trunk of the tree. It is inscribed "Quebec Taken MDCCLIX." A second medal commemorating the conquest has a bust of King George II on the obverse and on the reverse a robed female Victory under a spruce or fir tree with a beaver climbing up the other side. It is inscribed "CANADA SUBDUED MDCCLX SPAC." Both these medals were reproduced in Johann Friedrich Joachim, *Das neu eröfnete Münzcabinet*. 4 vols (Nurnberg: n.p. 1761–73), 2: pl. 40. (the second volume was published in 1764). John Kirk's medal, the first one with a face of Wolfe, was struck sometime around 1760. Being Kirk's best-known medal it was shown in 1777 at the Society of Artists exhibition as part of a tribute to the recently deceased artist.

24 Freeman O'Donaghue, *Catalogue of Engraved British Portraits Preserved in the British Museum*, 6 vols (London: British Museum 1908–1925), 4: 526, no. 9.

25 The print is illustrated and catalogued in Elizabeth Carrol Reilly, *A Dictionary of Colonial American Printers' Ornaments and Illustrations* (Worcester: American Antiquarian Society 1975), 377, no. 1566; illustration of print in Worcester Art Museum, no. 8619.

26 *The Painted Past. Selected Paintings from the Picture Division of the Public Archives of Canada* (Ottawa: Public Archives of Canada 1984), no. 3. A copy of the Highmore portrait, given by James Morgan in 1897 to Chateau de Ramezay, Montreal, is included in Students of Concordia

University, *Selected Catalogue of Work in the Permanent Collection of the Chateau de Ramezay, Montreal* (Montreal: Concordia University, Dept. of Art History 1985), no. 144. An eighteenth-century replica of the Highmore portrait is in Royal Ontario Museum, Toronto, and reproduced in Theodore Allen Heinrich, *Art Treasures in the Royal Ontario Museum* (Toronto: McClelland & Stewart 1963), plate. An enlarged copy, perhaps from the late eighteenth century, is illustrated in J.F. Kerslake, "The Likeness of Wolfe," *Wolfe Portraiture & Genealogy* (Westerham: Quebec House 1959), pl. 9, and discussed in J.F. Kerslake, *Some Portraits of General Wolfe* (London: National Portrait Gallery 1959), no. 4. See also John Kerslake, *Early Georgian Portraits*, 1: 319.

27 *Gentleman's Magazine* 56 (1780).

28 Brian Allen, *Francis Hayman* (New York and London: Yale University Press 1987), 69.

29 Accession numbers 254 and 251 respectively.

30 Bland, an acquaintance of Wolfe, served at Dettingham, was a major general at Culloden, and in 1753 was appointed chief of the forces in Scotland.

31 For Townshend as a Sackville partisan see [Edward Thurlow], *A Refutation of the Letter to an Honourable Brigadier General* (London: Stevens 1760).

32 Letter received on 16 November 1759.

33 See The Captain of a Man of War, *A Parallel (in the manner of Plutarch) between the case of the Late Honourable Admiral John Byng, and that of the Right Hon. Lord George Sackville* (London: Stevens 1759).

34 *The Monitor*, 1 December 1759, 1376.

35 *British Magazine* 1 (March 1760): 213, reprinted in the *Scots Magazine*, 12 (April 1760): 203.

36 J. Purves Carter, *Descriptive and Historical Catalogue of the Paintings in the Gallery of Laval University Quebec* (Quebec: L'Evenement Print Co. 1908), 118–19, no. 314.

37 Christie and Manson, 12 February 1852, no. 300. Subsequently in the collection of Viscount Lee of Fareham.

38 With Spink & Sons, Ltd. ca. 1931–37.

39 Edward Foster, auctioneer London, 2 May 1822, lot 90. Webster, *Wolfe and The Artists*, pl. 4. New Brunswick Museum, Drysdale Notebook, 75 notes "Revd. Abbe Verreau of this City [Quebec] is the fortunate possessor of a portrait of Gen Wolfe from life," by Hudson. Beckles Willson, "Portraits and Relics of General Wolfe," *The Connoisseur* 23 (1909): 6, coll. F. Blizard Esq.

40 George Jones, auctioneer, London 6 May 1825, lot 235. Christie, Manson & Woods Ltd., 24 June 1977, lot 107. "Apparently General Wolfe … Said to have been painted to the order of Miss Lowther after Wolfe's death." E.K. Waterhouse, *Gainsborough*, (London: E. Hulton 1958), 96: "quite unlike the admitted portraits of Wolfe." Another supposed Gainsborough portrait of James Wolfe is illustrated in Beckles Willson, "Portraits and Relics of General Wolfe," *Connoisseur* 23 (1909): 7. Another "Gainsborough" "Wolfe," noted in Kerslake, *Early Georgian Portraits*, 313, pl. 1, passed through Christie's on 5 May 1883, lot 23.

41 Paul Leicester Ford, "Portraits of General Wolfe," *The Century Magazine* 55 (January 1898): 329.

42 George Jones, London, auctioneer, 8 April 1825, lot 42, then James Webber, London, auctioneer, 16 July 1825, lot 58, "wholength portrait of General Wolfe."

43 "Portrait, termed of General Wolfe," Christie's, London, 11 March 1825, lot 60.

44 *Three Centuries of British Paintings* (London: Thos. Agnew & Sons Ltd 1978) lists pl. 59 as General James Wolfe. The signed and dated painting is now catalogued as "Anon. Officer," Stanford University Art Gallery.

45 The only portrait, other than Schaak's picture, exhibited publicly in the eighteenth century as representing General Wolfe was a sketch in chalks sent by the sixteen-year-old future engraver James Fittler to the Free Society exhibition of 1776. It was no doubt a copy after an engraving.

46 A complete list of productions in America is given in Gerald Kahan, *George Alexander Stevens and the Lecture on Heads*, (Athens, Georgia: University of Georgia Press 1984).

47 The frontispiece to the 1765 edition of the *Lecture on Heads* shows an assortment of the busts with the author holding one up as he would do in the performance. Reproduced in John Brewer, *Common People and Politics, 1750's-1790's* (Cambridge: Chadwyck-Healey 1986), pl. 16.

48 G.A. Stevens, *A Lecture on Heads* (Dublin: Byrne, Wogan, Jones, Moore and Dornin 1788), 57–8. Stevens's head of Wolfe may have looked like one in Mrs Solomon's London wax work museum in the latter part of the century, note by Rosamond Bayne-Powell in *Travellers in Eighteenth-Century England* (New York: Benjamin Blom 1972), 89.

49 For example see Christie's, 23 November 1984, lot 85, "Circle of David Morier, an officer, on a horse claimed to be General Wolfe," from the collection of Lord Leconfield.

50 *Notes and Queries*, Ser. 1, 5 (1852): 98. Also New Brunswick Museum, Drysdale Notebook, 131–9.

51 Painting in Helmut von Erffa and Allen Staley, *The Paintings of Benjamin West* (New Haven: Yale Univesity Press 1986), no. 719.

52 The full inscription is given in Kerslake, *Some Portraits of General Wolfe*, 3–4.

<div align="center">CHAPTER TWELVE</div>

1 David Howard Dickason, *William Williams, Novelist and Painter of Colonial America* (Bloomington and London: Indiana University Press 1970), 213–15.

2 Dennis Montagna, "Benjamin West's *The Death of General Wolfe:* A Nationalist Narrative," *American Art Journal* 13 (1981): 76.

3 William T. Whitley, *Artists and Their Friends in England 1770–1799*, 2 vols (New York: B. Blom 1928), 1: 287, quoting from an obituary in *La Belle Assemblée.*

4 Edward Edwards, *Anecdotes of Painters who have resided or been born in England* (London: Leigh and Sotheby 1808), 298. Barry "probably with a view of demonstrating his knowledge of the human form ... chose to paint the figures as nudities." Edwards perhaps confused Barry's *Wolfe* with the nude general in Wilton's monument or with Barry's fleshy *Adam and Eve* – a picture faulted for its Italianate immodesty – exhibited at the Royal Academy in 1771.

5 *Morning Post & Herald*, 9 April 1776.

6 Algernon Graves, *Royal Academy of Arts. A Complete Dictionary of Contributors* (London: n.p. 1906).

7 Quoted with the other reviews in William L. Pressly, *The Life and Art of James Barry* (New Haven: Yale University Press 1981), 60.

8 *Public Advertiser,* 4 May 1776, quoted in Pressley, *Life and Art of James Barry*, 60.

9 Pressly, *Life and Art of James Barry*, 61.

10 J.C. Webster, "Pictures of the Death of Major-General James Wolfe," *Transactions of the Royal Society of Canada*, 3rd ser. 19 (1925), 63.

11 William Smith, *An Oration in Memory of General Montgomery Drawn up and delivered Feb. 19, 1776 At the desire of the Honorable Continental Congress* (Philadelphia: John Dunlap 1776), 18.

12 Ibid., 32–3.

13 Letter dated 16 December 1775, reprinted from *Pennsylvania Gazette*, 24 January 1776, in Norman Philbrick, ed., *Trumpets Sounding: Propaganda Plays of the American Revolution* (New York: Benjamin Blom 1972), 218.

14 Smith, *Oration*, 33.

15 See also poem "To General Carleton" in *Scots Magazine* 38 (June 1776): 328, comparing him to Wolfe.

16 Whitley, *Artists and Their Friends*, 1: 375.

17 The Quebec Chapel was replaced by the Church of the Annunciation, completed in 1914, on Bryanston Street, London W1.

18 Thomas Anburey, *With Burgoyne from Quebec* (Toronto: Macmillan 1963), 55, first published as vol 1 of *Travels Through the Interior of Parts of America*, 2 vols (London: William Lane 1789).

19 "The Genius of America; An Ode," in "The Poetical Works of John Trumbull," *The Colonnade* 14 (1912–22): 467.

20 Kenneth Silverman, *A Cultural History of the American Revolution* (New York: Crowell 1987), 314.

21 William Livingston, *America* (New Haven: Thomas and Samuel Green [1770]), 8.

22 Wolfe may have been especially admired in Lewes, where a bust of him is said to have been in the old castle there. The bust, now unlocated, reportedly survived a fire in the castle in 1834. Under the bust were the lines:

> Let no sad tear upon his tomb be shed,
> A common tribute, to the common dread.
> And let the good, the Generous and the Brave
> With godlike envy, sigh for such a grave.

New Brunswick Museum, Drysdale Notebook, 99, apparently taken from *Notes and Queries*, ser. 1, 5 (1852): 32, where the bust was said to be in the "Old Castle at Quebec, though burnt."

23 New Brunswick Museum, Webster Canadiana Collection, no. 1985.

24 NA, 1970 (5).

25 *A Garland of New Songs* (Newcastle upon Thyne: J. Marshall n.d.), 7.

26 Philo Musico [Chauncey Langdon], *A Select Songster or a collection of elegant songs with music prefixed to each* (New Haven: Daniel Bower 1786), 54–6 (the only song of American origin in this song book); *Four Excellent New Songs* (New York: John Reid 1788). Nathaniel Coverly Jr (c. 1775–1824) printed the song as a broadside possibly as early as 1796. He sold it from his Milk St. shop in Boston. See Worthington C. Ford, "The Isaiah Thomas Collection of Ballads," *Proceedings of the American Antiquarian Society* 33 (1923): 63–4, nos. 55, 56.

27 Paul Fussell, *Samuel Johnson and the Life of Writing* (London: Chatto and Windus 1972), 68.

28 "Letter of Samuel Paine upon Affairs at Boston in October, 1775," *The New-England Historical and Genealogical Register,* 30 (1876): 317.

29 M____r P_____t, *Peace, A Poem*, (London: Bew 1778).

30 Francis von a. Cabeen, "The Society of the Sons of Saint Tammany of Philadelphia," *The Pennsylvania Magazine of History and Biography* 25 (1901): 443.

31 Weldon B. Durham, *American Theatre Companies 1749–1887* (New York: Greenwood Press 1986), 13.

32 C.D. Odell, *Annals of the New York Stage*, 15 vols. (New York: Columbia University Press 1927–49), 1: 229, quoting *Royal Gazette*, 4 October 1783.

33 Richard Plant, "Drama in English" in *The Oxford Companion to Canadian Theatre*, edited by Eugene Benson and L.W. Conolly (Toronto: Oxford University Press 1989), 149.

34 "Ode wrote at Boston in New-England On the Repeal of the Stamp Act," *Public Advertiser*, 1 July 1766.

35 Thomas Hutchinson, *Strictures upon the Declaration of the Congress at Philadelphia*, quoted in Bernard Bailyn, *The Ideological Origins of the American Revolution* (Cambridge, Mass.: Harvard University Press 1971), 155.

36 *The Poems (1786) and Miscellaneous Works (1788) of Philip Freneau*, edited by Lewis Leary (New York: Delmar 1975) facsimile reprint of *The Poems of Philip Freneau* (Philadelphia: F. Bailey 1786), 48–9.

37 Anon, *Dialogues in the shades between General Wolfe, General Montgomery, David Hume, George Grenville and Charles Townshend* (London: G. Kearsley 1777), 12.

38 Ibid., 22, 28–9.

39 Ibid., 67.

40 Ibid., 94, 106.

41 John Turnbull, *The Poetical Works of John Trumbull, LLD*, 2 vols (Hartford: S.G. Goodrich 1820), 2: 97.

42 Hugh Henry Brackenridge, *The Death of General Montgomery in Storming the City of Quebec* (Philadelphia: Robert Bell 1777), 39–40. Also reprinted in *Trumpets Sounding; Propaganda Plays of the American Revolution*, edited by Norman Philbrick (New York: B. Blom 1972), 221 ff.

43 Brackenridge, *The Death of General Montgomery*, 7, 8.

44 Timothy Dwight, *America or a Poem on the Settlement of the British Colonies Addressed to the Friends of Freedom, and their Country* (New Haven: Thomas and Samuel Green 1780), 6.

45 Benjamin Young Prime, *Columbia's Glory or British Pride Humbled: A Poem on the American Revolution* (New York: Published by the author 1791), lines 380–2, 390–3.

46 Words printed in the *Morning Chronicle*, 10 July 1776.

47 *The Parliamentary History of England*, 36 vols (London: T.C. Hansard 1806–20), 18: 1079.

48 William Cowper to Joseph Hill, 31 January 1782, in *The Letters and Prose Writings of William Cowper*, edited by James King and Charles Ryskamp, 5 vols (Oxford: Clarendon Press 1979–1986), 1: 12.

49 A description of the re-enactment was given in "An extract of a Letter from a Correspondent of Quebec," *Montreal Gazette*, 6 September 1787.

50 *Abram's Plains: A Poem by Thomas Cary*, edited by D.M.R. Bentley (London, Ontario: Canadian Poetry Press 1986), 12–13, lines 302–21. See also Susan Glickman, "Canadian Prospects: Abram's Plains in Context," *University of Toronto Quarterly* 59 (1990): 498–515. Another early Canadian poem, published in London in 1797, has a short passage on Wolfe: *Quebec Hill; Or, Canadian Scenery. A Poem in Two Parts. By J. Mackay*, edited by D.M.R. Bentley (London, Ontario: Canadian Poetry Press 1988), lines 177–85.

51 Joel Barlow, *The Vision of Columbus* (Hartford: Hudson & Goodwin 1787), 161. This passage appears verbatim in Joel Barlow's *The Columbiad* (Washington: Joseph Milligan 1825), lines 287–92.

52 Ibid., lines 262–70.

53 William Dunlap, *History of the Rise and Progress of the Arts of Design in the United States*, (New York: Benjamin Blom 1965), 102.

54 Louis Winstock, *Songs & Music of the Redcoats* (London: Leo Cooper 1970), 58. The song was originally known as "Why, Soldiers, Why?" It was sung publicly as early as 1729. See also Anon., "A Soldier's Song," *The Journal of the Society of Army Historical Research* 6 (1927): 249 n157.

55 John Clarence Webster, *Wolfiana*, (Shediac, New Brunswick: Privately Printed 1927), 10–11.

56 Henry Murphy, *The Conquest of Quebec, An Epic Poem in Eight Books* (Dublin: Printed for the author by W. Porter 1790), 243, 298.

57 A print with a slightly improved composition was published in 1802 in which Wale's design was modified by the engraver Hamilton and transposed into a horizontal format.

58 Gertrude Seidmann, in "Nathaniel Marchant, Gem-Engraver," *The Walpole Society* 53 (1987): 73–4, no. 127, fig. 129, dates Marchant's sardonyx intaglio, which she calls one of his masterpieces, to before 1789. Schiavonetti's engraving was made for Sir Richard Worsley, the owner of the gem, to illustrate volume 2 of his *Museum Worsleyanum or a Collection of Antique Basso Relievo's, Bustos, Statues and Gems ...* (London: n.p. 1794–[1803]).

59 Benjamin West's Indian was replicated and used in a different environment by an ingenious printmaker of the period. He placed the Indian in the foreground overlooking Niagara Falls in a reproduction of an illustration from Father Louis Hennepin's *Nouvelle Découverte d'un trés*

grand Pays situé dans l'Amerique, first published 1697. The print with West's Indian at Niagara does not seem to have been published as originally intended. The two examples of this print known to the author (McCord Museum and University of Toronto Fisher Library) are both inscribed in hand "H Fussli fecit." The lettering of the print indicates it was intended for a book by Henry Vernon. I have been unable to find any such book. The plagiarizing printmaker was probably a member of the Zurich Fussli family, probably Heinrich IV Fussli (1755- 1829).

60 Charlotte Cowley, *The Ladies History of England from the descent of Julius Caesar to the summer of 1780* (London: S. Bladen 1780), plate between 546–7.

61 Cowley's description of General Wolfe was taken from the *London Magazine,* November 1759, or from one of the several other journals and newspapers that printed the same text.

62 The appearances of Wolfe in novels of the period are listed in Robert Bechtold Heilman, *America in English Fiction 1760 – 1800* (New York 1968, repro. 1937, Louisiana State University Press), 88 and note. As well as the works discussed below Heilman's list included the following: Ms. Rowson, *Mentoria* (1791); Ann Thomas, *Adolphus de Biron* (Plymouth: For the authoress 1794); Anon., *A Collection of Scarce Curious and Valuable Pieces, Both in Verse and Prose* (Edinburgh: T. Ruddiman & Co. 1773), 18ff; Anon, *Memoirs of an Unfortunate Queen* (1776) 246–7; Samuel Jackson Pratt, *The Pupil of Pleasure* 2 vols (1776), 2: 62; Anon., *Adventures of a Hackney Coach* (Dublin, 1781), six-line poem on Wolfe on p. 15; Anon., *Argus* (1789), 1: 191; Anon, *The Bastile* (1789), 2: 113; and Scott, *Helena* (1790), 2: 8.

63 William Beckford, *Modern Novel Writing,* 2 vols (London: G.G. and J. Robinson 1796), 2: 156.

64 Herbert Croft, *Love and Madness. A Story Too True in a Series of Letters,* 4th ed. (Dublin: J. and R. Byrn 1786), 97.

65 Harriet and Sophia Lee, *The Canterbury Tales* (London: Pandora 1989), 28.

66 Ibid., 29. Fortunately, Henry survived.

CHAPTER THIRTEEN

1 In a musical version of Dunlap's *The Glory of Columbia,* which opened on the New York stage in 1803 and which was produced regularly for the next forty-four years, the audience was invoked to,

　Behold Montgomery in the north,

　Rush like the tempest furious forth,

His virtue, truth, and courage vain,

Like Wolfe he sinks on Quebec's plain,

A glorious death his only gain.

Grenville Vernon, *Yankee Doodle-Doo. A Collection of Songs of the Early American Stage* (New York: Payson & Clark 1927), 75.

2 See H[enry] D[rury], *Ode to Major-General Simcoe* (Exeter: Trewman & Sons [1798]).

3 See Anon, "To the Memory of Generals Wolfe and Moore," *Quebec Mercury*, 1 March 1914, 66.

4 J.M. LeMoine, *Picturesque Quebec* (Montreal: Dawson Brothers 1882), 504.

5 William Thackeray, *The Virginians* (1857–59), chapter 19.

6 Ibid., chapter 49.

7 Gilbert Parker, *The Seats of the Mighty* (Toronto: McClelland and Stewart 1971), 145.

8 Thackeray, *The Virginians*, chapter 19.

9 John Playfair, "An Account of the Life of Robison," *Transactions of the Royal Society of Edinburgh* 7, reprinted as "Life of Robison," in *John Playfair's Works ... with a Memoir* (1815): 126–7. The story is retold by Henry MacKenzie in *An Account of the Life and Writings of John Home, Esq.* (Edinburgh: Archibald Constable & Co. and London, Hurst, Robinson & Co. 1822), 17 note. The next appearance of the story was in an essay by William Hazlitt published in the *Literary Examiner* (September–December 1823). See *The Complete Works of William Hazlitt*, edited by P.P. Howe, 21 vols (London and Toronto: J.M. Dent 1932–34), 20: 128.

10 Scott to Southey, 21 September 1830. *The Letters of Sir Walter Scott*, edited by H.J. C. Grierson, 12 vols (London: Constable 1932–37), 11: 392.

11 Robert Southey to Sir Walter Scott, 26 September 1830, *New Letters of Robert Southey*, edited by Kenneth Curry, 2 vols (New York: Columbia University Press), 2: 356.

12 The *Elegy* was an unusual book for Wolfe to own. All the other titles known to have been owned by him were strictly connected with his profession of arms, for example Humphrey Bland's *Treatise on Military Discipline* (1727), Thomas Lediard's *Naval History of England* (1735) and *Les Rêveries ou Mémoires sur l'art de la guerre de Maurice Comte de Saxe* (1757). It was even said that when he fell at Quebec he had in his pocket John Barker's *Treasury of Fortifications* (London, 1707). Wolfe admitted that he was not widely read and claimed that he wanted to "repair the damages" of his limited education. Wolfe to Rickson, 2 April 1749, Arthur G. Doughty and G.W. Parmelee, *The Siege of Quebec and the Battle of the Plains of Abraham*, 6 vols (Quebec: Dussault 1901), 6: 2. For the dozen

titles, with one exception on military subjects, once owned by General Wolfe and now in the National Library of Canada, see Michel Brisebois, "Books from General Wolfe's Library at the National Library of Canada," *National Library News*, 28 (February 1996), n.p.

13 Robert Wright, *The Life of Major-General James Wolfe*, (London: Chapman and Hall 1864), 575. Elizabeth Burton, in *The Georgians at Home 1714–1830*, (New York: Scribner 1967), 294n, said, "Gray's famous *Elegy* ... was once disliked by many a school child in Canada, where it was a 'set poem,' chiefly I feel because General Wolfe recited it to his men whilst crossing the St. Lawrence to scale the Heights of Quebec."

14 Thomas Carlyle, *The History of Fredrich the Second, called Frederick the Great*, 6 vols. (New York: Harper 1862–74), 5: 446.

15 [John Strachan], "Letter to the editor," *Quebec Gazette*, 7 June 1804. For the proposed monument see L.F.S. Upton, "The London diary of William Smith, 1803–1804," *Canadian Historical Review* 47 (1966): 146–8.

16 Barry Cornwall [Bryan Waller Procter (1787–1874)], "Wolfe & Montcalm," ms. poem dated 1860, NA, Northcliffe Collection, C-370.

17 *The Centenary Volume of the Literary and Historical Society of Quebec 1824–1924* (Quebec: L'Evenement Press 1924), 174–5.

18 Louis Fréchette, *Poems of a Snow-eyed country*, edited by Richard Woollatt and Raymond Souster (Toronto: Academic Press 1980), 68.

19 *The Royal Magazine* 1 (December 1759): 310.

20 Jean Trudel, "A propos de la statue de Wolfe," *Vie des arts* 59 (summer 1970), 35, transl. 78.

21 The sesquicentennial of the battle was marked by naming of streets after Wolfe in Quebec and elsewhere. A community in Saskatchewan was named after Wolfe. The names of Wolfe Cove, Wolfe County, and Wolfestown in Quebec, Point Wolfe River in New Brunswick, Cape Wolfe and Wolfe Inlet in Prince Edward Island, and Wolfe Island in Ontario all date from the eighteenth century.

22 *The Proposed Wolfe Memorial Church in Quebec*, pamphlet by William Wood, 59 Grande Allée, Quebec, dated 10 December 1913.

23 See *Wolfe: His Association with Bath* (Bath: Bath Chronicle Office [1908]), a pamphlet "Issued on occasion of Sir Gilbert Parker unveiling a mural tablet on the residence of General Wolfe No. 5 Trim St."

24 Adolph[us] E.L. Rost of Oxford also created a maquette for a monument to Wolfe showing a boyish general with outstretched hand lifted up in benediction. In the maquette Wolfe stands on a short column with four kneeling men on a plinth – representing the different forces of the period. Photograph in NA, Horn Collection, MG18, N51, vol. 1, file 2.

25 *Souvenir of the Service held at St. Alfege Church Greenwich on Friday, Nov. 20th, 1908 on the occasion of the unveiling on the 149th anniversary of his burial, of a mural tablet*, 15.

26 The collections include those created by David Ross McCord, who presented his material to McGill University in 1919; John Ross Robertson, whose collection was given to the Toronto Public Library; John Clarence Webster, who turned over his collection to the New Brunswick Museum; and John Horn, whose scrapbooks on Wolfe are in the National Archives of Canada. The other great collector of the period was the Dominion Archivist Sir Arthur George Doughty, who acquired vast quantities of material on Wolfe for the National Archives of Canada, including transcripts made of the material in the large Wolfe collection of Frank Sabin.

27 *New Britain* 42 (July 1993): 4.

28 *The American Film Institute Catalogue of Motion Pictures Produced in the United States*, executive editor Kenneth W. Munden (New York: R. R. Bowker 1971–), 1: 1052.

29 W. Stephen Bush quoted in *The Moving Picture World*, 23 May 1914, 1061, advertisement, and 30 May 1914, 1224, advertisement. Bush's preliminary story on the film was printed in *The Moving Picture World*, 1 November 1913, 472 and his review was published in *The Moving Picture World*, 21 February 1914, 954–5.

30 "'Wolfe' is Spectacular," *The New York Dramatic Mirror*, 27 May 1914, 34.

31 A more recent reproduction, in this case quite loose, of West's *Death of General Wolfe* in a film occurs in the scene of the death of General Reynolds in *Gettysburg*, directed by Ronald F. Maxwell (Turner Pictures, 1993). The exotic uniforms of the Zouaves make up for the absence of the colourful Indian in the scene.

32 For a Canadian native artist's response to West's picture, see *KANATA: Robert Houle's HISTORIES* (Carleton University Art Gallery, 1993).

33 See also J. B. Handelsman, "Mortally Wounded at Quebec Wolfe Forgets His Last Words," *New Yorker*, 1988, NA acc no. 1988–293–1.

34 Margaret Atwood, *The Robber Bride* (Toronto: MacMillan Bantam 1993), 25.

35 Simon Schama, "The Many Deaths of General Wolfe," *Granta* 32 (Spring 1990): 14–56, reprinted in *Dead Certainties (Unwarranted Speculations)* (New York: Alfred A. Knopf 1991), 3–70.

36 Jonathan Richardson, "An Essay on the Theory of Painting," in *The Works of Mr. Jonathan Richardson* (London: n.p. 1773), 24.

37 Reverend Robert Bromley, *A Philosophical and Critical History of the Fine Arts, Painting, Sculpture, and Architecture* (London: Printed for the Author, 1793), 59.

38 *Le Sort de l'Amérique,* National Film Board of Canada, 1996, C 9296 062. The film is described on the videocassette cover as "a sometimes funny, sometimes moving, always ironic account of the meeting between play-write René-Daniel Dubois and documentarist Jacques Godbout on the minefield of history."

39 Martine Rainville, "Jacques Godbout, A Happy Phoenix," *Point of View* 30 (Fall 1996), 15.

40 J[ohn] P[ringle], *The Life of General James Wolfe, The Conqueror of Canada: Or, The Elogium of that Renowned Hero, Attempted according to the rules of elo-quence, with a Monumental Inscription, Latin English, to perpetuate his memory* (London: G. Kearsley 1760), 25.

Index